Performing Policy

Performing Policy

**How Contemporary Politics and
Cultural Programs Redefined
U.S. Artists for the
Twenty-First Century**

Paul Bonin-Rodriguez

First published 2015 by
PALGRAVE MACMILLAN

Palgrave Macmillan in the UK is an imprint of Macmillan Publishers Limited, registered in England, company number 785998, of Houndmills, Basingstoke, Hampshire RG21 6XS.

Palgrave Macmillan in the US is a division of St Martin's Press LLC, 175 Fifth Avenue, New York, NY 10010.

Palgrave Macmillan is the global academic imprint of the above companies and has companies and representatives throughout the world.

Palgrave® and Macmillan® are registered trademarks in the United States, the United Kingdom, Europe and other countries.

ISBN: 978–1–137–35649–9 hardback

This book is printed on paper suitable for recycling and made from fully managed and sustained forest sources. Logging, pulping and manufacturing processes are expected to conform to the environmental regulations of the country of origin.

A catalogue record for this book is available from the British Library.

Library of Congress Cataloging-in-Publication Data

 Bonin-Rodriguez, Paul.
 Performing policy : how contemporary politics and cultural programs redefined U.S. artists for the twenty-first century / Paul Bonin-Rodriguez.
 pages cm
 ISBN 978–1–137–35649–9 (hardback)
 1. United States – Cultural policy – 21st century. 2. Arts and society – United States – History – 21st century. 3. United States – Civilization – 21st century. I. Title.

NX705.5U6 B66 2015
700.1'030973—dc23 2014029179

Transferred to Digital Printing in 2015

To Hank

Contents

Prologue viii

Acknowledgments xvii

1 Introduction: Performing Policy 1

2 A Politic of Purpose: "The Arts and the
 Public Purpose" (1997) 29

3 New Work Now! The Austin New Works Theatre
 Community (2012) 50

4 Accounting for Capital: The Creative Capital
 Foundation (1999–Present) 71

5 A Survey Course: Teaching Artists and/as
 Producers (2013) 90

6 Linking Creative Investments: *Investing in Creativity*
 (2003) and LINC (2003–2013) 107

7 Proposing Place: Creative Placemaking
 (2010–Present) 127

8 Coda: Performing Policy 142

Notes 147

Bibliography 188

Index 201

Prologue

I used to say that I made my first full-length solo performance, *Talk of the Town*, for less than $100, and that $100 began my career as an independent performance artist. Part of the $100 paid for two baseball caps, which cost me $16. Onstage, in addition to some old jeans and tennis shoes, I wore a new t-shirt, which I got on sale for $8. My props were limited to a towel from home and a chair I found backstage at the theatre. A friend took the promotional photos *gratis*. Film and processing cost about $45. Another friend designed the poster for free. I spent $24 for flier replication, which I distributed at bars and restaurants throughout San Antonio. The year was 1992, and we had something called the personal letter. I sent out 200 handwritten ones inviting friends and acquintances to come to "my show." I spent $58 on stamps. The actual subtotal here is $151, so it should be clear from the beginning that there was more pretense than precision in my $100 claim.

In February 1992, on the first two nights of my first full-length show at Jump-Start Performance Co., I drew crowds of nearly 100 each night, an overwhelming number given that the theatre had only 50 seats. Many audience members sat on carpet squares spread along the apron of the stage. I split the box office revenue with the theatre after we had deducted for costs. My take was about $600. I paid the lighting designer $150 with the income. A longtime friend contributed $300 to pay for the making of a promotional video. Supplies and reproduction quickly added another $100. I used to say that I spent $100 to make my first show, but my expenses actually added up to $701, while the income, both earned and donated, added up to $900.

At first glance, I made a net profit of $199; however, were I to consider the whole budget more holistically, I would find more shortcomings. These expenses do not account for the labor of friends and family who gave time, expertise, and even materials. My grandmother provided the envelopes and helped me stuff and stamp them. My own labor costs would also include the time spent writing both the show and invitations and distributing the fliers, as well as the subsequent letters to theatres and spectators, the video replication, the press packets, and the postage for all the performances spaces where I then proposed work. The postage and supplies (t-shirt, fliers, envelopes), as well as the professional services (lighting design, video production), appeared as itemized deductions on

my taxes at year's end. I was already learning the value of archiving my costs and keeping track of my contracts in practice, although I was not always owning up to them in my story of a $100 performance.

These expenses also fail to include the trip to North Carolina I made in August 1991 to attend Alternate ROOTS, a meeting of community-based artists who have formed a core of influence for me. At ROOTS, I shared my work-in-progress with a number of performance artists and critics, including Tim Miller, Keith Antar-Mason, Katherine Griffith, Keith Hennessey, Jane Goldberg, Linda Burnham, and Ann Kilkelly. After ROOTS, Tim made it possible for me to perform at Highways Performance Space in Santa Monica, CA, in November, on a mixed bill of queer-themed work titled "Five Sleazy Pieces." I paid for my transportation and expenses, and Highways provided the housing. I split the box office earnings with Highways and the four other performers. I made less than $100, but I secured a slot for the summer of 1992 in Highway's Ecce Lesbo/Ecce Homo Performance Festival, a prominent festival of queer work. The Highways gig snowballed into others. That summer, I also appeared at Josie's Cabaret and Juice Joint in San Francisco's Castro and Hot!, a Celebration of Queer Culture at Dixon Place in New York's Bowery.

The trio of appearances in the summer of '92 represented a "touring history" upon which I would soon build a career. I returned to Josie's and to Highways several times each over the next three years, presenting later iterations of Johnny's story or bringing other work. The return engagements, when coupled with new bookings, would provide me with a sense of career momentum. Each new step up felt less steep than the last, yet each new risk felt greater, given that I was now competing with my own history. I was also having to manage relationships with the presenters, collaborators, journalists, and returning audiences who now represented stakeholders and the future viability of my work.

My $100 story does not take into account the contributions of mentors and friends who helped my works find a home. I owe much to Jump-Start Performance Co.'s artists and administrators, especially Steve Bailey, who managed the theatre from its inception until 2011, and who has been one of my long-term collaborators. The late Sterling Houston, who became my brother in the worlds of writing and performance, was the theatre's longtime artistic director. Jump-Start was my performance home for 18 years. I owe much to the 30 or so artists who have been Jump-Start company and staff members, donating time, creativity, labor, and money to keep the company going. My early career also owes a lot to Tim Miller, who encouraged me to try that first work at ROOTS. I met

up with Tim in Houston in January 1992, just two weeks prior to the premiere of the whole show to share my in-progress piece. In a hotel coffee shop and in completely apologetic tones, I read him my second act. "Keep going, Paul," I remember him saying. "It's lovely; it works."

Nor, finally, does my $100 story take into account my opportunity costs, namely the contract that I turned down the day after *Talk of the Town* first closed in San Antonio in February 1992. Jump-Start had offered me a second run in April which I wanted to do; however, I was scheduled to rejoin the Colorado Ballet for a tour of *Swan Lake*, but the ballet's tour dates would prohibit me from taking up Jump-Start's offer. One hour before the plane took off from San Antonio to Denver, I called the ballet and backed out. Although I had been late in doing so, I felt I had made a powerful decision on the direction of my life.

My work was inspired by that of other queer performers I had seen, or would see, including Tim, Holly Hughes, Luis Alfaro, and Carmelita Tropicana. I was taken by their political savvy, their AIDS activism, their comic skills, and their provocative tales of queer and Latino/a survival and joy, but I was also challenged by the fact that they depicted being queer as an urban trope, something that happened in New York, Los Angeles, or San Francisco. I saw no rural representation, and I wondered what it would be like to be queer in small town Texas (as I had been), to be healed from what had been a violent experience (as I needed to be), but also to find joy while still there (which I desperately wanted to believe was possible). What would it be like to recast my history in a supportive community of a theatre space, especially at a time when a very conservative Christian culture war was reminding me daily, on the national stage, my homespun experiences of being an outcast?

I was fortunate that identity-based work was big at that moment. My show was about all things Texas: the small town where I spent some formative years, queer desire, feeling rewarded for one's work. The show's tagline was "A Sexy Tale of Tex-Mex Queerhood" to indicate the hyphenated nature of a relationship that emerges in the show, but it also belies the hyphenated nature of my own identity. The show's description was something like, "Johnny, an irrepressible small-town sissy boy and fast food worker finds love, lust and Lady Bird Johnson at the local Dairy Queen." Johnny's candid accounts of entitled fundamentalists who came for "Wednesday night Christian Steak Fingers Special," of charming and unself-conscious drive-through customers, and naked runs in the sprinklers of a football field were Texas-based stand-ins for the freedom-of-expression arguments on the national stage. Also, at the

heart of the show and its successors was my own desire to feel at home in my skin, in my town, in a state of mind called Texas.

Johnny's early popularity, as well as the fact that he/I still had tales to tell, prompted me to pursue a serialized route. Johnny's second solo show, *The Bible Belt and Other Accessories* (1993), was also a success, as was the third, *Love in the Time of College* (1994). Within two years of my first work, I was making a living as an artist from my home in San Antonio. The bulk, though not all, of my touring was between 1992 and 2001, which for the arts was a period of relative stability and growth, sandwiched between two recessions. Yet the decade of the 90s was also the time when many artists were relocating to New York, Los Angeles, and San Francisco to find work, the places where I was regularly touring.[1]

The enduring run of those first shows provided a revenue stream from which I pursued additional projects. Owning up to my own urban existence, I left country tales and fast food far behind. In subsequent shows like *Memory's Caretaker* (1999), *Quinceañera* (1997), *Simplicity* (1995), *Katherine's Joint* (2001), *The Great Chittlin' Debate* (1996), *Fringe and Fringe Ability* (2004), *Higher Planes* (2006), and *A Ranch Home in Manhattan* (2009), I wrote more about my Latino identity, race, class, culture, belonging, the legacy of Vietnam and the war in Iraq, mental health, and AIDS.[2] Only some of these were solo shows; several of those works were collaborations that followed a longer development process common to theatre. Working with colleague artists and designers, I fundraised and tried out the shows in more than one city before the official opening.

Early success was a great thing; it was also a terrible thing. Having to top one's self can be harrowing. Too often, I feared my accomplishments were serendipitous more than anything else. I did not always think about process in great detail, but assumed it was my job to make my work in private and then bring the show to an audience. "Working in private" as a writer-performer still meant writing the show, which took months of editing and revising; writing the press releases; getting the posters designed, printed and distributed; hiring the lighting designer, costume designer, and director; securing the space; writing personal letters and making phone calls to all those who would come; hiring a camera crew, editing videos; designing and affixing labels; contacting presenters; and sending out press packets and proposals to the spaces across the nation. What my fears of serendipitous success revealed, then, was that I was collapsing all that went into the process, abstracting my labor and that of those who had to work with me, even downplaying what represented our shared accomplishments in a successful production.

Part of my doubt and blindness came from my background. I had not been trained to think of my work from the standpoint of an arts producer. In undergraduate studies, I focused on creative writing, but I also trained as a dancer. Later, I pursued master's studies in communications and worked as a writer-producer for a television documentary series about US Latinos called *Heritage/Herencia*. There I learned to edit, to write press releases, and to title segments, but also how to efficiently guide a production crew so that none of the limited resources were wasted. All of these skills were critical to my art making, to organizing my work, and even to playing different roles both onstage and off. Ballet training gave me physicality but also taught me to devote, even forgive, long hours spent pursuing an ideal rather than a workable solution. The fact that a dancer considers himself lucky if he is working at all contributed to my meekness in contract negotiations. Likewise, the fact that television segment producers run on tight schedules to adhere to production schedule meant that I was accustomed to "doing whatever it takes" in limited time to get the show in shape. From the outset, I did not trust process, nor did I feel comfortable presenting "a workshop production" rather than a final version.

Perhaps because of all of these circumstances, both relational and processual, I saw my career through a lens that looked something like the glasses one gets at a 3-D movie. The tint of one lens was colored by *opportunity*; the other was *obligation*. Part of this conscientiousness arose from the fact that I came to my craft during the culture wars of the 1990s, the period when debates over the public funding of the arts dominated the national stage and threatened the future of all the theatres where I toured. In San Antonio, my colleague artists and arts organizers and I experienced the culture wars of the 1990s as a local phenomenon. A city councilman who ran on a conservative platform sought to redirect arts funding from hotel occupancy taxes (HOT) to the well-endowed San Antonio Sports Foundation. The move ultimately contributed to a series of cuts to the city's cultural budget. Although the bulk of cultural funding went to the major organizations (with budgets over $2 million), the small amount given to the small and mid-size organizations was critical to our survival. Like many, I joined the protests, signed up to speak at city hall, polished my rhetorical skills, and generally grew deflated that the folks sitting on the dais, including Councilman Sports, were not paying attention.[3] The city's moves against arts funding also led to the defunding of the Esperanza Peace and Justice Center in 1998 for its support of a Lesbian Gay Film Festival. The subsequent lawsuit, the *Esperanza Center v. the City of San*

Antonio (2001), was the first test case for *The National Endowment for the Arts v. Finley et al.* (1996), the case that capped off the culture wars of the era.[4] In a landmark ruling, San Antonio District Judge Orlando Garcia argued that the Esperanza Center had been unjustly targeted for its association with historically marginalized groups—women, people of color, and queers. Suffice it to say that in my South Texas city, as in the small town of my youth, as in the fast food kitchen onstage, I felt in the center of the nation's cultural divide.

Nationally, I also saw myself obligated to the arts presenters who had become friends, whose life stories, successes and health crises I knew well. My job was to produce a great show, but also the copy and the photos that would bring in audiences. My job was to fundraise and to secure contracts to pay all those who worked with me. My job was to reach out to those individuals and journalists I had met while traveling and to shill my show by passing out fliers late at night on the streets of whatever city I was in, to give a good workshop, to stay for the postshow discussion, to write a thank-you or a testimony for a grant, even to read a grant in process, and to make a donation—or rather, capital reinvestment in my field.

When city, state, and federal grant-giving organizations asked me to serve on panels, I considered it my duty to assess the project narratives and study the budgets to the best of my ability and to participate in the policy discussions that happened at the end of each. When asked to serve on the board of local and national arts organizations, I said yes to ensure the future of my artistic homes and hideaways. A writer friend of mine told me that at one point she realized that to get her work done she had to eschew all board and panel service. I thought, that may work for a writer, but for a community-based writer-performer artist-citizen, it just won't do.

Sitting with arts administrators, I noticed the gap between our respective approaches and concerns. The artists I knew tended to focus on more immediate questions, like the next gig or their new show, in plain and simple language. Arts organizers and policy experts deployed a common vernacular to explain phenomena in the arts sector. Phrases like "mission creep," "founder's syndrome," and "capacity building" encapsulated complex dynamics in some cases, untested hypotheses in others. I was just finding my way in these processes myself and often felt that my staged performance of Johnny's naiveté was a stand-in for my own as an artist.

At the same time, the language used by my arts-organizing colleagues also revealed that they had codified certain practices and assumptions

and learned to render them in shorthand to turn their attention to long-term strategizing, which was tied to some aspect of their organizational funding. I had not yet begun to think how I might plan to sustain my work over the long term. My funding came from one-off tour dates and short-term project-specific grants. More than once, I fell deeply into debt and jumped out of it thanks to some grand, lucrative art gesture or compact touring period. My body and spirit were getting tired, and I was nowhere nearer planning for the future.

Determining my value—or at least the price the market would bear—remained challenging. Sometimes I thought that my work in San Antonio should be free because I knew the struggles many local cultural organizations went through, and sometimes I thought I should be well paid to set a standard. In negotiating my contracts, I could act with magnanimity or toss out a series of microaggressions, concerned that if I gave up a bit of ground I was showing I was weak. Materially, I had no sure footing. It wasn't that I didn't think about money. I just didn't know how I should think about money and support for me. Depending upon the organization or the booker, the price went up or down. In negotiating my contracts I often imagined myself as part of a spate of performers. A low figure from me could make it harder for others. Yet when I arrived at the performance spaces, I often found them taxed, facing deficits, their administrators doing the work for love in the absence of money, and I was reminded that the arts economy was as much a mystery to others as it was to me. It took a long time for me to realize that a performer's demands, when combined with his track record, his relationships to community, and his planning and marketing resources, offer to organizations the means to fundraise and grow. Such are the *upward demand dynamics of nonprofit fundraising.*

Did I see my board service as building up critical skills or just as demanding service? That depended on my mood, which was often informed by my exhaustion. Did I think of myself as a policy expert, or an individual building up grassroots policies? Honestly, I was more comfortable thinking about audiences with respect to the space than with organization building. I took refuge in the moment the house lights went to half and the stage went dark before coming up with a slow 1–2–3, and I could launch into a monologue or scene.

It would take me a long time and a lot of study to realize that what we are calling the creative sector today was and remains remarkably avowed and supportive. It would take a long time for me to see the full commitment reflected by all of its players—the artists, arts organizers, policy scholars, teachers, and even many in government. It would take even

longer for me to shift my lens from *obligation* (a word that implies a debt) to *partnership* (a word that implies exchange). That intellectual shift was made possible when I finally acknowledged that a working artist already shares a coleadership role in the arts sector through production but also through the amount of organizing required of him to make art. As I demonstrate in this book, the moves in contemporary arts and culture policy that have happened since the 1990s follow on two principles—opportunity and partnership—and the acknowledged combination of these two principles makes the biggest intervention on practice in recent history. The question remains how to make the opportunities evident, the terms of partnership legible, and the relationships between artists and communities long lasting.

An economist reading my story would easily point out the theme of scarcity underlying the narrative—the beleaguered company and perhaps even the mid-career slump that hit me when I had begun to grow tired and wonder if I could keep up the energy. The scarcity present in my story regularly manifested itself in discounted labor, the volunteer time spent with local arts organizations, including a dance service organization I co-founded. As cultural economists have long observed, many arts professionals, especially artists, willingly discount their labors by accepting nonmonetary rewards in and for the process of making art. Discounted labor is a broad category, insinuating a number of possible commitments, presumptions, and circumstances. The visual artist who parts with a painting or sculpture for less than she paid for in materials has incurred opportunity costs, living expenses, and perhaps even studio time. The choreographer whose spends commissioning monies on studio time, musicians, other dancers and costumes, but who must barter with a lighting designer at little or no cost may well be discounting labor for all involved. She may be discounting her own work mostly, banking on a box office return or hoping that touring fees will come in after she has gained press and gotten a video. The playwright who joins a theatre company and commits time to writing grants for the company and helping maintain the facility discounts her labor as well.

My brief time with the Colorado Ballet, which began in Tampa, FL, in 1987, shows how discounted labor can be inscribed through practice. In response to declining patronage and the nation's own economic woes, the Tampa and Colorado Ballet companies had teamed up in 1987.[5] The logic of their partnership was based on the idea that dancers constituted the greatest expense for both companies, a problem that could be ameliorated by sharing talent. In this particular configuration, the dancers who were lucky enough to be hired had less bargaining power

since the combination of two companies had resulted from a culling. I joined on a temporary contract as a guest dancer. I was paid a fee of $250 a week from which I had to cover my own taxes and expenses except for ballet shoes. I received no health insurance. I was glad to be dancing, but consistently nervous about the precariousness of my circumstances. Given those memories, the bookings as an independent artist, for which I would make hundreds, even thousands on a weekend, felt like a windfall.

Moreover, the experience of committing to a company like Jump-Start offered a type of altruistic comfort, a belief in reciprocity.[6] As long as I could believe that we were all working for the same purpose, I could stay invested. Each year, Jump-Start struggled to raise funds for its space and its education and production programs, to pay its staff modest wages with benefits. We enjoyed the respect and support of our local arts funders; yet time and again we found ourselves up for major philanthropic money, only to be cut in a final round. As economists William Baumol and William Bowen (1968) had proven decades before, we were clearly living out the scarcity principle underlying the theory of "cost disease," in which organizational commitments to infrastructure overwhelm the nonprofit's capacity to raise new, even adequate, funds.[7] Over time, I began to wonder if the purpose we worked for was more about sustaining commitments in modest measure than really reaching for abundance. More importantly, I wondered how a theory of artists' contributions to practice might signal a way of claiming abundance.

My research and writing in these pages brings together several streams of thought and practice: the experiences of an artist, organizer, and advocate in commercial, nonprofit, and community art forms; the study of a performance scholar who places his more familiar readings in performance and cultural studies, alongside an admittedly less familiar terrain of urban planning and economics; and the crossover artist who has been actively working nationally two decades. By acknowledging these roles, and even highlighting those areas of policy where I am still taking lessons, I seek to make plain, compelling, and accessible a particularly rich period of artist policy development in the United States. In addition, I seek to make clear the rich potential for an artist-driven approach to arts and cultural policy.

Acknowledgments

This book represents the expertise of many artists, arts administrators, advocates, and arts and policy scholars, many of whom play multiple roles and in so doing model the uniquely engaged model for arts policy development this book defines.

A Visiting Fellowship in the Culture and Creative Communities Program of the Urban Institute in Washington, DC, supported me as I began this book and exposed me to the federal side of arts policy. I am especially grateful to Maria Rosario Jackson, who sponsored my work there and continues to offer insights and challenge my work. My thanks also to Rolf Pendall, who directs the Metropolitan Housing and Communities Policy Center. I also benefitted from travel support from the Ford Foundation's Institute of International Education's Global Travel and Learning Fund and the Ginny Williams Family Foundation.

Those who worked at or with LINC generously shared their expertise and insights during its run. Thanks to the many artists and organizers who engaged my work, especially Holly Sidford of Helicon Collaborative, Sam Miller, Judilee Reed, Grisha Coleman, Liz Lerman, Hirokazu Kozaka, Rise Wilson, Candace Jackson, Taya Mueller, Andrew Simonet, Angie Kim, Nicholas Pelzer, as well as Cora Mirikitani, John Killacky, Theaster Gates, Tom Schorgl, Megan Van Voorhies, and Diane Scott.

Likewise, the many artists who worked on the Austin New Works Theatre Community generously contributed their insights and shared their work. I thank Bonnie Cullum, Caroline Reck, Etta Saunders, Heather Barfield, Shawn Sides, Brad Carlin, Jenny Larson, and Conor Hopkins for always keeping me in the loop. I thank Katie Pearl, Diane Ragsdale, and David Dower for providing insights to the project as well.

This project could not have been possible without the input and inspiration of Ruby Lerner, who continues to lead Creative Capital's innovative programming.

Dr. Alberta Arthurs and David Mortimer inspired my research at a critical moment and generously provided me with materials and feedback throughout the writing process. I thank Mr. Mortimer for so generously sharing the work of the American Assembly with me. I thank especially Dr. Arthurs, who continues to be a leader in thought and organization when it comes to exploring and expanding the public purpose of the arts.

My students at the University of Texas at Austin also provided insight at critical moments. Thank you Scott Blackshire for your contributions to the first-year study. Thanks also to Natashia Lindsey, Lydia Nelson, Bart Pitchford, Russ Dembin, Katie Van Winkle, Nicole Martin, Abimbola Adelakun, Meredyth Pederson, Oladotun Ayobade, and James McMaster.

Caron Atlas, Jan Cohen-Cruz, and Ann Markusen enaged my work at critical moments. Other colleagues and experts who have generously provided support and offered insights include Roberto Bedoya, Jamie Bennett, Steve Bailey, Clare Croft, Linda Essig, Gary D. Beckman, Aaron Landsman, and Sixto Wagan.

My research for this project was well supported by the University of Texas at Austin and other Austin-based collaborators. Many thanks to my administration in the College of Fine Arts for supporting critical research leaves and funding the research necessary for completing this book.

I am also grateful to my colleagues at the University of Texas at Austin who continue to encourage my work as artist-scholar. Charlotte Canning, Omi Osun Olomo/Joni. L. Jones, Deborah Paredez, Rebecca Rossen, Andrew Carlson, Laura Gutierrez, and Joe Randel, thank you for challenging me, inspiring me, and encouraging me. Megan Alrutz, David Justin, Roxane Schroeder-Arce, Jim Glavan, and Brant Pope have directly supported my work on this manuscript and continue to encourage my efforts to integrate theory and practice. Douglas Dempster and Francie Ostrower engaged my thinking at critical times and remain great resources. Beth Kerr, our fine arts librarian, has been an amazing resource and ally.

I owe a tremendous gratitude to Susanne Shawyer, who worked closely with me as I brought this document together, as well as Shannon Baley who generously reviewed the work with me. Nicole Gurgel provided insights at critical times. Jaclyn Pryor came to my aid more than once.

To my editors and readers on this project, I am grateful for your keen insights and constant encouragement. Paula Kennedy and Peter Cary, thank you for championing and guiding me through this project.

The cover photo for this book was generously provided by Grisha Coleman, the choreographer and creator of *echo::system*, photographed by Heidi Reigler, and portrays Monstah Black [aka Reginald Ellis Crump], Anitra Brooks, Soomi Kim, and Sherwood Chen. Thank you for your amazing work.

Finally, much love and gratitude to my family and friends who continue to support my life and work in academia and theatre. Academic

careers can be taxing on everyday commitments and longtime connections. I thank you for your understanding and graciousness in my long and many absences. Thank you so much, Mom, Stephen, Carlos, Andrea, and Ginny for your support throughout this project. Thank you to my many colleagues at Jump-Start for many years of great work and comradeship. Thank you, Gustavo, Steve, Margery, Zach, Matt, Kyle, and Michael. Thank you Jan, Julius, Fitz, and Margo. You all helped me bring this book to fruition.

Finally, Hank, thank you for your ongoing support, encouragement, and cheer.

1
Introduction: Performing Policy

Performing Policy demonstrates how a movement in arts and cultural policy begun in the 1990s redefined US artists' roles in American society and enhanced their prospects for the twenty-first century. What I am labeling a movement can be traced to a vast and still-growing archive of "gray literature," the policy position papers (aka "white papers") and scholarly monographs on arts and cultural policy and planning that began appearing in the late 1990s. These documents and the meetings from which they emerged countered the claims of a culture war that dominated the last decade of the twentieth century. Upon the publication of these reports, a number of arts initiatives soon followed. Artist-focused foundations and programs emerged to support artists' capacity to contribute to vibrant cultural communities. Their progress was charted by their metrics, the "findings" that contributed to more innovations, additional studies, and programmatic evaluations.

The multiplying effect of policy to practice and back again continues even today, manifesting greater opportunities as well as deeper understandings about what the arts and artists bring to the nation and what they require to work well. Broadly, contemporary arts-focused studies tease out old dichotomies that once relegated "art" to the museum, the symphony hall, or the opera house and the artist to her studio. Observing that for too long the nation has focused on the European high arts, they call for cultural projects that engage the specifics of place. Acknowledging that twentieth-century arts policy relied too much on the nonprofit arts instrument and the leveraged grant model, they propose new models for arts support, greater recognition of the for-profit and community cultural sectors, and even time-based programs

1

that maximize innovation in the short span of a decade, and then go away to make room for new ones.

As a set of *"decisions (by both private and public entities) that either directly or indirectly **shape the environment** in which the arts are created, disseminated, and consumed,"* today's cultural policy efforts represent an admixture of ongoing political, social, and economic projects.[1] Contemporary cultural policy theorists regard art and art making as critical "texts" of everyday life, practices that mark and mediate distinct cultural locations.[2] For the first time in the history of US arts policy, a number of policy-informed initiatives also address the nation's culturally and ethnically specific communities.[3] As a result, today's artists are often tasked to reframe their identities and articulate their practices to demonstrate how their skills and ways of thinking uniquely testify from and about a particular public, a municipality, and a nation. I am concerned with what these materials, as an archive that determines policy's and philanthropy's practices, have to offer artists directly. While a number of cultural policy scholars, economists, political scientists, and bloggers continue to follow new trends, gather data, and forge new policy directions, the sum of innovations has not been assessed in such a way that the implications translate readily to the artists. By reading contemporary cultural policy development, contextualizing those roles historically, and rehearsing their scenarios, I propose to bring cultural policy and artistic practice into a productive conversation—one that illustrates how artists can more effectively become the agents and cocreators of policy's work.

Performing Policy proposes that the lens of performance analysis focusing on contemporary cultural policy development can effectively illuminate the players and their practices and offer a new way of thinking through the requirements of being an artist in the United States. I use performance both to describe an intentional practice—a "doing" to quote linguistic theorist J. L. Austin—and a type of optimization, as in "job performance."[4] Performance studies, as a "multivocalic," intersectional discipline that emerged in the academy in the 1970s through the shared interests of anthropology, theatre studies, and the visual arts, offers a precise and multifaceted lens from which to read contemporary arts policy.[5] The locus of performance studies' analysis is embodiment, the ways in which performing subjects represent and also shape human relations through lived interactions. Embodiment cannot deny particular subjectivities at play—race, class, gender, sexuality, age, ability, and citizenship status among them—and so its presence is already in conversation with contemporary policy analyses.

The artist as producer, or the artist-producer

Since the late 1990s working US artists—writers, musicians, visual artists, and performing artists[6]—have been charged to function as *producers* of their creative works as well as the creative visionaries of their art. In addition to their art making, artists in the United States must regularly attend to concerns of financing, space, staffing, training, marketing, and contracts, among other concerns of production. As producers, or *artist-producers*, they now function as multidisciplinary professionals bridging the sectors of art, business, technology, policy, and education. Taking into account the benefits that artists bring to communities as "tradition bearers and cultural workers,"[7] as well as acknowledging the actual costs and expertise required to make lasting cultural and social change, begs the question: how should today's artists reward and promote their practices as well as themselves? While the notion of a struggling artist may still hold purchase in the national imaginary, how might an artist-based theory of contribution to society realize political, social, and economic effects for artists themselves?

By deploying the term "artist-producer," I do not seek to change artists' nomenclature, much less burden artists with cumbersome introductory banter. However, I do want to point directly to the hybrid lens through which contemporary arts and cultural policy literature and organizing increasingly portrays artists and structures their practices. The notion of a "hybrid" identity emerged in postcolonial studies, particularly in the writings of Homi K. Bhabha (1989) through his attempts to dissolve the oppressive division between "the master and the slave" by highlighting the ways that ethnic and cultural traditions can prevail against the totalizing—the homogenizing and hierarchically ordering—forces of global capitalism.[8] Similarly, in my own study, hybridity offers a means to align artists' practices with those of theorists and organizers who have been strategizing on their behalf. Drawing on Bhabha's work, cultural theorists Michael Hardt and Antonio Negri (2000) refer to "hybridity" as a "realized politics of difference" and "liberation" that attenuates post-modernity's presumptions of universality with postcolonial theory's focus on place.[9] Here I use a hybrid approach to offer an embodied agent for place-specific approaches, such as the work of the Pa'I Foundation in Honolulu, Hawaii. There, master teacher Vicky Holt Takamine sustains the tradition of Hawaiian hula through a teaching program and performance company and maintains a community arts space where artists may produce work and find entrepreneurial arts training.[10] My thinking about hybridity is also informed by Mexican cultural theorist

Hector Garcia Canclini. In *Hybrid Cultures* (1995), Garcia Canclini offers three key "levels" of hybrid organization and study. First, hybridity recognizes the necessity of a cross-disciplinary lens, or "nomad social sciences"; second, hybridity works across time, negotiating past tradition with present circumstance; and third, the study of hybrid cultures always takes the researcher beyond the specific "boundaries of cultural research," taking into account "ethnic cultures and new technologies, and artisanal and industrial forms of production."[11] In the same vein, my study uses hybridity to distinguish how artists are also called to work across disciplines, to bridge times, traditions, and disciplines to define the role they play in communities. In a manner consistent with all of these cultural theorists, I deploy the term "artist-producer" for reasons both ontological and epistemological to illustrate the role artists play in communities and support how they think through their practices. Consequently, I use the term "artist-producer" to mark three distinct registers.

First and foremost, when creating work today, *artists often function as the de facto producers of original work and of their own opportunities.* Much of the contemporary cultural policy paradigm is predicated on studies developed since the late 1990s. At that time, economists, urban planners, and arts advocates recognized that the exponential growth of the nonprofit infrastructure between the 1970s and the 1990s wrought an unfeasible system.[12] The 2001 and 2007 US recessions, fluctuations in the market, and even challenges to the nonprofit tax code have further panicked nonprofits and the philanthropies supporting them.[13] The term "artist-producer" indexes the expressive and coproducing role anticipated by nonprofit organizations that require a type of artist who can bring audience-worthy works to the fore. As well-known choreographer Wally Cardona acknowledges, he must also act as an "administrator," a grant writer, a fund-raiser, and a bookkeeper in "a project-to-project world" to produce his work.[14] Contemporary granting programs like the Creative Capital Foundation, which I profile in Chapter 3, situate artists as the capable producers of their artistic vision who work alongside other professionals. At the same time, few artists work solely in the nonprofit sector; many ply their trade in commercial sector jobs, as well as community outlets.[15] Artist entrepreneurship, with its dual focus on "venture creation" and "habits of mind," also responds to this kind of artist-producer.[16] In this study, I embrace artist entrepreneurs, but I do not ask artists as entrepreneurs to embrace uncritically the business entrepreneur's ties to a world in which the rules of supply and demand are more evident and the incentives are primarily financial.[17] The bottom line for

the artist-producer may be more weighted by effectiveness of cultural expression than profit; however, the concerns of adequate resources to see that vision realized and artists rewarded remain of concern. In this capacity, I also share an alliance with "cultural entrepreneurship" and "artist entrepreneurship," the two terms used to hail the creative organizational role artists play.[18]

Secondly, today *many artists also work as producers of public good.* Many contemporary studies of the arts and artists focus on the socially bonding elements of cultural expression—poetry, music, but also urban design, to name a few. Artists animate neighborhoods. Their works bring people into the close alliance of community, but also facilitate dialogue across distinct cultural histories and experiences. Building on the work of Edward Said, Columbia School of the Arts dean Carole Becker identifies artists as "public intellectuals" because they act "as spokespersons for multiple points of view and advocates for a critique of society."[19] Several arts policy theorists have begun to name this type of work in ways that resonate with the artist-producer. Urban policy expert Maria Rosario Jackson (2011) identifies US artists who work at the intersection of art and community development as having "hybrid careers."[20] Performance scholar Jan Cohen-Cruz (2010) uses the phrase "social call, cultural response" to describe contemporary performances that testify to, protest, and intervene on injustices such as anti-immigration movements or the Patriot Act. In doing so, these works pursue "cultural democracy—collective expression of the people, by the people, and for the people."[21] Choreographer Liz Lerman, whose works regularly engage distinct cultural groups, acknowledges: "One reason I have organized my life the way I have, with one foot in the art world and one foot in the community, is my realization that each of these shifts in my goals taught me something useful to take into the other realms of my work."[22] In *The One and the Many* (2011), art critic Grant Kester echoes Lerman's assertion and historicizes the development of a collective ethos among many contemporary visual and installation artists working internationally. Unlike their modernist predecessors, who assumed a critical distance from their subjects, these artists work with communities over long periods of time, developing projects that address complex social concerns and contribute to public needs. Their installations include artistically transformed public parks and housing developments in blighted urban areas in Hamburg, Germany,[23] and beautifully constructed water wells that acknowledge gendered labor divisions and local mores about women's modesty in Kondagaon, Bastar District, Chhattisgarh, India.[24] Kester theorizes that in response to neoliberalism's dedication

"to eliminating all forms of collective or public resistance…to the primacy of capital," a number of today's artists are also less concerned with proprietary interests than social benefits.[25] Similarly, performance scholar Shannon Jackson uses the term "social works" to index politically engaged performances that maintain a materialist critique, but also work toward sustainability.[26] All of these efforts point to Lewis Hyde's assertion in *The Gift* (1979) that the arts exist in two simultaneous economies, "a market economy and a gift economy."[27] I share with him and with all of these scholars a sense that publically engaged artists "illuminate the human condition, contribute to the vitality of communities, and to the broader aesthetic landscape, as well as…promote social change and democratic dialogue."[28]

Finally, rather than coining an ungainly portmanteau, "artistproducer," I have loosely affixed the producer title to the artist with a hyphen and occasionally even say artist as producer, for good reasons. First, as cultural economists point out, artists generally make work with collaborators who have distinct skills that complement production. The choreographer working in concert dance often collaborates with a lighting designer, musicians and composers, costume designers, and stage managers. These professionals represent the "motley crew" required to bring a work to market.[29] Similarly, the choreographer who hires a manager to help with bookings is working to work with someone who can support her. The dancer Deborah Hay, whose solo works, group works, and workshops have all been well-documented, has always hired "project managers." These managers function as the coproducing intermediary working between Hay and the spaces in which she performs and teaches, yet Hay maintains a guiding, even curatorial partner role to those who present her.[30] By aligning and ordering the artist and producer roles, I mean to point out that the artist and producer roles can be played separately. I also want to indicate that artist-producers, as coproducers of a process and a vision, must also guide budget and structure. Illustrating the necessity of collaboration in art making can also ward off critiques of unproductive solipsism. In "Words to the Wise Performance Artist: Get Help. Collaborate, Grow" (2005), *New York Times* critic Margo Jefferson characterizes artists who overplay their solo creator role as modeling a "*les art c'est moi* syndrome." Jefferson astutely observes that great artists like Martha Graham and George Balanchine frequently collaborated with equally skilled designers and composers who helped render their works complex rather than "artistically claustrophobic."[31]

For some, the use of the term producer is inherently problematic because of a producer's association with the financial bottom line.

Recently, a filmmaker I met at the South by Southwest Festival in Austin told me about the term "preditor," which he explained as a producer who maintains editorial control. The preditor is an example where a producer wrests artistic control from a director, perhaps even preying on talent, and in this sense also signals the problem with the word "producer" as the individual whose financial focus comes at the expense of artistic expression. The Institute for Curatorial Practice (ICIP) resists the term producer for the same reason. Founded at Hampshire College in 2011, the program prepares individuals to work collaboratively with artists during the development process, helping to shape a work and build its markets. ICIP imagines curators as vested partners to artists. The curator recognizes aesthetic and political concerns as much as expenses and opportunities.[32] By identifying the artist as a producer, I am interested in highlighting those aspects that speak directly to each artist's own bottom line, such as the appropriate budget size to realize the vision of a work. In response to the curator as partner, how might an artist's creative and organizational acumen amplify the possibilities of the partnership?

To support this project of theoretically mapping a period of rich policy of development, I focus on synthesizing the work of scholars and arts organizers whose works help explain the dynamics of contemporary policy initiatives. Using performance as a site of analysis as well as a means of expression allows me to model how a cultural policy paradigm has already been the shared project of many policy performers and to ask, what roles for artists have yet to be imagined and cast? To help answer this question, I turn to the critical theories that support my field of performance scholarship. Critical theory marks a type of empirically informed analyses that emerged in the academy in the early twentieth century, first in the social sciences and later in the humanities, to describe and historicize human relations and material culture. Asserting critical theory's essential relationship to performance studies, feminist performance scholar Jill Dolan describes critical theories as "ways of thinking of social relations that can't be proved empirically but can be carefully and ethically argued."[33] Introducing "theory" in a book that is addressed to artists and those who organize on their behalf also speaks to the binary of "theory vs. practice" common to those who assert the value of the lived experience over the studied. Writing about performance artist Peggy Shaw, Dolan quotes the artist inveigling students, "Get out of school.... [G]et out of this fucking school and go start a theater.... With forty thousand dollars you can ... build a building or something or make a play. Don't give it to this college."[34] Shaw's distinguished career as a theatre artist and cofounder of the Split Britches theatre company offers

evidence that theory need not be the measure by which works are made or valued. However, as a feminist and "self-described butch lesbian," Shaw's work has been valuable to the theories of contemporary feminist performance theory.[35] I would also argue that the evocative scholarship about her and her history has been fundamental to galvanizing a generation of theatre makers, whether they actually appear onstage or work in the house. Consequently, I see performance theory, informed by critical theory, which is itself informed by art and artists, even those taking a critically distancing stance against academia, as a part of the food chain that sustains the nation's arts and its understanding of artistic practices.

With respect to my own project, the predominance of empirically structured studies and reports that have led to a new artist definition necessitates that I analyze cultural policy as a form of cultural discourse and in terms of capital. In doing so, I return policy findings back to the bodies they represent for political purposes. I define discourse as language that conveys power and organizes bodies through its clear and evident association with other, established structures of power. This definition borrows heavily from Michel Foucault's notion of an "author function" to describe the social and political hierarchies undergirding language. The author function privileges the one who gets to write the story over the one whose story is being portrayed, but also makes room for new forms of discourse to intervene.[36] Here I seek to liberate the artist's body in the "subject of study" role by pointing to the many discourses that reiterate each artist's connection to a greater cultural infrastructure and suggest how artists might benefit by taking up policy's discursive work from the grassroots of practice.

My focus on the means by which arts policy shapes and measures rewards invites an analysis of how artists can more effectively judge the value of their life and work not only economically but also socially and culturally. Recent policy documents use terms like "trust capital" and "intellectual capital" to describe the relationships forged between artists and organizers or the knowledge built up through policy's efforts.[37] These and other examples of capitalizing the arts follow from French theorist Pierre Bourdieu's foundational notions of social and cultural capital. Bourdieu's work illustrates how nonmonetary rewards can "accumulate" and even "persist" much like their economic counterpart *vis-à-vis* institutional and interpersonal relationships, in ways that echo the validating qualities of discourse.[38] One builds social capital through a network of "durable" peer relationships through which one's standing or accomplishment can be recognized. Cultural capital comes variously, including through training and accomplishment, such as an acclaimed

showing of one's work. By opening up a space for thoroughly deciphering capital, I seek to support how artists measure it, share it, and trade it, but also do not succumb to the belief that a lukewarm reception to one particular work represents a death knell to a career. As the stories in this book and the whole arc of its inquiry attest, capital accumulates by increments and through relations built over time. Capital is also supplemented by relationships outside of tight circles of discipline or practice, the "weak ties" who introduce one to new ways of looking at the world.[39] One of this book's greater claims is that the infusion of arts organizing and cultural policy with theorists from urban planning has made the biggest changes in contemporary artistic practice.

Drawing on the work of both Foucault and Bourdieu to demonstrate how discourse shapes the lived performance and experiences of gender, French feminist scholar Susan Bordo brings the work of both theorists back to the body. Referring to the body as "the text of culture," she asserts that "through the organization and regulation of the time, space, and movements of our daily lives, our bodies are trained, shaped, and impressed."[40] The policy studies and initiatives highlighted in this book demonstrate how contemporary cultural programs have inscribed and even prescribed artists' lives. The cultural program that offers artists seed money combined with professional development training and marketing assistance and convenes a cohort of grantees begins a "text" of practice. The artists who build on the opportunity, knowledge, and relationships forged through the program and practice expand the text through their ongoing work. Likewise, the artist who participates in or reads a study about artists lives and uses that knowledge to expand her repertoire of practices contributes to a cultural policy text. In these instances, artists demonstrate how "[t]he term script denotes not a rigid dictation of performed action but rather a set of invitations that necessarily remain open to resistance, interpretation, and improvisation."[41] Artistic practice—embodied, rehearsed, and revised—becomes the means by which cultural policy texts are articulated through the body.

Because of these scriptive relations, I am concerned with how the policy efforts I assess judge good performances and reconcile artists with their role in society. How too, do these projects address ongoing findings that US performing artists "on average, earn considerably less, work fewer weeks a year, and face higher unemployment than other professionals with comparable education levels?"[42] Yet I am also interested in asking how artists might use Bourdieu's forms of capital and iterations of agency to measure success socially, culturally, and economically and manifest more opportunity and greater reward individually and locally.

How might artists see an emerging dance company's successful run of a show as capable of contributing to more abundant dance audiences for a whole community of dancers rather than succumbing to zero-sum arguments that one's success is another's loss? How might those companies who see themselves in the shadow "horizontally differentiate" themselves enough to share in a successful colleague company's spotlight?[43] How might the successful company see its generosity as having the potential to build and sustain a healthy dance following and train an abundant dance talent pool? In other words, how might the social and cultural means by which capital is distributed and productively circulated invite a spirit of reciprocity in a local dance scene? If the nearly two decades of policy research I evaluate have shown anything, it is that in the cultural policy sphere more production can lead to and introduce more production.

Pierre Bourdieu's work gestures to my final theoretical approach in *Performing Policy*, which has to do with the existence of an artist's potential for intervention in an archive of policy that currently informs practice nationwide. Although embraced as a sociologist, Bourdieu's work is more often cited in "argumentative" approaches in public policy analysis and policy making, which emerged in the academy in the early 1990s. Rejecting previous, "neopositivist" methodologies that presumed policy could be the direct application of social science theories and data analysis, policy analysts turned to arguably more iterative ones. As part of the policy changes of the last two decades, argumentative policy's strategies expanded to include "practical argumentation, policy judgment, frame analysis, narrative storytelling, and rhetorical analysis, among others."[44] All of these moves are essentially performative ones, requiring the researcher to take onto her body some actions that reflect the relationship forged with subjects through research. In other words, by looking inward, policy scholars adopted some of the same practices to explain data from which they had previously extracted information from communities.

I see the remnants of argumentative analysis in approaches to arts policy studies that combine research with advocacy.[45] I also see the basis of an artist approach to policy in the work of artists who organize for new programs of support, such as a collective of theatre artists I feature in Chapter 3 and the place-based projects I evaluate in Chapter 7. As I show in these stories and others, policy's prescriptions have largely been accurate, yet the movement from prescription to implementation has been neither fast nor clear-cut. I do not consider this fact surprising. The last 17 years of argumentative cultural policy development have sought

to revolutionize 60 years of cultural practice in the US and to intervene on long-standing notions about artists.

Methodologically, the "page to stage" process of my analysis hails the distinctions of archive and repertoire theorized by Diana Taylor (2003). Taylor describes the archive as a body of inscribed knowledge, a canon of discourses reflecting those in power.[46] As reflected in the documents I assess, the archive structures the organizational hierarchies that undergird discourse. Much like policy, Taylor's archive follows an organizational mandate and carries a "legal weight"; however, the archive does not easily tell the whole story of its subjects who may play against its discursive status, in protest or parody, or even through syncretic approaches to addressing the archive's claim to truth.[47] The repertoire represents embodied interactions, all those acts usually thought of as "ephemeral nonreproducible knowledge."[48] Taylor distinguishes the repertoire to mark different forms of historical durability, in her own words: "to function as vital acts of transfer, transmitting social knowledge, memory, and a sense of identity."[49] Following Taylor's assertion that the archive and repertoire are not binaries, I assess the decision-making processes and publications that shape policy's interaction with artists, as well as artists' responses in kind.[50] Taylor uses the term "scenarios" to describe the "meaning making paradigms" that shape the repertoire.[51] Offering a clear structural model that acknowledges the place of engagement, the players, their terms of interaction, and the nature of proceedings, she demonstrates how a reading of performance is as critical as that of the archive.[52] Given my own background as a writer-performer, I also use all of these methodologies to tell the story of contemporary cultural policy development.

Admittedly the origins of Taylor's theoretical distinctions are markedly different from my own, yet our reasons are similar. Taylor writes to critique US Latin American Studies programs that begin their inquiries with legacies of conquest, as recorded in the archives, establishing distinct subject positions and legacies for those in power and those who are not.[53] At times, I do suggest that arts policy operations reinscribe distinct hierarchical roles. In other words, the bulk of artists, scholars, and organizers I examine all negotiate through their respective fields, skillsets, and experiences the terms for a cultural future, and the model has historically been hierarchical. But I also demonstrate how artists' organizing efforts regularly test those roles. Equally, I recognize when and how those who hold the dominant roles propose a power-sharing position, particularly prevalent since the 1990s.[54]

From artist organizing to creative placemaking

Around the first years of the twenty-first century, a series of landmark reports appeared, significantly expanding the nation's understanding of the relevance of arts to everyday life. Broadly, these research reports covered issues of changing tastes and consumption habits, the relevance of culture to economic and social stability in communities, and the challenges facing artists and arts organizations in the new economy.[55] The diverse group of scholars and organizers who created these reports included economists, urban planners, sociologists, political scientists, and even activist philanthropic programs. The documents and their subsequent initiatives followed three streams of thought. One stream focused the arts as it had been historically framed as a network of organizations and spaces. In many ways, this view relied on economics to draw on findings about long-standing concerns or trends. Another focused on the role of arts in community, how the arts and artists func-tioned as critical players in urban and municipal places. This stream of thought relied heavily on the work of urban planners and sociologists. A third stream that focused on how the arts could or should be valued bound the two together and appeared variously in each area, taking on the concerns of political science but also illuminating the areas where the arts and artists could play valuable roles, in education, health, and medicine, for instance.

The Performing Arts in a New Era (2001) easily represents the stream focused on the arts as it had historically been framed. Published by RAND Corporation and drawn from data gathered over two decades (between the 1970s and the 1990s), the report documented systemic and field-wide patterns and emerging barriers to artistic practice and organizational sustainability in the new market economy. The study noted that arts participation, while also growing, would be divided between live and mediated forms, allowing individual curation and drawing audiences away from traditional performance events. In light of these challenges, the study anticipated that large organiza-tions relying on imported blockbuster shows would grow bigger, monopolize their elite funders, and maintain market dominance. Small organizations would assume greater creative risks than their larger competitors, but lacking economic resources would rely on volunteer labor over paid artistic support. Medium-sized organiza-tions would play a mediating role, either attempting to grow through more risk-averse strategies or increasing work with small, community-based organizations pursuing artistic risk. In light of their position

downspout from these conditions, emerging artists would encounter increased barriers to entry and to sustainable careers.[56] Subsequent study from the perspective of artists would prove all of these forecasts correct.[57]

From a place-based community perspective, the Urban Institute—a nonpartisan think tank—published a series of reports under the rubric of its Arts and Culture Indicators Project (ACIP). The five publications of the *Art and Culture in Communities* (1996–1998) move from the space-based perspective in the RAND report to argue for a more complex understanding of how distinct cultural and geographical places thrive because of arts and culture.[58] Whereas much of the arts and culture sector had been looking at participation in terms of declining audiences and patrons to traditionally high arts venues,[59] ACIP's five publications track participants' activities to more intimate sites such as homes, churches, and community centers. Dispensing with traditional dichotomies like "high vs. low, formal vs. informal, [or] fine vs. folk," the authors argue that cultural participation is central to daily life. The documents also assert that a democratic approach to community development requires not only a focus on housing, health, education, and social services but also opportunities for cultural expression.[60] ACIP's concern with how people inhabit community spaces expanded conventional thinking on urban planning and returned arts and culture policy to Jane Jacobs's enduring analysis of urban landscapes made in *The Death and Life of Great American Cities* (1962). Like Jacobs, these researchers asked: what was going on inside of spaces and on the streets? How were people coming together and for what purposes? Rather than presuming that the space would choreograph the action, they wanted to know how people animated neighborhoods through the cultural practices they shared.

The stream of thought dedicated to "value" can be found in the RAND Corporation's *The Gifts of the Muse* (2004). *Gifts of the Muse* argues against what had become a shopworn approach to defending the arts on the basis of their instrumental purposes, like "building up test scores and improving literacy."[61] Like the *Arts and Culture in Community* series, *The Gifts of Muse* looks to the supply and demand sides of the arts to observe how, why, and to what ends people engage in the arts. It also seeks to erase many of the same dichotomies: between high art and low art, between public benefits (like academic performance) and private ones (like "pleasure"), between past (when the arts were seen as critical to democracy) and present (in which they are regarded as a luxury).[62]

Combining all three approaches, the other studies that I examine more specifically in these pages, like the Urban Institute's *Investing in*

Creativity (2003) and Leveraging Investments in Creativity's *Crossover* (2006), focus specifically on the supply side where artists ply their trades in local and national markets and communities. They draw from census data about artists, surveys assessing how publics value artists, and interviews and case studies to illustrate how artists work in communities and through organizations. The studies quantify and qualify artists' needs, assess the structures of sustainability at present and over time, and argue for new ways of thinking about longstanding concerns about the arts.

The impulses and destinations shared by all of these archival documents render them part and parcel of an arts and cultural policy movement. First, in their accounting of resources, they are intertextual and reflexive. They cite each other and build on all research to date. Second, they cumulatively testify to what has been a period of heightened commitment and activity in the arts and cultural policy, which includes the researchers and philanthropies that support them. The names of policy scholars and arts organizers (Jackson, Markusen, McCarthy, Stern and Seiffert, Sidford, and Tepper) appear regularly like popular artists on tour. The reports also bear the logos of philanthropic foundations (Rockefeller, Ford, Duke, and Wallace, among others) and the imprimatur of think tanks (RAND, Urban Institute, SIAP). Third, these publications, as well as the scholars who created them, share a common historical awareness, a commitment to comprehensiveness, and a political savvy. They foreground what the arts contribute to the nation. The archive proclaims the arts poorly understood and poorly rewarded at the expense of America's economic and social vitality as well as its democratic well-being. The publications are also self-critical. Arguing that all study to date is incomplete, under-theorized, and inconclusive, these studies theorize the next best area of inquiry on the same pages where they argue their findings. In doing so, the authors shore up arguments for their own ongoing purpose, relevance, and sustainability. Fourth and most importantly, these reports offer methods by which their understandings can move from research to social, economic, and cultural change immediately.

As a result of these shared approaches, the period of data gathering for many of these publications also represented a period of preemptive intervention. Their efforts were, in the words of *Investing in Creativity* (2003), "conceptual, empirical, and practical," modeling new ways to think about the relationship between diagnosis and prognosis.[63] *Crossover* (2006), for instance, features profiles of artists to demonstrate in compelling narrative form how they strategically construct sustainable

careers by accessing different markets. These illustrative features do the double work of promoting the artists and embodying the study's findings for those who might resist teasing apart the economic "theory of crossover" which demonstrates how, when, and for what reasons artists move across commercial, nonprofit, and community sectors.[64] In the same vein, many of the studies find purchase and even case study examples in specific arts-focused organizations that emerged before, during, or as a result of research publications. For example, since the 1990s, NYFA Source has been the nation's most comprehensive resource for artist opportunities, like grants, as well as residency and training opportunities. Built on the foundations of the New York State Council Arts' "Visual Artist Hotline," first created in 1971, the database was greatly expanded—conceptualized, funded, and produced—in 2000 as part of the research phases of *Investing in Creativity*.[65]

Some organizations that emerged during the same period I write about, like the Creative Capital Foundation (1999), and later United States Artists (2005), improve upon known funding models, specifically the National Endowment for the Arts' individual artist fellowship program. They award project seed money, as the NEA did, but couple it with professional development training and other forms of technical assistance.[66] Others, like Leveraging Investments in Creativity (2003–2013), a ten-year initiative incited by *Investing in Creativity* and more commonly known as LINC, sought to construct models for more sustainable artistic careers nationwide.[67] The networks built by these programs anticipated and supported contemporary crowd-source fundraising mechanisms like Hatchfund, Amazon's Kickstarter, and Indiegogo, which put artists directly in touch with their patrons.[68]

By the time these reports were printed, uploaded online, or both, the ideas and opportunities they offered were already known and being implemented in communities. Subsidized by the philanthropies and made widely available, this complex and expansive public arts policy movement was already in full swing by the first few years of the twenty-first century. I argue that the new terms of engagement the effort defined were threefold: the movement offered deeper knowledge of the nation's complex arts infrastructure; it created innovative mechanisms for funding and support constructed in response to past models; and it set out clearer terms for the time, capital, and resources needed to make being an artist a realistic option in the nation's economy. These terms affected not only US artists' daily practices but also the very concept of what it means to be a working artist, even in cases where making art was not an individual's primary job. What changed was not so much the

ontological definition—the answer to "What is an artist?"—but a clearer picture of what would be required to bring art to the public in the social, political, and economic spheres of the twenty-first-century nation. The abundance and energy of these efforts represented a bold response to what had been a particularly punishing decade in the 1990s.

Culture war origins

The majority of cultural policy materials developed over much of the last two decades have relied on documenting artist behaviors and theorizing "best practices" against the needs of the nation's broader cultural infrastructure. These works have been crafted to speak to those who study artists or work with them through organizations. In doing so, they have followed an arm's-length approach common to nonprofit funding since the late 1990s. Although more than two decades have passed since that period, the term "culture war" has again assumed a prominent place in political rhetoric. Much like its late twentieth-century antecedent, the more recently touted culture war encompasses a host of wedge issues including abortion, gay marriage, publicly funded health, guns, and big government.[69] More than 20 years ago, publicly funded arts programs addressing many of the same identitarian and rights-based issues served as the locus of attack.[70] The passage of the Williams/Coleman Amendment in 1990, which established decency clauses for the NEA, also ushered in an era of tightened scrutiny. Artists who had been subsidized either directly, or through their work in funded arts spaces—among them, Andres Serrano, Barbara DeGenevieve, Robert Mapplethorpe, filmmaker Marlon Riggs, and the poet Sapphire, as well as the "NEA Four"[71]—were assailed as indecent by conservative groups for creating works that addressed issues of race, gender, sexuality, and religion. In 1996, the Republican-led 104th Congress cut the NEA's budget substantially, exacting a very public redress from art and artists.[72] The cuts also paved the way for the elimination of the Individual Artist Fellowship program (in all areas but literature), and instituted the standard, "pass-through" method of artist funding, whereby artists generally receive support via funds filtered through nonprofit organizations.[73]

The de facto approach to cultural policy at the time would ultimately be labeled by Joni Maya Cherbo and Margaret Jane Wyszomirski as the "Public Leveraging Arts" paradigm. Under that model, the nation regarded the arts to be an "asset for diplomacy" and argued for its support "in parity with the sciences." The arts were understood through "discrete disciplines," rather than cultural locations or communities; the

paradigm itself was "primarily concerned with professional nonprofit arts organizations."[74] In the nonprofit sector, that same period was known as the Ford era. Beginning in the late 1950s, the Ford Foundation led the nation's philanthropies in developing a leveraged grant model, building a network of regional "high arts" institutions, and supporting the growth of arts training programs to produce "a skilled labor force for increasing the number of arts organizations."[75] The "high arts" in this case were not simply opera, ballet, and theatre, but also a network of disciplinary-specific artists' centers, where artists could build skills, ply their trades, and meet communities.[76] By the 1990s, these arts spaces were established and had artist administrators who could wield the same discursive skills as their philanthropic funders. As John Kreidler (2000) and others have argued, the growth of the nonprofit sector during the Ford era of funding produced a bloated nonprofit infrastructure by the end of the 1980s. This sector found itself precipitously balancing its own sustainability concerns with political and mission-based commitments to artists.[77] Kreidler likens the state of nonprofit organizations to a "Ponzi scheme" that could not last.[78]

Although the bloat of the nonprofit sector and the decency concerns about artists would seem to justify new research highlighting the value of the arts and new means for supporting artists, populist arguments against public arts funding elided a more problematic political history. For much of the century, public support had been the result of two federal policies, one passive, the other political, and both self-serving to those with far more power than the nation's artists. On the one hand, national policy had come from the passive tax benefits undergirding the nonprofit mechanism, which allowed individuals and corporations to divert pretax earnings to charitable entities, including arts organizations, churches, and schools. Combining these resources, arts and culture workers had enterprisingly constructed a massive, though unsustainable, and poorly understood arts infrastructure.[79]

On the other hand, for much of the previous five decades, the nation's approach to supporting artists and the arts had been a mix of self-serving political aims, encompassing Cold War-era diplomacy, which included America's cultural competition with Soviet Russia. In other words, artists had been funded to serve the state, though not to invest themselves or assert their guidance in the complicated, power-leveraging negotiations of resources and boundaries common to statesmanship.[80] The subject position of artists was already fixed, and the recognition of that position could be troubling to those who believed their work as critical to the nation's understanding of itself as a democracy. In his

study of the origins of the National Endowment for the Arts' visual arts program, Michael Brenson quotes founding trustee Gifford Phillip's stated conviction that artists should be "inner-directed...not seduced or corrupted by money, the obsession with which was threatening to undermine [America's] moral and spiritual purpose."[81] Philip's idealization of authors reinscribed the starving artist model. In her history of the National Endowments for the Arts, Donna Binkiewicz observes that the arguments against federal arts policy based on a suspicion of artists' motivations and values were more prevalent during the Works Progress Administration than they were when the National Endowment was signed into law. The tensions of the Cold War convinced legislators that artists could shore up America's image as a model of liberty and cultural freedom in its race with Soviet Russia.[82] Brenson demonstrates that whether artists were being characterized as troublemakers, market naïfs, or emissaries of the state, they assumed a leadership role in the development of the Endowment's programs, specifically through the peer panel process.[83] Admittedly, those artists who early on played a guiding role were largely class-privileged, white males; however, the progress of years and increasing diversity initiatives found the institution far more diverse by the mid-1990s than it had been in the 1960s. Nevertheless, the rise and fall of a leveraged art model of funding did little to advance a fully sustainable model or, I would argue, an common idea that aspiring artists could build viable careers.

Socially, the programs under scrutiny shared a liberal impulse of Johnson's Great Society and Roosevelt's New Deal, where artists as cultural workers were acknowledged as critical to the United States' well-being. Yet the tide against publicly funded arts had been turning since Reagan-era politics of the 1980s advanced notions of "privatization and personal responsibility" as a public good in itself.[84] The policy efforts that followed the cuts to federal funding in the arts during the Clinton administration acted as a kind of triage and attended to rebuilding the cultural crossroads first damaged in this moment. In deference to Reagan era politics, but also as a result of a political reality, much of the support for the new research came through the philanthropic sector, both public and private, and was guided by a number of nationally focused organizations. Like airplanes towing banners, the program acknowledgments circled back to the foundations that supported them and hailed those who might benefit from supporting the next, new version of the same project. In other words, these efforts generated the publicity needed to catalyze and sustain a dynamic period of policy development.

Broadly, the dawn of the twenty-first century found the arts and cultural policy sector of United States focused on understanding and advocating for the arts (and artists) according to multiple forms of capital—cultural, social, and economic—they produce. These same reports seemed to be peeling away a focus on high art and looking for ways to let arts and artists find purchase across the nation. They eschewed the culture war charges that the arts (and artists) were indecent, unimportant, or irrelevant and asserted that the arts' benefits should be evident. Ironically, this particular discursive political turn was enabled by a co-option of the values-based rhetorics circulating during the culture wars.[85] The arts, one critical report asserted, serve "broad public purposes."[86]

If capital was to be the currency, then cultural policy would be the transactional medium through which the nation's arts would be expensed. A number of scholars, arts organizers, and some artists gathered around the idea of constructing a progressive, arts-focused cultural policy for the nation. Their goal was society's thorough consideration of what the arts bring to the nation and a quid pro quo for work well done. Through research they sought to demonstrate what the arts contribute to the nation. And through the circulation of that material, they banked on society seeing, at last, a chain of relationships stretching from art to culture, from culture and identity to individual expression, from well-being to productivity before landing on the shores of prosperity. Echoing the findings of Arts and Culture Indicators Project, one scholar argued that cultural policy was everywhere, "in the boardrooms and on the streets," but also in the home where families operate along ethnic or cultural lines and speak languages reflective of their origin.[87]

Other policy analysts took a more direct route, eliding the process of development and going right to the medium: "Culture, many will say," writes Gigi Bradford, "is a vehicle for individual expression; policy is legislation en masse." For Bradford, policy offers citizens the tools and systems to anticipate and negotiate ever-changing relationships with each other and their environment.[88] Without fail, all of these definitions imagine cultural policy as an ideal system that should finally account for true diversity in representation. The task is immense, given that the diversity hoped for may at any point be called on to account for multiple points of access: the individual identity markers of participants (race, class, gender, age, ability, sexuality, citizenship status, and access); the structures of organizations with respect to identity or arts focus ("artist-centered, community-based, and ethnic arts organizations"); and the geographical and disciplinary dispersal of opportunities (dance in Philadelphia, visual arts in the Great Plains, theatre in Austin).

The policy scholars and arts organizers who sought the development of an arts and culture policy argued that for too long, the nation had used arts and culture as a political football, calling on it in times of crisis to lift up the nation's spirit or shine its images, while at times dismissing it as representative of the few, or the educated elite. In a petition circulated during the 2004 presidential race between George W. Bush and John Kerry, a number of arts advocates made an explicit request for a national cultural policy "that secures the role of the not-for-profit arts in international exchange grounded in a domestic cultural policy that values our own national diversity." Their eight-point memo reads as a reparative to the cuts witnessed in the decade past: a raise in funding to the National Endowment for the Arts, increased and guaranteed support for public media, and arts programs in the public schools, to name a few.[89] By and large the call for a cultural policy was often prescriptive when making demands and diagnostic when thinking how the arts and culture sector would approach the work when those demands were not met.

Moreover, in 2004 as in 1997, the nation encountered by those arts advocates was distinctly different than that of the mid-1950s when the Ford Era began, or than that of a decade later in 1965 when the National Endowment for the Arts was established. A new kind of self-directed "generosity" emerged in the form of neoliberalism. Arguing that equality of opportunity had been reached and that individuals could help themselves far better than the government could help communities, neoliberalism's advocates rolled back the social justice agendas of the twentieth century. They pursued "fiscal austerity privatization, market liberalization" and governmental relations that favored private industries as the generators of opportunity, rather than organized labor or a strong public sector committed to health, education, and welfare.[90] As the economy shifted from an industry- to an information-based one, the effects of neoliberalism could be felt broadly. Individuals set adrift from the workforce and the social safety net found themselves seeking new opportunities in the market, much like artists had during the twentieth century. Since all art basically functions between production and reception, between art makers and audiences, the invitation to connect more directly and sooner with consumers offered US society a reason to argue that artists had the resources to make their own way. With political constraints coming from one side and economic opportunities coming from another, artists had a new reason to pursue market-based opportunities. More compellingly, they also had reasons to resist and make art about the probusiness and antisocial services agenda of contemporary

politics that fueled the controversies of public funding for the arts in the 1990s and that threatened the well-being of citizens every day.

The crux of this transaction reveals one last important point about policy. Aside from legislation directly affecting the arts, as in copyright concerns, the bulk of policy development has occurred in the nonprofit sector, under the aegis of philanthropic funding. My own look back on policy requires that I write about it from a nonprofit perspective, although my analysis of artists' prospects requires me to engage and index the multiple markets and sectors where artists regularly ply their trade.[91]

This book examines and synthesizes this immense and densely packed period of arts and cultural policy development or, as it was later termed, "arts and creative policy" development in the United States.[92] The "creative" moniker has a mixed valence. In many ways, it justifies arts training and epistemology and connects the arts to a network of other creatively identified fields, like architecture and even software design. However, the creative designation has also been critiqued for too easily aggregating artists with those whose work fits more easily and more regularly in the commercial sector, at the expense of recognizing the distinct costs and benefits of each field.[93] Whereas those professionals, and also those who study and organize the arts, including myself, work in organizations, or "firms," artists more often work contract by contract in the market.[94] Consequently, the artistic richness of a community does not amount to artist stability, even when artists play a significant role ginning up property values for the cities and towns where they live. As a result, I do not use the term "creative" easily, because what it gains in capital and alleged market company, it loses in culture, or meaning. Culture, on the other hand, signals where and to what the arts make their greatest contributions. The arts explain and expand contemporary cultures. They also serve as a medium for deciphering historical ones, and it is on the terms of contributions to capital that twenty-first-century arts policy has staked the arts' values.

In this book, I use the terms arts and cultural policy to index the ways that arts and culture are organized and validated through research, development, and practice. Additionally, I often couple "policy scholars" and "arts organizers" to show who is doing that research and programmatic development in surveys, reports, and programming. To be clear, I am not arguing that the two roles are necessarily distinct. Many an arts administrator has a scholarly knowledge of her field. I also recognize that many artists contribute to public policy in the arts through their exemplary practices. By combining policy scholars, arts organizers, and artists in

my analysis, I seek to identify a form of grassroots cultural policy, one instantiated and made normative by all those who have a vested interest in cultural production, meaning artists, too. Jan Cohen-Cruz uses the term "grassroots theatre" to describe theatre made on the ground in specific places, with specific communities, and in observation of specific traditions and spirits.[95] It is presumably at the grassroots level where artists might meet—having left the high rise's boardroom and found each other on the street. In a grassroots cultural policy scenario, artists are not just the recipients of new programs or the subjects of studies, both of which have been designed by professionals who are good at organizing. Instead, artists are presumed cocreators of the cultural life in the communities where they reside. This new status does not result from artists having taken on the formal role or founded an arts organization. Instead, I argue that the current arts and culture policy paradigm is proposing through various means that artists regard equally the expressive nature and organizational demands of their work.

Performing Policy examines how policy questions have been shaped, by whom, and to what ends to speak to a larger constituency that includes artists across the nation, in all disciplines and all stages of career, in addition to those who study them. I am particularly interested in addressing emerging artists and mid-career artists who are trying to become familiar with a local community, better recognized for practice, and knowledgeable about arts markets at large. How might an artist read arts policy reports highlighting artists' needs and find opportunity? In other words, rather than seeing herself restrained by artists' needs throughout history, how might that artist use a vast archive of policy to free up her own method? In addition to policy and programmatic reports and white papers, *Performing Policy* locates the discourses that structure contemporary artistic practices in blogs and academic texts, as well as the nonprofit and for-profit guidelines, artist support initiatives, professional development programs, increasingly complex contracts and copyright concerns, and artists' stories (including my own). As reflected by these last points especially, my own discursive analysis intentionally turns from policy to performance to interrogate how documents and programs become enacted by artists in everyday life and work. My experience as an artist, cultural policy advocate, and scholar has taught me to acknowledge that the shining example of the successful and accomplished, though-not-yet-a-superstar, artist provides an easy index to the potential for a connection between art making and power. In other words, I too feel there is a place for a realizable exceptionalism that can be promoted through a reconsideration of the word

"artist." At the same time, my own geographical commitment means that my more substantive examples in this book, as well as my questions about national research, come back repeatedly to the question of place. How might each example work in the cities where I live and work—San Antonio and Austin, respectively—as well as in other cities and towns across the nation that are not considered artists' epicenters? Moreover, my experience as an artist and performance scholar tasks me to present the materials with a clear and evident accounting of how I have received certain ideas and resisted others. Rather than complaining about the power roles enabled by policy research, I wish to testify to how an artist might approach the archive and repertoire of policy to find his own place contributing to and advocating policy locally and nationally.

In this book, I evaluate recent cultural policy history as something of a long season of performance, to assess how ongoing issues have been studied and how new information and approaches have been applied into practice or toward a next step. I focus on what the documents say, how they frame artists' concerns, and how they invite new modes of practice. On this last point especially, I am also interested in asking how these operations, whether they be policy reports or organizations, anticipate a receiving audience. Do they address artists, arts organizers, philanthropists, and policy scholars, or only a few of these? Most of the documents I rely on are published. They tell the story of policy through their subjects, their methodologies, and even their acknowledgments. Some of the documents I rely on were not published, but instead served as background materials or routes not taken. Occasionally I use personal interviews in the case where critical information, such as a route not taken, was missing from the public record.

The two significant events that bookend my inquiry exemplify the mostly public, but sometimes private, nature of my approach. *Performing Policy* begins with an analysis of "The Arts and the Public Purpose" (1997), a meeting of arts organizers, policy scholars, and artists that represented a galvanizing moment in cultural policy development. Responding to the culture wars and taking a bipartisan approach at a moment when public support for the arts was anything but, "The Arts and the Public Purpose" advanced a broad policy agenda that would be teased out in all subsequent development. Leveraging Investments in Creativity, known as LINC (2003–2013), was a ten-year initiative that supported the research and development of new systems for artist support in the United States. The organization's period of work across the nation, its commitment to artist research, to artist-focused approaches to policy, and to underserved communities represents a significant policy exercise

that has since been taken up in other initiatives. In general, I rely on unpublished materials or interviews to fill in the record and to demonstrate the ambitious, forward thinking terms on which much policy development has transpired. By reading events between 1997 and 2013 as a "social call and cultural [policy] response," I am able to index how these specific paradigm shifting projects shaped the skills and knowledge now anticipated of artists in their daily practice.[96] At times, I do document the statements made by policy's authors at various meetings. In some ways, these statements reveal me to be an insider, a border-crossing figure who goes between production and policy, with side trips to education. I also turn to my own practice as an artist, as a teacher, and as a colleague to many who are still plying boards and pounding the clay to ask how these documents might become more effective, practical tools.

I raise these questions to respond to a critique of philanthropy that informs my own questions about an artist approach to organizing and to sustainability. The market is big. Ideally, the number of potential audiences and supporters is vast, yet for the artist who is struggling to build a following or who has just received a rejection for a grant or proposal, the names of highly publicized funders, well-known grant programs, and successful grant applicants can feel like a crushing weight on one's belief in the validity of his own practice. In the words of motivational economists who look at behavior to describe how individuals make decisions, rational and not, extrinsic forms of rejection can "crowd out" any inner feelings of worthiness, desire, or hope that artists may have.[97] The chain of support in the arts, flowing from large philanthropies through arts organizations to artists, or even from local critics to local arts companies, does not represent the only way a choreographer might distinguish herself, especially if she is from an underserved community. Nor in the opinions of some critics and advocates does such a flow represent what some might consider the most reflective of integrity. As social justice organizers and economists point out, large-market philanthropies represent privatized good at the expense of the public one. One way of looking at their vast holdings is as money robbed from the US Treasury through a tax code. The feminist activist organization INCITE: Women of Color Against Violence (2007) persuasively argues that the history of philanthropic giving also hides what have been violent engagements in foreign countries and that giving often comes with a caveat or limitations, which will protect largely conservative boards.[98] The INCITE group has been vocal about earning all income from communities, a measure that would seem possible with online crowdsourcing; in my

own experience, artist support organizations often advocate for artists who know and are known by their community. Similarly, the artist and philanthropist Peter Buffett (2013) has been critical of "The Charitable-Industrial Complex"—its meager record of giving compared to the wealth of its funders, and even its presumptuous efforts at imposing a set of values in culturally specific communities.[99] I am particularly interested in how contemporary artists might articulate their cultural contributions and use that advocacy to collectively and conscientiously create public and private support as activist policy partners.

To some, the artist-producer term may be too evident, even redundant, given that I am essentially combining the terms for one who makes art with one who makes art possible. To others, it might represent a radical turn from what we can expect of an artist. My hope is that the term adequately and fully invokes the important role that artists play in communities and through their work for those who make art, those who appreciate it, and those yet to be convinced. What I am seeking through this term is a sense of *ethical hybridity*, an accounting for the many tasks artists are required to do in their work, not only for those who make art but also for those who are in the position of remunerating art makers.

Analyzing the political origins and practical applications of recent policy advancements, I demonstrate how the redefining of artists and policy makers took place and to what ends, but I also argue that the most significant step remains: for systemic, even historical changes to take effect, a new theoretical ground must be established, one that first imagines and then situates artists as co-organizers of the nation's cultural infrastructure.[100] As of today, much of the programmatic innovation and insight has come from the policy community, resulting in an infrastructure that more directly connects artists with constituent audiences and funders. Developments have been delivered piecemeal through the rollout of individual program studies and networking platforms, as well as feature articles heralding each innovation in art operations. For the artist recipients, each new technology or program to master comes with its own set of demands and the concomitant challenge of fitting the latest opportunity into an already complex practice.[101] What the cultural policy sector has not delivered in its paradigm-shifting work of the last 17 years is a clear job description for the term "artist."

Performing Policy proposes to take up that definition. In call and response, the chapters alternate between historical developments in cultural policy since 1997 and case studies of contemporary moments when artists are called to rehearse and perform policy as artist-producers. Nearly two decades of arts policy development have

amounted to one significant shift. Whereas past models of cultural policy and support focused on the establishment and maintenance of arts spaces, contemporary developments are focused on place, with a careful attention to the sum of a variety of spaces, which may include arts spaces, but also community centers. Cultural theorist Michel de Certeau (1984) refers to spaces as *"practiced places."*[102] In contemporary cultural policy, such practiced places include traditional arts venues, as well as "parks, churches, community-based organizations, retail schools, health agencies, and a range of municipal departments."[103] Places exist as "a configuration of positions" that can be mapped geographically.[104] Spaces then exist as part of a locality. The contemporary cultural policy formation of "creative placemaking," which I take up in my final chapter, represents the cultural sector's focus on a strategy by which "public and private spaces" as well as "structure and streetscapes" are reanimated with the input and investments of artists and other cultural workers.[105] As a result my own book follows a teleological journey from the arts and the spaces, as we knew them, to the arts and places that are becoming.

Chapter 2, "A Politic of Purpose," assesses how the findings of the 92nd American Assembly, a 1997 meeting titled "The Arts in the Public Purpose," foreshadow what would become arts and cultural policy's agenda coming out of the culture wars of the 1990s. As the third of three such agenda-setting documents published in one year, yet the one with the greatest archival legacy, the 92nd American Assembly set the terms by which much arts policy would be developed. The meeting also framed artists' roles in such a way that their skills as producers would be called on in future arts and culture organizing. This chapter assesses how the meeting organized power on behalf of the arts and proposed a policy future.

Chapter 3, "New Work Now!" analyzes the terms by which a collective of theatre artists, the Austin New Works Theatre Community, planned for a shared future and assesses the outcomes of the project. Through their production of a "Vision and Strategic Plan," the self-named Austin New Works Theatre Community articulated not only their roles, relationships, and challenges as artist-producers but also the conditions they feel they require for a more productive future in the Austin arts community. Written originally as part of a larger grant to a foundation, the document ultimately failed to earn the Austin artists the immediate rewards for which they initially hoped; however, the document's production facilitated a closer working relationship among artists, one that is still reaping benefits. In addition, and perhaps more importantly,

this chapter asks how policy and philanthropy might better attend to the grassroots policy efforts of artists.

Chapter 4, "Accounting for Capital," examines how the Creative Capital Foundation has shaped the development of contemporary policy by constructing a new model of arts funding that combines the tools of venture capitalism with more traditional artist grant mechanisms. Since 1999, Creative Capital has introduced a number of innovative programs that combine seed funding efforts with training and ongoing assistance to animate the producing role that artists play in their work. Using Pierre Bourdieu's theories of economic, cultural, and social capital, this chapter demonstrates how Creative Capital models different types of capital transactions and shares capital with artists who function as artist-producers through the organization's programs.

In light of contemporary policy development, Chapter 5, "A Survey Course," demonstrates a policy-informed approach and methodology to a humanities course for first-year theatre and dance students. Challenging notions that artist entrepreneurial training and humanities training are distinct concerns, this curricular case study argues that policy can inform methods of critical thinking and materialist inquiry relevant to humanities-based learning. In the process, the roles that artists play as producers become evident and relevant to the students' real world efforts already in process, even in courses that take up artistic literatures and languages, including dance.

Chapter 6, "Linking Creative Investments," assesses two significant policy developments, a landmark study and an artist-focused initiative, to show how both frame the need for an artist-producer. *Investing in Creativity* (2003) represents the most comprehensive study to date of US artists' work patterns and lives. Based on a study of 14 different urban locations and a rural composite, the study demonstrates how artists are consistently tasked to produce certain conditions and opportunities to sustain productive careers. *Investing in Creativity* served as the basis for Leveraging Investments in Creativity, or LINC (2003–2013), a ten-year initiative dedicated to developing new models for artist practice and sustainability in the United States. Assessing LINC's outcomes against its initial proposals, this chapter offers a picture of the work that remains to be done in policy after a productive period of development. In both the study and the initiative, the artist-producer serves as the individual who might successfully navigate ongoing challenges and make the most of LINC's legacy.

Chapter 7, "Proposing Place," analyzes how "creative placemaking," a concept coined by the National Endowment for the Arts in 2010, tasks

artists to function as producers of community development. The program has also enabled the Endowment's emergence back into a central, critical role in shaping the nation's cultural life. Creative placemaking represents the combination of urban development methods with artistic practice to support vibrant communities with strong artistic engagement. Through the NEA's "Our Town" grants and the ArtPlace America initiative, place-making has become widely known in some towns and cities. In others, its effects have yet to be recognized or accepted. By framing the term historically and theoretically, this chapter offers artists the means to recognize how placemaking has affected the spaces of artistic production and the opportunities it offers to artists as producers.

Throughout my research, a number of people with whom I have spoken have referred to the site of policy development as "the policy table." Taking up that metaphor, I locate policy's table in each chapter and describe its make-up, as well as its intended use for each program, as a way of staging the accomplishments that have taken place and imagining the ones that have yet to be constructed.

2

A Politic of Purpose: "The Arts and the Public Purpose" (1997)

The 92nd American Assembly

On the afternoon of May 29, 1997, in Harriman, New York, nearly 80 arts professionals and advocates convened for the 92nd American Assembly, "The Arts and the Public Purpose." The invitees had been carefully selected according to their expertise, their knowledge, and their skills to help reverse what had become a punishing period for arts and culture in American history. Broadly, the meeting proposed to counter attacks to public arts funding made by culturally conservative politicians, critics, and citizens that had begun in the 1980s.[1] Writing of this time in the United States, cultural critic Carole Becker (1994) argues, "America was pitted against itself."[2] Works of art deemed offensive offered the most visible medium through which the politically progressive "desire for multiplicity"—social, sexual, and cultural or ethnic—was regularly challenged by reactionary conservatives' "desire for stasis and a retreat into the homogenous status quo."[3] Political scientist Margaret Jane Wyszomirski (2000) refers to the political maneuvering around the arts during this period as "polarized and raucous contention bearing little resemblance to policy discourse."[4] Echoing Wyszomirski, sociologist Stephen Tepper (2003) concludes that public "grievances" over so-called obscene art were not national debates; they were, instead, community specific conflicts over popular culture.[5] The public vetting of morality issues was not limited to performance or photography, of course, but infiltrated every aspect of government. Two days prior to the American Assembly meeting, the Supreme Court ruled 9–0 that a sitting President, Bill Clinton, could be sued for sexual harassment for sexual advances he made in 1991 toward a former Arkansas employee, Paula Corbin Jones.[6] On the national stage, as well as in arts spaces, unruly bodies offered

sites from which political, economic, and social capital was being lever-aged and gained.

At stake for those who advocated on behalf of the arts was the notion of "cultural democracy," the right for the United States' many cultrually specific groups to have their forms of expression respectfully engaged, even celebrated, rather than excoriated or silenced.[7] Some years before the meeting, cultural policy theorists Don Adams and Arlene Goldbard (1990) had argued that "the campaign for cultural democracy in the US must begin with the articulation of a sweeping vision, not in specialist terms, but in inclusive, accessible language."[8] It was in this spirit that the 92nd American Assembly was first proposed and its report produced.

In light of the subsequent operations and even the challenges it helped illuminate, the 92nd American Assembly, "The Arts and the Public Purpose," attests to a decided shift in US cultural policy made in the final years of the twentieth century. The published record of the meeting's proceedings avers a period when the philanthropists, arts organ-izers, arts supporters, and also artists worked closely and in quick time to define the nation's approach to arts and culture according to the arts' contributions to society, rather than its more publicly portrayed posi-tion as exploiter of tax dollars.[9] The story of the meeting, its careful cura-tion and implementation as an American Assembly, and the substance of its final report provide an excellent case study for how public policy intervened in arts discourse at a troubled time. The 92nd Assembly *prac-ticed and produced power* by shaping discourse—by making plain and evident the arts' connection to capital and to democratic institutions, but also its rootedness in contemporary concerns.[10] The report's final recommendations forge multiple, critical directions in arts and policy discourse, fundamentally redefining the relationship between the arts and US society. Evidence of the 92nd American Assembly's enduring legacy can also be found in the policy archive it influenced in close alli-ance with its recommendations, or in an inspired variation on them. A close reading of the meeting's legacy illustrates how artists' practices have been organized since the 1990s, but also how policy performs its role in shaping cultural production.

In light of the 92nd American Assembly's influence, I am especially concerned with how the event framed artists and how the meeting's procedures and final recommendations avail artists of an understanding of their place and potential in performing policy. How might the 92nd meeting's proceedings contribute to the current definition we have for artists if we read it as "The *Artist* and the Public Purpose?" Posing this

question amounts to a resistant reading. The final report asserts that the meeting's focus is decidedly different from cultural policy's usual focus on "the needs of the arts and artists."[11] However, among the final recommendations is the idea that "a pool of artists should be identified to provide creative leadership to continuing efforts resulting from this Assembly."[12] The report also declares that the greater arts sector is poorly understood and in distress. The commercial sector is susceptible to market fluctuations; nonprofits are overtaxed and underfunded and not able to support artists as well as their own bottom line. At the end of the food chain, artists are at risk unless they can provide additional assistance economically, politically, and socially.[13] In other words, the meeting was premised on the notion that artists would play a significant role in twenty-first-century art organizing operationally and in terms of infrastructure.

The findings and recommendations of the 92nd American Assembly make room for an artist as producer, one who could share the burden and the promise of a publically invested arts model by connecting to purpose, at every point. The artists present for the event as speakers, panelists, and participants included playwright David Henry Hwang, choreographer Donald Byrd, artist Judith Baca, community-based theatre director Dudley Cocke, and actor James Earl Jones.[14] As public intellectuals and artists, their works have addressed issues of race, representation, and civil rights, place, and community—the issues that frame many of the final recommendations of the report. None is credited as having participated on the drafting committee of the final report. In this capacity, artists appear at first as advisors at the well-appointed table of national arts organizing, perhaps even downstream recipients of policy operations, but not as its key record keepers. Yet I would argue that the archive describes the role that policy would propose for artists in the twenty-first century.

The 92nd American Assembly had been instigated and coplanned by Alberta Arthurs, the astute former Director of Arts and Humanities at the Rockefeller Foundation, who was serving a one-year appointment on the Council in Foreign Relations. During that year Arthurs also planned an American Assembly affirming the importance of the arts in American life and strategizing its future.[15] Arthurs is a key figure in arts organizing at the national level. As various biographies and reports attest, she has maintained a critical place in arts organizing for more than three decades, first during her time at the Rockefeller Foundation and since as an independent consultant. Her cultural investments are broad, covering cultural diplomacy, religion, the future of the humanities, the efficacy of

meetings, the future of education, and the future of museums.[16] Nearing the end of her 14 years at Rockefeller in 1997, Arthurs had become aware that the current system for arts support in the United States did not meet the needs of the people, much less artists. Like many arts professionals of the Ford era, Arthurs recognizes the Ford Foundation's role in developing and stabilizing the nation's arts infrastructure during the twentieth century.[17] At the same time, she observes that the period's emphasis on supporting nonprofit organizations privileged the high arts institutions favoring those who could "afford leisure pursuits." This high-culture focus placed "less emphasis on community-based, diverse, unincorporated or amateur artists and audiences, or on the ways in which arts engagement can contribute broadly to society as a whole."[18] With the Assembly, she hoped "to right the balance, to give attention to the many ways that the arts are made, and the many roles that the arts play in society."[19] Arthurs' proposed focus also offered a means to counter the controversies that had been surrounding the arts.

As a nonpartisan forum affiliated with Columbia University, the American Assembly has a history of presiding over critical public policy issues of the day. Prior to "The Arts and the Public Purpose," the American Assembly had taken on the subject of the arts only five times in its 46-year history. All of those meetings positioned the arts within a liberal paradigm, questioning the obligation of the state to supporting the arts.[20] The 92nd Assembly's immediate arts predecessor, the 85th Assembly, "The Arts & Government" (1990), had been a contentious affair. John Frohnmeyer, the beleaguered chair of the National Endowment for the Arts, had delivered an opening address.[21] Serving under President George H. W. Bush, Frohnmeyer was a lawyer whose specialization in the First Amendment had not prevented him from buckling under political pressure and including an "obscenity clause" in the agency's guidelines.[22] The Preamble of "The Arts & Government" report acknowledges the "content restrictions" of the obscenity clause signaled the end of "unfettered artistic freedom in the original N.E.A.," and offered and opened up a set of Constitutional questions with respect to the nation's obligation to support its culture and to represent all of its people.[23] Perhaps as a result of the conflicts that marked its process, "The Arts & Government" report is a very terse and brief document that begins with a caveat that the meeting's findings do not reflect the agreement of all those involved.[24] According to Arthurs, who already had a decade-long history with the American Assembly by 1997, the 1990 meeting was "characterized largely by attention to diversity issues ... that needed discussion."[25] It had also made evident the need for a meeting

theme that could embrace diverse perspectives and stakeholders and offer new strategies.

With David Mortimer, a longtime associate of the Assembly and its current president, Arthurs agreed on Frank Hodsoll as the meeting's cochair. As the former head of the National Endowment for the Arts under President Ronald Reagan, Hodsoll had successfully grown the agency's budget and initiated its research agenda with an *Arts in America* report that mapped the nation's cultural assets; he had also created a national task force to support the growth of touring networks in the performing arts.[26] His image as a conservative Republican complemented Arthurs' more progressive leanings and offered the event a bipartisan credibility.[27] With funding from a number of blue chip philanthropies and corporations, including the AT&T Foundation, the Ford Foundation, the Rockefeller Foundation, and Time Warner, Inc., Arthurs, Hodsoll, and Mortimer began. They assembled a steering committee that included sociologist Joni Maya Cherbo as "research director," Margaret Jane Wyszomirski as "chair of the steering committee," and Daniel Ritter, a former US Counsel, as "director."[28] Following the meeting, Cherbo and Wyszomirski published two more books that advanced the notion of a new policy.[29] Over the next eight years, the Arthurs–Hodsoll collegial partnership fostered four more American Assembly meetings dedicated to arts advocacy, producing three reports and expanding the 92nd Assembly's archival legacy. Happening at a time when arts policy communities were often "fragmented" and "disorganized,"[30] the first Arthurs–Hodsoll Assembly meeting brought together a diverse group of experts to advance an ambitious agenda.

To be clear, neither the meeting nor the report of the 92nd American Assembly was unique for rallying support for the arts at that time. "The Arts and the Public Purpose" stands as one event and document of an especially productive period in arts policy reorganization and advocacy. In 1997 alone, three national reports on the arts were published, and "The Arts and the Purpose" was the last. In January, the National Endowment for the Arts (NEA) had released the results of Chair Jane Alexander's four-year tour of American Arts, *American Canvas*. Typical of the NEA's approach to funding at the time, the document focuses on the status and contributions of the nation's nonprofit arts infrastructure.[31] Alexander and *American Canvas* author Gary O. Larson were also present for the 92nd Assembly. In February 1997, the President's Committee on the Arts and Humanities released *Creative America*, its own report on the crisis of culture policy. *Creative America* also argues that the arts are critical to democracy, and its reflections on the contributions of

the arts to a strong, democratic America echo "The Arts and the Public Purpose" document. Five committee members were also present at the 92nd Assembly, including President's Committee Chair John Brademas, President Emeritus of New York University, NEA Chair Alexander, and the report's funder, Harold J. Williams, President and CEO of the J. Paul Getty Trust.[32] As the final statement on what was a productive year in arts policy advocacy, "The Arts and the Public Purpose" can be seen a surplus with respect to all previous efforts—an attempt to expand the idea of what arts policy can or should be and to decipher what the arts needed to bring that policy to effect.

Reintroducing a revolution

From the outset, the 92nd American Assembly pursued a careful political and rhetorical approach that took full advantage of the Assembly's history, as well as the expertise of those present. By Arthurs' account, both she and Hodsoll agreed that the 92nd American Assembly meeting would have to resist the defensive approaches that argued for public arts policies on terms set by opponents to arts funding. The planning committee chose a time-tested strategy for revolution in the United States by combining public statements of values with notions of hard work and public good.[33] The participants' report on the final event as well as the planning documents draw lines of connection between the 92nd American Assembly and another revolutionary meeting, the Second Continental Congress of 1775–1776. The "Preamble" section of the report echoes Jefferson's first lines to "The Declaration of Independence," substituting the arts for the bodies of constituents. Jefferson begins with "We the people"; the 92nd American Assembly report begins with, "We have come together to examine what public purposes are served and ought to be served by the arts in America, in all their grand variety."[34] There is in this first page of the full report no apology for art that had been vilified in the culture wars. Instead the opening boldly asserts that the arts are a significant aspect of American life. Strategically, the document hails the memorable and the quotidian, high culture and popular entertainment: "from Sunday school Christmas pageants to symphony orchestras to fashion design to blockbuster movies." The "Preamble" also links the vitality of the commercial arts sector with its nonprofit alternative, arguably the sector more under attack during the previous decade. Drawing a line between the lucrative film industry and its popularly understood poorer relation in amateur theatre offers evidence of the power of cultural production.[35] The section is also quick to shine a spotlight on those

constituents and professionals who might confer their capital and clout to this essentially bipartisan, pro-arts work. The meeting's participants represent "a community of workers and executives of media conglomerates, poets and Broadway producers, critics and politicians, choreographers and professors, architects and public officials, philanthropists and movie stars." Their different identities, labor practices, and political affinities have brought them together "across differences, politics, and aesthetic perspectives to conclud[e] that there are public purposes to the arts that we all share, indeed that all Americans share."[36] The subtext here, of course, is that those in the room see themselves as illustrative of the greater public sector. With respect to cultural industries, they are legion, diverse, and connected to multiple forms of capital; their political power comes from a shared purpose that has been negotiated across difference. They are also ready to wage their own battle with rhetorical weapons, research, and campaigns, just as the colonists had prepared their armories more than 200 years before. In doing so, the document asserts that the arts find their value in benefiting all people and ends by calling on Americans to "join us in these efforts" of ensuring America's cultural well-being.[37]

By riffing on the Declaration of Independence, the members of the 92nd American Assembly were taking a performative approach.[38] They were evoking and thus performing the ways that freedom of expression as a civic value had been imagined into being in the United States. They were also echoing the queer performance artist Tim Miller, who penned "An Artist's Declaration of Independence" (1990) after his individual artist grant from the NEA was first revoked by the National Council.[39] That action set the stage for what would become *The National Endowment for the Arts et al. v. Finley et al.* (1998). In a process that parallels and expands on Miller's work as a touring artist, the authors of the report propose to move this performance of policy beyond the room and diasporically across the nation through multiple studies, reports, and program proposals. Broadly, the ambitious purposes assumed and attained by the members of the American Assembly point to its efficacy in performing statecraft—addressing public, shared concerns with a careful consideration of political, social, and economic benefits to be had from attending to them. Effectively, in the first few pages of the report, the participants link themselves to culture and erase any distinctions between culture and the political and economic systems of power in democracy.[40] Miller—along with his coplaintiffs Holly Hughes, Karen Finley, and John Fleck—used political subjectivity, including his experiences as one of the "NEA Four," to fuel his performance career and his

role as a public intellectual.[41] The participants of the 92nd Assembly use their political subjectivity to perform their response to the current political crisis and to co-opt the terms of the debate.

Scenarios of a state power

The connection between performance and policy goes well beyond flourishes of rhetoric that cleverly embed the proceedings of policy meetings in history, but also follows from the way that policy performs its repertoire through specific alliances, formations, and practices. Diana Taylor deploys the concept of scenarios as a means to supplement the reading of archival history by taking into account embodied practices.[42] Scenarios account the "physical location" of an event and the "social actors" present, the "formulaic structures" of encounters. These may determine outcomes or inspire "reversal, parody, or change," circumstances which can be accounted for by any one Assembly meeting. Those who engage scenarios must "situate ourselves in relationship to [an event], as participants, spectators, or witnesses," a task that may challenge artists and scholars to consider the legibility and accessibility of the policy's practices. In keeping with Taylor's notion that scenarios are "not necessarily or even primarily mimetic," each Assembly chair sets the unique tone for any one meeting. Finally, Taylor asserts that "[t]he transmission of a scenario…draw[s] from various modes that come from the archive and/or the repertoire."[43] As a performance scholar focused on arts and culture policy, I am concerned with the play inherent in a policy meeting and how the scenarios of these convocations reveal the means by which policy structures power and takes action. My analysis follows from the Assembly's history, interviews with Mortimer and Arthurs, as well as background materials, and the agenda made available to the participants.

As indicated by the opening of the report, the enduring legacy of the 92nd American Assembly follows from its capacity to gather and wield strong rhetoric and discursive power at a critical moment in arts policy history. In every aspect of its process, as well as its representation, the organization represents its role as democratic, forming alliances with experts who are working for the common good. The American Assembly defines itself as a "a national, non-partisan public affairs forum [that] illuminates issues of public policy by commissioning and issuing research and publications and sponsoring meetings."[44] Twice a year, the organization stages an interrogation of an urgent problem as a productive site of learning and exchange. Indeed, the Assembly's

history of gathering policy scholars from other think tanks and universities, along with philanthropists and other vested professionals and advocates, makes it something of a meta-resource for greater policy directions.[45]

The 92nd Assembly assumes authority and relevance by first associating itself with a historical site of national, capitalist power.[46] As its predecessors had done, the 92nd American Assembly convened at Arden House, a stately gilded-age mansion on 450 acres of verdant parkland in upstate New York. The home was built by railroad magnate E. L. Harriman in 1909 and bequeathed to Columbia University in 1950 as the dedicated event home for the organization. Arthurs observes that being in Arden House contributed to the efficacy of the proceedings:

> Arden House had a way of actually informing the debate. It was a place that participants had to themselves, a place of many rooms and corridors and gathering spots, a place to share, a place that inspired sharing.[47]

In the words of cultural theorist Michel de Certeau, Arden House was a "practiced place" for the participants.[48] During the 92nd Assembly, its halls were haunted not only by the nation's philanthropic history that saw those with fortune wield significant economic and social influence on the public good but also by the memory of meetings past. The participants might have thought of, and been motivated by, the American Assembly's earlier arts meetings, like the "Arts and Public Policy in the United States" (1984) or even "The Performing Arts in American Society" (1977). As the 92nd Assembly's predecessors could easily attest, these stagings and restagings of policy discussions allowed pressing social matters to be worked out in detail over time and among policy professionals whose connections to the political and economic resources in foundations, the academy, and government allowed for sustained engagement and repeated interventions.

Participants of the American Assembly join in a lineage of policy work stretching back to the mid-1950s, when the Ford era in arts policy was just emerging and the United States was adjusting to its role as a global leader and embarking on what would become its most dedicated period of social legislation. The organization was a dream project for General Dwight D. Eisenhower, who regarded its founding as the "greatest accomplishment" of his tenure as President of Columbia University from 1948 to 1953.[49] Eisenhower's work designing and building the Assembly demonstrated his capacities as statesman, as well as his

convicition that the nation deserved a nonpartisan forum where people with differing beliefs could debate values on intimate terms.[50] From the outset, Eisenhower found that the partisan nature of politics and the goals of the Assembly were not always easily aligned. The organization's approach to critiquing and reimagining the possibilities for the nation, which in itself made it inherently political, required it to be knowledgeable of its audiences and careful and methodical in its practices. Since its first meeting, "The Relationship of the United States to Western Europe" (1951), the American Assembly has been a significant forum for the identification, diagnosis, and intervention in some of the greater domestic and international issues of the day, including health, education, and poverty.[51] Consequently, throughout its history, the Assembly's embrace of arts as a topic signaled the importance of the issue to public policy, its tacit acceptance of a vibrant arts sector as critical to democracy as economic and political issues.[52]

Perhaps as a result of the political stakes in any one convening, American Assembly meetings adhere to a formulaic process.[53] The structured approach supports an equal consideration of all the public policy issues engaged. Meeting topics come to the organization through a variety of sources, including professionals in the field and members of the Assembly board. The organization's documentation of its publications indicates that all meetings are predicated on the assumption that the issue at hand is critical, the available background research is extensive and even disparate—requiring a synthesized interrogation—and that about sixty or seventy experts can be found.[54] In general, Assembly meetings are held over a period of three days during which participants watch panel discussions and work in breakout groups responding to questions and background research that they have all reviewed. For each breakout, a chosen rapporteur documents the dialogues that will contribute to the final report that is composed by a drafting committee in what Mortimer acknowledges is usually an all-night session.

On the final day of the Assembly, all participants convene one last time, at which time the draft is read out loud and participants negotiate over final wording. According to Mortimer, this final reading represents a moment when individuals should make their differences known and when those who hold opposing positions are tasked to negotiate a final deal. Taylor notes that scenarios force those within them to situate themselves with respect to the event "as participants, spectators, or witnesses."[55] In the diegetic space of an American Assembly meeting,

such a scenario also must account for experts. The invitation to dissent for the purposes of agreement undoubtedly puts the convictions and expertise of the more vocal participants on display and in contest. Taylor also indicates that an openness to multiple and diverse outcomes brings to scenarios a chance for "reversal, parody, change."[56] Potential reversal is evident in the caveat that opens the report of the 85th American Assembly, "The Arts & Government": "[I]t should be understood that not everyone agreed with all of it."[57] The public purpose theme and the bipartisan constituency of the 92nd Assembly made room for these negotiations to take place as part of the proceedings.

Mirroring Taylor's assertion that the "transmission of the scenario... can draw from various modes that come from the archive and/or the repertoire," participants come to the meeting after having reviewed a common archive of background essays.[58] For the 92nd Assembly, those essays were later revised, anthologized, and published as *The Public Life of Arts in America* (2000). The background materials demonstrate the breadth of knowledge available, as well as what would become the meeting's ecosystemic approach. For artists reviewing "the Arts and the Public Purpose," the chapters presage the tone of the final report and offer clues to future considerations of policy. Wyszomirski's "Raison d'état, Raisons des Arts: Thinking About Public Purposes" connects the public purpose notion to eras and events in American history and maps it on axes of core values (like "community" and "prosperity") that have emerged as a result. The Puritans, she notes, were not antiart, as commonly thought, but instead required it to have "a moral purpose." She cites Alexis de Toqueville's "doctrine of enlightened self interest properly understood" to in apparent challenge to the prevailing philosophies of Adam Smith ("enlightened self interest") that had firmly taken root in political discourse by 1997.[59] In "Toward an American Arts Industry," historian Harry Hillman Chartrand attempts to align arts policy with the American Industrial Organizational model. Chartrand recasts the US industry as a dynamic relationship with four key elements: "buyers and sellers"; "enterprise," which he defines as "productive activity" that is not necessarily profitable; "industry," a relationship between buyers and sellers; and "sectors," or a group of industries.[60] Chartrand's economic history offers multiple sites from which artists might measure practice. In "Public Involvement in the Arts," Judith Higgins Balfe and Monnie Peters rely heavily on the National Endowment for the Arts Public Participation data to chart consumption and engagement and to map the many different types of art available to people. In "The Career

Matrix," Ann M. Galligan and Neil O. Alper return to the supply side to chart:

> a baseline profile of who and how many artists there are, how they prepare for their careers as professionals, where and by what means they make a living as practitioners, at a variety of art forms in both for-profit and the not-for-profit sector; and how they compare to non-arts professionals.[61]

Drawing on their work together and with other scholars, Galligan and Alper encapsulate critical issues that resonate with contemporary policy, including the demographics of artists, material supports such as "health insurance," and "retirement."[62] They also look at potential new policy directions, including a better understanding of how artists work across commercial, not-for-profit, and self-employed sectors. Essays such as these—as well as the panels that took up their issues in discussion[63]— implicate the public purpose not only in terms of political and social engagement but also in deference to particular historical markets, supply and demand.

Assembly projects are underwritten by philanthropies whose own missions, programs, and initiatives align with the topic at hand and whose representative program officers attend. The philanthropic buy-in means that meetings can and often do go right into other meetings, research, and programmatic initiatives.[64] Each meeting publishes a report of its proceedings as well as its findings and recommendations, which represent a herculean effort of the planners and participants, but also add to an archive that structures the engagement of the subjects studied. In line with Taylor's assertion that "a scenario is not necessarily, or even primarily mimetic,"[65] Mortimer maintains that the hope of any successful Assembly is that the initial meeting spawns multiple outcomes, regional meetings, new Assemblies, and multiple publications. For artists participating in such meetings, this replicative function offers up a career modality, in which one's work producing public knowledge makes possible a next project. Participation also offers a form of social capital, a means by which artists might be recognized as peers to the systems structuring practice.

The conclusion of any Assembly meeting generally brings two or more outcomes. The final report is published at some point in the first few weeks after adjournment and distributed to the participants and the press. The participants are encouraged to request more copies, in paper

or digital form, to distribute among their own policy communities and constituencies as it might benefit their missions and projects. The publications of any related books are promoted through the Assembly website as part of the portfolio of projects emerging from the meeting.[66] Thus the power of these meetings lies not merely in their ability to connect to the issues of the moment but also to find traction in future policy directions. The imperative to work across time explains the rich, historical language in the final report.

The final report

"The Arts and the Public Purpose" is an intertextual document of relevant scholarship carefully cobbled from disparate histories, disciplines, and experiences, reflecting Taylor's notion that "the transmission of a scenario reflects the multifaceted systems at work." The report also reveals the easy slippage between "the archive and/or the repertoire," as policy theorists and advocates performed their roles.[67] As the report's preamble indicates, none of the ideas presented at the meeting were new. However, the document strategically touches on key themes circulating in the arts at that time, hailing those experts present at the meeting, and those consigned to the past. Like its predecessor and successors, it follows the policy report paradigm: executive summary, problem statement, background and previous research, findings, and recommendations. The report also elaborates on a repetitive device common to landmark studies, which return multiple times to their essential findings after viewing them through a different question, disciplinary approach, or data set. Inclusive of its "Executive Summary," it returns to eight of its nine recommendations four times. The report also constantly navigates between the key terms. As evidenced by an outline of its headings and subheadings, "The Arts and the Public Purpose" attempts, in verse and chorus, to marry purpose or value to sectoral concerns and arrive at a political imperative for new policy strategies. For example, a major section dedicated to "The Arts in American Life" is followed and reframed by "The Public Purposes of the Arts"; likewise, "The Arts Sector" is followed by "The Arts Sector and Public Purposes."

Each section takes a unique approach to the argument. "The Arts in American Life" demonstrates the wide variety and uses of arts in the United States, overwhelming the reader with its breadth and complexity. The rhetoric regularly employs poetic devices to sustain the rhythm and the reader's interest. The writing is alliterative and consonant. Substantively

it brings together arts sectors, aesthetic movements, cultural practices, and well-known artists:

> movies and mambo, abstract expressionism and the dozens, singing commercials and standup comedy, Charlie Parker and Georgia O'Keeffe, advertising logos and Bruce Springsteen.[68]

The alignment stages what would become known more popularly in the twenty-first century as the "creative sector," an amalgamation of cultural expression that combines commercial forms of art, high art forms, and community expressions.[69] The arts are also spatially celebrated. They are everywhere doing the important work of bonding society:

> The arts in our country celebrate and preserve our national legacy in museums, concert halls, parks, and alternative spaces; they also inhere in the objects and buildings we use every day, and in the music we listen to in our car, workplaces, homes, and streets.[70]

The mention of "alternative spaces" demonstrates the intention of the meeting's participants to create a bulwark against the right wing cause. Alternative spaces had been targeted during the funding wars of the 1990s.[71] The infinite variety of public and private spaces depicted in this document in which the arts are engaged marks everyone as a consumer. The right wing pundits who had used the term "art" to connote elite tastes are called out for the innocuous act of switching on their radios.[72] The arts become a test site for liberty (freedom to choose) and democracy (majority rule, perhaps, but also diverse inclusion). Despite what will emerge as a focus on nonprofit and commercial arts, this statement also offers a cogent sense of all three arts sectors by sidebarring "the not-for-profit, commercial, and unincorporated arts."[73] "The Public Purposes of the Arts" outlines the four key arguments of purpose: the arts help "define what it is to be an American...contribute to quality of life and economic growth [...] form an educated and aware citizenry [and] enhance individual life."[74]

From accomplishments and core values, the report moves on to define the unique organizational concerns of "The Arts Sector," implying that the place of artists is *in relation* to spaces, institutions, and the greater infrastructure. The document focuses mostly on the nonprofit and commercial sectors, the contributions made by the arts and artists, and the need for systemic rewards. An excerpt bracketed from the text notes

that " ... artists are poorly paid and lack health and retirement benefits."[75] The fourth section of the body, "The Arts Sector and the Public Purpose," reinscribes the four key contributions on sectoral demands to elicit findings. For instance, the authors argue that values such as "quality of life" and an "educated and aware citizenry," combined with the inherent risks in making art, demand "greater attention to the art sector's financial security" and "improved educational programs in the arts."[76]

In light of the 92nd American Assembly's political imperative, the eight final recommendations of "The Arts and the Public Purpose" describe forms of capital that fuel the arts and implicate artists as key partners in the nation's cultural future. To illustrate their applicability to the contemporary artist paradigm, I have highlighted the specific calls to artists that have met legible efforts in cultural policy and practice. The report's first two recommendations ("Achieving Collaboration and Partnership" and "Improving Financial Support and Investment") outline the types of businesses and economic sectors that invest in and produce the public purposes of arts and call for even greater investment. These two areas effectively situate economic capital "at the root" of ongoing change and development.[77] "Achieving Collaboration and Partnership" begins its call for greater organizational clarity by naming the "commercial, not-for-profit, and unincorporated parts of the arts sector" as the key mediums for arts support and call for greater cross-sector exchange.[78] Businesses, as well as state and local governments, are tasked to employ and/or partner with artists in varying capacities and to publicize those efforts.[79] This is the model currently undertaken by "creative placemaking" efforts, where state and local governments partner with businesses and artists to enhance the cultural activity of a city.[80] "Improving Financial Support" illustrates mechanisms by which a priori goals might be achieved. For instance, commercial arts institutions and not-for-profit institutions are tasked to work together to seek leveraged funding opportunities, and foundations large and small are called upon not only to support the arts and "specific projects" in that capacity, but also to develop "prizes and competitions."[81] One example of this today is the United States Artists, an award program that brings together foundation funding with private fundraising to directly support the work of artists.[82] With a focus on identifying the entities and partnerships that best serve the arts and artists, the first recommendations offer a structural lesson for contemporary understandings about the arts.

The next three recommendations ("Making the Arts More Accessible," "Preserving the Nation's Heritage," and "Improving Education and

Training") address forms of cultural capital, the means by which the arts build educated and supporters.[83] Bourdieu theorizes that cultural capital can be conferred upon a bearer through systems of training, marked accomplishments, and/or claims on the archive, through either authorship or ownership.[84] The bulk of policy changes outlined in this section address where arts occur (place), the means by which arts are delivered (medium), and the equitable dispersal (distribution). Cultural capital serves as the currency by which artists benefit from these concerns. "Making the Arts More Accessible" addresses the three ways that arts can be understood as part of the greater culture nation-wide as a result of its distribution systems, both current and immanent. Artists are encouraged to use new technologies of distribution, which has occurred through social networking and crowd-sourced fundraising efforts. Artists are also tasked to weave their work into the social fabric of community.[85] The foundation for this work today has been accomplished through both research on cultural participation and a renewed support for artist-driven and community-driven cultural programming efforts.[86] With its focus on the United States' legacy, "Preserving the Nation's Heritage" bears the most enduring public purpose among eight recommendations. It is also the one that reflects the clear distinctions between the archive, with respect to preservation of existing works, and the repertoire, with respect to recognition of living artists. Specifically, "Preserving the Nation's Heritage" focuses on the challenges and standards of preserving the arts that individuals and institutions face. Artists are called to take part in documenting their works, and the greater arts sector is called to award artists for their legacies.[87] More recent efforts at livestreaming and archiving live dance and performance through "Howl Round" and "OntheBoardsTV" represent a policy focus on the preservation of ephemeral artistic forms.[88] Following Bourdieu's assertion that cultural capital emerges from educational paradigms, "Improving Education and Training" represents a question of sustainability writ large by speaking to the role that education plays in "lifelong learning."[89] Artists are acknowledged as potential teachers. The education system is also tasked to research training and to take a more expansive approach that prepares artists to serve a public purpose.[90] More recent research efforts such as the Strategic National Arts Alumni Project (SNAAP) offer a means to track the postsecondary careers of artists.[91] A more on-the-ground training effort exists through a panoply of programs supported by the Creative Capital Foundation since 2003.[92]

The final three recommendations ("Meeting Research and Evaluation Needs," "Strengthening Advocacy," and "Furthering the Dialogue")

recognize the deep social relations, or forms of social capital, that support an affectively rich and mutually sustaining arts environment. Bourdieu defines social capital as "the aggregate of the actual or potential resources which are linked to the possession of a durable network of...institutionalized relationships of mutual acquaintance and recognition."[93] My own choice to include research as a category of social capital recognizes the participants' shared understanding that adequate research on the arts was sorely lacking. For example, "Meeting Research, Information, and Evaluation Needs" acknowledges that the arts are poorly understood and asserts that research can provide the means and the tools for greater social credibility and agency for cultural workers. This section offers a litany of policy resources missing, including various types of research reports, including "[i]ssue analyses," "[c]ase studies," "[l]ongitudinal studies of artists' careers," and "[b]etter information" about the arts policies of other nations.[94] On the domestic front, many contemporary studies have pursued these methodologies, including *Investing in Creativity* (2003), *Crossover* (2006) and the work of SNAAP (2010).[95] A lull in foundation support for the study and exchange of international cultural work occurred during the first decade of the twenty-first century; however, in 2010, The International Federation of Arts Councils and Culture Agencies (IFACCA) announced that it would begin building a database of international cultural policies.[96] The recommendation, "Strengthening Advocacy" follows Bourdieu's observation that "the volume of social capital possessed by a given agent [...] depends on the size of the network he can effectively mobilize [...]."[97] The cultural sector is challenged to mobilize and to partner for political advocacy, but also to remain in dialogue with politicians, so that the concerns of both sides are apparent. Strengthening Advocacy suggests that "a single "umbrella organization should be considered for the purposes of determining shared goals."[98] While Americans for the Arts identifies itself as a central advocacy organization for the arts, the work of strengthening advocacy has been done piecemeal by a number of organizations, like those featured in this book.[99] The final recommendation, "Furthering the Dialogue" reflexively gestures to the work of the 92nd Assembly and posits that its legacy will be fulfilled through numerous associated meetings. Likewise, it reflects Bourdieu's notion that social capital is "the result of endless effort of institutions, of which institution rites" build, maintain, and "reproduce lasting, useful relationships that can secure material or symbolic profits."[100] Throughout this section, the participants call for more meetings through which issues and accomplishments of public purpose might be recognized.

Through its recommendations, "The Arts and the Public Purpose" plotted a way to cultural equity; however the effort remains an ongoing project. Writing in 2004, Roberto Bedoya, who as the Chair of the National Association for Artist Alliances (NAAO) participated in the 92nd Assembly, observes an arts policy community that is still "exclusionary," despite the lessons of the culture wars and the responses made to those lessons.[101] More recently economist and urban planner Ann Markusen (2013) has written about the effects of cultural wars on artists, noting that they are "only now emerging from the bumptious cycle of structural downs and ups an institutional changes [s]ince...the early 1990s."[102] With respect to nonprofits, Bedoya notes that philanthropists still favor "first-tier arts service organizations" over culturally and ethnically specific organizations as well as artist-driven ones. He attributes this to the culture wars and the conservatism of the arts sector.[103] He asserts that "traditional high arts disciplines"—presumably museums, ballets, and symphonies and the like—already wield power in the marketplace and too often overshadow the research and development efforts of smaller organizations that answer to specific communities, and undercut not only programmatic support for artists but also the arts as a community practice.[104] Similarly, Markusen finds "woefully underserved are the thousand of immigrant arts organizations, often volunteer-run, that are nurturing and innovating with traditional arts forms and are using artists' skills to fight for community rights to space."[105]

In a recent study of philanthropic giving to the arts, Holly Sidford (2011) documents that the majority of arts funding does not favor diversity or the broader communities proposed as sites for art in "The Arts and the Public Purpose":

> Only 10 percent of grant dollars made with a primary or secondary purpose of supporting the arts explicitly benefit underserved communities, including lower-income populations, communities of color, and other disadvantaged groups.[106]

Funding's entrenched devotion to "wealthier, more privileged institutions" hails the need for artist-producers who can effectively integrate their works into broader communities through strategic partnerships.

Arthurs nods to all of these points when she candidly acknowledges that for much of the latter half of the twentieth century, both philanthropy and the policy community were too devoted to "a professional arts scene." Both raised up high arts disciplines and prioritized professionalized artists over amateur ones. These professional organizations priced

cultural productions in accordance with the market, in effect making cultural expression and engagement less a right than a commodity. Positing change as an ongoing process, she points to the efforts of the 92nd Assembly:

> What you see now (and in "The Arts and the Public Purpose") is an effort to right the balance, to give attention to the other ways that the arts are made, and the role that the arts play in society. And you see that in the report an attempt to really understand how the arts function across the for-profit, nonprofit, and community sectors.[107]

In other words, the document represents a long-term plan to effect change, to establish paradigms for research and future work. The policy archive imagined by the 92nd Assembly represents a cultural commons where arts organizers, scholars, *and* artists might find their opportunities imagined into being.

Bedoya's critique on behalf of artists and culturally specific organizations testify to his likely contributions to the 92nd American Assembly. NAAO had played an especially active role in galvanizing support for artists during the culture wars, not only through its "art blasts" and calls to arts advocates to lobby Congress, but also by joining as a coplaintiff in *The National Endowment for the Arts et al. v. Finley et al.*[108] In his current capacity as the Executive Director of the Tucson Pima Arts Council, Bedoya's organizing and theorizing on programs that support cultural specific communities, which I take up in Chapter 7, represents one among many 92nd American Assembly alumni who continue to make significant contributions to arts policy by working directly with artists in culturally specific communities.

With respect to artists, Markusen describes the period of arts policy development since the culture wars as "a panoply of experiments and initiatives in funding, entrepreneurial training, space provision, organization building, and lifelong learning opportunities and program creation" and notes that the work of synthesizing these experiments is still ongoing, largely because artistic practice spans multiple forms of engagement and because artists contribute to multiple forms of practice.[109] Speaking of the same time span, Arthurs cautions that "we have a tendency to want to protect [artists]. We're still heroicizing them. There are artists who are activists, and there are others who are not, but more and more artists are [activists]." She observes new modes of practice, including "social change art" as the means by which artists are embedding their work into communities.[110]

The American Assembly's approach to the arts over the next eight years followed directly from the 92nd Assembly. Not surprisingly, given the report's repeated citation of the for-profit and nonprofit nexus in the recommendations of "The Arts and the Public Purpose," the next arts meeting of the American Assembly addressed the understanding of arts sectors. Within a year, the "convener of thinkers" embarked on two meetings under the rubric of one Assembly, titled "Deals and Ideals: For-Profit and Not-for-Profit Arts Connections" (1998–1999).[111] As the report makes clear, the participants were adamant that the risk and innovation in the not-for-profit sector, as well as its susceptibility to market fluctuations, made its support from the commercial sector critical. In 2002, the 100th American Assembly convened "Art & Intellectual Property."[112] The issue of the poorly understood marketplace and especially the protections of intellectual property in the digital age had been critical to former NEA chair Bill Ivey and would later be featured in his book *Arts, Inc.* (2008).[113] In 2004, the 104th American Assembly convened "The Creative Campus: the Training, Sustaining, and Presenting of Performing Arts in America's Higher Education."[114] Through its essentially dual focus on one type of artistic production as well as on education, the meeting embraced a host of public policy concerns that were previously addressed by the 92nd Assembly.

Through its advocacy and in its calling together of supporters in a fight, "The Arts and the Public Purpose" reads as something of a revolutionary artifact. The report and its archival legacy reflect the moment when arts advocates redirected a negative tide in the culture wars' attacks on the arts using smart, political resources that included historical rhetoric, strategically ordered priorities, and clear terms for future engagement. The power represented by the American Assembly, its Columbia University host, and its Eisenhower legacy all lent the event validity in the battle for arts policy, as did its apparent bipartisan approach. Reading the document's rich, supportive, and polemic tone, one can see an ambitious attempt to integrate artists into the fabric of arts organizing and industries, not only to raise up artists and empower them but also to support a suffering nonprofit infrastructure. At the same time, as the document makes clear, that policy's study on research and advocacy with its focus on "the needs of arts and artists" had prevented US society from developing an understanding of how "the arts can and do the needs of the nation and its citizens."[115] In many ways, "The Arts and the Public Purpose" argues that the arts have been doing the work of multiplying capital on a modicum of national investment. The potential return on investment is projected in numerous ways, as various

forms of public good, from education to cultural vitality and prosperity. The document excels at negotiating a politically difficult moment. With respect to artists especially, it seems to be trying to contain the cultural expressions that have become political kryptonite—to place those works within a context, but also to assert the value of what artists do. The document also unwittingly problematizes the role of artists. Artists are presented as part of an ecosystem. Professional artists are represented in the room, on the stage in panels, and in the report. Amateur artists are not present. Nor do the final essays find a place for artists. To read the document, then, one sees a vacillation between ideals and outcomes. On its own, the report offers up a sharp disciplinary distinction: there are those who are considered experts on the subject of arts and artists, and there are those who consider their expertise to be making art. This unhelpful binary might justify artists' inability to imagine their leadership role in future policy development. At the same time, the document's rich and careful insights into the concerns of artistic practice offer clear terms by which artists might participate in ongoing change.

3
New Work Now! The Austin New Works Theatre Community (2012)

A community proposal

In 2010, after a year of preparation, a group of Austin theatre artists received news from the Andrew W. Mellon Foundation that they would be receiving a $90,000 planning grant to study how, in their own words, "to make Austin a center for real [theatre] work."[1] By the time of the announcement, the group had already spent a year strategizing for a future in which they could feel supported and rewarded artistically, physically, spiritually, emotionally, *and* economically—their terms for "real work." As was explained in the artists' contract with Mellon, the planning grant was the first step in a potentially tiered funding process. The award period was expected to cover an 18-month period for research and strategizing for possible multiyear funding from the Foundation.[2] The result of the artists' in-depth process is a strategic plan titled the "Austin New Works Theatre Community" (2013), a proposal to Mellon for $600,000 of resources for the local theatre infrastructure.[3] Less than a decade after Richard Florida (2002) proclaimed Austin an exemplar of a vibrant, creative class city in which artists contribute to economic vitality, local theatre artists had categorized and put a price tag on their abilities and their dreams.[4]

Almost two years after submission to Mellon, the proposed project remains unfunded, a fact that has left many of the artists I have spoken to disappointed and discouraged. On the surface, the document's greatest accomplishments would appear to be the fact that the concentrated time and development efforts instituted a closer working community and supported the creation of a common website.[5] The "Austin New

Works Theater Community" reflects more than the dashed dreams of Austin's theatre artists or perhaps even the disappointment of a foundation that hoped to model an artist-driven funding paradigm. Elements in the document show the artists productively performing policy. In the process of researching their shared challenges and ambitions, they negotiated contractual terms with each other, the city of Austin, the region, and the nation. In doing so, they created systemic, collaborative, and informed working relationships. In keeping with Austin's reputation as a laid-back city, the "policy table" that best represents the Austin New Works Theatre Community effort stands in sharp contrast to the Arden House setting of the 92nd American Assembly. Instead of a mansion, it is an outdoor picnic table at the Butterfly Bar, a full-service bar attached to the Vortex Theatre where the artists gathered regularly for meetings, check-ins, and working happy hours as they talked through the details of the process.

With respect to arts policy, the document also shows the artists attempting to submit a strategic plan in deference to policy's traditional operators rather than in a productive partnership defined by mutual validation, complementary skills, and knowledge. Reading the plan in the context of recent policy history offers a clear picture of how the Austin artists began a process that may yet see returns and how other artists might benefit from their work. Marking the group's accomplishments offers a picture of hope for this project. On the other hand, reading subsequent lack of grant monies as a failure—which some Austin artists have begun to do—renders the participants' efforts a form of "tactics." Cultural theorist Michel de Certeau defines tactics as "calculated action[s]" lacking origins *and* destinations in systems of power.[6] Framing tactics as "the art of the weak,"[7] De Certeau distinguishes tactics from "strategies," the operations of those who actually hold power.[8] While the document is aimed at an easily legible site of power represented by a foundation, the actions it proposes reflect significant accomplishments and capacities on the part of the artists. Consequently, recuperating the document's value requires not only distinguishing the respective powers of the foundation and the artists but also reading it on terms shared equally by both. In keeping with the call of the 92nd American Assembly for policy leadership from artists, parsing the gap between each party's expectations and the project's outcomes offers a means to consider how artists might function more effectively and regularly as policy theorists and practitioners.[9]

The "Austin New Works Theatre Community" document is an impressive crowd-sourced effort, one that brings together knowledge and

skills. Numerous artists and arts supporters contributed to creating the plan which diagnoses gaps in support, articulates dreams, and argues for an equitable return on theatre's contributions to the local creative economy. The document asks how a city known as "the live music capital of the world" might widen its spotlight to shine on the work of twenty-three member performance companies who participated in its making, as well as those companies yet to be born.[10] Inclusive in the plan are mechanisms for coordinated marketing and ticketing, resources for additional rehearsal and performance spaces, childcare for rehearsal nights, a scenery cooperative, research for health care and wellness, as well as increased touring exchanges between Austin and neighboring cities. Mostly though, the artists ask how they might collectively capture the attention and commitment of audiences and funders. The origins of the plan reflect the artists' visibility on a national scale, as well as their readiness to define the resources that can support them collectively.

Policy history and the artists

The invitation to write their proposal followed from the Austin theatre artists' participation in *The Gates of Opportunity* (2007, 2009), a Mellon-funded national study conducted by David Dower.[11] According to former Mellon Foundation Associate Program Officer Diane Ragsdale, who commissioned the study, the Foundation had convened a series of dialogues with theatre makers on how artists might find greater access and agency in theatres nationwide.[12] While serving as the Artistic Director of Z-Space in San Francisco, Dower realized that his 20 years of work in San Francisco had rendered him aware of his artistic community's needs, yet unaware of the relevance of that knowledge on a national scale.[13] To see how the nation's theatres diversely supported new works, Dower proposed to Mellon that he meet with "generative [theatre] artists: playwrights, ensembles, and multidisciplinary theatre makers in fifteen different artistic communities, including Austin."[14] Dower deems his domain of inquiry the "new works sector," characterizing it as a site where artists' share the desire to maintain creative control of their efforts.[15] In effect, the artists recognized they were producing works in collaboration with "artist-focused spaces," but also competing against institutional demands that threatened the vision of their work.[16] As several of the Austin New Works Theatre Community members have noted, the combination of the success of some local companies and artists, the artist-focused model of its many theatre ensembles, and Austin's reputation as an arts town compelled Dower to include Austin

in his research. Dower told Ragsdale that he found Austin's theatre scene unique. Separately, the two met with Austin artists as they began their strategic planning.[17] Revising *The Gates of Opportunity* into a 33-page report with a new "Introduction" in 2009, Dower notes that Austin is "organizing as a community to connect the whole crowd into the national new works infrastructure."[18] In other words, and as members of the Austin New Works Community confirm, the artists were already at work on their proposal to the Mellon Foundation.[19]

Mellon's risk in funding a group of artists making original theatre follow from the efforts of the foundation's Performing Arts program to identify and address critical concerns in the field.[20] As part of a strategic redesign in 2004, the Performing Arts program introduced its New Play Initiative to respond to the challenges facing original theatre makers and to discern best practices.[21] Dower notes that his work was inspired by his participation in the 2002 Theatre Communications Group (TCG) conference, "New Works, New Ways" in Portland, which took place within one year of the publication of another relevant study that also reflects the direction of the Mellon's New Play Initiative.[22] *The Performing Arts in a New Era* (RAND, 2001) gathered data over two decades (between the 1970s and the 1990s) to document systemic and field-wide patterns indicative of growing barriers to artistic practice and organizational sustainability in the new market economy. Among its forecasts is the idea that large organizations relying on imported blockbuster shows will grow bigger, monopolizing their elite funders and assuming market dominance. Small organizations are projected to assume greater creative risks than their larger competitors, but lacking economic resources, they will rely on volunteer labor over paid artistic support. The study also suggests that medium-sized organizations will play a mediating role, either attempting to grow through more risk-averse strategies or increasing collaborations with the small, community-based organizations pursuing artistic risk. In light of this broad stratification, many artists will be find themselves weighing artistic visions against financial security concerns.[23] *The Gates of Opportunity* repeats many of these same claims, and anticipates many findings from *Outrageous Fortune: The Life and Times of the New American Play* (2009), which examines many of the challenges facing contemporary playwrights and theatre companies.[24] The Austin New Works Theatre Community's in-process planning was featured in "From Scarcity to Abundance: Capturing the Moment for the New Work Sector" (January 26–29, 2011), a meeting funded by the Doris Duke Charitable Foundation and conference convened at Arena Stage in Washington, DC, in which Dower, London, and a number of

other artists and organizers took part.[25] Moreover, their participation contributed to *In the Intersection* (2011), Diane Ragsdale's book-length report on the findings of the meeting and the national new play sector.[26] In other words, the Austin community's work responds to a particularly rich period of organizing, research, and programmatic development organizing around contemporary theatrical production. The spirit of these convergences would be echoed by the "Austin New Works Theatre Community" document, although many of the details would not.

At the same time, the funding of the Austin community was unique in policy circles for a foundation's direct support to a loose collective of artists.[27] While prominent foundations were and are still inherently cautious about funding artist groups directly, the Austin artists were the only community collaborative initiative to be funded as a result of Dower's research. The other Mellon projects mentioned included established institutions such as the Sundance Institute Theatre Lab, The Playwrights' Center in Minneapolis, and The Public Theatre in New York.[28] Although funds passed-through the Austin Creative Alliance, a local service organization, the artists were given free range to focus on the "dreamy dream" and to think of the support now and in the future as coming directly to them.[29] According to Christi Moore, who is the Executive Director of ScriptWorks, an organization that supports playwrights, the process allowed artists as a collective "to get to the nuts and bolts of longstanding problems and concerns."[30]

From the time it was first imagined, "the Mellon money," as it was called in frequent e-mails to the participants, served as a galvanizing force for the belief that change could take place. It brought together local artists to think through their concerns and to assert "a set of core values that include risk, cooperation, independence, and invention" as the terms of their effort.[31] In all, 114 individuals, including myself, would contribute to the process by offering language, edits, or resources to the working document or by participating in various meetings. These events included informal happy hours, a strategic planning retreat, follow-up sessions, two strategizing retreats, a regional theatre conference, ongoing breakout meetings, and a final party. The organizational structure was small at the core, but fanned out across the theatre community. The greater group was led variously by a triumvirate of theatre artists, from a group that included over time Katie Pearl, Bonnie Cullum, Etta Saunders, Caroline Reck, and Heather Barfield. This group variously oversaw document production, budgeting, and spending; built the website; and kept the community engaged.[32] The document's organization along eight "thought clusters" also invited a type of categorical

leadership. Each cluster was led by a member of the steering committee that met together regularly and served as core advisory group to the strategic plan.

Almost from the beginning the task of herding together the Austin artists and representing the full diversity and expertise of the community required significant efforts in tracking and documenting progress. The process was made more complex by the community's commitment to "consensus meetings [and] research," as well as its commitment to compensating the artists who were doing the work.[33] "Weekly Updates," first sent out by Katie Pearl and later from Caroline Reck, who succeeded Pearl as "Community Liaison," organized meetings, announced community members' productions, and worked to keep participants abreast of progress. Early e-mails show Katie Pearl rallying people to read the e-mails fully and closely and to attend community gatherings.[34] Similarly, Reck's numerous emails share findings, announce new opportunities, and offer observations in an attempt to keep the community motivated. In "Weekly Update #80," for instance, Reck announces that the "Communication and Strategic Center" met the week before and "got great input from community members"; she also invites the members to attend a meeting that week with staff from the Austin Creative Alliance to discuss the benefits of collaboration across disciplines, as well as the types of skill and training needed for local artists.[35] "Weekly Update #111" announces the final party to celebrate the proposal's submission.[36] Conducting research and building consensus are arduous processes, and so from the start, the process itself was positioned to take time.[37]

The time was multiplied by the fact that Austin artists connected to this project pursued a form of practice-based research, documenting their own experiences and sharing their observations with others.[38] The medium of that research, the eight thought clusters, demonstrates that the artists were working as artist-producers on a large scale, as they balanced their particular aesthetic concerns with material ones facing the greater community. The "Resource Sharing" cluster documented resources available, such as the currently existing Austin Scenic Co-Op, and resources needed, such as additional rehearsal space. The "Permeable Boundaries" cluster examined touring opportunities between Austin and other cities. "Artists' Well-Being" addressed health concerns and needs. Two clusters, "Audience Engagement" and "Civic Engagement" examined how artists might build and share audiences, and amass more leverage with the city of Austin, through alliances with other organizations. "Archiving" and "Community Identity" addressed legacy concerns as well as the diversity of the community. Finally, "Communications" facilitated

the progress, gathered audition announcements, tracked participants' needs, and constructed the website. Accounting for and integrating all of these efforts contributed to the time factor. Ultimately, the "Austin New Works Theatre Community" document took 28 months to produce and required one extension from the funder, an outcome that may not have served the Austin artists' subsequent proposal for funds.[39]

Nevertheless, the artists did produce a strategic plan that might be pursued over a period of five years. They offer clear goals that address sustainability, increased community participation, the strategic apportioning of resources and knowledge, and evaluation. In one category, called "Fulcrum: Size, Scale, Influence," the artists articulate methodologies for activating and sharing their audiences, raising their profiles and amassing cultural capital, and supporting wellness. Through their focus on their own maintenance, the artists assert that their own bodies deserve rewards for their contributions to culture. Under the heading of "Grid," the members strategize for all of the network technologies they might use, as well as the local, national, and international networks they might engage through production touring and presenting. In a section titled "Resource Center," the artists name specific material supports, like a scenic cooperative for local theatre, which remains in operation, and increased rehearsal and production spaces, which remain a need. They also speak of their legacy and establishing an archive for the preservation of their work.[40] Through the document the artists reach for the sum of social, political, material, economic resources they might need to make great work.

A complex contract

The way that the Austin artists pursued their work as a loose collective also represents the hybrid mix of the informal contractual agreements common to the community sector and the more formal reporting requirements of the nonprofit sector.[41] In effect, the artists were negotiating a very complex contract. The terms of this contract are best described using "contract theory," which explains how individuals in working relationships negotiate investments and reward.[42] Because contracts are drawn up as a way of guiding work agreements, they are rarely simple or "*complete*," meaning they do not "pin down every action each party will take and the reward received."[43] On the surface, the Mellon award offered an effective lure, the immediate allocation of resources to be shared by the participants and the prospect of future funds. However, the immediate challenge of putting together an initiative and writing a proposal

preempted the time necessary to develop as a collective and to develop the terms of individual, company-based, and composite concerns. The proposal first submitted in 2010 did not reflect all potential costs and rewards because it could not anticipate the labor and resources that had been expensed and would be expensed on the whole project, nor did it fully represent the realized expertise of people who would learn more as a result of the foundation's investment.[44]

With respect to the Austin New Works Theatre Community, the extra time spent fulfilling the terms of the grant was a challenge the collective had not predicted. The last 17 years of accomplishments of the arts policy sector in the United States point time and again to the fundamental unknowingness of rewards, the fickleness of audiences, the costs of producing art, even the mixed valence that the arts hold in society.[45] As three production seasons progressed for the artists involved and new opportunities emerged, the artists lost time to other projects as they labored to complete their work with Mellon. The members of the Austin New Works Theatre Community committed fully for a short time to the project and to make it work, but they knew that any future labor had to be carefully calibrated if not minimized to be complementary to their artistic practices over the long run. They were mapping the resources legible to them, but they were also imagining, seeking, and hoping for national resources that should be available to them. Managing the knowledge and access to these resources helped shape the leadership methodology, which constitutes the third section of the plan. As a result of these efforts, the artists' work of activating the existing infrastructure and keeping their organizational commitments streamlined represented a theoretical accomplishment, and a keen assessment of their work on a very taxing project. At the same time, the interior focus of the document and its lack of discursive grounding in contemporary policy initiatives belie the actual knowledge invested and the potential of the project.

Policy's discourse

To read the Austin "New Works" document alongside policy studies and initiatives is to witness the artists working to replicate policy on policy's terms, even as they unmoor themselves from the systems of power that might sustain them. At 31 pages, the document is absent of any footnotes or citations of relevant studies, including, most significantly, *The Gates of Opportunity*, *The Performing Arts in American Society*, and even *Create Austin* (2009), the city's own "Cultural Master Plan." Led

by The City of Austin Cultural Arts Division, the goal of *Create Austin* is to "identify Austin's creative assets and challenges, define goals, and establish recommendations to invigorate Austin's 'culture of creativity' to 2017."[46] *Create Austin* holds a direct relationship to the Austin New Works Theatre Community, as well as a complementary one. Whereas the New Works document is dedicated to the work of a group of artists, *Create Austin* focuses largely on creating the infrastructure of the Austin arts community and deepening relations among artists and creative workers, the business sector, local universities and colleges, and neighborhoods. One of the first recommendations to become a reality was the creation of "a community-based Creative Alliance," the Austin New Works Community's fiscal sponsor. As part of the Create Austin Master Plan, the Austin Circle of Theatres (ACOT), a theatre service organization that had been in existence since 1974, was transformed into the Austin Creative Alliance, the advocacy and support organization of the whole local creative infrastructure.[47] Many of the details of the plan would circle back to a need for a theatre-focused organization like ACOT.

Most notably, the "Austin New Works Theatre Community" document lacks visible signs of the methodical, intertextual research that supported its programmatic design and represents its proposed strategy. Although its claims and findings reflect deep work, the plan does not regularly document how conclusions were reached and how many stakeholders contributed to each finding and recommendation. Nor are there photos that might illustrate the aesthetic and cultural diversity of its constituency, as there are in *Create Austin*. Nor are there explicit statements about diversity beyond aesthetic and institutional diversity with respect to company sizes and mediums. Admittedly, Dower's own focus on the subject remains largely attuned to organizational structures and aesthetics and acknowledges that cultural diversity needs to be taken up by the New Works Sector. Also, by not citing the work of Mellon or other funders, the Austin artists do not align themselves with the philanthropic sector—"those who hold power" in this case[48]—signaling their cultural and social capital, as arts organizations commonly do. In short, this document, in which artists testify to personal circumstances, think through problems, and dream up shared solutions, fails to attach its authors' work to any cultural policy discourse that could give their argument weight and urgency. In short, the internalized focus of the Austin "New Works Theatre Community," combined with its formal, policy-attempting presentation, leaves it without a discursive anchor.

My reason for suggesting that artists be more explicit about their relationship to these policy precedents borrows primarily from Foucault's

conceit that "power is everywhere" but forms around specific disciplines, which serve as "regimes of truth."[49] Foucault positions power as rooted in discourse. Possessed of neither a solid form nor a will, power is wielded by those who can put discursive tools to use. In projects such as this, artists have the opportunity to perform power when they stand eye-to-eye with funders and researchers and address them on shared terms. I see moments of congruence with contemporary policy yet to be acknowledged discursively in the "New Works" document, particularly in the Austin artists' description of the local arts ecology as a pond of fish. In an early section titled "The New Works Theatre Environment," the Austin report describes the "arts eco-system" as a body of water with "a few big fish, many little fish, and a small handful of companies that have survived more than ten years and constitute the very thin population of middle fish." The "Vision and Strategic Plan" asserts that the smaller fish sustain their companies by relying on the middle fish. These older, midsize organizations provide professional assistance and rent space at reasonable costs to their smaller counterparts. On a national scale, these middle fish also support Austin's reputation as a center for new theatre work. The report observes that the three companies that maintain spaces, "The Rude Mechanicals, Salvage Vanguard, and the Vortex Repertory Company, have received national recognition and awards for the creation and production of new work."[50] The document also notes that two Austin performance festivals, the Frontera Festival and the Fusebox Festival, also provide additional opportunities for the creation of new work. Their argument about fish takes up Dower's observations in *The Gates of Opportunity* that "generative artists" contribute to a local and national "cultural ecology" through disparate, place-specific practices driven by "deeply committed...individuals and organizations."[51]

At the same time, the ecology argument resonates *The Performing Arts in the New Era*'s analysis of 20 years of changes in nonprofit arts. The study forecasts that big organizations will maintain market dominance through advertising resources and the low risks in supporting proven blockbusters. Very small organizations working closer to the community level will reflect the diversity of the local community and unique or specialized aesthetic forms, like puppetry or performance art. Middle-sized organizations will be forced to mediate the big and the small, either by becoming bigger and more risk-averse themselves or by making themselves more available to the local communities.[52] In other words, the Austin artists' research validates the findings of a national survey. But in failing to invoke the national survey, by "lacking origins

and destinations in systems of power," the Austin artists miss an opportunity to claim their place as coproducers of nationally relevant knowledge. They succumb to "tactics."[53] Finally, the Austin document fails to use Dower's definition for an "artist-focused" organization to illustrate how their loose organization models a new approach for the cultural sector and fulfills Austin's needs. In short, the artists perform the type of analysis common to policy, but by not claiming their coproducer role in the identification and formation of arts policy on terms clear or common to policy communities, they allow their efforts to read as less than what they actually represent.[54]

Centers versus services

The Austin artists' concerns and the opportunities inherent in their collective efforts were no doubt familiar to the Mellon Foundation and other arts policy scholars and organizers, given the number of research reports created in the last 17 years. However, the terms by which the Austin artists came together were unique to more contemporary concerns. This point becomes clear when one compares the informal Austin collaborative to past models of institutional building, nationwide and in Austin. Four decades ago, leveraged funding incentives, like the National Endowment for the Arts' Workshop Program (1972) compelled many artists to become organization builders. As Grant Kester (1998) has argued, these artists, many of whom were white and middle-class, constructed a vast network of alternative spaces, often in underserved communities.[55] By the 1990s, these arts spaces were established and had artist administrators who could wield the same discursive skills as their philanthropic funders. Consequently, with respect to arts policy and to artists, the 1950s to the 1990s also inscribed the very hierarchical set of mediated relationships, with funders above arts organization, who were themselves positioned more powerfully above artists, who remain subjects of study or subject to support.[56] These same positions were *reinscribed* when, after the significant cuts to the National Endowment for the Arts in 1995, foundations increasingly turned to funding artists through mediating nonprofit organizations. Recent arts studies and websites for arts organizations credit their blue chip funders even as they call for more radical or progressive approaches to policy. In light of this policy archive of iconic brands, it is not surprising then that the Austin artists begin the "New Works" plan by calling for their own brand identity, even as the artists insist that the goal of their work is to create a collaborative model with "a

low level of sustenance and maintenance" that avails more time to create work.[57]

Paradoxically, though, the early postculture war documents argued against a hierarchical approach that favored organizations and institutions. Arts and policy scholars and organizers advocated instead for a "systems-based approach," which includes "blurring the boundaries," "team building and training," and new, "interrelated" models of engagement.[58] In other words, in the redesign of the "Ford Era," the arts and culture sector did attempt to move the conversations past revered models of fundable accomplishment to more systemic relationships of support rooted in shared knowledge and values. This type of systems-based approach is what the Austin artists worked to structure in their protracted process.

In light of these recommendations, I submit that the entrenchment of foundation funding practices and the challenges faced by the Austin artists represent two sides of the same problem. If the arts and culture sector has yet to move away from a preference for institutional support, then a mechanism for validating the collaborative model tried by the "Austin New Works Theatre Community" does not yet exist either. The complexity of the artists' relations and their concerns demonstrate how artist-producers benefit from not only aesthetic and production-oriented skills but also a knowledge of policy history and developments, nationally and locally. However, the presumption of knowledge raises questions about how policy distributes its research, findings, and initiatives. Among recent efforts HowlRound, a website and organization that identifies itself as a "Theatre Commons," has become a forum for artists and theatre makers to share practices, concerns, and solutions. The site's leadership includes Dower and Ragsdale, as well as Polly Carl, Lynette D'Amico, Jamie Gahlon, Vijay Matthew, and Srila Nayak.[59] HowlRound has opened up a site for discourse; its findings even resonate with the writings in the *Grantmakers in the Arts Reader*, a journal that does host the work of artists, but has more recently focused on artists and organizations that can be informative to artists' collectives.[60]

Perhaps the most significant challenge that faced the Austin artists was the question of the form their initiative should take. In my meetings with members of the Austin New Works Theatre Community throughout the period of document development, the artists remained insistent that they were not engaged in organization building. What the Austin New Works Theatre Community artists were proposing through their model can best be described as a hybrid of an "artists' center" and an umbrella organization. Research on organizational

development in the arts demonstrates why their work was inherently complex. Economists Ann Markusen and Amanda Johnson (2006) use the term "artists' center" to describe one type of arts service organization defined by the distinct services it offers, such as "a dedicated space for gatherings, shared equipment...work areas, exhibitions and performances."[61] These spaces generally follow an "open door" policy, allowing those interested to use the spaces and services.[62] In other words, artists' centers offer the amenities of a uniquely local institution, providing a framework and a host of resources from which artists can make work relevant to their lives in the region, if not the nation's arts and culture sector. To repeat Dower's term, these spaces are truly "artist focused." Through their research on the Minneapolis area, Markusen and Johnson demonstrate how "dedicated artists' centers have an appreciable positive impact on artistic development, regional economies, and neighborhood development."[63] The "Austin New Works Theatre Community" document gestures to these findings. The artists argue that their work extends from many years of investments into the local cultural community. They assert that their contributions to the local cultural economy include a "de facto Austin theatre district" that helps "[d]ozens of ancillary businesses thrive."[64] Taking up a priority of Austin' Cultural Arts Board, which provides operational funding to nonprofit arts organizations, they also claim their work contributes to tourism. In arts policy, economic impact assessments remain a contested site for arts and artist validation, since they do not measure all the values that follow from cultural work.[65] Nevertheless, the Austin New Works Theatre Community's argument for its economic contributions represents a rudimentary attempt to garner a return on the investments already made by its members, as well as recognition for contributions to the city's economic vitality.

Austin's history of artists' centers and artist service organizations also complicated the New Work's hybrid strategizing from the start. Markusen and Johnson also offer insights that challenge the Austin artists' work. Significant numbers of artists' centers emerged in the 1970s and the 1980s from individuals and groups more dedicated to a particular art form or vision than a community. Markusen and Johnson also assert that more recent artists' spaces have been committed to "culturally specific programming and/or with an overarching commitment to diversity."[66] In doing so, these organizations have been following an integrated community development paradigm, one that takes into account not only the demographics of a particular neighborhood or community, but engages that community on aesthetic and cultural

terms.[67] Included in their analysis are the Asian-American Renaissance, the Native Arts Circle, and the Hmong Institute for Literature.[68] Although the Austin artists characterized their work as progressive and nonhierarchical, their document focuses on a traditional, disciplinary top-down funding structures rather than a community-invested paradigm. There exist companies in the initiative that represented racial and cultural diversity, and some of these appear on the "New Work Austin" website. For instance, Teatro Vivo engages and represents the Latino theatre community, and the Lipschtick Collective identifies itself as "a queer, Jewish multimedia performance collective."[69] Additionally, the three anchor spaces mentioned earlier in the document—the Rude Mechanicals' Off Center Theatre, the Salvage Vanguard Theatre, and the VORTEX Theatre—all exist on Austin's east side, which has been traditionally Latino and African-American. The New Works artists, however, do not critically engage place in their "Vision and Strategic Plan."[70] As Maria Rosario Jackson (2008) notes, "the public has a role to play in defining what is important to arts and cultural participation."[71] As a group, the Austin artists identify strongly with their city; however, they maintain the spotlight on a discipline at a time when cultural policy and philanthropy have shifted attention to place and community through concepts such as "creative placemaking."[72] The document carefully represents what the artists need, yet fails to proclaim what the artists are contributing to cultural diversity, quality of life, and community engagement in such a way that the benefits of supporting the collective are made evident.

The loose organizational model adopted by the Austin artists also gestures to the challenge of sustaining participation experienced by the group. Artists' centers generally go through an evolutionary cycle of professionalization, one "fraught with tension" as artists at the center of the organization face the need for to cede leadership to a dedicated staff.[73] By locating itself as the project of Austin Creative Alliance, rather than organizing as a nonprofit, the artists were attempting to skirt some of these tensions by using an umbrella organization. Umbrella organizations provide fiscal sponsorship to unincorporated artists and groups so that they may be eligible for awards tax-deductible donations. In recent years, a number of well-known national umbrellas have emerged, each offering additional resources, sometimes even the elements of an artists' center. Perhaps the best known national umbrella at this moment is Fractured Atlas, which formed in 1998 to help promote a select group of performers in New York. Four years later, Fractured Atlas reconfigured itself as a national artist service organization, providing artist members

with a host of services that would eventually include fiscal sponsorship, health and liability insurance, research into emerging resources, as well as direct technical assistance with small business management and training.[74]

In Austin, a number of umbrella organizations have a history of functioning as artists' centers in ways that resonate with the artists' concerns about organization building. The Austin Creative Alliance must balance all creative development for all disciplines, neighborhoods, and interests. Its goals and mission more easily align with *Create Austin's* focus on infrastructure. The Austin New Works Theatre Community document, with its more explicit focus on bodies (health and well-being and childcare being two examples), represents a supplement to Austin Creative Alliance's work. However, the Austin Creative Alliance's origins as the Austin Circle Theatres and the nature of the New Works document point to the need for an artist center specifically for theatre. In a similar manner, Dance Umbrella opened as a dance service organization in Austin in 1977. For its most productive years in the late 1980s and the 1990s, under the direction of Phyllis Slattery, who died in 2012, Dance Umbrella functioned as an artists' center by operating Synergy Studios and supporting local, national, and international dance artists.[75] Finally, ScriptWorks is an Austin-based alliance for the development of playwrights that regularly acts as the fiscal sponsor for artist companies and for the Frontera Festival, an annual celebration of new performance now in its twentieth year.[76] ScriptWorks is also a member of the Austin New Works Theatre Community. What these three examples demonstrate is that the artists' place-based assessment was already complicated by visible histories of how service organizations had found increasing traction in the community through evolutionary organizational growth and development. Through its careful attention to the artists' needs, the "Vision and Strategic Plan" establishes a need for an organizational medium that can effectively harbor the participants' shared concerns and benefit the greater community.

The takeaway

The Austin theatre artists, and in particular the small group of steering committee members who helped shape the final document, now labor to recuperate the takeaways from an exhaustive period of intense and demanding extra work. In my conversations with them, they point out the moments when artists came together most vibrantly and intensely. They point to the frequent happy hours, where artists talked with each

other about concerns; shared news of accomplishments, upcoming events and opportunities; and offered resources to each other, such as rehearsal space or set pieces. They talk of "Threshold," a two-day symposium they held in early September 2011, during which they hosted artists from New Orleans, San Antonio, Houston, and Dallas and asked how the five cities might activate a geographically specific touring network. They speak of the two retreats, which supported the bulk of writing; the website, which offers the names and missions of all the companies; and the fact that they are all now talking with or e-mailing each other and coordinating productions. They talk of their expanded mailing lists and some increases in audiences. They say with pride that they managed to get through the document taking a consensus-only approach. Some also talk of the enduring inequality across the theatre community, the fact that some companies enjoy privileges, which they wish for others, even for themselves. They credit this variously to inequality to race, culture, class, gender, and aesthetic, yet they also admit that they feel broadly supported by their colleagues. In short, the Austin theatre artists recuperate the project on social and affective terms, but mourn the loss it represents on economic terms, the terms that most seem to matter in a neoliberal economy. For them, the questions of funding, space, health insurance, childcare, and shared audiences remain painfully outstanding.

In light of all these findings and observations, I consider the work of the Austin New Works Theatre Community to be a growing success story. Some of the successes can already be found in returning to the process of the document's development. Others can be found in the outcomes that still continue to manifest and benefit the artists. The Mellon award offered the artists both a significant opportunity and a challenge, as they worked to create a program that would mediate their needs with their understanding of the foundation's expectations, one that other artists regard with suspicion. In "The Phantom Seats of Philanthropy," a post on HowlRound, theatre artists Adam Burnet and Jud Knudsen reflect on their ambivalence to philanthropy in general:

[Philanthropy] has made art a game of competition. It has created a business model of unreal expectations and subterfuge. We pettily envy fellow artists in light of their "successes," losing our generosity of spirit.[77]

The "phantom seats of philanthropy" is a mysterious phrase that might easily describe audience engagement concerns ("butts in seats"),

or philanthropy's absence from the workings of theatre. Burnet and Knudsen use the term, as well as what they consider philanthropy's competitive and poisonous paradigm, to call for a theatre made without money.[78] In effect, the authors seek to evade being cast as a failure in light of philanthropies' dictates, even though the philanthropic sector has long sought an integrated arts and creative sector.[79] Such was the spirit that marked the Austin New Works Theatre Community's planning process, if not the immediate outcome.

As a guide for future efforts, the hard-earned knowledge demonstrated in the Austin theatre community's "Vision and Strategic Plan" still has benefits to offer policy communities locally and nationwide. By comparing the Austin New Works Theatre Community's documents with other plans and programs, I see evidence of how philanthropies and artist collectives might more effectively collaborate in direct, rather than phantom, ways. For example, *Create Austin* names a consultant team that consistently worked through the process of the final document, which also included the feedback of more than 70 community members. The initial contract from the Mellon Foundation offered the Austin theatre artists the opportunity to work with a consultant team; however, in keeping with their collective ethos, the artists chose to work together. The presence of policy operatives early, with an intention for artist engagement might have carried the project to its hoped-for conclusion.

When I review artistic productions, e-mail blasts, and even audience numbers of the last few years, I also see evidence of how the efforts to organize as a policy community catalyzed companies separately and together. Such evidence can be found in the works created and the projects undertaken during that time. I see one significant example in The Physical Plants' *Adam Sultan* (2013), an elegiac play that incorporates a story, original music, Bunraku-influenced puppetry, and found objects as tribute to Austin theatre artists, whose deaths are announced by a narrator during the production. The Bunraku work reflected a collaboration between The Power Plant and Trouble Puppet Theater Company. The eponymous Adam Sultan, playing himself, is a stage musician who collaborates with many other companies.[80] His theatrically constructed story of survival and aging comes at the cost of mourning. In the play, the names of Austin theatre artists are read out loud and their imagined causes of death recited, a slight variation on the reading of the names ritual common during AIDS protests in the 1990s. For the play, playwright and Artistic Director Steve Moore invited three hundred Austin theatre artists to a party to donate objects that made them think of Austin

theatre, which could influence the production. Donors were asked to answer questions for a recording. Their photographs were taken, and the objects were sealed in a jar. Upon showing up, donors found their causes of death.[81] The Physical Plant's nights of hosting Austin theatre artists, the nights apparently when our fates were sealed, were rich and rewarding. People mingled, hugged, and shared news about projects in the works. In speaking about the show's relation to the Austin community's process, Moore credits the project "for giving [him] a renewed appreciation of Austin as a cauldron for new work....because new work is difficult work and because difficult work requires the support of a community."[82] The play offered an affectively and materially rich text for reading how Austin artists and spectators come together through theatre and performance.[83]

I also see a significant example of artist performing policy, as well as the importance of the "New Works" community, in The Rude Mechs' original production of *The Method Gun* (2009), which was under development at the inception of the "Vision and Strategic Plan" process. The Rude Mechs are a nationally known collaborative ensemble and one of the member companies of the New Works community. Company coartistic director Shawn Sides also served as one of the six members of the steering committee. First presented in a workshop in Austin in 2008, again in 2009, and later at the Humana Festival in 2010, *The Method Gun* is now central to the Rude Mechs' repertoire.[84] The play diegetically follows a company of actors, disciples of a fictional acting guru, Stella Burden, as they rehearse and perform an adaptation of *A Streetcar Named Desire*. Burden, we are told, abandoned the company, fleeing to South America and leaving them to finish the nine-year rehearsal process in her absence. Typical of the Rude Mechs style, the play blurs the boundaries between the Rude Mechs' actor-creators and their character counterparts. For instance, the Rudes, as they are called in Austin, begin their show by telling the audience they are beginning a show, but not before actually stopping to thank their sponsors, a constellation that changes according each location but includes funders and/or hosting institutions.[85] The Rudes introduce their company as an artistically and materially successful artist-led organization, before the actors become their fictional starving artist counterparts. The juxtaposition of material access in the introduction vs. the risks portrayed onstage demonstrates that visible success itself belies the hard work and sacrifice undergirding theatrical production.

Even more recently, the Vortex Theatre, which had played host to many of the events, raised more than $25,000 in a Kickstarter campaign

to support the purchase of new lighting equipment to realize its vision of making works that are rich in spectacle. In its 25 years of existence, the theatre had never run a fundraising campaign; consequently, the "thousand per year" goal seemed lofty. The campaign ran for one month, with money trickling in. In the last nine days, almost $18,000 remained to be raised. An all-out get-out-the-vote was trumpeted through social media and in-person calls, with the final total exceeding the stated goal. The fundraising coincided with the Vortex's twenty-fifth birthday celebration, a party lasting two nights and including performances and a looped video of testimonies from the Vortex's many colleagues and supporters. In preparation for the event, Associate Artistic Director Heather Barfield scanned more than 1,000 photos of Vortex productions from its archive and made them more available for documentation. The creation of archives was a targeted initiative of the Austin New Works Theatre Community document.[86]

Perhaps most significantly, the Fusebox Festival, which has a history of supporting local artists' work, is currently part of a consortium with Austin city planners, local developers, and citizens on the "thinkEAST living charette." The charette is part of a greater creative district, one that will include affordable live-work spaces, as well as performance spaces on a 24-acre site that was once an airline fuel storage facility. The thinkEAST owners have already been in dialogue with community residents of Austin's historically Latino/a and African-American eastside on how to develop the project to support and engage the neighborhood. The Fusebox Festival's current applications for funding propose to use "temporary structures for performances, installations, workshops, classes, food events, youth leadership programs, and intentional tenanting from the creative industries." The temporary nature of the structures, which adapts Fusebox Festival's somewhat nomadic existence, promises to offer Austin companies multiple sites to create new work.[87] Whether the relationship between the "Vision and Strategic Plan" archive and such accomplishments is causal or correlative may not always be clear; however, the writing process offered up the means for Austin's theatre artists to imagine and mark their collective progress.

All of these examples demonstrate the Austin New Works Theatre Community's expanded repertoire for amassing and exchanging various forms of capital. Material absence can easily be the fallback organizing principle for both theatrical production and policy alike, but evidence of material success is often what is sought after through the outcomes of both. Absence explains the overtaxed budget, the lack of available rehearsal space, the lack of data, and the lack of funding. Absence invites

the question never asked in the wake of a successful production, "How did you manage to make a living while bringing this work to the stage?" Material absence also explains longstanding research that "[on] average, performing artists earn considerably less, work fewer weeks per year, and face higher unemployment than other professionals with comparable education levels."[88] When artists align and articulate their relationship to capital, be it through a curtain speech or a long-range plan, they demonstrate their contributions as artist-producers. In addition to knowing each other better, the Austin New Works artists might now look out beyond their needs and ask, who are the individuals who come to our shows? How might we depict them in ways that represent our deep ties to community, as well as our support to local businesses? How might we see elements of a well-wrought plan through specific, targeted partnerships and initiatives? How, too, might we look to the policies that describe our work and articulate our accomplishments in light of them?

Through their work, the artists-producers of the Austin New Works Theatre Community developed and honed their material repertoire, accounting for the resources they do have, recognizing those needed, and identifying those that can be shared. They also uncovered sites where they might find more traction for their work in each other. In doing so, they performed policy in ways unique to the Austin community. To lay claim to their creative, affectively rich happy hours and exchange sessions, as well as their own accomplishments, Austin artists still can capitalize on the thoughts and actions already invested by recognizing three key takeaways. First, the terms of a funding cycle, be it one year or 18 months, represent seed time. They do not contain the accomplishments and effects of an artistic or policy initiative but only the time of its beginning. The accomplishments of the "Vision and Strategic Plan" remain significant. To believe otherwise is to succumb to a market-based ideology and overshadows the group's social and cultural accomplishments and the spirit of the process.[89] Secondly, all of the benefits that have accrued so far as a result of the process follow from what Vijay Mathew and Polly Carl (2013) refer to as a "commons-based peer approach" method of growing a theatre community. Building on the ideas of Yochai Benkler and Helen Nissenbaum (2006) in "Commons-based Peer Production and Virtue," Mathew and Carl characterize the commons approach as the means by which cultural workers remain in constant communication with their local communities and with each other, owning up to their assets and their needs and sharing resources to the benefit of the greater cultural sector.[90] The commons-based peer approach does not work against economic capital, but in complement

to it in ways that resonate with the Austin process. Finally, and perhaps most importantly, the successes made during the funding process, as well as those that have happened since, resulted from targeted initiatives with clear leaders performing clear roles. In the absence of a single, dedicated theatre artists' center, the "Austin New Works Theatre Community: Vision and Strategic Plan" represents a collection of opportunities ready to be taken up by community leaders. Many of those who participated in the documents' making are already able to testify in multiple, creative ways onstage and in practice to the issues relevant to them. Using the policy studies also relevant to them, they might demonstrate an eye-to-eye relationship to philanthropies and researchers and build support for the plan's findings. In turn, policy might assess how its own materials and processes might be more creative and more accessible to artists.

4
Accounting for Capital: The Creative Capital Foundation (1999–Present)

On a Monday, May 3, 1999, *The New York Times* broke the news of a revolutionary artist-focused philanthropy, the Creative Capital Foundation. With a unique approach to making individual artist grants, the foundation proposed to radically redefine how artists receive validation and reward in the twenty-first century.[1] As evidenced by the lengthy feature, "Private Donors Unite to Support Act by the Government," much of Creative Capital's buzz banked on the foundation's timely nod to the culture wars and the nation's cultural policy crisis. In her article, *Times* arts and business writer Judith Dobrzynski observes that the organization sees itself as a direct response "to cuts in Federal arts spending," specifically the nearly $10.5 million to 750 individual fellowships taken from the National Endowment for the Arts (NEA) during the previous decade. In the first year, the foundation planned to give out $1 million in grants. Much like the members of the 92nd Assembly, Creative Capital is framed in bold rhetoric, proclaiming itself willing to renew a battle on behalf of artists specifically.

Although the feature does not specifically name a politic, it traffics in a populist one-upmanship by putting the foundation on the national dais with the Christian Right. Archibald Gillies, President of the Andy Warhol Foundation, which provided the seed gift of $1.2 million to the fledgling foundation, introduces Creative Capital as a democratic, merit-based solution to the crisis of the arts:

> This is a boisterous, diverse country, and we have always had art that upsets people ... In this organization's absolute principles, one comes first and that is funding experimental, challenging art on its merits.

71

Then after selecting it, we see what the marketing potential is. The nature of content is not a factor.[3]

Randy Tate, the newly appointed President of the Christian Coalition, weighs in as an *éminence grise* speaking for the self-proclaimed "moral majority."[4] Stating hope that the foundation will "put forward images that strengthen society and family values"—that is, will curate its artists to be family friendly—he provides a perfect counterpoint to the freedom of expression leitmotif that dominates the feature.[5]

Stressing freedom of expression and/or free enterprise, Creative Capital polished up the individual artist fellowship program the government discarded some five years before and reintroduced it in a politically palatable light. Whereas federally funded individual artist grants provided only short-term support, Creative Capital distinguished its focus as a form of long-term *partnership*, rather than a "trickle down" program.[6] In addition to awards, artist fellows were poised to receive professional guidance to improve business skills and build their audiences. Just a few short years before that kind of help would have been written into a line item on a grant application as "technical support." The article notes that professional artists function best when working alongside "curators, producers, and publicity agents and others who can help artists devise a plan to present their work to the widest possible audience."[7]

By offering a set of supplementary skills to original artistic production, Creative Capital acknowledged artists must take a coproducing role in their own processes and proposed that they are the ones best poised to do so. Additionally, Creative Capital's grant promised to "come with a twist straight out of Wall Street and reflecting the business background of some backers like Jeffrey Soros, the venture capitalist (and nephew of George Soros, the billionaire financier)."[8] As part of the foundation's "free enterprise" approach, artists would be required to pay back part of the original award from the proceeds of their project. Anticipating its critics in the first feature, the foundation's proposal appears ambitious (in fundraising and scale) but sustainable (reliant on artists' capacity to build a market and refund a portion). The new artist paradigm being proposed is tempered by a radical pragmatism. Reflective of the nation's capitalist economy, the market becomes both the institutional medium and its validating destination. The burden of public purpose, which is now and newly being defined as market readiness in 1999, falls squarely on the artists who are not standing alone. "We will support what people across the country are saying is good art, exciting art, interesting art,"

Gillies notes in his closing comments.[9] Rather than focusing on the nature of content, Creative Capital concerns itself with excellence of expression, measured by a national standard of consumption. In this simple, even humble, parting salvo, Gillies acknowledges that the construction of discourse does not gain authority from the "spontaneous attribution" of a text to its creator, but "a series of specific and complex" social operations and alliances.[10] Moreover, he shows that the organization's power will emerge from the ongoing validation of a number of individuals who have been organized on a massive scale.[11] Whereas "The Arts and the Public Purpose" looked to a historic idea of America for its power, Creative Capital surveyed the nation's arts and cultural sector and assumed its discursive status by offering a much needed practice-based, market-ready policy.

Creative Capital entered into policy operations at a particularly rich time, and with much to offer to the conversation. In the shadow of the second anniversary of the 92nd Assembly, "The Arts and the Public Purpose," the Creative Capital Foundation advanced a new *artist* paradigm to complement the new arts paradigm offered by its predecessor. Rather than focusing on a model that advocates the social, political, and economic values of the arts *and* artists, Creative Capital proposed to contribute to cultural vitality by focusing specifically on artists. While a politics of freedom of expression was a nominal *raison d'être* of the organization, Reagan-era economics promoting personal responsibility and increased privatization were evident as well.[12] In contrast to the more earnest approach to de Toqueville's notion of "enlightened self-interest properly understood" taken by the authors of "The Arts and the Public Purpose," Creative Capital advanced a freedom of expression properly administrated and strategically marketed.[13] Through its operations the foundation revised the matching grant model that had dominated the arts for almost 50 years. The leveraged grant program had been constructed with matching requirements, which required recipients to find additional contributed income at rates as high as four times the original gift.[14] The Creative Capital Foundation proposed a partnership process that anticipated multiplying capital for abundant rewards. The policy table set by the foundation in 1999 was, and remains, something of a harvest meal, whereby all those whose expertise contributes to the artist's success are recognized. The select group of artists being feted were and are not conceived as passive guests of honor, but fellow chefs constructing a celebratory event. In the words of Ruby Lerner, founding CEO and President, these artists are now proposing to "bake change into the very DNA of [arts] organizations."[15]

Since its inception, Creative Capital's validity and vitality has followed from its comprehensive and complex capital transactions, many of which are operated in the public eye. Fully comprehending how the foundation creatively capitalizes artists' practices and to what effects requires an understanding of both nonmonetary and monetary forms of capital, introduced by Pierre Bourdieu (1986).[16] Bourdieu's notions of social and cultural capital explain how status is accumulated in a market economy. Social capital represents almost exclusively an individual or institution's network of allies and resources, his or its acknowledged, validating relationship to social, familial, and professional institutions. Cultural capital represents the status or knowledge that inheres through training and marked accomplishments, as well as recognized relationships to other cultural accomplishments.[17] The footnote relating one's writing to a famous scholar is a form of cultural capital; the prestigious names marking a foundation's board of director and the title of "Creative Capital grantee" are also forms of cultural capital. Creative Capital's tripartite focus on successful art making through a grant program, its ongoing media promotion for artists, and its nationally known training programs offer multiple means for artists to build accomplishments and important alliances. Situating the foundation's archive historically with respect to arts policy and showing how its practices attend variously to forms of capital demonstrate how the organization tasks artists to function as producers of their work. The same analysis offers a glimpse into the way that the organization also remains in the capital-amassing process, alongside its beneficiary artists, and to what effects. At the same time, many of the artists who have received support from the foundation have proved themselves to be hybrid artists working at the intersection of art making and public good. These artists have challenged the organization to rethink how it distributes capital among diverse constituencies.

The foundation's origin narrative has been told variously as having begun with Gillies and Brendan Gill, Warhol Foundation Board Chairman, who were thinking of new ways to support artists in light of the NEA's cut of its fellowship program; Gillies and Gill attended a talk by Lewis Hyde at a time when he was speaking about methods of artist wealth recirculation.[18] Lerner, whom Gillies credits with having made his early ideas manifest, also acknowledges her own experiences as Audience Development Director at Manhattan Theatre Club. There she saw that shows like *Ain't Misbehavin'* (1978) could be money makers. Lerner was an early director of Alternate ROOTS, and so her ideas were also informed by community-based modes of practice.[19] By the time of

Creative Capital's first public announcement in May of 1999, Lerner was already cultivating buy-in nationwide. According to Lerner, from the outset, the organization also thought it should reach out to the nation's artists and assure them that there could be new modes of support:

> Arch Gillies was thinking that the loss of the NEA for individual artists was pretty brutal. We don't talk enough about what it means to go from [artists] being respected to being excoriated, so the tour was about hope of the moment, of a new way to do grants. So I visited cities like New York, Los Angeles, San Francisco, Seattle, and San Antonio.[20]

At a moment when individual artist fellowships might be politically problematic, the Creative Capital Foundation was affirming them as a valid form of philanthropy. In advance of the tour, Lerner had reached out to me when I was performing in New York in the spring of 1999. She had introduced me to the program and invited me to come to the San Antonio session and to invite other artists. I did apply and become a finalist before being cut. My writing in these pages represents my own attempt to recognize the value of programs that curate their participants, but also make themselves available for ongoing application.

To begin understanding how Creative Capital derived its artist-focused policy, consider its diagnoses of the arts and cultural policy sector as expressed in its own research in 2005. In two published reports, "At the Intersection: a Programmatic Assessment of Creative Capital's Support to Artists" and "Funding Innovation: An Overview of Creative Capital's First Five Years," the organization articulated the many challenges faced by artists in 1999. In both of these publications, the role of the artist as producer that Creative Capital took up implicitly becomes more apparent. "At the Intersection" observes that the fields of performance, media, emerging [art forms, including video] and visual arts were in crisis, bereft of immediate need and long-term support opportunities. Independent artists face increasing challenges, including fewer stable theatres and presenters, fewer funds and opportunities for individual artists, and a problem of access to support for artists not living in the cultural centers of California and New York. Many artists were finding greater opportunities to live and make work in Europe, where they felt more supported. Opportunities included increased Internet capacity for distribution and greater acceptance for emerging fields and community-based theatre forms, but the start-up funds for these programs generally come from the artist's own pocket.[21] Into this breach, Creative Capital

introduced a program that began with the premise that artists are "cultural entrepreneurs who deserve the financial support and advisory services that are available to entrepreneurs in other sectors."[22] Rather than relying on public funding, as the arts had done in the past, the program would be financed by the private sector, by philanthropic foundations, and even the artists themselves.

In response to this premise, Creative Capital proposed a sustained period of critical support modeled on venture capital approaches:

> [These core ideas include] making a long-term commitment to a project; providing financial support beyond the initial award assuming benchmarks are met; an interest in capacity building; a commitment to providing services and assistance in addition to financial support; an interest in measurable outcomes; working to attract other investors/contributors to the project; and the desire for financial return on investment.[23]

Creative Capital's initiatives respond easily to the pro-business, pro-capital, anti-liberal culture born in the Reagan years of the 1980s. Cultural theorist Lauren Berlant calls the tide of enterprise one of "oppressive optimism," since those who question its focus on the value of wealth are often accused of being cynics and nonparticipatory citizens.[24] Rather than imagining an existence outside of capital, the foundation makes peace with capital to practice creative liberation and to support social change by resourcing projects that are at the intersection of art, technology, science, and social justice.[25] Similarly, the foundation's choice to focus on a grant program from the outset represents a politically paradox proposition, one anticipated by performance theorist Peggy Phelan. In a 1989 article on the culture wars, Phelan opines that to restore the individual artist grant program is to seek a conservative standard, rather than to imagine a radical departure that recognizes the actual capital value of art, and even use something of a payback mechanism.[26] A decade later, Creative Capital was attempting to revive a past model and to propose new terms for its future.

Following upon its ambitious announcement, the organization's opening was a phenomenal success. Lerner had thought that Creative Capital "wouldn't get too many applications because the process was "too interventionist, too businessy."[27] Yet the foundation received 1,810 visual, performance, and media applications, 50 percent more than the 1,200 the organization had anticipated. Artists from 46 states, Washington D.C., and Puerto Rico submitted applications,

demonstrating in quick time the organization's broad appeal.[28] Despite the fact that almost 40 percent of the applicants came from New York, Lerner was affirmed by the geographical spread in the first round. In a second follow-up article in the *New York Times*, she notes: "This says a lot about the need that is out there, about the pent-up demand."[29] Creative Capital was proving itself capable of jumping ahead of an arts and cultural policy sector committed to research by responding creatively to perceived needs of financial resources, training, and mentoring with program-based solutions.

The positive tenor of these first articles about the Creative Capital Foundation would only be amplified over time, helping the organization become a key creator of an artist-focused policy. More than a decade later, Creative Capital regularly garners features in prominent publications, many of them related to business and finance. A *Barron's* (2010) article refers to it as "an all new approach to philanthropy."[30] A *Wall Street Journal* (2013) headline proclaims Creative Capital the place "Where Good Ideas Go to Live."[31] The Harvard Business School includes the Creative Capital Foundation among its famed case studies (2010).[32] All of these articles, many of which can be accessed through the Creative Capital website, testify to its ascendancy as an "iconic brand," a marketable, utopian symbol into which consumers project their "personal and communal dreams" for attainable ideals.[33] The consumers in this case are artists, arts advocates, but also the publics who encounter artistic works. The ideals include a vital arts and culture sector, and sustainable, even thriving, artist careers, but also proposed are new modes of practice. The artists supported by the Creative Capital Foundation are various. They include The Yes Men (Jacques Servin and Igor Vamos), performance provocateurs and satirists who have been featured on national news outlets exposing abuses of corporate power. Jae Rhim Lee's mushroom burial suit offers a green method for bodily decomposition. A poetry project begun by Laurie Jo Reynolds, who identifies as a "legislative artist," contributed to the closing of an Illinois penitentiary that had subjected prisoners to inhumane conditions. Documentarian Laura Poitras, who received support for *The Oath* (2010), her film about Osama Bin Laden's former bodyguard, also helped publicize Edward Snowden's exposure of surveillance abuses of the National Security Administration in 2013.[34]

Consequently, the brand that Creative Capital has been working to develop has placed artists at the vanguard of social and cultural change, making the work of artists sustainable and contributive to a better society. Iconic brands "generate vast amounts of capital" by guiding

consumers' perceptions and choices, so that the brand's merit is both evident and logical.[35] The foundation's recirculating and recruiting programs ensure that an opponent cannot easily stay one for long. The organization is even quick to criticize itself and then rebrand that effort as a new direction in pursuit of the perfect mix of for-profit, nonprofit, and community inputs. Of the organization Lerner notes, "We are our own art project day to day."[36] All of these efforts point to Creative Capital's capacity to maintain its relevance and status in the twenty-first-century cultural marketplace, where it mediates capitalism. To follow Creative Capital's progress in journalistic features, organizational assessments, a complex website, and e-mail blasts is to marvel at how Creative Capital carefully negotiates and multiplies capital in the process.

A campaign for social and cultural capital

From the beginning, Creative Capital has been very attentive to its pedigree in both policy and practice. In doing so, the organization has cultivated social and cultural capital. The Foundation's symbolic association with the culture wars represents what Bourdieu refers to as the "objectified state" of cultural capital. The "objectified state" relies upon a connection to material items, such as well-known works of art. The organization's accomplished board members, its knowledgable spokespersons, its capable program heads, and its notable business consultants bring social capital to the foundation's efforts. To legitimize these associations, the organization has always put a business spin on an older model of philanthropy, while still maintaining that its work is fundamentally about "good art."[37] Gillies' early presence in the published record represents an institutional authority. As the Warhol Foundation head, he personifies Warhol's legacy. Dobrzynski's article notes that the Andy Warhol Foundation had led "[n]early two dozen foundations and business" in providing the first $1.2 of the $5 million in start-up funds.[38] The Andy Warhol Foundation had also offered the Creative Capital housing in its offices in Soho, from which the organization only recently relocated.[39] Warhol famously rocked the art world for more than three decades with his own particular love for art and commerce. Yet as critic and scholar Isabelle Graw observes, Warhol's position, like Creative Capital's, was much more complex, "stretched between the poles of market conformity and resistance to the market" as expressed by Creative Capital's affirmation of funding experimental

work.[40] Aligning the two brands effectively multiplied the institutional authority of both.

The roster of Creative Capital's Founding Board of Directors named in the first Dobrzynski article, "Private Donors Unite to Support Art Spurned by the Government," appeared to replicate the overlaps among institutions, commerce, and art. They also amounted to a diverse archive of celebrity in arts and culture. They include university deans, MacArthur Fellows, film directors, corporate executives, performance artists, and self-described CEOs. Many of the organization's board members have been with it since the beginning.[41] The longstanding commitment of prestigious board members, like the endurance and popularity of its programs, demonstrates Creative Capital's enduring and expanding authority over arts and culture policy discourse.[42]

Through its operations, the foundation has sought to confer these forms of capital upon grantees. Since its inception, the organization has not only ordained artists but also in some cases resurrected their careers. In fact, among all the articles that have been written about Creative Capital, the two Dobrzynski articles are unique in their absence of artist input. Every single mention in *Variety*, *Art in America*, *American Craft Magazine*, *FastCompany*, and *Barron's*, as well as every foundation report, comes bearing the animated testimony of the foundation's participant artists. Some, like visual artist Lynn Hershman Leeson, a "68 year old visual artist from San Francisco," testify to the organization's powerful intervention in their stalled careers.[43] Upon receiving a Creative Capital Foundation Fellowship in 2008 and beginning her training in its methods, she also received a prestigious Guggenheim Fellowship in 2009, "after being turned down 26 times."[44] During the same year of the article, one of her paintings was appraised at $1.8 million. Brent Green, "a 26-year old self taught animator," claims the Foundation not only funded him, but counseled him to increase his initial film budget from $14,000 to $43,000.[45] The increased amount included funds for the necessary technical equipment as well as a salary for Green, which he had not initially included. According to Green, Creative Capital convinced him that he "deserved money to make this [film], and you can actually get it finished if you pay yourself."[46] Creative Capital's public embrace of artists who have spent years trying, as well as emerging artists, represents its commitment to an embodied history and future all at once.

These efforts at increasingly capitalizing artists and their projects are not unidirectional in nature. As Lerner candidly remarked at a recent talk, "We're a fake foundation."[47] Unlike other charitable foundations which are endowed, Creative Capital must raise all of its resources;

consequently, all of its programs and promotions must amplify its fundraising efforts. In its first 15 years, the organization has invested $30 million through both "financial and advisory support" in 419 projects involving 529 artists, while also growing the demand for its support services and working tirelessly to meet that demand.[48] Much of the organization's original funding came from the Warhol Foundation, which gave a strategic gift of $10 million in its first decade, requiring the organization to match much of it and to put aside $1 million in cash reserve. Lerner is proud that the organization has never had to access that reserve money.[49] Bourdieu's theory posits how different forms of status and distinction do not always lead to economic capital.[50] However, the Foundation banks on the fact that the economic capital can be leveraged through social and cultural strategies, as well as new fundraising streams like a proposed online marketplace for its artists' work that "doesn't have to be limited to objectmakers."[51] Looking ahead, Lerner realizes that the organization "needs good impact stories" so that it can better articulate the validity of each artist's work and sustain the organization.[52]

Programming

Today, Creative Capital continues to amend and to promote its programs so that they appear as meaning-making paradigms that address artists' individual needs and encourage their sustainable enterprise. Creative Capital envisions its programming in four thematic parts: "support the project, support the artist, build community, [and] engage the public."[53] These components are realized through the organization's grant programs, technical assistance consulting, workshops and retreats, and promotional mechanisms such as its website, e-mail blasts, and ongoing training webinars. Functioning at the core of all of these concerns, and thus the repertoire it shapes for artists, is an applied form of patronage. In other words, it is a form of patronage that applies specific perform-ances of skill and efficacy to and from its recipients. It is through these performances that the organization also manifests capital for artists and for itself.

The grant

The grant program is the genus of the Creative Capital's program-ming, the one aspect that relates to all others, as either motivation (for training or promotional activities) or facsimile, as in the case of its ancillary grant programs (the MAP Fund, Creative Capital/

Warhol Foundation Arts Writers Grant Award, and the Doris Duke Performing Artist Awards).[54] The grant program is also the one program that demands the curatorial, and therefore discursive, input of the organization and artists, who help compose the peer panel that reviews the applications. For those artists who are chosen as grantees, the foundation offers immediate economic benefits by capitalizing each project with up to $50,000 in direct funding. These funds may be used broadly to cover production expenses, even funding the purchase of important film and video equipment, as in the case of the filmmaker Brent Green, the grantee profiled in a 2010 *ARTNews* feature. Creative Capital takes steps to support each participating artist's understanding of the whole material process as s/he develops a single work. Benefits are delivered incrementally throughout the grant period. All artists selected for a Creative Capital award can participate in an orientation and retreat focused on building professional development skills. These steps provide a gateway to ongoing technical assistance support, the career development services valued at $40,000 that make up the remainder of the foundation's stated commitment of up to $90,000 per project.[55]

The organization has developed a seven-year cycle of granting. For the artist recipients, Creative Capital commits to working with each project for three to seven years within each cycle. This time-dated approach allows the foundation adequate time to work with each project and still maintain organizational efficacy. In this current cycle, begun in 2012, the first-year application recognizes "Visual Arts and Film/Video," and the second year looks at "Performing Arts, Emerging Fields, and Literature." The third year attends to "follow-up work with grantees," during which Creative Capital does not accept any applications. In the fourth, fifth, and sixth years, the organization repeats this sequence. For the final seventh year, "Capstone Period," the organization focuses on all awardees from the previous seven-year cycle.[56] The organization's grant cycle signals its own learning through practice and its need for reflection and recapitalization. In Lerner's own words, "We're not set up to be a grant factory; we're set up to work with artists in an intimate way."[57]

"Performance," writes Diana Taylor, "is an episteme, a way of knowing."[58] In this relatively simple sentence, Taylor expands performance from its more commonly understood theoretical framework as "a doing" to a more reflective operation. Similarly, grants are an episteme, a process for artists to know and reflect on themselves, their art, and the means by which each makes the other a reality. Following a general

formula of cover letter, project narrative, budget and budget narrative, work samples, and supporting materials (evidence of past work as expressed in biography/biographies for collaborations, press materials, and work samples), grants require artists to systematically plan each project and to situate both project and process in light of one's past, as well as one's short- and long-term plans. Writing a grant requires but also evidences optimism, a dedication to the work, and a belief in one's readiness to produce the work and fulfill the requirements of the granting organization.[59] In the process of pursuing a grant, as in all fundraising, artists must account for and situate their relationship to all three forms of capital. With respect to cultural capital, artists signal their worthiness for grants through strategically articulated proposals. They also document past accomplishments, whether they be in the form of a cultural good like a book or expert training.[60] Artists demonstrate social capital through the names of collaborating artists, the byline of a known arts critic, a touring history, even the name of a presenter willing or likely to show the work. In many grant programs, the name of such an organization is also the fiscal sponsor. The applicant's consideration during the granting process will also likely generate a form of social capital as peer panelists consider each artist's work. The Creative Capital website depicts the organization's approach to grant making as an informal, embodied practice that takes place in phases:

> Our individualized approach provides grantees with sequential financial support and tailored advisory services to enable their project's success and help them build sustainable careers.[61]

On the website, iconic gender-neutral stick figures depict various aspects of the grant-making process from the standpoint of the funder and the artists, whereby each artist's repertoire is honed around the work. Creative Capital's approach is tiered through multiple stages, beginning with a letter of inquiry, from which the organization may solicit an application, which will undergo peer panel review. For many artists, especially those who are just beginning their careers, the peer panel process represents the one time that they will leap momentarily from the repertoire to a convened archive. Thinking through and gathering all of these pieces of evidence to go through the grant process, much less to be awarded, demands a commitment to projecting one's work across time, as well as within a very specific time frame. It is also a way for an artist to get information through feedback, whether it be in the form of comments, acceptance, or rejection.

In addition, Creative Capital's actual description of its "payback" scenario resonates more closely with its pro-artist, adaptable brand. Lerner admits that the original intent behind the payback came from Gillies, who hoped that a critical mass of successful artists could help support the organization.[62] In 2005, Creative Capital observed that its original use of "[p]aying back" was now understood as "giving back."[63] Lerner recalls that even in an early focus group, one artist had candidly said, "I love this; I'm not a beggar in the process."[64]

Today, the organization's description follows a narrative that begins Lewis Hyde's *The Gift*, as a form of wealth that grows through repeated exchange.[65] According to Lerner, only about six of the projects it has funded have formally paid back a portion of profit, but nearly 50 percent of awardees have given back through donations to annual auction and donation of speaker's fees, making contributions to annual campaigns, or in-kind donations.[66] The notion of payback touted in 1999 now stands in as a way for artists to think through the many forms of capital required to sustain cultural work for themselves and others.

Professional development program

Today, the Creative Capital hosts a spate of training programs that are made available widely to artists. The Professional Development Program (PDP) represents the organization's single biggest contribution to the arts and cultural sector, a testament to the organization's democratic purpose. The program was founded by corporate consultant Colleen Keegan, who regularly teaches the intensives. She is joined by a group of practicing artists, many of whom are Creative Capital grantees and therefore more accomplished in its methodologies and able to testify from their career perspectives. Session descriptions, which can be found on the Creative Capital website, are dedicated to arts business skills marketing and public relations, grant writing, and long-term planning. The PDP serves as the embodied knowledge of the organization, the essence of the organization's methodology, as well as a vital form of artist accreditation and networking. Through the PDP, Creative Capital has reached nearly 8,000 artists in 350 communities.[67] Given the scale of its reach as well as its central role in the granting process, the PDP offers the collateral benefit of drawing more artists to the program. Introduced in 2003 and conceived as the professional development component of the grant, the program has since grown to include eight different curricula that are available either as in-person workshops or webinars. These programs anticipate an audience that is diverse in identity and needs. In addition to the core curriculum, the one-day workshops and webinars include sessions on social

networking and the Internet, ethical marketing, performance documentation, speaking about one's work publically, community engagement strategies, marketing, and artists' finances. There is also a workshop for native Spanish speakers ("Taller Professional de Desarrollo para Artistas"). Workshops range in price and structure from a $25 ninety-minute webinar to the Core Curriculum Intensive—which I have taken[68]—which is often hosted and funded by a local arts or civic organizations for up to two dozen artists at a rate of $22,000–25,000 per weekend.[69] All of these programs offer clear interventions into specific aspects of each artist's repertoire.

The Creative Capital organization at first treated its materials and methods as proprietary to their own awardees. It soon became clear to Lerner that the organization's mission could be expanded if it systematized an approach that could go out and reach more artists and not just awardees:

> We started hearing early on that our own grantees were sharing information with friends. I came back and said there is no reason for this to be privatized. We should make this more available, so we raised money to build a workshop to train our artists as trainers.[70]

In addition to teaching for the organization, a few artists have developed their own consulting brands. In 2009, Battenfield published her own methodology for artist professional development, *The Artists Guide: How to Make a Living Doing What you Love*. Playwright Aaron Landsman maintains a blog and lectures and teaches on sustainability as an artist.[71] Choreographer Andrew Simonet, a popular Creative Capital webinar host, developed Artists U in Philadelphia in 2008, a longer-term (six-month) training program. Now in its eighth cycle, the program kicks off each year with a one-day intensive led by Keegan. It has been franchised to Baltimore and used to create new training programs in South Carolina; Artists U also hosts "Planning Mondays"—a year-long, open-door, free production and career planning service offered to Philadelphia artists.[72] Simonet also recently self-published *Making Your Life as an Artist* (2014), a free book that has been downloaded by nearly 60,000 readers.[73] Lerner calls these efforts "Creative Capital 2.0 enterprises" and acknowledges "they have taken [artist training] in many different directions." As evidenced by their respective websites, all three artists maintain productive, evolving careers. These three examples are not alone in demonstrating the organization's commitment to developing artists who can produce art and can use that knowledge in influential ways.[74]

They also model the types of artists who can contribute to knowledge production about cultural policy first called for in "The Arts and the Public Purpose."

The website

The Internet is the primary means by which the Creative Capital Foundation promotes, or recapitalizes, itself daily, weekly, and monthly. The organization is tireless in its efforts to promote artists, and its website and frequent e-mail blasts are a testament to the can-do spirit of the organization, perhaps even a belief that excitement and abundance follow from repetition. The website maintains a vast database of its allied artists and projects and promotes them across a spectrum of interests. Monthly, the website features a rotating section of "6 Featured Projects" and "6 Featured Grantees." A section titled "On Our Radar" features 300–500 artists who have made it to the semi-final round in the granting period and thus represent those for whom the organization still has a vested interest.[75]

Creative Capital's promotional efforts are essentially lateralized operations, a project shared by the organization and its artists. The website and promotional materials, as well as the PDP and the grant programs, rely on the full buy-in of artist-producers who provide the organization with the evidence of their success. In doing so, these artists play willing partners in a larger project of programmatic validation and sustainability. It is through this material effort, symbolically represented in promotions, that the organization actually transmits its cultural capital to its artists, confers social capital, and shores up its own brand. These programmatic efforts demonstrate exemplify the regular exchanges of capital between the foundation and artists, as well as the means by which artists help shape the organization's repertoire and inform its contributions to arts policy.

Mediating capital

Much of the organization's power it extends to artists comes from its careful attempts to deploy social capital, a network of relations on behalf of artists. In his critique of social capital, sociologist James Coleman (1988) observes that social capital relies on anticipated forms of reciprocity.[76] Critical to Coleman's notion is the depth of relations between subjects.[77] Creative Capital's reasonably limited grantee numbers and cycles, its grantee retreats, as well as its promotional efforts cultivate the inclusionary aspects for social capital, as well as cultural and financial capital, for those fortunate enough to

be grantees. But as Coleman argues, those same conditions of inclusion of some create an exclusion for others.[78] The educator Alfie Kohn has argued that award systems in general rely on a notion of scarcity, putting values on merit rather than hard and meaningful work.[79] With respect to artists, the conditions of inclusion/exclusion and scarcity have contributed to a documented ambivalence toward grants among working artists.

The landmark study, *Investing in Creativity: A Study of the Support Structure for U.S. Artists* (2003), provides significant insight into this paradoxical aspect of social capital as it relates to grants, but it also points to the esteem still held for the Creative Capital's work. The study notes that a majority of artists value large dollar awards and grants that covered more than a year; however, the research finds that the bulk of national awards available last only "1 year (42%) or less (23%)," while those with a duration of more than 1 year amount to only 3.1 percent. *Investing in Creativity* also observes that many artists choose not to participate in seeking awards, citing "altruism (others need it) more," direct options in the commercial markets or nonprofit sectors, lack of awareness, or discouragement based on a perception of bias in the awards system. Moreover, many respondents see grant writing as "a skill that is independent of artistic ability—and that grant recipients are usually the best grant writers, not the best artists."[80] With respect to the Creative Capital Foundation specifically, the study finds that by 2003, many artists have come to admire Creative Capital, regarding it as "responsive, and attuned to artists needs."[81] They see its fellowships as "monetarily generous," but they also recognize that the organization is too small to adequately respond to the vast need in the field.[82]

Throughout its history, Creative Capital has sought to cultivate a notion of inclusion and possibility for artists across the nation. Officially, the organization maintains that it "supports diversity in all its forms" through its programs and services, including "gender, race/ethnicity, geographic distribution, art forms and creative process, age, and experience."[83] In *At the Intersection* (2005), Creative Capital's five-year assessment, the study's authors noted that the geographical distribution of awards had been disappointing to the organization.[84] In the first five years, the organization had favored artists in New York and California. The study concluded that it needed to address the composition of its panels, but also asserts the need for more initiatives like the Creative Capital Foundation, which was already finding itself challenged to recapitalize itself and support more artists each year.[85]

Currently, Lerner notes that the organization's approach to diversity has changed; rather than seeking to fulfill quotas or touch on all regions, Creative Capital has assumed a more holistic approach based largely on content.

> Regionally, our mandate is that we have to support people pushing the envelope in a global context. A lot of communities in the country are conservative, and cutting-edge artists often feel the need to leave. My response to any community is this: "It's your job to build an infrastructure to keep those exciting artists there." In the communities with strong infrastructural support, we have a lot of artists—we have 18 artists from Seattle, for instance. I have a different point of view now. Of course, now if we end up supporting only downtown choreographers in New York, I would want to shoot myself.[86]

To maintain diversity, however, Creative Capital takes peer panel input from a diverse group of consultants and evaluators drawn from a multi-layered peer process. A team of about ten readers will each sort through initial applications relevant to their region. Lerner says that the regional readers have the value-added benefit of knowing the applicant's work or becoming familiar in the process. From the central office, a core group of three readers—two of whom are Creative Capital grantees—will each read a third of all applications. The organization relies on racial, ethnic, gender, and geographic diversity in its peer panel make-up at all levels.[87] addition to these strategic efforts, Lerner also advocates for a diversity of content. She remains most excited about finding the "Laughtavis[ts], bioartists, technologist artists, and legislative artists" who are bringing energy and vitality to the nation's arts through their practices.[88]

The organization's longstanding support for artists who are making work that is relevant to free speech finds it in the cross-hairs of other national issues. In "Assessing New Anti-terrorism Policies: One Reader's Response" (2005), Lerner writes of the Foundation's response to new anti-terrorism agreements required of one of its funders as a result of Executive Order 13224 issued by President Bush after 9/11. Facing the requirement that the organization must guarantee that its artists will not engage in terrorist acts to receive funding, she recounts how the Board chose to sign the award letter from the funder acknowledging consent, but refused to pass the anti-terrorism language onto the artists. In doing so, Creative Capital reaffirmed its longstanding support for artists, and showing that the organization saw itself as an intermediary that could effectively shield and support its artist grantees.[89]

Through its programs, the Creative Capital Foundation has returned artists to roads both taken and deferred between the Great Depression and the Vietnam War, when the nation modeled its two federal arts programs. With respect to policy history, the organization responds to the origins of the leveraged grant in arts, a model imperfectly adapted from the sciences, where industry regularly incentivizes innovation. The earliest leveraged grants developed by the Ford Foundation were two to five years and required twice or four times as much in matching funds. Over time, this significant match requirement leveraged donors and increased the field. It also rendered art making a largely earnings based enterprise, even in the nonprofit arena.[90] Consequently, Creative Capital's calibrated use of venture capital models is neither unprecedented nor surprising. Indeed, the Foundation's programs have revived the machinations of the commercial sector, where artists worked primarily at the beginning of the twentieth century, while still availing artists of the incentives of the nonprofit sector and teaching them how to advocate for themselves. Through a series of transparent operations, the organization brings attention to artists' work on the premise that a focus on process and audience will lead to reward, alert artists to their material circumstances, and bring stability to their careers. Comprehensive efforts such as these raise a very big question about the nonprofit sector's effects on artists for the four decades preceding the program's inception: had the growth of the nonprofit sector between somehow imbricated itself on its creative workers, normalizing the image of a "nonprofiting artist"? What Creative Capital's programs demonstrate most profoundly is that all professional artists are essentially for-profit artists, who must articulate and leverage multiple forms of capital across multiple levels of engagement.

Much like "The Arts and the Public Purpose," Creative Capital's discourse is built on liberatory hopes; however, its efficacy relies on more distinct capital, even "capitalist," outcomes. The revolution it has proposed comes as a mixed blessing: while it fits easily within a neoliberal framework where market solutions are emphasized, the organization also manages to offer a collaborative means by which artists can rebuild their careers. Its programming is built on a model that marks successful artists and also makes room for others to rise up, cultivating an infinite variety of accomplished artists across a diverse spectrum of disciplines and traditions. What Creative Capitals efforts ultimately reveal is that the greater arts world is a social one in which capital builds up through the input of many players. Some of these players will find success as they make their ways self-knowingly through the available

avenues of artist sustainability and support defined by applied programs like Creative Capital. Ultimately the Foundation imagines artists as partners to the nation's arts and creative sector as well as the Foundation itself. Its politics of access can be liberating to all who are ordained by it and who build up their practice through a seven-year period of focus on self and work. Others, however, may be motivated by the Creative Capital's careful command of discourse to keep trying.

As contemporary policy research has shown, Creative Capital's challenges and its potential were far more complex than could be explained in a single press release or news feature, especially one oriented toward raising the profile of a new, ambitious philanthropy. In its decade and a half of existence, the Foundation has shifted the arts and cultural policy paradigm through programmatic intervention and invention. Time has proven Creative Capital's early popularity significant, a glimpse of the organization's capacity to wed itself to symbolically important causes, to dream big, and to work out the details in the doing, as well as in post-production retrenchment, reflection, research, and redevelopment. In the words of Ruby Lerner, Creative Capital follows an ethos that "good programs are good policy."[91]

5

A Survey Course: Teaching Artists and/as Producers (2013)

"Anticipated Career and Education Outcomes"

At the beginning of the fall term in 2013, I invited the 120 first-year students in the Department of Theatre and Dance to participate in a blind survey titled "Anticipated Career and Education Outcomes." The survey was part of a pilot study that was designed with curricular intent. As part of a humanities-based seminar for first-year students, "Languages of the Stage" (LOS), students were made familiar with arts education research. Specifically, we read and discussed findings from the Strategic National Arts Alumni Project, or SNAAP (2010), a longitudinal study that charts the professional outcomes for students trained in fine arts higher education programs. In my section of the course, comparing students' stated anticipated career objectives to SNAAP's findings opened dialogue on the students' values and desires and the diverse postgraduate outcomes they may encounter. My class's use of the survey, combined with a study of Austin's working theatre artists, contributed a policy-informed version of the course. The course also supported a reconsideration of my own teaching, in particular a materialist approach to a humanities course, while my colleagues and I prepare to redesign LOS to support a new undergraduate curriculum.

Historically, LOS has introduced students to multiple forms of theatre, dance performance, and criticism, and the various theatrical languages of each. Among my colleagues, Andrew Carlson imbued his class with questions about ethical decision-making. He used theatrical texts like *Hamlet* and the National Theatre of Scotland's production *Black Watch*, about Scottish soldiers in Iraq, as sites for dialogue about ethics and the types of contributions artists make to public culture.[1] Rebecca Rossen focused on performance criticism, the body, gender,

and race. Together we scheduled guest artists for all classes to share, like choreographers Lar Lubovitch, playwright Kirk Lynn of Austin's Rude Mechs theatre company, and Allison Orr, whose company Forklift Danceworks produced PowerUP!, a site-specific dance work with utility company engineers, or "linemen," that fall.[2] My students attended performances and studied theatrical works, musicals, performance, and dance. Working in teams, they conducted research on local theatre organizations. Studying *Crossover: How Artists Build Careers across Commercial, Nonprofit and Community Work* (2006), we considered how artists access multiple economic sectors through their work.[3] We also compared the findings of our own study to those of SNAAP as a way of opening up the conversation about why and what the students chose to study in the Department of Theatre and Dance. In all of these ways, my students, as well as my colleagues and I, used performance as a "politically engaged" modality for thinking through creative civic engagement and public purpose.[4]

Recent movements in arts policy and higher education have delivered artist training and professional development to a crossroads marked by multiple discourses and models of development. The politically motivated recommendations from "The Arts and the Public Purpose" (1997) task cultural policy communities to revolutionize *"education through the arts, education about the arts, and education in doing the arts."*[5] The tripartite approach proposes a culturally invested future by promoting arts literacy broadly. Yet it also calls to mind many concerns about the relevance of artists' education—the nature of training, viable prospects for those who pursue artistic careers, and even the trajectory of those fine arts students who do not. Creative Capital's many training programs demonstrate a host of skill-building repertoires focused on artists as producers, even entrepreneurs. Here, however, I am concerned with how a policy-informed approach to an ostensible humanities course can productively balance the tensions of higher education and an emerging arts entrepreneurship movement that seeks to bring professional efficacy to scholarly training. How might this mediated combination support artists to function as producers and public intellectuals, as well as advocates who can articulate the arts' values while building the skills and literacies that brought students to fine arts training in the first place? In "The Humanities, the University, and Public Policy" (2000), William Bennett argues against my course's proposal: "the humanities are not a technique, knack or subbranch of public policy."[6] Framing the humanities as the study of "the dreams, hopes, fears, disappointments, failures and aspirations of those who make and are affected by public policy,"

he argues that the humanities' concerns are comparatively narrow in scope. At the same time, Bennett makes a space for those who love the humanities to perform policy by arguing that the "nation's public policy should not be framed by men and women whose only interest is public policy."[7] In effect, Bennett calls for the humanities to inform and enlighten public policy decisions, a relationship my course proposed to begin building by applying the humanities to public policy concerns as well as personal decision-making ones.[8]

Pursuing a course of study that engages policy's knowledge about artists with the goals of a university program challenges teachers to curate the lessons most appropriate to the moment. Such an approach must account for the nature of the class, modes of arts participation, the concerns of higher education, the role of distinct cultural communities as well as the greater polity. The same approach has the potential to demonstrate to arts students that policy's portrayal of artists as research subjects can actually point to effective means of practice and, eventually, as a means to support their creative agency.[9]

Higher education

The legacy of the 104th American Assembly, "The Creative Campus" (2004), informs many of these challenges facing fine arts educators today. In the final report, faculty are charged to discuss "practical career preparedness in the arts," to avail students to local arts opportunities as spectators and workers, and to be available to "arts and nonarts" students.[10] In "American Medicis" (2004), an essay prepared for the 104th American Assembly, Douglas Dempster offers some background on this recommendation, depicting fine arts higher education in crisis with respect to cultural policy. He observes that contemporary cultural policy attends to research focusing on the systems of support for the arts and artists, and even political arguments over the past and future of the National Endowment of the Arts, which is funded at levels less than "a dozen large, public colleges":

> Yet there is little appreciation and even less measurement of the level to which American universities train professional and amateur artists, in large numbers, who have to a large extent fuelled the "arts boom" evident in communities everywhere.[11]

Dempster's argument reveals a number of issues that remain to be addressed. These include the purpose of arts training and its relevance

to the greater public purpose, as well as the actual data documenting the outcomes of those who receive arts training. Historicizing the development of the fine arts programs in the university, he recognizes the enduring and problematic divide between scholarship and practice.[12] He notes that distinct disciplinary approaches and a lack of policy-informed, new research among faculty has led to a "curricular stenosis," or narrowing. He contends that this stenosis hinders faculty from developing responsive curricula which will offer students market readiness or prepare them for creative work in a variety of fields.[13] Much like the recommendation from "The Creative Campus," Dempster imagines a teacher who is willing to take a hybrid approach with respect to scholarship and artistic practice. Such work anticipates the lives that the students will face, models a collaborative spirit among faculty, and a generalist ability that reflects the lifelong learning ethos of the classroom. This approach proposes that the theory- and practice-based learning in the arts will support the students in multiple ways as engaged members of society.

Dempster's writing frames issues in fine arts training that are relevant to higher education in general. In *College: What It Is, Was, and Should Be* (2012), Andrew Delbanco amplifies the challenges facing students when he assesses the multiple forces at play in the greater university system today. Observing higher education in "a period of wrenching change," he lists the conundrums facing students and faculty alike:

> globalization; economic instability; the ongoing revolution in information technology; the increasingly evident inadequacy of K-12 education; the elongation of adolescence; the breakdown of faculty as an academic norm; and, perhaps most important, the collapse of consensus about what students should know.[14]

Delbanco portrays a university in need of a policy commitment to its own original goal of providing a liberal education. In doing so, he takes up many of Clark Kerr's enduring arguments about challenges facing the modern university in *The Uses of the University* (1963).[15] Delbanco also recognizes the social and economic forces that are changing how we faculty teach. Facing students in a technologically advanced, economically unsure moment, he asks how higher education can resist being reduced to professional development concerns. In response and from an arts perspective, theatre scholar Nancy Kindelan advocates theatre studies as an ideal site for humanities-based learning, where students develop the critical thinking skills to combat a career-focused reductionism. Citing a white paper from the Association for Theatre in Higher

Education (ATHE), Kindelan positions theatre studies as a resource for multiple intellectual and social abilities: "research," critical engagement with questions of ethics, diversity, and "cross-disciplinary understandings," independent thinking, as well as a philosophically informed engagement with "learning communities," and "civic dialogue."[16] Kindelan's acknowledgment of "cross-disciplinary understandings" in particular hails the need for a humanities-based training across fine arts higher education to support artists who may be working in culturally specific communities.

The teaching hybridity called for by Dempster, as well as the values advanced by Delbanco and Kindelan, are addressed by policy studies about artists' lives, many of which combine research and advocacy to promote new training practices or forms of knowledge. As *Investing in Creativity* (2003) notes, "most arts schools and universities were perceived [by working artists] not to expose their students to the broad range of career opportunities available to them outside the traditional cultural sector."[17] *Transforming Arts Teaching: The Role of Higher Education* (2000) advocates for new forms of teaching that include contemporary professional development concerns and offers examples of college programs in its case study model.[18] *Dance from the Campus to the Real World (and Back Again)* (2005), a report that emerged in response to a study about dance outcomes, combines the testimonies and studies from choreographers, teachers, and arts organizers to demonstrate how dance students should prepare to transition from higher education.[19] By providing evidence of knowledge or accomplishment or solutions already in progress, these efforts epitomize forms of political and educational support first imagined in documents like "The Arts and the Public Purpose." But they also invite room for a student training in the arts to use research to think through career choices and opportunities.

What all of these arguments bring to the conference tables and desks of the fine arts classroom are questions of ethical hybridity. How might teachers effectively inculcate the material concerns of practice with scholarship in a way that prepares students to contribute to vital cultural communities across the nation? More importantly, how might these inquiries bring hope to those emerging artists who continue to pursue higher levels of education, yet earn less than workers in other fields?[20] The findings of policy do not run counter to humanities-based learning. Instead, they offer a means for students to productively shape and strategize passionate investments in cultural participation. Bringing policy-informed research and arts entrepreneurship skills into the humanities classroom supports the preparedness of artists as producers of both

knowledge and artistic work. The effort also opens up a meta-framework from which students might understand aesthetic considerations and material concerns informing both scholarly research and artistic practice. Following this argument, I introduced policy research, such as the "Anticipated Career" study, the SNAAP findings, and *Crossover* (2006) early in the semester and used them as supplementary texts for reading cultural production throughout the semester.

From a research standpoint, much of the data called for in "American Medicis" was realized with the rollout of the first Strategic National Arts Alumni Project (SNAAP) report in 2010. SNAAP is a longitudinal study of students from 154 fine arts programs across the country and represents the first significant attempt of fine arts higher education programs to adopt a measurement and evaluation paradigm for post-baccalaureate outcomes. Conducted by the Indiana University Center for Postsecondary Research in collaboration with the Vanderbilt University Curb Center, SNAAP joins a field of tests common to business schools for more than a decade. Yet SNAAP's origins and concerns are unique to fine arts. A number of trade magazines—*Businessweek, Financial Times, Forbes,* and *The Economist*—disseminate business school rankings. By and large these tests survey matriculating MBAs on their programs, classes, faculty, classmates, and career placement experiences. These rankings contribute to the price put on their graduating students' initial salaries.[21] SNAAP's impulses are very different from those of business schools. SNAAP draws data from a large sample of alumni from 1943 to the present and represents the effort of fine arts college programs to present a holistic picture of the benefits derived from fine arts training. SNAAP assesses outcomes with respect to career choice, income, prospective geographic location, and debt, among others.[22] Because SNAAP findings offer precise data about how many students have pursued their artistically informed careers, how students value their education, and how they support themselves, the results can provide compelling, largely quantitative evidence for the value of arts training in higher education.[23] For a freshman survey course, this data also illustrates the benefits and challenges to pursuing arts training and invites a multi-faceted approach that includes "*education through the arts, education about the arts, and education in doing the arts.*"[24]

In a manner that put the survey to immediate use, my "Anticipated Career and Education Outcomes" study intersected with SNAAP in interesting ways, and these pointed to the opportunities for a policy-informed curriculum. As a pilot effort performed by a professor making a hybrid move, pushing against "curricular stenosis," and attempting a methodology not common to his practice, my findings were preliminary but

sufficient to support critical engagement.[25] The survey revealed that the majority of my first-year students were 18 years old.[26] Coming of age in the twenty-first century, they were unfamiliar with the culture war of the 1990s and the efforts of arts policy in the last two decades. They were more likely to be more aware of recessions and unfriendly job markets, questions that SNAAP regularly addresses. However, the students answered a twenty-question survey that helped us discuss how they perceive career prospects at this moment in history. For example, SNAAP findings indicated that 25 percent of fine arts graduates feel debt has had a major impact on their career decisions, and 30 percent listed debt as their chief concern. More students in my survey, 40 percent, listed an "unfriendly job market," and another 20 percent indicated "unpreparedness for the real world" as a number one concern.[27] When offered a choice to live in places like "a small/rural community," or a "mid-size/urban city," or a "large/urban city," and an option to write down a proposed future home, the students named New York, Los Angeles, and Chicago as their three top destinations; these findings coincide with those of the students' professional counterparts. To live in these cities, the students proposed to earn more than their working counterparts: SNAAP's data indicates that fine arts graduates on average earn from $35,000 to $45,000 per year. More than 50 percent of the students surveyed in LOS, however, indicated that they wanted make between $50,000 and $70,000. SNAAP data actually troubles this finding by revealing that reward is not always commensurate with salary.[28] For example, dancers make the lowest salary and tend to experience the greatest sense of reward.[29] The sum of these comparisons set the stage for a materialist inquiry, adding another dimension to the types of performance analysis commonly taught in the LOS seminar. The same findings also challenged the class to begin regularly interrogating the resources required to make theatre and dance and to start measuring risks and rewards inherent in their proposed careers.

To earn their incomes as artists, the students felt that they needed to devote their training to artistic skills, writing skills, business skills, and then teaching skills, in that order. The students did not list entrepreneurial skills or technology skills as primary skills needed. In contrast, SNAAP notes that 99 percent of graduates list "creativity" as the first skill required to support a career—an option that was sadly missing from the pilot study—followed by networking, artistic skills, and technological skills. For a write-in "meta" question designed to support the subsequent conversation, "Which question did you find most relevant?" most of the students responding named the skills question as the most important to them, because it forced them to think of competencies

that would support their prospects. Given that the students were new to the program and that their declaration of a major represented the first time they had begun pursuing their career future as adults, naming skills appeared as a way of validating their own training choices. Moreover, 59 percent of the students also indicated that they planned to pursue graduate education within the first five years of receiving a bachelors' degree, and so skill building and preparedness were part of a plan already in place. As I shared the findings with students, and we compared them to national data, they became fascinated with how their presumptions lined up with the experiences of working artists. We used the findings to discuss our values and to parse out what terms like "creativity" and "networking" mean in light of their experiences with social media platforms versus the embodied networking and creative practices that support performance creation.

We continued to use the study and its information as we read plays and watched dance works that pushed at the common boundaries of humanities study; we examined performance literatures and languages, both written and embodied, as well as the representations of race, culture, class, gender, and sexuality, among others. We read plays such as Tanya Saracho's *El Nogalar* (2011), an adaptation of Chekhov's *The Cherry Orchard*, Lisa B. Thompson, *Single Black Female* (2012), musicals composed by Stephen Sondheim, and the Rude Mechs' *Stop Hitting Yourself!* (2013).[30] We saw a workshop version of *Stop Hitting Yourself!* in anticipation of its Off-Broadway opening at Lincoln Center Theatre 3 (LCT3) in January of 2014.[31] We also attended a shared-bill performance of Vincent Mansoe and UT professor Charles Anderson's company, dance theatre x, as well as Forklift Danceworks' *PowerUP!* (2013), Trouble Puppet Theatre's *The Head* (2013), and the department's production season.[32] Through all of our reading of scripts, biographies, and critical essays, my Teaching Assistant Russ Dembin and I challenged the students to ask questions about the development process for each work and the career trajectory for each artist or company we studied. How might searches for past reviews, scholarly essays, and company websites, as well as the credits in the published script point to the time and multiple inputs required for each performance work? How might each production avail itself of nonprofit and commercial resources, either in anticipation of a first production or later on as an adaptation or through the sale of merchandise?

Initiatives I study, such as Leveraging Investments in Creativity (LINC), have paid close attention to the United States' rapidly shifting

demographic by creating programs that focus on culturally specific communities.[33] Inspired by LINC and other initiatives, almost all of the performances we studied engaged questions of race and culture, class, as well as gender, sexuality, and belief. Our materialist inquiry also included these concerns as part of our artistic and scholarly goals. For example, Tanya Saracho's *El Nogalar* (2011) sets *The Cherry Orchard* in the midst of the drug war in northern Mexico; López (Chekhov's "Lopakhin"), the once-poor laborer who has acquired land and status through his drug connections, pines for the attentions and respect of the once-wealthy Maité ("Madame Lyubov").[34] In our discussions of *El Nogalar*, we discussed class, privilege, even our assumptions about Mexico's drug war, but we also raised questions about Maité's refusal to engage her financial condition. How did even a privileged past inform or hinder one's ability to attend to material concerns? Forklift's *PowerUP!*, as well as its predecessor *Trash Dance* (2009), which became a feature-length documentary that we watched, demonstrated the crucial, unnoticed roles our city workers play.[35] We talked about the class and capital assumptions that attend various jobs and how Orr's work sought to bridge them. Lisa Thompson's play *Single Black Female* (1999) presents the economic and social challenges of being an "SBF"—the disdain of marriage-advocating elders and the costs of living single.[36] Playwright and colleague Kirk Lynn presented a workshop on Shakespeare adaptation based on his forthcoming play, *Fixing King John*, which the Rude Mechs produced that fall. In all of these performances we were tasked to think about how artists, as public intellectuals, often engage questions about materiality.

In light of these experiences, we examined questions we should ask of professional artists and scholars to support the students' proposed careers. Russ and I asked the students if they had responded to Rude Mechs' request that audiences submit comments on *Stop Hitting Yourself!* to help the ensemble as it continued to revise the work in anticipation of its Off-Broadway run. If they were interested in studying the virtuosic work of Trouble Puppet Theatre Company, as many said they were, would they consider returning to another show and introducing themselves to the cast and director to make themselves known to local theatre professionals?[37] Many faculty in programs like ours are locally based artists, a fact that can benefit students in multiple ways. Anderson, Thompson, and Lynn are all faculty members at the University of Texas at Austin, and Orr has taught as an adjunct at Austin Community College, but has more recently turned her attention solely to her company. Both Orr and Lynn could testify to the years they had spent building their

companies, their increased professionalization. In the epilogue of her scholarly monograph *Beyond the Black Lady* (2009), Lisa B. Thompson writes eloquently about opening the Off-Broadway run of *Single Black Female* (2008) and its connection to her scholarly work.[38] The presence of all four in the academy did not signal an end to their creative work. How did the biographies of all four artists counter assumptions of the artist vs. teacher binary? In effect, the four modeled a through line in "American Medicis" pertaining to the University's critical role in sustaining and building a cultural workforce. All of these queries contributed a materialist and scholarly approach to a humanities-based topics course, one that allowed us to begin thinking how artists shape their choices to support their studies and vice versa.

My class was composed of avid theatre and dance students who were readily available to critiques of representation. They were less familiar with the economic terms of artistic practice. The class' composition was indicative of the opportunities facing higher education and the arts. More than half of my students identified according to a specific cultural and racial group: Latino/a, African-American, and East Indian. Many students spoke a second language, primarily Spanish, which some had only learned in school. When several non-native speakers took on Spanish-speaking roles during a reading of *El Nogalar*, they received compliments from their native-speaking colleagues. The students were keen to talk about issues and perform roles across the spectrum of race, class, gender, and sexuality without resorting to stereotypes. They argued vociferously, but also collegially, about these issues. Their audition repertoires, which many shared as part of a wind-up to a final performance, as well as their original performances and the research paper they wrote and revised throughout the semester, demonstrated that they had studied many plays, dance works, and musicals thoroughly. Yet the students also indicated that the discussions about the costs of making work were new to them. They were also unfamiliar with other concerns, such as which companies locally and nationwide created the types of work they were most interested in. In classroom discussions, we regularly asked how research on plays and dance works might contribute to a better understanding of how artists support themselves and each other. The students indicated they were eager to continue pursuing entrepreneurial training in tandem with their scholarly and artistic disciplinary training.

"Anticipated Career and Education Outcomes" supported the course's goal of addressing curriculum and even challenged my comfort in teaching. The initial findings, when compared to SNAAP, also revealed a need for me to think more broadly about my students' impulses in pursuing fine

arts careers, to avoid questions that overemphasize economic choices as well as discipline specific professional artist careers. A majority of my students indicated that they wanted a career in the arts or a career that mixed nonarts work with arts work. An assessment of 81,669 alumni tested by SNAAP in 2010 responds variously to this finding.[39] For example, 29 percent of those surveyed by SNAAP have never become professionals, and 47 percent of them do not currently work as professional artists; however, among that subgroup, 78 percent of those currently make art in their own time. They volunteer, but also serve on boards of nonprofit organizations.[40] Grounding LOS in survey findings challenged my own stenosis and prompted me to find ways to connect the course's inquiry to education outcomes that serve a wide variety of purposes, including art therapy, social works connected to place, arts administration, and advocacy. I say this because one of the key organizing themes of research on universities has been "the problem of oversupply," how artists flood the job market, given that "the number of degrees awarded in visual and performing arts has increased 73 percent between 1996 and 2010, from 75,000 to 129,000."[41] Yet a more nuanced understanding of the careers already imagined and proposed through fine arts training can offer students the means to think broadly about their prospects, to deepen their enjoyment of learning, as well as their investment in arts training.

Historically, the university has prized elite forms of training, but many students parlay their arts training to hybrid work or other fields.[42] Danielle J. Lindemann (2013) argues that we must now look at how arts training prepares students to navigate a "contingent economy," where individuals combine multiple jobs in firms or the market and assess the relationship between arts training and resilience.[43] Steven Tepper and Elizabeth Lingo (2013) explain the shift as a move to "generalization, flexibility, and broad competencies, rather than discipline specific skills." These "meta-competencies" speak to humanities training. They include "broad creative skills, commercial acumen, and the ability to work across multiple media platforms."[44] The approach of all of these scholars resonates with Dempster's notion that faculty and students alike must remain open and agile to lifelong learning and skill building. This trajectory is also more in line with the National Endowment for the Arts approach to artists as workers who occupy a number of occupations.[45] For teachers addressing these meta-competencies, these tools and practices of policy are a way to stage fine arts training. In other words, my study succeeded as a performative act: the "doing" of a survey rehearsed a repertoire the students may face as matriculating artists or professionals in some other career, who later fill out a study about their

experiences training as artists.[46] It also invited them to start researching and getting to know working artists in their continued study so that they feel more adequately anchored in practice.

The journey from art studies to art making generally follows a period of apprenticeship.[47] Working from a policy-informed approach a teacher might take into account that even though most universities are nonprofits, their budgetary operations are removed from the students' perspectives; consequently, they may not understand the distinct fiscal calendar orientations informing the different market sectors. Nonprofit arts organizations and many grant makers must schedule their seasons or designate their grantees far in advance and include those budgetary estimates at the start of their fiscal years, which may or may not operate on a January to December calendar year; consequently, any artist seeking funds or an opportunity in the nonprofit sector is generally working at least eighteen months in advance. Similarly, those artists working independently in the commercial sector, as opposed to taking job in the marketplace like a graphic design firm, may also have to familiarize themselves with gathering the stakeholders to support their work. In contrast, university students habituate to the quarter or semester systems used by their institutions. Each semester or quarter is a short-term production, a narrative that begins with exposition, rises to the climax of a final exam, and then winds down, like a play. As examples from Creative Capital demonstrate, many art projects or series of works take years to develop. Practicing artists must take into account sustaining their energy, committing to project development over a longer period of time, but also sustaining revenues through additional work that may or may not be creatively oriented. Many actors and dancers must acclimate to the audition seasons that take place regularly across different market-based cities. Independent filmmakers work in anticipation of festival seasons. Few artists work completely alone. Each video by Beyoncé is the result of numerous qualified artists and professionals attending variously to the concerns of production (composition, music production, videography, art direction, casting, choreography, costume, and make-up) and reception (marketing and promotions, distribution, legal concerns). Highlighting these various inputs and investments, even in the space of a humanities classroom, adds another dimension to the work's message and complicates the notion the production sprang from the imagination of a single creator. Tasking students to read work from a meta-perspective of the arts as a profession offers a supplementary text to evaluate artistic work.

Many of these materialist practices are embraced by entrepreneurship training in arts higher education, a repertoire that increasingly

includes research, skill and venture building, project promotion, and even argumentation.[48] With respect to my freshman class, my challenge was to introduce some of its practices as a medium for a humanities-focused introductory course. The outcomes also compel me to identify the distinctions between entrepreneurship training and those entrepreneurial practices that may be adapted to support humanities-based learning.

Entrepreneurship study and practice

Entrepreneurship identity and entrepreneurship practice occupy a crossroads of multiple political and social discourses in the arts, many of which address the question of skill building. Over the last decade specifically, collegiate arts entrepreneurship programs have grown significantly, garnering some "three hundred million *private* dollars" in additional capital.[49] A 2007 nationwide study of entrepreneurship curricula in college and university arts programs funded by the Kauffman Foundation found that higher education music programs represent the majority of these approaches, which appear variously as formalized programs, degrees, certificates, workshops, and initiatives. These programs espouse the idea that entrepreneurship training offers a means for sustainability, a way to train a new generation of activist arts workers.[50] New graduate and undergraduate degree programs and minors in arts entrepreneurship have emerged at Arizona State University, Southern Methodist University, and North Carolina State University. They are joined by new ones at Harvard University, Julliard, MIT, and the University of Southern California, among others. A recent study indicates that 130 university and college programs provide arts training under the rubric of entrepreneurship.[51] Their work is sustained by active bloggers and by three academic journals.[52]

Despite the proliferation in arts entrepreneurship programs at the university level, many of these programs have at first met with a mixed reception across the fine arts spectrum, revealing a need for courses that might introduce arts entrepreneurship principles in speculative terms. Gary D. Beckman the principal investigator of the 2007 study on arts entrepreneurship in higher education, observes that visual arts programs generally maintain "ambivalence" toward entrepreneurship training, while theatre programs show "little explicit interest" in pursuit. Beckman concludes that music education is more available to entrepreneurship studies because of its relatively conservative aesthetic approach exemplified by its predominant focus on form, discipline,

and distribution.[53] Yet the experiences in my class reveal that performance offers a means for theatre artists to embody those practices and to rehearse and perform them.

In business and economics, the development of entrepreneurship studies over the last three decades has wrought a number of approaches and concerns that appear particularly transferrable to artist pedagogy. Many definitions of entrepreneurship rely on Joseph Schumpeter's theory (1954), which positions entrepreneurship as the confluence of opportunities, skills and capacities, drive, and expectation of reward. Together, these influences bring new innovations in the market.[54] In "The Promise of Entrepreneurship as a Field of Research" (2000), perhaps the most widely cited definitional article in entrepreneurship studies, Scott Shane and Sankaran Venkataraman portray entrepreneurship as "the scholarly examination of how, by whom, and with what effects opportunities to create future goods and services are discovered, evaluated, exploited." Taking a more structural approach than Schumpeter, the authors posit entrepreneurship at the intersection of three distinct resources: 1) opportunities, 2) individuals who will exploit those opportunities, and 3) diverse business models that do not necessarily require the creation of a firm. Their work is predicated on "disequilibrium," the notion that entrepreneurial innovation results from asymmetrical information and opportunities.[55] The idea advanced by a disequilibrium approach is that opportunities are unevenly distributed, subject to risks, requiring of skill and talent readiness, demanding of an individual's alertness to opportunities and luck. These conditions may resonate with many artists accustomed to fickle audiences.[56] They also amplify the need for faculty to work against curricular stenosis to constantly think through and discuss the material structures and opportunities undergirding artistic practice. Taking on Schumpeter's notions, theatre scholar and practitioner Linda Essig argues that business entrepreneurship holds a circular relationship to the arts—applying innovation and efficacy to artistic practice offers rewards to business, but also "neighborhoods, towns, regions and cities," which return value back to the arts and artists through participation.[57] Her ideas in this manner resonate with the urban development focus of contemporary place making work. At the same time, Essig acknowledges that, contrary to Shane and Venkataraman, many artists are not motivated solely by profit, but other social and cultural rewards.[58]

Like many of entrepreneurship's advocates, Essig argues for the relevance, even urgency, for arts entrepreneurship training in fine arts education. Hers and Beckman's motivation in calling for the adoption

of arts entrepreneurship is supported by research and echoed by SNAAP and my pilot study "Anticipated Career and Education Outcome" survey. A 2010 comparative study of two hundred college music students and fifty music professionals conducted by the nonprofit Arts Enterprise also found that, much like my own students, the majority of music students still preferred to focus on their performance skills, rather than entrepreneurial skills. By contrast, their matriculated peers recognized that performance took up very little time of their postcollege livelihoods and as a result had sought additional professional development training, which, in retrospect, they now wished they had received some years before.[59] In light of these assertions, SNAAP's own finding that creativity is key, followed by networking skills, and then artistic skills, gestures to "creativity" as a shorthand for a producer-like capacity, a generalist skillset that bridges aesthetic and material concerns. SNAAP's skill model resonates with an ongoing move toward hybridity and generalization in artistic practice. Beckman also calls for a new definition for entrepreneurship that takes into account the social scientific theories of paradigm development as well as a curriculum that is not too narrowly focused on strict disciplinary practices.[60] Kelland Thomas calls for the adaptation of a case study approach that can track entrepreneurial legacies and expand practice repertoires.[61] These efforts also show entrepreneurship moving toward a policy community, making the combination of artistic practice and academic study less of a "shotgun marriage" than an amicable and productive one.[62] At the same time, but also playing close attention to policy, these moves make room for research on artists' lives and meta-commentary approaches to the classroom that work against disciplinary distinctions. As either a point of departure or a point of agreement for artists and organizers, the battles over the terms entrepreneur and entrepreneurship illustrates how artistic value, whether it is addressing product or process, is ideologically determined. This holds true for those who produce the work, as well as those who sustain or consume it.[63] What entrepreneur and entrepreneurship provide artists, arts organizers, and teachers at this moment are unstable signifiers ready for critical inquiry. Offering a productive gap in understanding, these concepts challenge stakeholders to interrogate not only their capacity but also resources. Understanding entrepreneur and entrepreneurship calls for a "critical cultural policy" approach, one that negotiates the concepts' meanings with the lived experiences, investments, and beliefs of those who use the words, those who disdain them, and those who ignore them.[64]

Mediating and merging teaching repertoires

My particular curricular assignments are divided among the humanities focus of a core curriculum, as a series of entrepreneurship courses, and my own scholarship into how policy shapes practice. I rely heavily on my background as an artist and a teaching artist who became a professor and scholar to navigate those roles and to pursue new curriculum development. I find Kindelan's argument, which echoes DelBanco's, particularly helpful when thinking through these various roles: "the educational community lacks an understanding" of how theatre studies contributes "skills of intentional learners, whose undergraduate 'holistic' education helps them become productive members of society."[65] What's helpful is not so much the oppositionality inherent in the comment as the foregrounding of intention. How do we prepare our students to pursue their educations with intention, but also an awareness of a greater knowledge available at the university? In the classroom, I find that the study of arts policy, its repertoire, and its research archive offers the means for students to recognize the goals of both humanities-based learning and entrepreneurship. Arts entrepreneurship's reliance on research to support its acceptance and legibility even parallels the actions of policy and responds to humanities education by sharing many of its same goals. More recent research on the "arts entrepreneurial mindset" reads as a response to Kindelan's claims, noting that entrepreneurial training supports the

1) capacity to think creatively, strategically, analytically and reflectively, 2) confidence in one's abilities, 3) collaborative abilities, 4) communication skills and 5) an understanding of the current artistic context.[66]

All of these skills respond to a humanities-focused education, but they also hail a need for teachers to measure when and how to use entrepreneurial and policy texts to amplify a holistic engagement with works of art, literature, music, and performance and to make those distinctions evident. Doing so supports the students' capacity to measure and mark the aesthetic and social goals that inform art making with the material aspects required to produce it.

Through the artist-producer model, I seek to mediate those tensions and, in my own teaching, to support a critical engagement with entrepreneurship while enjoying its vitality. As Delbanco so poignantly observes, "college should be...a place where young people fight out

among and within themselves contending ideas of the meaningful life."[67] The progress of policy from the disarray of the 1990s culture wars to the current moment has offered students the archival resources and the programs where they might exercise that meaningful life. Offering students a model that illustrates how they might pursue such a life as artists and producers also tasks them to function as a policy community—to study their individual and shared values and assumptions, as well as the valuable roles they may play in twenty-first century arts and culture.

6
Linking Creative Investments: *Investing in Creativity* (2003) and LINC (2003–2013)

"Valuing Artists, Seeding Innovation"

On a bright day in May of 2013, 180 arts professionals assembled for a banquet luncheon at the Ford Foundation offices in lower Manhattan to celebrate the end of an era. The event's lengthy title signaled its purpose: "Valuing Artists, Seeding Innovation: Celebrating Ten Years of Leveraging Investments in Creativity" represented the capstone event for "LINC," a time-based initiative that pursued innovative research-based practices to improve working conditions for the nation's artists. In its decade of existence, the program contributed more than $18 million in direct support to the nation's arts infrastructure and reached "tens of thousands of artists and community members."[1] LINC's greater claim was that it had changed the way the nation could think about artistic practice and cultural engagement by modeling new methods of cultural support and establishing new distribution strategies.[2] Prior to the culture wars of the 1990s and largely since, the nation's federal policy relied on the method of channeling support through state agencies and nonprofit organizations.[3] LINC did not shy away from this approach, but amended it through specific programs directly focused on artists' practices and targeted resources.

The LINC initiative grew directly from a national study of artists, *Investing in Creativity* (2003); the study's immediate application into the initiative points to the careful theorization and the activist efforts of a policy community committed to both projects. The study's research consisted of interviews in nine representative cities—Boston, Chicago, Cleveland, Houston, Los Angeles, New York City, San Francisco, Seattle,

and Washington, DC—plus a composite sample drawn from artists working in rural areas.[4] *Investing in Creativity* provided a national picture of artistic practice across disciplines—empirical data—as well as what it called "[p]ractical interventions, the asset-mapping and creation of resources for artistic practice."[5] Key among its many contributions are specific categories for the challenges artists face: "validation, demand/ markets, material supports, training and professional development, communities and networks, and information."[6] LINC would dub these areas the "domains" of its work.[7]

Through its research to practice ethos, *Investing in Creativity* and LINC modeled a dynamic, reciprocal relationship between an archive and repertoires coconstructed by policy scholars, arts organizers, philanthropists, and artists. "The Arts and the Public Purpose" characterized artists in terms of political engagement, by proposing that artists were part of a greater set of issues. The meeting set forth a prominent place for the leadership of policy communities in the new arts paradigm, but it also created a need for artists who could serve as policy partners to animate public purpose on a national scale.[8] The Creative Capital Foundation framed artistic practice with respect to capital and invited—and continues to invite—artists as producers to measure investments and rewards through the production process. The organization's ongoing "action to research ethos" demonstrated how policy changes could be realized through risk and trust in the artistic process. The Foundation's ongoing programming and practices cultivate innovative artists who have the capacity to coproduce their work with partner institutions. Creative Capital works with grantees from its central location, or through its peripatetic workshops. By contrast, *Investing in Creativity* and LINC proposed to intervene on arts policy and practice in geographically and culturally specific places, based on the public purpose roles artists perform in communities. Taking up Margaret Jane Wyszomirski's (2000) call to deliver the arts to public purpose through specific "Policy Strategies and Administrative Tools" and "Specific Policy Decisions and Actions," LINC created a program that offered a measureable legacy.[9] The journey from *Investing in Creativity* to LINC illustrates the relevance of artists as policy actors who produce works of art in place-based partnerships that may effect a public good. The policy tables set up by both the study and LINC were many and disperse; none was of equal dimension, but each had the same core materials: meticulous research that included case studies and data, creative leadership reflective of each location's specific culture, and an activated artist constituency working at the local and national levels.

The journey from study to action also illustrates the theoretical blending, or hybridization of various forms of capital with the dynamics of power/knowledge. Much like its predecessors in policy and practice, *Investing in Creativity* organizes its thinking around specific forms of capital. The categories of "Validation" and "Communities and Networks" represent iterations of social capital, the tight reciprocal bonds that form through invested social relations.[10] "Training and Professional Development" and "Information" support cultural capital, the sum of skills, knowledge, and accomplishment asked of artists.[11] Economic capital, or financial and tangible physical resources reflect the thinking behind "Demands and Markets" and "Material Supports." For those who contributed to the study, this neat teleology belies a hard-won struggle to break down disciplinary distinctions between researcher and subject, identify critical dimensions for intervention, and build empowered cultural communities. The study and the initiative that followed from it defined terms by which all artists might pursue ethical, rewarding practices. The interrelationship of the greater project's archive and its repertoire facilitated new partnerships among artists, publics, and policy communities; highlighted artists' contributions; and illustrated competencies required for vital cultural communities. At the same time, and perhaps more importantly, the place-based focus availed by the initial study brought to the arts a long-anticipated recognition of changing demographics and cultural diversity.[12]

Between 2008 and 2013, I served on LINC's "Artist Council," a small advisory group created by LINC's President, Sam Miller, to deepen the organization's artist-centered ethos and "model the artist as public intellectual and as policy informant."[13] Miller credits the genesis of Artist Council to the late poet Sekou Sundiata, whose stage performances combined media, music, and poetry to rehearse critical cultural issues, and to choreographer Liz Lerman, whose work on The Genome Project has identified new ways to express science through dance.[14] Judilee Reed, who succeeded Miller as Executive Director, affirms that the Artist Council provided critical "feedback...from an artist's perspective."[15] The group was headed by Lerman and included at various times Sundiata, dancer-choreographer Grisha Coleman, artist and Buddhist monk Hirokazu Kozaku, artist and urban planner Theaster Gates, the artist-activist Favianna Rodriguez, and filmmaker Molly Davies. As one of several who served in an ongoing capacity, attending semiannual meetings and greater gatherings or conducting site visits, I saw the threads of the artist-producer model come together as a method for articulating the artist's role in LINC's work. These same potentials

illuminated conceptual and material challenges still facing US artists, many of which were made evident by the initial study. Given that many of LINC's programs funded artists directly, its meetings regularly featured artists' projects and input. The Artist Council offered LINC an additional site to assess the organization's ongoing research findings and rehearse its programmatic concerns.

Investing in Creativity (2003)

As with the two other programs I profile in Chapters 2 and 4, the origin of the *Investing in Creativity* study follows from the politicized funding climate of the late 1990s, when individual artist support was of major concern. Yet the greater combined initiative directly followed from a partnership between philanthropy and policy dedicated to discerning relevant forms of artist support. In 1999, Susan Beresford, President of the Ford Foundation, reached out to foundation program officers for new ideas that would amplify its portfolio of projects.[16] Holly Sidford, who was then Program Director for Arts, Parks and Adult Literacy at the Lila Wallace-Reader's Digest Fund, recalls a conversation with Ford Foundation Deputy Director for Media, Arts and Culture, Christine Vincent, who was exploring two possible "big bets" for arts initiatives, one having to do with artists and another about "stimulating individual donors to [directly] support cultural groups," both of which would ultimately be funded. Over dinner, the two settled on support for artists. Recognizing that, in Sidford's words, the nation's "lack of basic, solid information about artists and their lives was holding back policy and program development," Sidford and Vincent proposed to undertake an "unprecedented study" of the support systems that enable artists' work. By her own account, Sidford was also looking for a way to recast the nation's regard for artists. The study she devised would rely on "rigorous social science." It would take into account artists' needs and also their contributions to community, map the systemic assets that did exist, and synthesize all this information into recommendations for new modes of practice and support.[17] When Ford provided a seed grant of $100,000, Vincent asked Sidford, who would soon leave the Wallace Foundation, that she run the study. Preferring the organizer role, Sidford gathered the 38-funder consortium and with Vincent's input identified Maria Rosario Jackson of the Urban Institute as the Principal Investigator. Fundraising began in January 2000, and the study started six months later.

Sidford's adoption of the project had come at a critical time in her career. By that point, she had been Program Director at the Wallace Fund

for seven years. When she had joined the foundation, she had promised herself that she would stay no longer than seven years because she felt that "foundation jobs can be corrupting. It's easy to lose touch with reality, begin to believe the compliments people give you, and forget how hard it is to run a nonprofit cultural organization."[18] Taking on the study, Sidford was putting herself back to work in the trenches but also attending to a concern shared by her colleagues in philanthropy and the larger cultural field who had all "come through the culture wars and the vilification of artists in the public mind, and were concerned about the cuts to funding for artists in both public and private agencies." With the study, she was making a personal, but also field wide intervention into cultural policy, in substance and practice. Rather than proposing to be the organizer only, Sidford chose to maintain a role in the research process.

Jackson's introduction to the research project as Principal Investigator shares some lineage with "The Arts and the Public Purpose," in which she appeared as a panelist; however, her connection to the work predates the meeting and follows a separate stream. An urban policy expert who focuses on comprehensive community planning, revitalization, and the politics of ethnicity, race, and gender, Jackson was new to the Urban Institute in 1995 when she started a body of research on the roles of arts and culture in communities, artists' supports, and the integration of arts and culture in community revitalization and quality of life indicator systems. The series, which would ultimately be known as the Arts and Culture Indicator Project (ACIP, 1996–1998), demonstrates how arts and culture contributes to community vitality and how participation happens in multiple settings, many of them informal.[19] The study was originally commissioned by Alberta Arthurs of The Rockefeller Foundation and Joan Shigekawa, her deputy. Arthurs recalls that she received word that Urban Institute was undertaking a series of studies on community without taking arts and culture into consideration. Once ACIP was underway, Arthurs had been succeeded by Shigekawa, who has served variously as Deputy and Interim Chair for the National Endowment for the Arts since 2009. Jackson recalls Shigekawa remarking that the work would take at least two decades.[20] The herculean task proposed to unbind the arts and artists from their long held association with elite artists' practices by demonstrating the importance of the arts to culturally and ethnically specific communities.[21]

From the beginning, Jackson brought her distinct approach to the *Investing in Creativity* project. As with ACIP, her framework followed from the urban planning perspective "that in most instances the

circumstances of place have a lot to do with whether or not people can achieve what they want to achieve."[22] Reviewing the early literature on artists' supports, she considered it to be largely of a particular silo, one having to do almost exclusively with systems and cycles of support from the arts field without much consideration of artists' connection to place or their roles in communities.[23] The culture wars of the 1990s, she acknowledges, were not foremost on her register, but something she learned more about and accounted for among the elements informing artists' perceptions and conceits. *Investing in Creativity* mediates Jackson's approach with the cultural wars history known by its founders and funders. An introduction by Margaret Wilkerson and Alice Bernstein of the Ford Foundation refers to the "funding declines of the 1990s" as a site of crises and impetus for the study; however, the report begins by marking "geography—or place—as the critical context in which the various elements of support [for artists] interact."[24] The rhetorical shift from crisis to community, which would emerge out of a productive tension between research and advocacy, represents a disciplinary expansion. The same shift offered a new discursive foundation upon which new forms of policy could be imagined, argued, and put into practice.[25]

Working from complementary perspectives of arts policy/philanthropy and urban planning, both Sidford and Jackson shared a goal of thinking expansively, as well as a research to action ethos that would prove costly. Sidford describes the research process as "intensely deliberative." The means by which findings quickly morphed into action-oriented plans, goals, and initiatives shows that it was also activist. Sidford had assumed that the work could be done in one year's time at a cost of about $500,000. In the end, the project took three years and cost $3 million, as a result of adding several components to the original design. These included adding more sites for local research. Moreover, when the process of research uncovered programs that would not only help the study complete its goals but also create much-needed infrastructure, the research team allocated time, money, and expertise to that program's development. One year into the work of *Investing*, the researchers realized that there had never been a public opinion poll about the nation's attitudes toward artists.[26] Among its key findings was the fact that while people appreciate opportunities to consume art, they do not necessarily hold artists in high regard.[27] One can see both the ideas of validation and the need for arts-informed communities and networks emerging from this perspective.

Two other significant interventions took advantage of emerging technologies to make research for artists and about the artists more widely available. NYFA Source, the nation's database for artist opportunities, divided by geography, discipline, and award or service type, emerged from this paradigm. The database had begun as the Visual Arts Hotline, a project of the New York State Council on the Arts.[28] Sidford notes the database's efficacy had not been studied. Lacking resources, the Council had not interrogated its significance to the nation. Given that both the inventory of awards and resources available to artists and the artists' regard for them promised to support the study, the researchers allocated additional support and focus. Variously, though not completely, these initiatives addressed "Communities and Networks," "Information, Markets and Demands," "Material Supports," and even the knowledge undergirding "Training and Professional Development." The ability of any one initiative to reflect multiple forms of support demonstrates the researchers' hard-earned efforts in discerning distinct support modalities that could prove useful to artists.

A productive tension

The advocacy required to sustain the study and its greater effort of constructing a bases of support for artists also challenged the project team to carefully monitor the study's integrity. At the same time, they were tasked to keep funders and other stakeholders engaged to underwrite a growing project.[29] The negotiations represent the tensions at the heart of the socially invested policy. In his argument for what he calls "public entrepreneurship," a type of activist policy work reflecting his own argumentative turn, Peter Marris argues that "policy makers/studiers have to be good storytellers—storytelling is the language of persuasion."[30] Yet he also checks policymakers to make sure that they remain rigorous in their representation and "not mis-represent the facts."[31] The different demands required of Jackson and Sidford in their respective roles as storytellers to distinct audiences generated a productive tension that marked the process, but also contributed to the study's rigor. Moreover, the mediated approach set the stage for the study to perform what political scientist John Kingdon (1984) refers to as "policy entrepreneurship."[32] Policy entrepreneurs bring together "three separate streams—problems, policies and politics" at strategic moments, highlighting the critical issues at hand and offering solutions to effect change.[33] Through their careful balance of investigative inquiry and advocacy, Sidford and Jackson identified the issues of concern to artists and created an agenda for interventions.

The stakeholders negotiating across research and advocacy multiplied throughout the project. At the Urban Institute, the research team grew to include eight credited writers who conducted fieldwork or contributed expertise.[34] Sidford, who was also looking forward to an initiative that would create change, turned variously to colleague-advisors to read the findings emerging in piecemeal and rehearse scenarios of application. These people included Sam Miller, a colleague who succeeded Sidford as the Executive Director for the New England Foundation for the Arts some years before, and choreographer Liz Lerman. The group also included John Killacky, a filmmaker and arts presenter who had played a key role defending free expression during the 1990s when he was the Executive Director of the Walker Arts Center in Minneapolis and the Yerba Buena Center in San Francisco.[35] At that time, Roberta Uno became a Senior Program Officer in the Freedom of Expression division of the Ford Foundation and began working with the study.[36] Uno had come to Ford from the University of Massachusetts at Amherst, where she had created New WORLD Theatre (1979–2009), an esteemed institution that commissioned and supported theatre by artists marginalized by color, as well as class, gender, sexuality and aesthetic.[37] Uno shared with the other stakeholders a commitment to supporting and knowing more about artists across diverse cultural communities. These values would ultimately shape the programming at LINC.

The tensions first drawn between advocacy and research would only be compounded during the preliminary finding phases of *Investing in Creativity*. The researchers aspired to engage communities being studied in the process of knowledge production.[38] Through a series of rollout meetings, research teams returned to the communities to share preliminary findings with the subjects who had been interviewed and take feedback. Jackson observes that the rollout meetings had two functions: "to vet the findings and to take the temperature for what can happen here." The study's stakeholders were already concerned with identifying places where future initiatives might "find traction," teams of artists and arts organizers ready to apply the research.[39]

These focus group moments represent embodied and enacted negotiations, as well as the opportunity for subjects to reverse their positionality, from objects of study to activated subjects.[40] Given the unique proposition, the shift was something many artists did not readily comprehend. Jackson acknowledges that "[a]nytime you show an entity a picture of itself, there will be discussions and resistance." She recalls that upon hearing findings, subjects would regularly ask the researchers, "What are you going to do for us now?" The researchers took this moment to

turn the question around and to suggest the local stakeholders consider how the artists might design their future.[41] The researchers tasking the community to see its own role and potential in contributing to change. The focus group negotiations that situated artists and local arts organizers as active participants in policymaking exemplify a description of power that John Gaventa (2003) attributes to Foucault as

> diffuse rather than concentrated, embodied and enacted rather than possessed, discursive rather than purely coercive, and constituting agents rather than being deployed by them.[42]

Multiple strategy-making sessions happened among the various participants, revealing this Foucauldian power dynamic and pointing to the project's capacity to shape arts policy discourse that could embrace many communities.

Sidford observes that by the summer of 2002, she and the researchers had landed on the "six key themes or domains," which would inform the study's final design and eventually determine LINC's areas of focus and its own aspirations for artists.[43] From a research perspective, Jackson testifies that the findings came as a result of a long, deliberative process:

> We didn't start the study with a pre-baked theoretical framework. The framework grew out of the Urban Planning orientation with a focus on place and our initial exploratory work. We went in with some questions about place-enabling circumstances and limiting circumstances. In the end, the framework was the biggest finding of that study.[44]

The hard-won work would ultimately reflect in the comprehensiveness of the study.

Investing in Creativity contributes poetry, evocative language, and compelling passages to depict the challenges faced by artists, the sacrifices made, and the rewards not realized, despite artists' many contributions to public purpose:

> Artists have also helped us interpret our past, define the present, and imagine the future. In spite of these significant contributions, there's been an inadequate set of support structures to help artists, especially younger, more marginal or controversial ones, to realize their best work.[45]

These introductory comments are echoed several times in the first pages of *Investing in Creativity*. Their resonance with "The Arts and the Public Purpose" follows from a road not ready to be taken in 1997, when "the needs of the arts and artists" were put aside to advance a new form of advocacy. Even so the study frequently intersects with its archival predecessor. One rationale for the study portrays artists as "stereotyped as removed from everyday life and societal processes, [although] fundamental to our cultural heritage and critical to everyday life."[46] Another framing statement observes, "Comparatively, little attention has been paid to artist *per se*, either individually or collectively, as creators and presenters of work; to the diverse contributions they make to society; or to the mechanisms that support them and their work."[47]

Artists are presented historically, on social, public, affective, and even urgent terms. Using census data on artist employment, *Investing* notes that while artists' numbers are increasing, they are

> typically underpaid in relation to their education, skills, and societal contributions [....and] often under-recognized and undervalued by funders and policymakers both inside and outside the cultural sector, as well as by the media and the public at large.[48]

Responding to this gap in knowledge and echoing the tone of earlier documents, *Investing* articulates its focus as "the societal contributions of artists, the training that prepares them for diverse roles in a democratic society, and the sources of support on which they rely."[49] Embracing both need and contribution, the authors challenge the reader to determine his/her position with respect to the story, and to take up the study's charge to identify the modes that best support artists.[50]

Leveraging Investments in Creativity (LINC)

Given the concerns about the future of support for artists just a few years before, the study's capacity to sustain energy and cover growing costs during preliminary stages marks a significant buy-in of the greater cultural sector. This buy-in followed from *Investing*'s proposed contributions to policy's archive and its repertoire that cultivated invested subject leaders and philanthropic resources. Prior to the final publication of *Investing in Creativity*, Sidford had begun fundraising for the next iteration, which she imagined as a 10-year, $350-million "big concept" program called "Wellspring."[51] At the time, the Ford Foundation was then closing down a number of its major initiatives. These included

the New Directions/New Donors program, the Working Capital Fund, the Internationalizing the Performing Arts program, the Animating Democracy Program. Holly Sidford and Sam Miller forwarded their ideas on supporting new initiatives in targeted regions to Ford. Uno contributed her interest in promoting philanthropy's response to demographically diverse communities.[52]

In 2003, Uno, Sidford, and Miller proposed to the Ford Foundation "a 10-year campaign style to recognize and build on Ford's legacy work of distributing opportunities nationally." In deference to the declining popularity of building endowed organizations that did not support artists directly, they suggested an initiative that was "nimble, lightly staffed, and responsive." The program would "seed innovation by offering challenge grants to communities, particularly those that had been around the table at the study [as well as] underserved communities" that had not. Each community would identify which of the six domains on which it would focus its work.[53] Ultimately, Ford would contribute the first $10 million to the project.

LINC's interventions worked at all levels of operation, from its programming to its organizational model, staffing, and conventions. Through all of these aspects the organization developed arts leaders regionally and nationally. Starting with a small core and fanning out across communities, literally hundreds of individuals contributed to LINC's making; consequently, the presence of nearly 180 arts professionals, researchers, and philanthropists at the banquet was slight compared to all those who had engaged in making LINC's project possible. Yet the size of the central organization was small, compared to its reach, consisting of a staff of no more than six at any one time. The staff was supported by a series of more senior advisors, individuals who had worked on the project for three years prior to the organization's official creation. These included Sidford as credited founder, and Jackson. Through the small staff, the organization sought to leverage most of the work and resources out into the field and to activate leadership across the arts. As Uno notes, LINC's staff implemented a number of the significant interventions the organization proposed to make on behalf of the cultural sector. In light of LINC's commitment to raising new leaders and engaging the United States' diversity, a majority of the staff was Asian American, Latino, and African American. Many were trained as artists and still in their twenties and thirties. In 2008, LINC President Sam Miller, who had run the organization since its inception, ceded daily operations to Executive Director Judilee Reed. Reed, who is Asian-American, was in her in her early thirties at the time. Like Miller, she had come to LINC from the New England

Foundation for the Arts. Likewise, Risë Wilson, an African-American artist who had served as a research consultant to Uno and as a partner in the Artography program, served as LINC program head for its Diverse Artist Spaces program.[54] Nationally, LINC ran five overarching initiatives, often in partnership with other artists and artist-run organizations and funders across the United States. LINC's crossover among the programs and communities is a testament to its own hybrid origins as well as its commitment to empowering artists to become leaders.

"Original research"

LINC continued the model of aligning research with practice first imagined by Sidford and implemented during the *Investing in Creativity* study. Arguing that "lack of accurate knowledge permits outmoded systems of support to be sustained," LINC commissioned "nearly twenty original reports and publications."[55] The landmark study *Crossover* (2006) countered conventional wisdom about artists' work habits.[56] Other studies, such as *Artist Space Development: Making the Case* (2007) and *Natural Cultural Districts: A Three-City Study* (2012), demonstrated municipal benefits of artist space- and arts place-based strategies.[57] *Health Insurance for Artists* (2010) used data about artists' insurance coverage taken from another study, *Artists in the Economic Recession* (2010) and "measured the impact" of the Patient Protection and Affordable Care Act (2010) on artists' lives.[58] All of these studies were made freely available through the LINC website.[59] The presence and mix of research demonstrates the hybrid knowledge anticipated of artists as they navigate and produce works in the twenty-first-century marketplace.

"Place-based change" and "Artist health benefits"

The Creative Communities program developed new methods of artist empowerment in fourteen different communities nationwide. Reed considers LINC's greatest accomplishment to be its translation of the study's six domains into change-based programming.[60] Following LINC's close adherence to the study, these programs supported artist space development, training and professional development, health care, as well as information resources and networks, yet they also cultivated systems of validation. The original Creative Communities constituency drew directly form the research pool of *Investing in Creativity*. LINC also put out a request for proposals from additional communities, offering grants for communities to conduct planning with local artists and submit new requests for funds. The planning grants brought in Philadelphia, as well as Kansas City, Montana, South Carolina, and Native American

Artists of the Northern Great Plains.[61] A number of communities focused on artist training.[62] Still in existence, these programs combine venture creation, business training, and "habits of mind" as they task a community of learners to support each other's careers.[63] Addressing the issue of information, the Chicago Department of Cultural Affairs built Chicago Artists' Resource (CAR), an open-source website, where artists can pursue and share information about resources. CAR is a comprehensive site, arranged by discipline, but also by a calendar of opportunities and happenings, which allow for disciplinary crossover.[64] Other Creative Community partners focused variously on space. For example, ArtHome, in Brooklyn, combines place-based research on housing with an artist "homebuyer training program, matching grant savings programs, and peer lending programs" to help artists buy homes.[65] With support from LINC, the Massachusetts Cultural Council (MCC) conducted the research necessary to develop "83 artist space projects in 43 Massachusetts communities with a total of 645 units of live/work of studio space" for artists.[66] Springboard for the Arts—an artist support organization in Minneapolis—organized around the issue of artists' healthcare. Between 2007 and 2013, the organization helped 4,000 artists and family members access artist healthcare through a multifaceted program that offers emergency relief, support in the form of voucher, health fairs, and education.[67] Springboard's work in this capacity also responded to the second targeted program, "Artists Health Care." Working in advance of the Affordable Health Care Act, the Health Care Health Insurance for Artists initiative developed new methods of support, cultivated new resources, and promoted legislation, largely through a partnership with The Actor's Fund.[68] All of these programs, which borrowed from and contributed to original research, provided the means for artists to become coproducers of opportunity in communities and more rooted and rewarded for their efforts.

"Targeted awards" and "Space development"

Under the rubric of "Targeted Awards" and "Space Development," LINC addressed the nation's diversity and intervened on past models of funding that prioritized elite arts organizations. Working with the Ford Foundation, LINC supported "Artography: Artists in a Changing America," a grant program that focused on demographically diverse institutions and artist companies to counter the historical lack of diversity in funding, which is referred to as an issue of "cultural equity," or inclusion.[69] Drawing from early research on the benefits of artist spaces and the sources that support them, LINC also initiated an Artist-Space

for Change program to generate more artist live-work spaces and artist centers nationwide. Miller credits Reed with broadening "artist specific real estate strategies to emphasize culturally-driven community space development," an approach that created "artist-inclusive spaces that are artist-led but not arts specific."[70] Arguing that artist spaces contribute to "community development, cultural equity, transmission of cultural heritage, and the integral role of artists and arts organizations in the life of every community," LINC instituted two programs: "The MetLife Innovative Space Awards and the Ford Foundation Space for Change Planning and Pre-Development Grants."[71] All of the programs integrate artists and arts organizers into the process. These programs relied on "the commission of relevant research, facilitation of peer learning, and rigorous technical assistance."[72]

As a result of the shared commitment to both programs, several Artography grantees also benefited from the Space Change program. One example, Los Cenzontles of San Pablo, California, an artist-run organization and band created by musician Eugene Rodriguez, built its center, developed its media programs and its distribution networks, and deepened its relations with the local community with the help of the Space for Change program. The Los Cenzontles academy trains musicians who have trained in traditional, regional genres of Mexican music (jarocho, banda, boleros, son, and rancheros) as well as country and western music and rock and roll. In its nominal, leadership role, the band Los Cenzontles serves as artist-producer model and engine to the greater organization and in so doing performs the purpose of its space.[73] The Pa'I Foundation, also an Artography and Space for Change grantee, supports traditional Hawai'ian hula dance through a training program and professional company. Its space contributes to the local artist community. Prior to LINC support, the city of Honolulu had only favored traditional Western high arts like the ballet and symphony, ignoring traditional arts, isolating the company from artist peers. LINC's support, which flowed through a core group of artists, including founder Vicky Holt Takamine and her son Jeffrey Takamine and a group of dancers, models how artists can juggle artist and producer roles and catalyze cultural change and development.[74] Another Artography grantee, Urban Word in Manhattan, supports young artists developing their skills in the "changing poetics of spoken word and hip-hop" and uses them to support the students' transition to higher education, modeling how art making can produce opportunities not only for artists, but emerging scholars and professionals as well.[75] In 2009, under the Space for Change program, the International Sonoran Desert Alliance, which

was established by the Tohono O'odham Nation in 1993, rehabilitated the historic, abandoned Curley School in Ajo, Arizona. The site now provides "affordable live/work spaces for 30 artists, artisans, and creative home businesses." The center has also "brought new investment into the area" and helped raise property values, creating connections between the artists' contributions to local culture, social engagement, and economic well-being.[76] Reed notes that when LINC began, "the independent artist was seen as an outlier." Rather than building a new infrastructure, LINC chose to "encourage and support existing infrastructure to become more supportive and make relevant place-based resources" for artists by making artists "part of the resource strategy."[77] Variously, all of these programs put artist-led programs at the center of cultural change. All of these efforts were on display, either in video or published form, at the LINC Capstone event at the Ford Foundation in May of 2013.

"Valuing Artists, Seeding Innovation"

"Valuing Artists, Seeding Innovation" included elaborately produced videos that demonstrated the breadth of the organization's accomplishments. Moreover, the final message was that this event was a send-off, a chance to demonstrate to others that LINC had harnessed power for the arts and cultural sector and used it well to effect change. Sitting next to me at the luncheon, one artist, whose LINC-funded project had set forth a new paradigm for artist training, commented on the presumed cost of the luncheon, noting that the same amount of money might have supported more than one artist for a whole year. As the comment attests, the economic power so easily on display that day also signals a set of capital-informed tensions that still mark arts philanthropy and policy development. Those in the room represented largely the philanthropoids and organizers, the individuals who are paid salaries to do work on behalf of artists who struggle to make ends meet.[78] Given that many artists still struggle—a fact to which LINC's research attests[79]— these tensions rise up, not in spite of all the good work that has been done by organizations like LINC, but because of them.

As dessert was being served, a panel of speakers ascended to the dais for the first session, "A Decade of Innovation and Achievements." The panel included Maria Rosario Jackson, who has since left the Urban Institute to become a Senior Advisor to the Kresge Foundation and to pursue other projects, as well as Ford Senior Program Officer Roberta Uno. The panel also included Artist Council member Theaster Gates, who has developed

several artist-run spaces in Chicago, and John Killacky, who served as the Program Officer for the San Francisco Foundation, which contributed to the LINC's Creative Communities program.[80] The nature of the panel's structure and the comments reflected the spirit of LINC; they were variously positive and affirming, self-reflexive and critical, moving from an accounting of what had changed, what had not, and what remained to be done. Beginning with the question of what had changed, Sidford offered that the last ten years had ushered in more conversations about artists. John Killacky noted that artists were actually participating in those conversations after being marginalized by the culture wars rhetoric. Citing Esther Robinson, the founder of ArtHome, he said that LINC had forged "trust capital" between policy and artists. Maria Rosario Jackson said that she considered artists to be leaders throughout "the diaspora of LINC" and that LINC had contributed "a catalytic piece of a paradigm shift." Theaster Gates added that the initiative's approach allowed the interventions to be specific to a place. Observing that "it's faulty to presume you fund an organization and it will trickle down," Roberta Uno asserted that LINC had intervened on an older arts policy paradigm. In effect, the panelists demonstrated that LINC had created a social space through which regional artists became more activated as local leaders and national partners.

When Sidford then asked the panel to respond to the work that remains to be done, the panelists demonstrated that they had been thinking deeply about entrenched social, racial, and class-based positions in the arts. Jackson returned to the original survey of attitudes toward artists to say that "people value works of art, but not artist as workers." She noted that attitudes had changed, but she was also concerned with LINC's legacy, "Who's going to mind the national picture?" she asked. Killacky followed that race in philanthropy is still a significant issue. Citing Sidford's study, *Fusing Arts, Culture, and Social Change* (2011), he noted that "organizations led by people of color get only 7% of grants and 14% of philanthropic dollars."[81] His question of how grantmaking could more effectively take on questions of cultural equity was echoed by Uno, who characterized this struggle as the challenge of adding "the cultural equity and structural racism lens" cultural organizing and to philanthropy. In all of their responses, the panelists pushed for LINC's social change efforts to be at the forefront of future policy development.

In keeping with both the celebratory nature of the day and the spirit of her work on both the study and the report, Sidford asked the panel to finish by saying, "what LINC made possible?" Gates stayed specific to his own practice, noting that as an artist, LINC "allowed me to translate big

ideas into an actualized mode that was about place." Killacky observed some of the accomplishments in research, training and professional development, and funding for artists made through a partnership between the San Francisco Foundation and the East Bay Foundation. Nodding to the fact that much artist support still flows through inter-mediary organizations, he also cautioned, "LINC changed the funding, not the paradigm." Taking up Killacky's claim, Jackson added that LINC had activated a national arts network, which was "necessary to feed the paradigm shift," indicating that the process is ongoing. Roberta Uno pointed to ways LINC's work had organized new methods for proposing artist support. Echoing a claim that Sam Miller makes to explain how LINC's time-datedness forced it to stay relevant to research, Uno noted that "LINC shifted [the] temporality of support." Gesturing to LINC's practice of offering long-term, multi-layered interventions and taking up Killacky's concern, she added that LINC had shown, "the flexibility, the nimbleness, and the commitment of not pouring money into the infrastructure, but putting it out into the field."[82] LINC's time-datedness had undoubtedly offered an imperative for those who worked with it to plan for a future without the organization—to forge partnerships and modes of sustainability at the local level; but LINC's disappearance had also opened up the question of "what next?"[83]

Reflections

Implicit in the title "Valuing Artists, Seeding Innonvation" was the question: if LINC had valued artists and seeded innovation, what was needed for those seeds to take root and grow? A year after LINC's closing, those who were there at its founding have reflected on the changes enabled by the initiative, as well as the gaps left in its absence. From the standpoint of public policy, Jackson recognizes that "LINC ended up becoming an important source of leadership. It [also established] a networking func-tion, the ability for people to have a national perspective and still have local grit and traction." Following up on her comments about "the national picture," she recalls Lori Pourier, Director of the First People's Fund, acknowledging at the capstone event that LINC enabled the Native artist organization to be part of a "national [US] conversation" for the first time. Jackson asserts that LINC's practices moved the cultural sector beyond a granting approach, but still believes that the work of "creating an environment . . . that's more hospitable for artists to do their work" remains to be done.[84] In other words, LINC's cross-disciplinary maneu-vers and empowering programs were enabled by its efficacy in policy

entrepreneurship—identifying problems, developing policies that insti-
tuted new modes of artist support and practice, and demonstrating how
those changes were critical to cultural democracy. Continuing that work
will require a new policy entrepreneur approach, one that effectively
argues that the work is still ongoing.[85]

As a Program Director at the Surdna Foundation, Reed concurs that
the work of creating a hospitable and rewarding environment for artists
remains to be done and points to a "window of opportunity" through
her thoughts on the work of artists:

> Within philanthropy, there's also a continual push around how we
> define artists.... [We have] an expectation that artists are going to
> be the problem solvers, working across sectors in innovative and
> intervening ways, or arts and culture is going to be the glue that
> binds together community development, social change, and gener-
> ates community cohesion. We put a lot of pressure on artists, and
> they continually rise to the challenge, and they [still] make very
> little.[86]

Reed positions artists still in struggle between capacity and compensation.
She believes that artists "reveal the human narrative" and demonstrate
"problem solving" capacities desired by Fortune 500 companies. Taking
up a theme in Jackson's response, she says that artists "must keep a place
at the table" as "long-term partners" to policy and philanthropy.[87]

Following up on the impulses that informed Ford's support for LINC,
Uno sees LINC's legacy in Ford's development of United States Artists, an
annual major awards program that responded to the void left by the elim-
ination of the National Endowment for the Arts individual artist awards
following the 90's culture wars.[88] United States Artists has made signifi-
cant inroads in galvanizing donors from across the cultural and non-arts
sectors. Also, LINC's focus on multi-local tables of support and its address
of cross-sector issues, such as health care and artist-driven space develop-
ment, served as a precursor to and ran parallel to other developments in
the field. Foremost among them is the growth of creative placemaking,
which finds its purpose in LINC's place-based approach. Uno has served
on the design teams for LINC, United States Artists, as well as ArtPlace
America, a ten-year placemaking initiative launched in 2010. ArtPlace
America is the unprecedented collaborative of national and regional
public, private, non-arts philanthropies, the NEA, six Federal agencies,
including Housing and Urban Development (HUD), the United States
Department of Agriculture, and the Department of Transportation, and

a half dozen banks. Moreover, LINC's successes helped galvanize her work in the Ford Foundation's Freedom of Expression area to support those culturally and ethnically specific organizations committed to social justice that have been marginalized by philanthropy, including the First People's Fund, Alternate ROOTS, and the National Association of Latino Arts and Culture. She speaks with pride about Ford's work with Youth Speaks, an organization that provides training and engagement in spoken word performance to support youth empowerment.[89] In this capacity, LINC fulfilled many of its original objectives.

As a member of the Artist Council, I was afforded the chance to travel to distinct communities where LINC initiatives took place. Between 2009 and 2011, I observed firsthand how multiple training programs combined their institutional discourses and pedagogical repertoires to mediate entrepreneurship with place-based concerns. These programs include The Artist as Entrepreneur Institute in Cleveland and northeast Ohio, Artists U in Philadelphia, PA, Artist, Inc. in Kansas City, MO, and the EDGE Professional Development Program in Seattle and Washington State. Additionally, in 2011 Grisha Coleman and I conducted interviews with groups of artists in Chicago, Los Angeles, and Rapid City, SD, where we met with Native artists from the Northwest to Maine to support some of the final studies that were being written. In 2012, I spoke with Artography grantees about their experiences. All of these observations contributed to LINC's research but also my thinking, and I speak about them now to acknowledge the reflections from the standpoint of an artist. In all of these meetings, I, as well as Grisha, encountered artists who were passionate about their work and excited that their local prospects had been expanded by targeted programming focused on artistic practice and sustainability. The training programs that were held over long periods of time and relied on dense mentorship networks availed artists of the validations and competency challenges to continue working. At the same time, these programs often encouraged, and in some cases required, artists to serve as mentors to each other, effectively deepening peer relations. Those artists most enthused by LINC-supported work were those who could easily recognize their partnership role to the local policy community and/or the national organization, either through the vested roles they had assumed as mentors and colleagues, or as part of a cohort of local grantees. Those who accessed the national organization through their role as grantees consistently testified to the benefits of their meetings with LINC-supported artists from across regions. The leadership Jackson calls for, the artist recognition still asked for by Reed, and the place-based supports shared by Uno speak profoundly to

policy's repertoire, which is rooted in such dense, nurtured relations. The story of LINC and its origins offer artists a case study for how artists as policy entrepreneurs might supplement and continue LINC's work by being alert to place-specific challenges, articulating the need for policies to support the local cultural community, and organizing for political action in partnerships with other policy professionals.

7
Proposing Place: Creative Placemaking (2010–Present)

Scenarios of opposition and hope

The concept of "creative placemaking" holds a significant position at this moment in contemporary artistic practice and policy in the United States. In the introduction, I mark the transition from the older policy approach to the newer one as a shift of focus from spaces to places. Policy's focus on organization building during the Ford era directly contributed to an overburdened nonprofit infrastructure.[1] The four-decade dominance of the paradigm obscured a complete understanding of the arts' economic sectors—commercial, nonprofit, and community—and veiled the terms of artistic participation. Art happened in the "art palaces," the theatres, museums, concert halls, or in alternative spaces and galleries. Their funding was understood to flow through philanthropy or commerce, but not some mix of the two. The informal, or community sector—the local craft fairs, buskers, informal jam sessions, and church-based gospel singing—was not fully recognized as part of the nation's cultural accomplishments. In keeping with the progress of contemporary policy development, creative placemaking is understood by its originator, the National Endowment for the Arts (NEA), as an operation in which "partners from the public, private, nonprofit, and community sectors shape the physical and social character of a neighborhood, town, city, or region around arts and cultural activities."[2] In this equation, artists working across all sectors are poised to play a critical role shaping the life of communities. Placemaking performs a discursive leap from space and lands on a platform constructed from a hybrid disciplinary material: urban policy, economic development, artistic practice, and cultural expression among them.[3] In so doing, placemaking takes up the question of diversity long deferred by the arts' past focus on funding elite institutions at the expense

of economically and culturally varied populations. Taking up urban poli-cy's claim that "diversity happens at the borders of racially and ethnically homogenous communities,"[4] placemaking proposes to highlight the heterogeneous potentiality of place-based cultural and artistic practices.[5]

Under this new paradigm, the materials for the arts and cultural policy table have been shipped out to regions nationwide, where the local arts and cultural policy sector will presumably assemble them according to the specific needs of the hosting municipality. Maria Rosario Jackson (2012) eloquently touches on this metaphor when she writes:

> The places in which people make culture might be thought of as cultural kitchens, where people sort out tough issues and create the identities and forms of representation that they share with each other and offer the rest of the world.[6]

The kitchens scenario depicts people gathered around a table, or counter, bringing the experiences of the outside world into an intimate moment of focus, deliberation, and even celebration. For artists as artist-producers, then, what I present as a contemporary place-based perspective shapes the hosting role they are poised to play both animating and negoti-ating the particular experiences of a people, a tradition, or a history, and contributing to cultural vitality and equity in cultural expression.[7]

Through targeted programming and policy analysis, placemaking's agents have sought to make the term palatable to a new generation of artists who may choose not to move to a cultural hub to pursue their careers. The requirement of some agencies like the NEA that public-private partnerships be at the center of placemaking has availed both neoliberal critiques and critical interventions. I am concerned with the translation of terminology and its application to artists' lives, in light of some resistances I have witnessed. From a policy perspective, histori-cizing placemaking offers greater perspective on its usage and potential; however, fully understanding the concept, its potential impact, even why it receives resistance requires a more theoretical investigation into the concept of place, as well as some illustrative examples. My impulses in this chapter are inspired by three different experiences with presenta-tions dedicated to place and the question of the arts, in which the trans-lation of space to place was neither evident nor readily accepted.

December 2013: a meeting of visual and performing artists and arts presenters from across the country. A panel on creative placemaking that features three excellent thinkers on the subject ends, as panels often do, with questions from the audience. The speakers have offered provoca-tive insights on creating placemaking opportunities across culturally

specific and marginalized communities. One has even argued eloquently that "claiming one's place" is a political act, requiring arts organizers and artists to recognize histories of cultural and/or racial oppression. The first responses to the talks offer affirmations and ask for clarifications about the presentations or comments on starting programs. The place-making examples begin to multiply. At one point one artist shares frustration at not finding placemaking opportunities as accessible or legible in her home community. "I made a lot of sacrifices to do this work," she says, "but I can't make a living here." The comment coming from that artist surprises me—just before the session, she had told me that she was leaving her mid-size city in the South to take a position with a prestigious community-based theatre company in Los Angeles. I thought her happy, but clearly, her decision was marked by ambivalence. The artist was echoing a finding I later read in a cultural indicator report, "Houston is a great city to get started, or to be at the top, but without any clear path from the bottom to the top, people will move on."[8]

On a similar note, two other events take a resistant turn during the talkbacks. In September 2013, at a university symposium focused on the intersections of arts and culture, economic development, and technology industries in economically vital cities features insights of policy analysts, mayors, academics, and one arts presenter who has managed to create a major biannual event by aggregating a tour of arts studio spaces. The questions again begin with a few clarifications and comments, and then a theatre artist challenges the panel to explain how all of these efforts might translate into a space for her company. The city official sitting next to me who has worked on this issue acknowledges the question is important, but the tentativeness of the city's current proposals prohibits her from offering insights. Instead, she plans to come to solutions by pulling together a focus group to study the subject. Some months later at an arts summit in April 2104, an expert on the subject of creative placemaking ends a presentation filled with illustrative examples of how artists are producing opportunities in communities nationwide. The presentation goes from more formal examples of placemaking to leadership positions that artists are now playing in local governments or industries, as a result of their placemaking initiatives. The first question asked of the expert challenges the concept of placemaking: "Why are we having to make places now? We made our places. Isn't the term just another way of branding arts support?"

With respect to all three of these moments, the questions posed by artists and community members follow from multiple forces, first and foremost from the semantic and disciplinary gaps in understanding. The meetings have also succumbed to the resistances that commonly occur in arts organizing when the wind-up to the event has not included strong constituency

building through preparation and a proposed method of follow-up engagement.[9] Perhaps the questions point to the need for a common understanding of terms. The defensiveness in the assertion that "we have made our places," that one has "a company," or that one has "paid [my] dues" all represent a bulwark of validation, a sense that the speaker cannot understand artists' hard work and investments, and the endless struggle to get work recognized. These positional articulations easily address specific formations of power and privileges attending specific discourses, roles, and titles. Surely the urban planner, the scholar makes more money than the local individual artist? Perhaps the comments easily represent a long-brewing distrust aimed at the business sector, at public policy, even at arts policy and philanthropy for not having done enough to support, honor, and recognize artists' contributions in specific communities. Such a suspicion elides the work that has been done, but also illustrates points made by both LINC and Creative Capital—one organization or initiative can only do so much. There are likely even concerns that the rubric of placemaking is a conspiratorial strategy of philanthropy, closing off revenue streams that have been years in the making and signaling, once again, that philanthropies have a short attention span.[10] As even the authors of the NEA's original white paper, "Creative Placemaking (2010)," note, "countering community skepticism" is a challenge facing the work.[11]

Artists have often been portrayed as oppositional in spirit, to the market, conventions and norms, and/or politics; these oppositions have been on ethical grounds, but also in the spirit of play and exploration.[12] My experiences of the culture wars of the 1990s in San Antonio brought an oppositional tenor to my artistic practice borne from a sense that the artists' centers I accessed were under siege. A number of publications since that period have taken on the theme of opposition as a signal of liberty and a measure of cultural democracy.[13] However, almost all of the initiatives since the culture wars of the 1990s have sought to knit artists' work into the fabric of community, to support potential oppositionality in artistic expression, and/or use it for programmatic critique, while still building new modes of access and reward for artists.

All of the chapters in this book so far have also explored various iterations of *place* as it relates to the role anticipated of artists as producers. In the previous chapter, I demonstrate LINC's merging of geographical places with specific domains of support as outlined in the report *Investing in Creativity* to show how artists play agentive roles in community. My own efforts in higher education find me attempting to place the prospect and costs of practice into the study of performance literatures and languages, embodied and not. The Creative Capital Foundation works to locate and support the nation's most avant-garde artists and

to advance them in the nation's public profile. The place-based organizing of the Austin New Works Theatre Community demonstrates how artists operate in relation to the city and the work that binds them, even attenuating the challenges that might pit them against each other, such as the need for adequate rehearsal and production spaces. All of these approaches flow back to the idea of "public purpose" and the role of the artist in society as discussed in the first chapter, an idea that finds traction in contemporary policy efforts dedicated to place.

Scenarios of a federal policy

The concept of creative placemaking represents the culmination of policy efforts begun in the mid-1990s, as well as a return of the NEA to its central role in setting the nation's arts policy agenda. According to economist and urban planner Ann Markusen, she was contacted by NEA Chair Rocco Landesman and Senior Deputy Chair Joan Shigekawa in 2009 to conduct a study linking arts and cultural participation with community development. By that point, Markusen notes, Shigekawa had already coined the term "Creative Placemaking" for the study and program to capture the ways that the arts and artists were already contributing to the vitality of cities and towns, making them unique places to live.[14] The concept of creative placemaking resonates with ideas and themes first advanced in the "Soul of the Community" (2008), a three-year study initiated by the the John S. and James L. Knight Foundation, in partnership with Gallup. "Knight Soul of the Community" measured how "attachment"— a notion used to capture how individual's favorably perceive their sense of belonging to community of people and place—supports economic growth. Key among the measures of attachment, along with economic opportunities, good education, and strong leadership, is "aesthetics," the notion that beauty contributes to happiness and quality of life.[15]

The partnership of Landesman and Shigekawa stands as a significantly abundant period in arts organizing at the federal level, and certainly the one that revolutionized the practices of the NEA. Much of this abundance appears to follow from the unique combination of Landesman's and Shigekawa's distinct perspectives. As chair and vice-chair, Landesman and Shigekawa came to the NEA as two arts insiders from different market sectors, the combination of which appears in placemaking. Before becoming the tenth chair of the NEA, Landesman was known as a commercial theatrical producer, whose credits include the Pulitzer Prize-winning play *Angels in America* and the musicals *Big River* and *The Producers*.[16] Landesman was a productive outsider to bureaucratic arts policy, and he used that outsider status as a benefit. Regarded by reporters as unusually

brash and irreverent for a political appointee, within a few months of his confirmation as chair, Landesman spoke candidly about the NEA's meager funding and observed that his predecessors had toed the bureaucratic line in ways that did not challenge an older granting model.[17] Under his chairmanship, the NEA expanded its repertoire, becoming as much of a think tank as a funding agency. Landsman's own repertoire was something of a champion and provocateur. In his first year and throughout his term, Landesman canvassed the nation, with his "Art Works Tour," bringing attention to the cultural vitality of large cities, as well as mid-size and small municipalities.[18] Shigekawa came to the NEA after serving as Associate Director for Foundation Initiatives at the Rockefeller Foundation, as well as the Nathan Cummings Foundation; her work had been primarily in the nonprofit sector.[19] In her tenure at Rockefeller, she had commissioned the Arts and Community Indicator Project (ACIP) studies on communities and followed through on their delivery, which examined the role that artists play in cultural communities.[20] These experiences would come together through a merger with creative city concepts.

The term "creative city" was first introduced in Germany and Britain to describe how creative and cultural forces contribute to economic vitality.[21] In the United States, the idea of creative city was both popularized and embodied by Richard Florida's (2002) notion of a "creative class." Building upon Karl Marx's economically deterministic notion of class, Florida defines the creative class as "a cluster of people who have common interests and tend to think feel and behave similarly."[22] In Florida's original proposal, the creative class represents the clustering of a disparate group—computer programmers, economists, and artists, among them—whose practices require creative thought and action that spills over into tastes for after-hours opportunities, like concerts and museum going.[23] Creative class workers structure their work in what Florida calls "horizontal labor markets," where individuals are presumably less concerned with "climbing the corporate ladder" than fully exploring and identifying by a primary occupation and bearing responsibility in cultivating its fulfilling role in their lives.[24] At the crux of Florida's original work was the presumed reciprocal relationship between cultural opportunities and creative industries, each attracting and enriching the other. Many cities used Florida's ideas to build up their cultural infrastructures. Challenges to Florida's original book and his follow-up work, *Cities and the Creative Class* (2005), have been many. Critics have pushed against his conflation of education levels, income, and class, as well as his selective use of census data, such as same-sex households rather than race, to mark diversity.[25] Others have noted that Florida's findings cherry-pick positive detail and ignore "alternative explanations" as well as direct challenges to his data.[26] Even more recently,

Florida (2013) has acknowledged that creative class clustering is limited to a few cities and that the presence of a creative class has done little to trickle down to economically diverse constituencies.[27] In other words, while artists might contribute to the soul and greater vitality of a community, the equation cannot be presumed to work in reverse.

Despite the missteps and flaws, Florida's idea of tethering economic development in cities to a bloc of individuals that includes artists has challenged many arts advocates to expand critical thinking connecting cultural practices to vitality and the roles that artists play in both. Writing with Harold L. Vogel, Joni Maya Cherbo and Margaret Jane Wyszomirski (2008) depict "the arts and creative sector" as a "national infrastructure" that embraces public and private sectors, contemporary network technologies, and the laws governing and protecting cultural goods and artifacts.[28] The arts and creative sector model they propose recognizes the role the arts and artists play in creating culturally rich and distinct communities, but also the ways that artists use spaces to produce rewards. As policy scholar Caron Atlas (2013) notes, these interventions may also include "protecting the value of what is in danger of being lost (such as public ownership of airwaves or traditional cultures) and about engaging new opportunities (such as place-based cultural economies or rebuilding after [a hurricane])."[29] In *Building Community: Making a Space for Art* (2011), Jackson expands on the roles that artists play in these dynamics as "co-creators [of art], organizers, advocates, social critics or provocateurs, community leaders, educators, and contributors to various kinds of experimentation, among other roles."[30] Such notions resonate with the concept of an artist as a producer of opportunity, and a contributor to public value. In *The Rise of the Creative Class*, Florida coins the term "the big morph" to refer to "a hybridization of the Protestant work ethic and the Bohemian ethic brought on by the collision of corporatism and technology's demand for creative inputs."[31] I would add that arts policy setting and arts organizing have also made a similar claim, perhaps even adding an ethos of civic engagement and/or intervention by tasking artists to function as coproducers in the nation's cultural agenda. The question begged by all of these notions is how and when do artists lay claim to social, cultural, and economic rewards for their work, a question the NEA has taken up in multiple ways.

From a standpoint of federal policy, Landesman and Shigekawa enacted the biggest morphing of the NEA since its founding, and these revisions to its practices reimagined the agency's idea of what artists can do and where they produce work. Following upon the arrival of Landesman and Shigekawa in 2009, the NEA argued that the arts have a role to play in every aspect of society, and across many places. The significance of this assertion can be found in the NEA's partnerships with 20 or more cabinet-

level departments, as well as federal and state agencies. For example, in partnership with the Department of Health and Human Service, the National Institutes of Health, the National Science Foundation, and the US Department of Education, among others, the NEA created the "Federal Interagency Task Force on the Arts and Human Development" to support research on promoting the instrumental values that the arts bring to health and education.[32] Since 2010, the NEA has partnered with the Department of Defense to support Blue Star Museums, "a program that supports free museum admission to active duty military personnel and families from Memorial Day to Labor Day"; the two entities also partner on the NEA/Walter Reed Healing Arts Partnership (2011–present) "to support creative arts therapies for service members and their families."[33] The NEA partners with the Citizens Institute on Rural Design and the Mayor's Institute on City Design to support community and regional development, as well as, research, and training opportunities.[34] All of these partnerships demonstrate an agency that seeks to reach multiple places by expanding its own repertoire and network of relationships, moving past an older practice of funding places through direct allocations to state arts agencies. It is in this spirit that creative placemaking was first created.

Space and place

Much like arts entrepreneurship, the concept of creative placemaking offers an unstable signifier from which vested parties are still working out terms of agreement. Theoretically framing "space" and "place" can provide a foundation for those efforts to begin. From the standpoint of arts policy, the focus on "place" in placemaking represents a hybrid formation, bridging a past policy focus on building a network of artist organizations, or "spaces," with a broader emphasis on culturally rich and diverse communities, or places.[35] Cultural theorist Michel de Certeau refers to spaces as "practiced places."[36] For theatre artists, opera singers, dancers, installation artists, even recording musicians, the easily legible spaces are the theatre, the rehearsal room or studio, and the gallery that hosts repetitive practices. Spaces can draw artists and eventually the public into a tight circle: the darkened theatre that reanimates when the lights come up. However, de Certeau's elaboration on spaces as "the intersection of mobile elements" opens spaces up to creative placemaking.[37] Spaces can exist on a traffic bridge in Pittsburgh that has been "yarn bombed," its suspension systems playfully adorned by community knitters.[38] Spaces are also designated through performances that take place on the streets of San Jose, CA, reanimating downtown

at night.[39] Places, by contrast, represent "the order (of whatever kind) in accord with which elements are distributed in relationships of coexistence."[40] Their vectors travel in multiple directions, traversing across distinct neighborhoods and towns, but also connecting them in the process. For artists as producers, placemaking points to the disciplinary distances and occupational locations such projects travel in "partnership" building, acquiring "financing," and "clearing regulatory hurdles."[41] Given the practices and partnerships required of artists, placemaking tacitly calls for new forms of organizational rehearsal running concurrent with artistic production processes.

Broadly, creative placemaking cultural projects are proposed as lateralized partnerships forged across market sectors. Focusing on both intrinsic values and instrumental ones, these projects speak to the concerns of public policy, most legibly housing, urban growth, stability and vitality, and even health, wellness, and lifelong learning of people.[42] These projects follow from the shared investments of public/private partnerships focused on development, as well as nonprofit cultural organizations and artists, who make up "the third leg of the cultural stool."[43] The NEA's Our Town, a grant program introduced in 2011, applies an urban policy ethos to an artistic practice. Our Town focuses on the "livability of communities" and rewards arts-centered projects that "transform sites into lively, beautiful sustainable places."[44] The grants require that all projects be represented by triadic partnerships formed by participants from the public sector, the private sector, and an artist, who must maintain the public–private partnership ethos. As of 2013, Our Town has offered grants in all 50 states, distributing more than $60 million in capital, for 190 projects.[45]

In 2010 the NEA helped establish ArtPlace America, a national, ten-year initiative to amplify creative placemaking efforts to bring additional public and private resources alongside the Our Town program. The adoption of the ancillary program offered a means by which the private sector might scale and maintain the work for the long run.[46] In its first four years, ArtPlace America has, as of 2014, distributed $42.1 million to 134 projects in 80 distinct communities.[47] Its grants range from $50,000 to $500,0000; the organization's funders represent a mix of private and public philanthropies, federal agencies, and financial institutions.[48] ArtPlace America frames its work as seed funding for

> entrepreneurial projects that lead through the arts, ... enjoy strong local buy-in, integrate with a community's economic development and community revitalization strategies, and have the potential to attract additional private and public support of the community.[49]

The program specifically requires that "art, art making, or artists [be] at the heart of the mix" and that it reflect the "distinctiveness of its place" and represent "diversity."[50] Artists participating as placemaking partners and producers are positioned to operate as "subject[s] of will and power," performing what de Certeau calls "strategies."[51] Even though these placemaking efforts occur in the context of a grant program, the leadership position asked of artists turns away from the "tactics" practiced downspout of hierarchically shaped policy operations, challenging artists to form relations with all those who stand to benefit from placemaking operations.

What I have labeled as a transition from space to place has not been worked out as a binary exchange, but a dialectic. As Our Town and ArtPlace America program guidelines make clear, arts spaces and nonprofit organizations are still very much a critical element of a contemporary place-focused policy as part of the aggregate picture. In a report that has been foundational to placemaking and "creative city" advocates, Maria Rosario Jackson and Forence Kabwasa Green (2007) present artist space development as

> an important issue for people concerned with a range of social issues, including economic development, civic engagement, community collective action, and community quality of life.[52]

The focus on "place" ties the outcomes of the local arts and cultural sector to neighborhoods, businesses and city, state, and federal government that will participate in, contribute to, or benefit from culturally invested spaces. In this manner, placemakers are presumably tasked to reflect, engage, and respond to the diverse communities their works engage.

As a result of placemaking's highlight on specific towns, regions, as well as policy's own history in prioritizing relatively nondiverse high arts enclaves, the rubric has raised eloquent statements on behalf of diverse communities. In *People, Land, Art, Culture, and Engagement: Taking Stock of the PLACE Initiative* (2014), Roberto Bedoya, who is now the Executive Director of the Tucson Pima Arts Council, uses the issue of "belonging" to challenge contemporary arts policy focused on place:

> Creative placemaking is much more than what manifests physically within the built environment. Before you have places of belonging, you must feel you belong—to a community, a locale, or a place.[53]

Tucson's largely nonwhite population and its historical home to two Native American tribes, The Tohono O'odham and the Pasqua Yaqui Nations, bear a legacy of oppression and "dis-belonging."[54] The Tucson

Pima Arts Council's own placemaking program, PLACE, focuses on part-nerships between artists and communities. Together, the stakeholders pursue artistic projects that "engage personal memories, cultural histories, imagination, and feeling to enliven a sense of 'belonging with the participants and audiences they reach."[55] Projects such as "Finding Voice," an after-school writing and photography class themed on "community issues" for high school students with "limited English proficiency," focused on "individual and collective partnership."[56] "Liberation Lyrics," a youth poetry slam, demonstrated "civic engagement."[57] With a "stewardship of place" objective, a choreography project by NEW ARTiculations Dance Theatre called "FLOW" researched and performed longstanding issues facing the Tucson's desert watershed. "Troubling the Line," a symposium of gender queer and transgender poets by the Casa Libre en la Solana, supported the "cultural self-determination" of its artists.[58] Under the rubric of "bridging difference," "CAST Encore!," the Clean and Sober Theatre (CAST), worked with homeless youth to create performances that told their stories to the city's residents. Other Tucson placemaking projects have focused on aesthetic accomplishment and "community health and well-being."[59] For the 53 projects funded between 2010 and 2013, Tucson has measured success according to each project's ability to foster a sense of belonging among its participants and witnesses.[60] Bedoya's portrayal of PLACE points to the program's focus on the specifics of location, tradition, and history as much as enterprise. PLACE also demonstrates artists playing a leadership role in marking and contributing to the community members' sense of attachment.

On the surface the PLACE process may seem like just another short-term grant initiative to the artist who does not see that placemaking's focus on the partnerships availed through practice offers a means by which artists might continue to build networks and resources. However, Bedoya maintains that the program began a process of building relationships among artists and communities and between the Tucson Pima Arts Council and artists as they met throughout the process to strategize on long-term goals.[61] At the same time, political maneuvers common to culture wars era challenged the program. After three years of support from foundations and the city, a period that produced 53 placemaking projects and a research report, the arts council faced a proposed 70 percent cut to its budget from the city. The figure was later lowered to 12 percent after the arts council, its supporters, and PLACE artists mounted a response. Moreover, the foundations that had supported the project moved on to other initiatives, leaving the artists and the arts council to strategize on how to further support projects and, quite possibly, to theorize on the length of seed funding and

depth of engagement required to nurture placemaking projects. Bedoya sees this period as a "lull," one in which the cohort of artists and the arts council might deepen their sense of belonging and challenge placemakings urban development leanings through a consideration of "place-keeping," a term he heard from an artist in Detroit whose own concerns resonated with respecting the historical character of a neighborhood.[62] Placekeeping ties placemaking to notions of heritage, a rubric through which arts and culture always find purpose and support. Bedoya's reach for it represent one arts leader's attempt to shore up the bonds of support for the local artists who are still investigating how community members forge a sense of belonging through expressive practices. At the same time, the challenges faced by PLACE raise questions about how the policy sector, which includes state, local, and national governments as well as philanthropy, might modify and lengthen its terms of engagement with artists as cultural workers as they build their place-benefiting repertoires.

The economic and social disparities wrought over the past three decades as well as the global forces of neoliberalism, have been experienced by many as a sense of social and economic dislocation. In a countereffort, arts policy practitioners, theorists, and arts organizers like Bedoya and Jackson, Markusen, Shigekawa, and Landesman, as well as programs and initiatives like Creative Capital and LINC, have critically shaped their work to support a vibrant cultural sector in which artists actively contribute to the cultural identity and practices of a community. The sum of these efforts have diagnosed the challenges facing artists and communities. They have demonstrated how community belonging is realized. They have even highlighted the multiple reciprocal benefits shared between artists and placemaking partners. Yet, as Tucson's experience shows, the means by which artists might see returns on their contributions over a long term are still being worked out.

In her talks, Markusen has used placemaking and its emphasis on place as an opening to a greater discussion on the place of the artist. Taking up an "artists [can] work everywhere" theme that she has written about, she points to artists who have been welcomed as artists into unique jobs.[63] She mentions the work of Marcus Young, a behavioral and conceptual artist originally from Hong Kong, who was hired as an artist-in-residence by the City of St. Paul, MN. When asked where he would like to be placed, Markusen notes that Young chose the Public Works Department, with its focus on the city's physical infrastructure.[64] She also points to Gülgün Kayim, a Cyprian immigrant and theatre artist who, as the Director of Arts, Culture, and the Creative Economy for the City of Minneapolis, which hires artists to remake parts of the city.[65]

Following a hybrid impulse shared by Kayim and Young, other artists have, of course, expanded their repertoires, crossed disciplines and, in the process, produced new definitions for what artists do. Choreographers Liz Lerman and Grisha Coleman have both turned to the sciences. Lerman's Genome Project brings together genetic researchers and dancers to produce works that exchange the scientific and creative impulses under-girding science and artistic production.[66] Coleman's *echo::system* (pictured on the cover) brings together art, environmental sciences, technology, information, and place to construct distinct environmental "biomes." Participants approach these environments through "action stations," hybridized technological constructs, such as treadmills with screens that project images of natural environments under threat. Moving between public spaces to concert halls, the five *echo::system* stations, #1Abyss, #2Desert, #3Forest, #4Prairie, and #5Volcano, challenge participants to engage with questions on how human interactions with the earth will influence and determine its well-being.[67]

Similar is the case of Austin artist Allison Orr, whose Forklift Danceworks created *Trash Dance* (2009) with Austin Resources Recovery workers, as well as *Power UP!* (2013), with Austin Energy staff members and "linemen." Even more recently, Orr produced *Play Ball!* (2014), a baseball-themed work placed on the baseball team of Huston Tillotson University, a historically black college and university (HBCU). The performance of *Play Ball!* was the culminating event of a three-day celebration of Downs Field, the home of Austin's Negro League baseball team, where such nota-bles as Satchel Paige and Willie Wells played. Orr produced the work in partnership with Austin's African American Cultural Heritage District, which plans to renovate the space into a multi-use cultural facility, where games and arts events can both be staged. The event drew more than 1,500 spectators. For Orr, *Play Ball!* led to similar partnership and project in Japan, as well as potential for other baseball-themed works with major and minor league teams.[68] The popularity of the feature length docu-mentary *Trash Dance* (2013) has brought national exposure to Orr's work, which she has been developing since 2001.

Orr's dance theatre works use the equipment, materials, and work practices of specific, often overlooked professions to animate the city's history and its operations. She couples these performances of everyday life with original musical scores by composer Graham Reynolds, lighting design by Jason Amato, and accompaniment by the Austin Symphony Orchestra. While Forklift Danceworks, a nonprofit organization, fund-raises for the bulk of the project, the city offices generally contribute space, time, labor, and additional resources. Part of this approach follows

from the fact that the employees must be on the payroll and on the clock for insurance to cover them while they are operating equipment or climbing poles, as required by Orr's work. In the case of *Trash Dance* and *Power UP!*, the city offices "compensated" for rehearsal time by allowing the workers to rehearse choreography (which may include truck driving, trash collection, and pole climbing) on workdays. Employees also received overtime for their time in performance. For *Power UP!*, Austin Energy also covered the cost of bleacher rental for 1,500 people. For Orr, these relationships have been building since she staged her first public performance with Fire Department workers in 2001, one month after the events of 9/11.

Orr cites multiple influences in her work. She credits visual and conceptual artist Mierle Laderman Ukeles, who has been an unsalaried artist-in-residence at the New York City Department of Sanitation since 1977. Ukeles' body of work builds on her "1969 Manifesto for Maintenance Art," a document that resonates with the artist as producer model that Orr also embodies. In the document, which is a proposal for work that focuses on the maintenance of her life and work, Ukeles lists the quotidian demands that compete with art making that echo what Orr regards as the challenges of her own practice: "being a parent, in a relationship, having a company and making work." Ukeles' manifesto also asserts that artists must continually return work and make it available for constant feedback. Finally, Ukeles calls attention to the other works and workers who are returning each day to the maintenance of life and work through practice, those who work in human services like the ones that Orr's projects feature.[69] Orr also cites choreographer Liz Lerman, with whom she worked for a year, as well as her teachers at Mills College for teaching her about the public purpose and possibility of art making.

She considers among her greatest accomplishments to be its diversity of engagement:

> My work is the most successful when I hear after a show from a lineman, "Man there were a lot of tree huggers in that audience." We get people who have not mixed in any other scene, Republicans, Democrats, urban people, and people from the country. I love the grumpy old guys, those who would normally feel alienated by arts experiences, but find something to like in the show.[70]

What Orr's comments point to is the inherent heterogeneity of the works made about and for the lives of people who regularly cross the borders of distinct communities through their role as city workers, or identities as baseball players, or as something else. I saw this heterogeneity in action while

attending a performance of *PowerUP!* Sitting in the stands next to me at the performance, a woman and her four children narrated the show as their husband-father scaled the poles, telling me each moment's relevance.

Orr's efforts have given her a knowledge-base and network within the city's infrastructure, allowing her to deepen the relationship between art making and public purpose and to cross the borders through her engagement with non-traditional artists. Yet Orr is not the only Austin artist who has a knowledge of the city. Many of Austin's producing artists have become familiar with the city through its Cultural Arts Board, which provides operational support to the individual companies, as well as the Austin Creative Alliance, or even the city-run performance spaces that they often rent for rehearsals and performance.[71] What makes Orr's work unique to placemaking is its careful mixture of aesthetics, places, identities, and practices.

Strategically cultivating any one work's audience requires a recognition of its places of impact. Cultivating the conditions of sustainability requires that one engage and build the public around the work in the process of its making. Placemaking presumes that the oppositionality attributed to artists is part of a greater conversation about a community's concerns and assets already in process. At the intersection of placemaking's challenge and creative city aspirations is the notion that artists' skills lend themselves to a greater public purpose beyond the confines of a disciplinary specific work. Art is not merely about its representation of lives, but also about its direct engagement with various publics and public issues.

As a concept and a practice, the work of creative placemaking represents something of a trend at this moment. The *Grantmakers in the Arts Reader* features lessons and case studies each month. ArtPlace America sends out announcements about its programs on Facebook each day. Placemaking has even merged with entrepreneurship in dialogues, tasking artists to consider how geographical relevance can become a staging question, or "habit of mind."[72] For artists as producers, the question remains: how might creative placemaking encourage sustainable support for locally invested projects? For communities, and specifically for the prospective public and private partners who will participate, the question is: how might artistic work become better understood as part of what Roberto Bedoya refers to as "the cultural commons," as an aspect of community wellbeing on par, or at least in consideration with, the environment, health, education, and welfare? Regardless of the answers to these questions, the various placemaking agents, from those who work under the rubric to those like Markusen and even Florida who continue to raise questions about the significance of cultural workers, are all challenging US society to consider how artistic practice is critical to cultural belonging.

8
Coda: Performing Policy

"Some friends and I are making a show—may I speak to you about grants?" I am often asked this question by students, full of hope, who have just embarked on a new project or created a new production group. As a scholar who researches and teaches courses on artist markets, who works nationally advocating artist-driven grassroots cultural policies, and who has worked as an artist and arts administrator, I am presumed to be a teacher of rainmaking. Within the last few years especially, the University of Texas Department of Theatre and Dance has been actively promoting the development of new work as a means for performing artists to create rewarding, self-determined careers. As a result, this type of question is not only frequent but also critical to the epistemological goals we have for our students. The question is also huge, requiring far more than a quick meeting or response. Given its role historically, the grant teaches some very fundamental lessons to students and emerging artists. Rewards are not instant. Most institutional funding and support generally takes at least 18 months, time enough for the organization to write an artist into the next fiscal year. Most grants require that artists already have a proven track record of three–to–five years professional experience. Time well spent researching grants exposes artists to the gifting organization, other artist recipients, and their projects rewarded. While still technically in apprenticeship, students who fundraise in other ways can still garner and build multiple forms of capital. More importantly, however, grants represent only one element of a multilayered approach to an arts and culture policy agenda that has been in development since the 1990s. Grants, then, are also a historical formation, even an assumption, from which other forms of support and artist engagement have been imagined.

Afforded with a knowledge of the full progress of recent arts and cultural policy, I wonder how our students might emerge from university

programs ready to participate in local arts policy decisions? How might such knowledge enable them to better contribute to the artistic and geographic communities where they find a home? *Performing Policy* models an inclusive approach to policy development by illustrating how artists, arts organizers, and arts scholars communicate and trade ethically and productively across professional identities, but also in collaboration; but the greater focus of my project is to move the discourse from the singular first person "I" in "How do I get a grant," to the first person plural "we" implied by questions such as "How can I introduce my work into the fabric of community; how can I share what it has to offer and receive the rewards it seeks to deserve?"

The journey from "public purpose" to "creative placemaking" charted in this book reveals a dramatic shift in arts and cultural policy development since the 1990s, one that informs each of the case study chapters. The Austin New Works Theatre Community artists who worked closely the last few years to envision and inscribe a new set of policies at a local level echoed LINC's efforts nationwide. Comparing the two suggests that the $600,000 requested by the artists was perhaps too slight and that the efforts required more core organization. LINC's efforts in combining research with practice and even Creative Capital's efforts at combining practice with research—efforts that have been taken up by placemaking—implicate a new repertoire of skills anticipated by all those who participate in the nonprofit cultural sector today. But they also anticipate a spate of mechanisms traditionally associated with other sectors. For artists, these municipal incentives may include dedicated artist spaces, regulatory support for public arts projects, and even nonprofit community development corporations that can offer investment capital to projects that contribute to the vitality of a neighborhood or place.

Throughout this book, I use the terms "artist-producer" and "artist as producer" to index how contemporary arts policy that emerged from the culture war of the 1990s has redefined US artists' practices. Both phrasings express policy's hybridization of artistic practice, a move that aligns creative concerns with the organizational demands as two aspects of one process. The same set of terms mediates history's focus on artists as expressive agents with the entrepreneurial capacities asked of many artists today. In part, this move reflects the needs of many workers who find themselves increasingly squeezed out of the workforce. Artist-producers cultivate opportunities in the shadow of a highly competitive market. From the standpoint of those who create and contribute to cultural policy through practice, organization, and initiatives, these

twin realities of market competitiveness and cultural maintenance have been of equal concern.

I have also used the term artist-as-producer to point to the public role anticipated of today's artists. Through the lens of creative placemaking and socially invested arts, many communities look to the arts and artists to usher in a set of benefits, including community cohesion, cultural expression, and dialogue across distinct ethnic and cultural identities. The term "cultural entrepreneurs" has been used to describe how artists poised this work.[1] The term "policy entrepreneurs" has been used to describe how artists, as well as other cultural practioners, might advance the importance of artists' work in communities.[2] Artists may reanimate a public space or create a public event that brings together communities across the differences of identity and belief to model a socially engaged, if not a just and rewarding, future. At the same time, a number of artists have begun to move beyond the confines of traditional spaces to make works that intersect and speak to the sciences, medicine, and the environment by producing close collaborations across disciplines.

My focus has been primarily on professional artists, those who seek to derive all or some significant portion of their income from art making. However, as contemporary policy research makes clear, most artists work across sectors, in commercial work, with nonprofit organizations, but also in the loose affiliation of community.[3] An impromptu outdoor musical performance in a neighborhood or on a city street relies on an artist who produced the moment. Placemaking takes into account these actions, but also recognizes that even "impromptu" performances may require artist-producers to acquire municipal permits from and the agreement of merchants and neighbors.

Finally, by aligning the artist-producer, I have proposed that artists might look to the easily multiplied demands of making art and consider how their work will benefit or follow from one or more producing partners. The credits of film and television offer a clue to this model, demonstrating that a production takes time and the input of many organizers. Since the beginning of the twenty-first century, the numbers of arts nonprofits has again increased. The newer entities "represent more than 30 percent of all arts nonprofits nationwide."[4] Many arts spaces, in particular, rely on the capacities of artists who can produce audiences, who have produced not only a compelling show but also excellent marketing materials. Artists are also tasked to produce audiences, spectators, and consumers in the context of space.

The medium for the change to artists' lives, as well as the medium of my analysis has been cultural policy:

*the decisions (by both public and private entities) that either directly or indirectly **shape the environment** in which the arts are created, disseminated, and consumed.*[5]

As evidenced by this concise definition, artistic practitioners are expected to contribute to arts policy through their work. With respect to my study, the term artist-producer points to artists' role as producers of arts policy, as well as broader public policies, through works that contribute to the policy's archive and repertoires that make manifest the conditions for a healthy cultural infrastructure. The same definition also points to the efforts of policy itself, and the ways its professionals are "shap[ing] the environment" in which the arts are made. All of the initiatives and projects I have written about have modeled, or at least expressed a hope, that the table of policy will be equally shared by artists and policymakers alike.

My method of analysis has been performance, an examination of the embodied exchanges that have cultivated and illustrated this new definition of artistic practice. While my own background reflects multiple forms of staged performance, I seek to make this study available to all disciplines. At the same time, I find performance to be especially critical to the study of artists' lives.

I completed the first draft of this book during what seems an especially hot summer in Texas and a heated political moment. Less than a mile from my office, the Republican-led Texas Legislature fought to dismantle *Roe vs. Wade*, the Supreme Court decision of 1971 legalizing and making possible women's access to safe abortions. Through the combined efforts of a filibuster and a particularly cacophonous protest, State Sen. Wendy Davis and a galvanized group of supporters blocked a first vote in the Texas legislature. On that same day, the nation's Supreme Court overturned the Defense of Marriage Act, but also dismantled aspects of the Voting Rights Act and the Indian Child Welfare Act. Back in Texas, under the leadership of the governor, the legislature regrouped and brought the bill to safe passage, or an unsafe outcome, depending upon one's views.[6] For much of June and some of July, protesters stood outside in the sun in protest. Many of our students from the Performance as Public Practice Program testified on the harmful outcomes of the proposed legislation and the benefits of women's health before the legislature, what humorist Molly Ivins once called, "the lege," a metonymic reference to the cliff that many protesters saw poor women and children being tossed over. The confluence of these three events demonstrated that the culture war once focused on the arts has moved to more immediate concerns of

the body and babies, to gay marriage, and to race. The students' efforts and passion in testifying demonstrated their own belief that performance scholars, with their carefully argued understanding of representation, affect, and the body, have a significant role to play in organizing and responding to a host of policies. They also demonstrated palpably the role of performance in public policy: Wendy Davis' filibuster was comprised of testimony from people who had been shut out of the public hearings only days earlier; 700 people registered to testify at those hearings (which was the start of the citizens' filibuster), and 300 were turned away when one representative arbitrarily cut off testimony around midnight. In their absence, Wendy Davis' (thin, white, blonde, able) body came to stand in for many more bodies on the Senator floor as she spoke their words.[7]

In many ways, the events of June represent an ongoing retrenchment of the Great Society programs formed more than four decades ago, the same period that set forth the nation's first formalized approach to arts policy. President Johnson signed the Civil Rights Act (1964), the Voting Rights Act, and the National Foundation on the Arts and Humanities Act (both of 1965). Writing them at that time, Johnson foresaw a Texas that would turn Republican for years to come. At this moment, Texans, as well as non-Texans, are beginning to talk about another tide shift and Texas turning back to Democratic, because of its Latino/a population and because of actions like Davis' and her supporters, who for one raucous summer, illuminated place for many Texans who have been traditionally silenced.

To any movement, of course, the moment of definition is the critical, galvanizing step, one in which stakeholders become conscious of each other's investment and shared interest, articulate their role in response to the state, and decide who will carry the work from the home, to the streets, and forward to the future. With all of these events, local, national, and international, whether we are acting as spectators or performers, we find ourselves wrestling with how to express this moment. I am particularly interested in how artists, who have historically provided insight into the human condition, might continue to find purpose but also purchase in an increasingly complex world. Through my work I also seek to support the artist-scholars-activists who participate in the protests and continue to make their works mean something to the communities where they—where we—work.

Notes

Prologue

1. Ann Markusen, "Urban Development and the Politics of the Creative Class," *Environment and Planning* 38: 1928.
2. *Memory's Caretaker, Text and Performance Quarterly* 24.2 (2002): 161–181. *The Great Chittlin Debate*, with Kitty Williams, in *Jump-Start Playworks* (San Antonio: Wings Press, 2004), 165–190. *Quinceañera*, with Alberto Antonio "Beto" Araiza, Michael Marinez and Danny Bolero Zaldivar, in *The Color of Theater*, ed., Roberta Uno and Luci Mae Sao Paolo Burns (London: Continuum, 2002), 261–302.
3. Chris Williams, "Group Says Arts Cut Actually Targeted Gays," *San Antonio Express-News*, September 19, 1997; David Anthony Richelieu, "Council's Art Attack Echoes with History," ibid, September 21, 1997; Susan Yerkes, "First They Rob Peter—Now They Mug Paul," ibid, August 29, 1997. In a move that would resonate with the general tone of the culture wars, press accounts at the time followed the councilman's extra-marital affairs, particularly his attempts to be recognized as the father of a child by a woman who was not his now former wife. Despite the fact that the politician had risen to prominence as an aide to former Mayor Henry Cisneros, a liberal, my colleagues and I often read his attacks as an attempt to shore up a conservative base. We relied on this notion to explain the number of self-identified Christian counterprotestors at "citizens to be heard" meetings, yet the Esperanza trial would bring out a stronger divide in the city. See Chris Anderson and Travis E. Poling, "Marbut Is in Dispute over Visitation Rights," ibid, March 15, 1998; Rick Casey, "Beyond Weakness: The Marbut Affair," ibid, September 26, 1999.
4. In an essay posted online, Esperanza Center lead attorney, Amy Kastely, describes the ruling's significance for marginalized communities and its relationship to the Supreme Court's ruling on *The National Endowment for the Arts et al. v. Finley et al.* in 1996. See "Our Chosen Path: Esperanza vs. The City of San Antonio," *Esperanza Peace & Justice Center*, September 16, 2013, http://www.esperanzacenter.org/cityofsatodos_fs.htm.
5. Sara Jarrett, "Dancers Working: Mile-High Majesty," *Pointe*, May 2001, 28. The partnership of the two companies was not unprecedented. As early as 1983, the Cincinnati Ballet and the New Orleans ballet formed a "sister city" alliance. Jack Anderson, "David Mcclain, 51, Cincinnati Ballet Director," *The New York Times*, December 16, 1984. http://www.nytimes.com/1984/12/16/obituaries/david-mclain-51-cincinnati-ballet-s-director.html.
6. I use the term altruism here because altruism and its discontents provide an excellent pivot from which to understand fundamental issues facing the artists in the United States. Robert Trivers' (1971) notion of "reciprocal altruism" (aka "tit for tat") explains how individuals respond in kind

to perceived and real acts of kindness. Robert Trivers, *Natural Selection and Social Theory: Selected Papers of Robert Trivers* (Oxford: Oxford University Press, 2002).

7. Cost disease explains how the successful growth of arts organizations causes them to expand beyond their capacity to sustain the organization. William J. Baumol and William G. Bowen, *Performing Arts, the Economic Dilemma: A Study of Problems Common to Theater, Opera, Music, and Dance* (New York: Twentieth Century Fund, 1966); Gregory Besharov, "The Outbreak of the Cost Disease: Baumol and Bowen's Founding of Cultural Economics" *History of Political Economy* 37.3 (2005).

1 Introduction: Performing Policy

1. Steven J. Tepper and Stephanie Hinton, "The Measure of Meetings: Forums, Deliberations, and Cultural Policy," Working Paper 27 (Princeton, NJ: Princeton University Center for Arts and Cultural Policy Studies, 2003), 3. Emphases original.
2. Maria Rosario Jackson, "The Artist and their Publics in Cross-Sectoral Projects—Lessons Learned and Future Questions." Keynote Address, Leadership in the Arts Summit," University of Houston, April 5, 2014.
3. Roberto Bedoya, *U.S. Cultural Policy: Its Politics of Participation, Its Creative Potential* (New Orleans: The National Performance Network, 2004). Holly Sidford, *Fusing Arts, Culture, and Social Change* (Washington, DC: National Commitee for Responsible Philanthropy, 2011). Maria Rosario Jackson, *Developing Artist-Driven Spaces in Marginalized Communities: Reflections and Implications for the Field* (Washington, DC: Urban Institute, 2012).
4. J. L. Austin, *How to Do Things with Words*, 2nd ed. (Cambridge, MA: Harvard University Press, 1975), 6.
5. Diana Taylor, *The Archive and the Repertoire: Performing Cultural Memory in the Americas* (Durham, NC: Duke University Press, 2003), 12.
6. These categories, more expansively defined as "writers; visual artists (including filmmakers and photographers); musicians; and performing artists (including actors, directors, choreographers, dancers)," represent four subgroups defined under US Census Bureau of Labor Statistics Codes. Ann Markusen, "Urban Development and the Politics of a Creative Class: Evidence from a Study of Artists," *Environment and Planning* 38 (2006): 1925.
7. Jackson, *Developing Artist Driven Spaces in Artist-Driven Communities*, 2.
8. Writes Bhabha: "The language of critique is effective not because it keeps forever separate the terms of the master and the slave, the mercantilist and the Marxist, but to the extent to which it overcomes the given grounds of opposition and opens up a space of translation: a place of *hybridity*, figuratively speaking, where the construction of a political object that is new, neither the one nor the other, properly alienates our political expectations, and changes, as it must, the very forms of our recognition of the moment of politics." See Homi K. Bhabha, *The Location of Culture* (New York: Routledge, 1994), 37. Emphasis mine.
9. Michael Hardt and Antonio Negri, *Empire* (Cambridge and London: Harvard University Press, 2000), 145.

10. Holly Sidford, Laura Lewis Mandeles, and Alan Rapp, *Cornerstones* (New York: Leveraging Investments in Creativity, 2013), 34–35. See also http://www.paifoundation.org. See also Maria Rosario Jackson, *Building Community: Making Space for Art* (Washington, DC: Urban Institute, 2011), 9.
11. In deference to his project, I wish to point out that Garcia Canclini's book more directly addresses the circumstances in Latin America "to develop a more plausible interpretation of the contradictions and the failures of our modernization"; however, I would argue his greater project relates directly to the circumstances faced by US artists as cultural practitioners. See *Hybrid Cultures*, trans. Christopher L. Chiappari and Silvia Lopez (Minneapolis and London: University of Minnesota Press, 1995), 2–3.
12. John Kreidler, "Leverage Lost: Evolution in the Non-profit Arts Ecosystem," in *The Politics of Culture: Policy Perspectives for Individuals, Institutions, and Communities*, ed. Gigi Bradford, Michael Gary, and Glenn Wallach (New York: New Press, 2000), 147–168.
13. See Carl Grodach and Michael Seman, "The Cultural Economy in Recession: Examining the US Experience," *Cities* 33 (2012): 13.
14. Wally Cardona, "Success in 10 Minutes or Less: Reflections on Life and Work as a Contemporary Artist," *Dance from the Campus to the Real World (and Back Again): A Resource Guide for Artists, Faculty, and Students*, 128–131. Ed. Suz<shapeText></shapeText>anne Callahan. Washington, DC: Dance/USA, 2005, 130–131.
15. See Ann Markusen et al., *Crossover: How Artists Build Careers across Commercial, Non-profit and Community Work* (Minneapolis: Humphrey Institute of Public Affairs, University of Minnesota, 2006), 11–20.
16. Essig, Linda. "Not about the Benjamins: Arts Entrepreneurship in Research, Education, and Practice." Keynote Address, Arts Business Research Symposium, University of Wisconsin-Madison, WI, March 13, 2014. Essig's text can be found on her blog, "Creative Infrastructure." http://creativeinfrastructure.org/2014/03/19/the-ouroboros-last-good-business-practices-and-the-arts/
17. Essig also resists this dichotomy by arguing that artists who show good practices may do so to support the social and cultural goals of their project as much as the economically prosperous ends. Ibid. See also Paul Bonin-Rodriguez, "What's in a Name? Typifying Artist Entrepreneurship in Community-Based Training," *Artivate: A Journal of Entrepreneurship in the Arts*, 1.1 (2012), http://www.artivate.org/?p=115
18. For an assessment of the unique role artists play as cultural entrepreneurs, as well as the challenges they face, see Ann Markusen, "How Cities Can Nurture Cultural Entrepreneurs," Policy brief for the Ewing Marion Kauffman Foundation, Mayor's Conference on Entrepreneurship, Kansas City, MO, November 20, 2013. Accessed April 12, 2013, http://www.kauffman.org/what-we-do/research/2013/11/how-cities-can-nurture-cultural-entrepreneurs
19. "The Artist as Public Intellectual," in *The Politics of Culture: Policy Perspectives for Individuals, Institutions, and Communities*, 240–241. See also Caron Atlas, "How Arts and Culture Can Advance a Neighborhood-Centered Progressive Agenda," in *Toward a 21st Century for All: Progressive Policies for New York City in 2013 and Beyond* (New York: Arts & Democracy Project). Accessed May 1, 2014, http://21c4all.org/culture

20. Jackson, *Building Community, Making Space for Art*, 6. See also Maria Rosario Jackson, "Revisiting the Themes from the 'Investing in Creativity' Study: Support for Artists Pursuing Hybrid Work," in *Workforce Forum* (Washington, DC: NEA, 2009), http://www.nea.gov/research/Workforce-Forum/PDF/Jackson.pdf

21. Jan Cohen-Cruz, *Engaging Performance: Theatre as Call and Response* (London and New York: Routledge, 2010), 74. See also James Bau Graves, *Cultural Democracy: the Arts, Community, and Public Purpose* (Urbana-Champaign: University of Illinois Press, 2005).

22. Liz Lerman, *Hiking the Horizontal* (Middletown, CT: Wesleyan University Press), 157.

23. See Grant Kester's writing on *Park Fiction*, the public part installation in Hamburg, Germany. In *The One and the Many: Contemporary Collaborative Art in a Global Context* (Durham and London: Duke University Press, 2011), 204–210.

24. See Kester's writing on *Nalpar* (Water Pump Site). Ibid., 76–84.

25. Ibid., 5.

26. Shannon Jackson, *Social Works: Performing Art, Supporting Publics* (New York: Routledge, 2011), 14.

27. Lewis Hyde, *The Gift: Creativity and the Artist in the Modern World*, 2nd ed. (New York: Vintage Books, 2007), xvi. Hyde's thinking and writing has been critical to the formation of the Creative Capital Foundation. See Lewis Hyde, "Being Good Ancestors: Reflections in Arts Funding since World War II." *Kenyon Review* 3.1 (2008): 5–18.

28. Alice Bernstein and Margaret B. Wilkerson in "Introduction: Why Artists Need More than Creativity to Survive," in Maria Rosario Jackson et al., *Investing in Creativity: A Study of the Support Structure for US Artists* (Washington, DC: Urban Institute, 2003), i.

29. Richard Caves, *Creative Industries: Contracts between Art and Commerce* (Cambridge, MA: Harvard University Press, 2000), 6.

30. Deborah Hay, Interview with Artist, April 25, 2014.

31. Margo Jefferson, "Words to the Wise Performance Artist: Get Help. Collaborate, Grow," *New York Times*, January 1, 2005. Accessed May 1, 2014. http://www.nytimes.com/2005/01/01/theater/newsandfeatures/01jeff.html?_r=0

32. Sam Miller, Interview with Author, April 11, 2014. See also http://www.hampshire.edu/academics/curate.htm, Accessed date May 29, 2014

33. Jill Dolan, *Geographies of Learning* (Middletown, CT: Wesleyan University Press, 2001), 135.

34. Jill Dolan, "Introduction: A Certain Kind of Successful," in *Peggy Shaw, Menopausal Gentleman: The Solo Performances of Peggy Shaw*, ed. Jill Dolan (Ann Arbor: University of Michigan Press, 2011), 9.

35. Ibid., 1. See Sue-Ellen Case, "Introduction," in *Split Britches: Lesbian Practice, Feminist Performance*, ed. Sue-Ellen Case (London and New York: Routledge, 1996), 1–34.

36. In "What Is an Author?" Foucault establishes the linguistic and social forma-tions that enabled his study of institutions in *Discipline and Punish* (1966, trans. 1970) in *The Foucault Reader*, ed. Paul Rabinow (New York: Pantheon Books, 1984), 101–120. Foucault (1998) also observes, "Discourse can be both an instrument and an effect of power, but also a hindrance, a stumbling point

of resistance and a starting point for an opposing strategy. Discourse trans-
mits and produces power; it reinforces it, but also...renders it fragile and
makes it possible to thwart." In *The History of Sexuality: The Will to Knowledge*
(London, Penguin), 100–101.

37. Holly Sidford, Laura Lewis Mandeles, and Alan Rapp, *Cornerstones* (New York:
Leveraging Investments in Creativity), 52–53.

38. Borrowing a phrase already operating in this book, Bourdieu is a "crossover"
figure in the humanities and the social sciences, the greater academic divi-
sions that I address. Writing between the 1960s and the turn of the century,
Bourdieu's work was coterminous with the period I write about. Coming at
a dynamic moment in the development of critical theory in the humani-
ties, it draws from many of the same impulses as the work of Roland Barthes
and Michel Foucault, whose works address the power dynamics at work in
human communication and organization and the social processes under-
girding cultural production. Bourdieu's work continues to inform the fields
of anthropology, philosophy, politics, and economics, and particularly the
arts and education. First introduced in Bourdieu's study of the relationship
between aesthetics and class, *Distinction* (1979), the forms were clarified
and amended in later works such as "The Forms of Capital" (1983), which
Bourdieu identified the forms as having resulted from his study of the rela-
tionship between education and class access. In a later work, *The Rules of Art*
(1996), Bourdieu argued that art is integrally tied to social relations from
its access. Pierre Bourdieu, "The Forms of Capital," in *Handbook of Theory
and Research for the Sociology of Education*, ed. John G. Richardson (New York:
Greenwood Press, 1986), 241–258.

39. The notion of "weak ties" from network theory describes how acquaintances
made with individuals who have different alliances and forms of knowledge
serve as bridges to "the outside world." See Albert-Laszlo Barabasi, *Linked*
(New York: Plume, 2003), 41–43.

40. Susan Bordo, *Unbearable Weight: Feminism, Western Culture, and the Body*
(Berkeley and London: University of California Press, 1993), 165.

41. Robin Bernstein, *Racial Innocence* (New York and London: New York University
Press, 2011), 11–12.

42. Kevin F. McCarthy et al., *The Performing Arts: Trends and Their Implications*
(Santa Monica, CA: RAND Corp, 2001), xx.

43. Caves, *Creative Industries*, 6.

44. Frank Fischer and Herbert Gottweis, "Introduction: The Argumentative Turn
Revisited," in *The Argumentative Turn Revisited: Public Policy as Communicative
Practice*, ed. Frank Fischer and Herbert Gottweis (Durham, NC: Duke
University Press, 2012), 1–3.

45. Maria Rosario Jackson et al., *Investing in Creativity: A Study of the Support
Structure for US Artists* (Washington, DC: Urban Institute, 2003).

46. Taylor, 19–20. I take up some of these ideas and themes in a recent article,
"The Staged Business of Writing for/about Art: Artists in Public Practice." In
Theatre Topics 16, no. 1 (2014): 25–37.

47. Taylor, 19–20.

48. Ibid.

49. Ibid., 2–3.

50. Ibid, 22.

51. Ibid., 28.
52. Ibid., 29–32.
53. Ibid, 20.
54. Separately, W. B. Worthen (2008) and Rebecca Schneider (2011) have crit-
 icized Taylor for reinscribing age-old dichotomies between body and text
 long dismissed by performance studies, or giving too much credence to text's
 capacity to maintain its dominance over unruly bodies, respectively. My use
 of Taylor's work in this study mediates those claims by following upon Bordo's
 assertion that discourses are inscribed through repeated practice. See Rebecca
 Schneider, *Performing Remains Art and War in Times of Theatrical Reenactment*
 (New York: Routledge, 2011). W. B. Worthen, "Antigone's Bones," *TDR: The
 Drama Review* 52, no. 3 (2008). I am grateful to D. J. Hopkins for making me
 more aware of the distinctions.
55. Betsy Peterson, "Cultural Policy Research in the United States: An Introduction
 to Studies and Articles Relevant to Folk Arts and Traditional Culture."
 (Supported by the Public Programs Section of the American Folklore Society,
 2011). https://scholarworks.iu.edu/dspace/handle/2022/13425
56. McCarthy et. al., *The Performing Arts in a New Era*, xvii–xxv.
57. Todd London, with Ben Pesner and Zannie Giraud Voss, *Outrageous Fortune*
 (New York: Theatre Development Fund, 2009).
58. Maria Rosario Jackson, Joaquin Herranz, and Florence Kabwasa-Green, *Art
 and Culture in Communities: Unpacking Participation* (Washington, DC: Urban
 Institute, 2003); Maria Rosario Jackson and Joaquin Herranz, *Culture Counts
 in Communities: A Framework for Measurement* (Urban Institute, 2002); Jackson,
 Herranz, and Kabwasa-Green, *Art and Culture in Communities: Unpacking
 Participation*; *Art and Culture in Communities: Systems of Support* (Washington,
 DC: Urban Institute, 2003); *Art and Culture in Communities: A Framework for
 Measurement* (Washington, DC: Urban Institute, 2003); Maria Rosario Jackson,
 Florence Kabwasa-Green, and Joaquin Herranz, *Cultural Vitality in Communities:
 Interpretation and Indicators* (Washington, DC: Urban Institute, 2006). See
 also F. Javier Torres, "Revisiting Research: Art and Culture in Communities:
 Unpacking Participation," *Grantmakers in the Arts Reader* 23, no. 3 (2012).
59. Since 1982, the National Endowment for the Arts has conducted the "Survey
 of Public Participation in the Arts." The data findings of these surveys provide
 researchers and arts organizers with information about consumption habits,
 including consumption through electronic media (like online media, videog-
 ames, and music listening), movie-going, art making and sharing, voluntary
 reading, art classes, and attending live performances or visual arts events.
 The survey provides one measure of cultural vitality. While its findings are
 enlightening, the *Survey*'s reliance on precedent—on adhering to categories
 that can be compared across years—also challenges nuanced thinking about
 how and where art is made and consumed. Highlights from the most recent
 survey (2012) can be found at "Survey of Public Participation in the Arts,"
 in *Research Report #57* (Washington, DC: National Endowment for the Arts,
 2012), http://arts.gov/sites/default/files/highlights-from-2012-SPPA.pdf
60. In addition to creating a framework for measurement, these studies argued
 for the recognition of cultural participation as part of "community 'quality-
 of-life' measurement systems" common to housing and urban policymaking.
 In 2012, Grantmakers in the Arts, a national organization that supports arts

philanthropy and research, decided to "dust off these policy reports" to assess how critical they have been to contemporary arts and culture organizing. See Alexis Frasz, "New Perspectives in Research: Revisiting Landmark Reports." *Grantmakers in the Arts Reader* 23, no. 3 (2012).

61. Kevin F. McCarthy et al., *Gifts of the Muse: Reframing the Debate About the Benefits of the Arts* (Santa Monica, CA: RAND Corp., 2004).

62. *Gifts of the Muse* also sought to embrace more "expressive logics" that creative expression was critical to everyday life; it had historically been recognized as critical to America's social and cultural wellbeing. See Joli Jensen, "Expressive Logic: A New Premise in Arts Advocacy," *The Journal of Management, Law, and Society* 33, no. 1 (2003).

63. Maria Rosario Jackson et al., *Investing in Creativity*, (Washington, DC: Urban Institute, 2003), 2.

64. See Ann Markusen et al., *Crossover*, 11–20.

65. Jackson, et al., 35–36.

66. See Creative Capital. About. http://creative-capital/about. See USA Artists. About. http://www.unitedstatesartists.org/about

67. See *Leveraging Investments in Creativity*. About. http://lincnet.net. Last accessed November 9, 2013. According to LINC President, Sam Miller, the LINC archive will remain online until May, 2014. Interview with author.

68. Crowd-source funding mechanisms demonstrate distinct approaches to the market. To leverage buy-in from patrons, both Amazon and US Artists take an "all or nothing" approach, requiring fundraisers to reach minimum pledge goals before actually charging donors. The direct and broad requests for funds made by artists through these programs make discussions about the funding of arts an urgent, even intimate, matter in public culture.

69. Jo Becker, "An Evangelical Is Back from Exile, Lifting Romney," *The New York Times*, 22 September 2012. Catherine Otterman, "Catholic Leader Is Turned Away at Exhibit He Deemed Offensive," ibid., September 28, 2012.

70. Bedoya, *U.S. Cultural Policy*, 4.

71. The NEA Four included performing artists Holly Hughes, John Fleck, Karen Finley, and Tim Miller, whose grant proposals to the National Endowment for the Arts were vetoed on grounds of "indecency" (1990). Of note, all but Finley (a feminist) are queer artists. The case was brought before the Supreme Court, *National Endowment for the Arts et al. v. Finley et al.* (1998), contributing to the permanent abolition of the NEA's individual artist funding program that I describe here. See *National Endowment for the Arts, et al., Petitioners v. Karen Finley, et al.* 524 U.S. 569 (1998). See also Sarah Schulman, *My American History: Lesbian and Gay Life During the Reagan/Bush Years* (New York: Routledge, 1994). See also "Legacy," Marlon Riggs, last accessed on December 10, 2013, http://marlonriggs.com/?page_id=6

72. Jane Alexander, *Command Performance: An Actress in the Theater of Politics* (New York: Public Affairs, 2000). See also Michael Brenson, *Visionaries and Outcasts: The NEA, Congress, and the Place of the Visual Artist in America* (New York: New Press, 2001).

73. Lewis Hyde, "The Children of John Adams: A Historical View of the Fight Over Arts Funding," in *Art Matters: How the Culture Wars Changed America*, ed. Brian Wallace, Marianne Weems, and Philp Yenawine (New York: New York University Press, 1999), 253–275.

74. Joni Maya Cherbo and Margaret Jane Wyszomirski, "Mapping the Public Life of Arts in America," *The Public Life of the Arts in the United States*, 11.
75. McCarthy et al., *The Performing Arts*; Kreidler, "Leverage Lost," 147–168.
76. Ann Markusen and Amanda Johnson, *Artists' Centers: Evolution and Impact on Careers, Neighborhoods, and Economies* (Minneapolis, MN: Humphrey Institute of Public Affairs, University Minnesota, 2006), 11–14.
77. Kreidler, 60–61. See also Bill J. Ivey, *Arts, Inc.: How Greed and Neglect Have Destroyed Our Cultural Rights*, ed. Bill J. Series Ivey (Berkeley, CA: University of California Press, 2008).
78. Kreidler, 158.
79. These conditions are listed explicitly in Cherbo and Wyszomirski, "Mapping the Public Life of Arts," 11.
80. Michael Kammen, "Culture and the State in America," in *The Politics of Culture: Policy Perspectives for Individuals, Institutions, and Communities*, ed. Gigi Bradford, Michael Gary, and Glenn Wallach (New York: New Press, 2000), 114–140.
81. Brenson, *Visionaries and Outcasts*, 3.
82. Donna M. Binkiewicz, *Federalizing the Muse: United States Arts Policy and the National Endowment for the Arts, 1965–1980* (Chapel Hill: University of North Carolina Press, 2004), 1–5.
83. Brenson, *Visionaries and Outcasts*.
84. Lisa Duggan, *The Twilight of Equality: Neoliberalism, Cultural Politics, and the Attack on Democracy* (Boston, MA: Beacon Press, 2003), 12.
85. Policy's adoption of values-based rhetoric represents a political use of "discursive frame analysis," a type of policy analysis that assesses the forms of language used to address critical issues. See Mary Hawkesworth, "From Policy Frames to Discursive Frames Analysis," in *Argumentative Policy Revisited*, ed. Frank Fischer and Herbert Gottweis (Durham, NC: Duke University Press, 2012), 114–146.
86. "The Arts and the Public Purpose: Final Report of the Ninety-Second American Assembly" (Arden House, Harriman, NY: The American Assembly, Columbia University, 1997), 4.
87. Caron Atlas, "Cultural Policy: In the Board Rooms and on the Streets," *Community Arts Network* (2004), http://www.communityarts.net/readingroom/archive/intro-publicpolicy.php
88. Gigi Bradford, "Defining a Cultural Policy: Introduction," in *The Politics of Culture: Policy Perspectives for Individuals, Institutions, and Communities*, ed. Gigi Bradford, Michael Gary, and Glenn Wallach (New York: The New Press, 2000), 11–12.
89. Arlene Goldbard, "Artists Call for Cultural Policy," in *PetitionOnline* (Artifice, Inc., 2004). http://petitiononline.com/art2004/html
90. Duggan, xii.
91. Markusen and Johnson, *Crossover*, 11–20.
92. Joni Maya Cherbo, Harold Vogel, and Margaret Jane Wyszomirski, "Towards an Arts and Creative Sector," in *Understanding the Arts and Creative Sector in the United States*, ed. Joni Maya Cherbo, Ruth Ann Stewart, and Margaret Jane Wyszomirski (New Brunswick, NJ: Rutgers University Press, 2008), 9–27.
93. See Markusen, "Urban Development and the Politics of a Creative Class."
94. Caves, 1–2.

95. Jan Cohen-Cruz, *Local Acts: Community-Based Performance in the United States* (New Brunswick, NJ: Rutgers University Press, 2005), 7.
96. Cohen-Cruz, *Engaging Performance*, 68.
97. Motivational economics is a field that combines psychology with classical economics to discern why individuals make the economic choices that they do. The term "crowd out" refers to the crowding out of intrinsic motivations—desire, altruism—by negative extrinsic forces. See Bruno S. Frey, *Arts & Economics: Analysis & Cultural Policy* (Berlin: Springer-Verlag, 2000), 145.
98. Andrea Smith, "Introduction," in *The Revolution Will Not Be Funded: Beyond the Non-Profit Industrial Complex*, ed. INCITE: Women of Color Against Violence (Cambridge, MA: South End Press, 2007), 1–18.
99. Peter Buffet, "The Charitable-Industrial Complex," in *The New York Times*, July 26, 2013, http://www.nytimes.com/2013/07/27/opinion/the-charitable-industrial-complex.html. Access date, May 29, 2014.
100. National Endowment for the Arts, *How Art Works: The National Endowments for the Arts' Five-Year Research Agenda with a System Map and Measurement Model* (Washington, DC : The National Endowment for the Arts, 2012), 40.
101. By 2002, a national survey of artists revealed that many saw little distinction between being an independent artist and a small, nonprofit corporation. Maria Rosario Jackson et al., *Investing in Creativity*, 45. Joni Maya Cherbo, "About Artists," in *Understanding the Arts and Creative Sector in the United States*, ed. Joni Maya Cherbo, Ruth Ann Stewart, and Margaret Jane Wyszomirski (Rutgers: Rutgers University Press, 2008), 75–91.
102. Michel de Certeau, *The Practice of Everyday Life*, 1984 (Berkeley, Los Angeles, and London: University of California Press, 1988), 117.
103. Jackson, *Building Community, Making Space for Art*, 6.
104. de Certeau, 117.
105. Ann Marksuen and Ann Gadwa, *Creative Placemaking: Executive Summary* (Washington, DC: National Endowment for the Arts, 2010), 3.

2 A Politic of Purpose: "The Arts and the Public Purpose" (1997)

1. The National Endowment for the Arts (NEA) charts these conflicts to the 1980s, when Congress began to question controversial representations in art, including the Metropolitan Opera's 1984 adaptation of Giuseppe Verdi's *Rigoletto*, featuring Mafiosi in New York's Little Italy, and 1985's NEA grants for poets whose works were deemed pornographic by a legislator. See Mark Bauerlein and Ellen Grantham, *National Endowment for the Arts: A History, 1965–2008* (Washington, DC: National Endowment for the Arts, 2009), 79. Other authors point to the end of the Cold War as the reasons for an increased focus on domestic issues. See Michael Brenson, *Visionaries and Outcasts: The NEA, Congress, and the Place of the Visual Artist in America* (New York: New Press, 2001), 99–100.
2. Citing Arjun Appadurai, Becker refers to the nation's desire for a "return to lost innocence, as a " 'nostalgia without memory.' " In "Introduction: Presenting the Problem," in *The Subversive Imagination*, ed. Carole Becker (London: Routledge, 1994), xii.

3. Ibid. Cultural critic Lauren Berlant also argues that the Reagan Presidency of the 1980s wrought a narrow "definitional field of citizenship," largely through the discourses that white, heteronormative, and middle-class citizens who reflected an idealized notion of 1950s America. In *The Queen of America Goes to Washington City* (Durham, NC: Duke University Press, 1997), 31.

4. Margaret Jane Wyszomirski, "Policy Communities and Policy Influence: Securing a Government Role in Cultural Policy for the Twenty-First Century," in *The Public Life of the Arts in America* (New Brunswick, NJ: Rutgers University Press, 2000), 93.

5. Stephen J. Tepper, "The Culture Wars: A Reassessment," Policy Brief (Princeton, NJ: Princeton University Center for Arts and Cultural Policy Studies, 2000), 3.

6. Linda Greenhouse, "Supreme Court, 9–0, Rejects Clinton Request to Put Off Suit on Sexual Harassment," *The New York Times*, May 28, 1997. Accessed May 2, 2014. http://www.nytimes.com/1997/05/28/us/supreme-court-9-0-rejects-clinton-request-to-put-off-suit-on-sexual-harassment.html.

7. James Bau Graves, *Cultural Democracy: The Arts, Community, and Public Purpose* (Urbana-Champaign: University of Illinois Press, 2005), 10.

8. Don Adams and Arlene Goldbard, *Crossroads: Reflections on Politics and Culture* (Talmage, CA: DNA Press, 1990), 42.

9. Lewis Hyde, "The Children of John Adams: A Historical View of the Fight over Arts Funding," in *Art Matters: How the Culture Wars Changed America*, ed. B. Wallis, M. Weems, and P. Yenawine (New York: New York University Press, 1999), 253–274.

10. See Michel Foucault, "What Is an Author?" in *The Foucault Reader*, ed. Paul Rabinow (New York: Pantheon Books, 1984), 108–113.

11. The American Assembly, "The Arts and the Public Purpose: Final Report of the Ninety-Second American Assembly" (Arden House, Harriman, NY: Columbia University, 1997), 11.

12. Ibid., 24.

13. Ibid., 14–15.

14. Ibid., 36–40.

15. Alberta Arthurs, Interview with the Author, July 31, 2013.

16. In addition to her contributions to the American Assembly archive, see, for example, Alberta Arthurs and Glenn Wallach, eds., *Crossroads: Art and Religion in American Life* (New York: The New Press, 2001). Alberta Arthurs, "Arts and Culture in the New Economy," *Journal of Arts Management, Law & Society* 32, no. 2 (2002): 83–86. See also Alberta Arthurs, "Social Imaginaries and Global Realities," *Public Culture* 15, no. 3 (2003): 579–586. Arthurs is also credited as project director in Steven J. Tepper and Stephanie Hinton, "The Measure of Meetings: Forums, Deliberation, and Cultural Policy," (Princeton University Center for Arts and Cultural Policy Studies, Princeton, NJ, 2003). See also "The Future of Humanities in American Life" (New York, NY: New York University John Brademas Center for the Study of Congress, 2013).

17. Sheila McNerney Anderson. "The Founding of Theatre Arts Philanthropy in America: W. Mcneil Anderson, 1957–65." In *Angels in American Theatre: Patrons, Patronage, and Philanthropy*, edited by Robert A. Schanke, 173–189. Carbondale: Southern illinois University Press, 2007.

18. Quotes Arthurs: "When I was a program director at the Rockefeller Foundation years ago, it became clear to us that the arts had been professionalized by those efforts in very successful and significant ways. The strengthening of orchestras, dance companies, theatres nationally elevated the so-called 'high arts.' It was an uplifting time. But the establishment of a professional arts scene and standards also created a distinct, higher status for distinguished artists and arts organizations. Ford's work generated interest in professional arts management, in the creation of arts centers, the establishment of ambitious budgets and fund-raising initiatives. These outcomes contributed to a sense that the arts were elite, meant for those who can afford leisure pursuits. There was less emphasis on community-based, diverse, unincorporated or amateur artists and audiences, or on the ways in which arts engagement can contribute broadly to society as a whole. These were unintended consequences of Ford's excellent work, in my view." Arthurs, Interview with Author.
19. Ibid.
20. The 22nd American Assembly, "Cultural Affairs and Foreign Relations" (1962), wrestled with the purposes of art in world culture. According to Robert Blum, the meeting's critique of how the United States had used artists as a tool of cultural diplomacy rendered it politically charged. See "Introduction: The Flow of People and Ideas," in *Cultural Affairs and Foreign Relations*, ed. Robert Blum (Englewood Cliffs, NJ: Prentice-Hall, 1962), 1–7.

 The 46th American Assembly, "Art Museums in America" (1974) was the first such meeting called solely on behalf of a cultural industry. Chaired by Sherman Lee, the longtime director of the Cleveland Museum of Arts, the meeting focused on the public purposes of museums as institutions, and addressed a number of concerns about state support still relevant today, especially at a moment when the city-owned Detroit Institute of Art faces the loss of its collection to help pay for its debt of $18 billion. Sherman Lee, ed., *On Understanding Art Museums* (Englewood Cliffs, NJ: Prentice-Hall, 1975). See also Ruth Smith, "A Case of Selling Art and Selling Out," *The New York Times*, September 10, 2013, http://www.nytimes.com/2013/09/11/arts/design/in-detroit-a-case-of-selling-art-and-selling-out.html?_r=0

 The following two arts Assemblies, "The Performing Art in American Society" (1977) and "The Arts and Public Policy in the United States" (1984) were both chaired by W. McNeil Lowry, the Ford Foundation Vice-President and head of its Arts and Humanities program who helped shape the arts paradigm the 92nd Assembly was addressing. The meetings brought together high arts bureaucrats, scholars, critics, and artists, some of whom played organizational roles in their companies, such as Dance Theater of Harlem Founder Arthur Mitchell and Arena Stage Producing Director Zelda Fichandler (1977); Alberta Arthurs, longtime Actors Theatre of Louisville Director Jon Jory; and Laura Dean of Laura Dean Dancers (1984). The very brief reports published by both meetings reveal an increasing understanding of the need for a cogent and strategic national arts infrastructure, one that does not assume that the current leveraging model will last. The 1977 meeting calls for greater support for the National Endowment for the Arts and that public and private agencies should cooperate to provide greater support for artists. Both address the ways that arts policy can counter marginalization of arts and culture; they also both

presume artists work within institutions under the patron state model. In the latter meeting, Lowry calls for a policy specialization: "Perhaps only in the last decade have most professionals in the arts realized they could not leave policy, or even advocacy, to lay perceptions." W. M. Lowry, ed., *The Arts and Public Policy in the United States* (Englewood Cliffs, NJ: Prentice-Hall, 1984), 3. See also W. M. Lowry, ed., *The Performing Arts in American Society* (Englewood Cliffs, NJ: Prentice-Hall, 1977). About Lowry, see Sheila McNerney Anderson, "The Founding of Theatre Arts Philanthropy in America: W. McNeil Anderson, 1957–65," in *Angels in American Theatre: Patrons, Patronage, and Philanthropy*, ed. R. A. Schanke (Carbondale: Southern Illinois University Press), 8.

21. The American Assembly, "The Arts & Government: Questions for the Nineties" (Arden House, Harriman, NY: Columbia University, 1990), 3.
22. Bauerlein and Grantham, *National Endowment for the Arts*, 95–97.
23. The American Assembly, "The Arts & Government," 7. For a longer discussion on the legality of the NEA's actions and the role of the government as patron, see Kevin Sullivan (1991) "Freedom, Funding, and the Constitution," in *Public Money & the Muse: Essays on Government Funding for the Arts*, ed. S. Benedict (New York: W.W. Norton & Company, 1991), 80–95.
24. After the disclaimer, the "Preamble" observes that the participants "met in the immediate aftermath of the most serious challenge to direct federal support of the arts in the twenty-five year history of the National Endowment for the Arts." The American Assembly, "The Arts & Government," 6.
25. Arthurs is listed as having participated in two previous meetings. See "The Arts & Government," 6. See also, "The Arts and Public Policy in the United States," 8–9.
26. Bauerlein and Grantham, *National Endowment for the Arts*, 85–86.
27. Arthurs and Mortimer provided details on the meeting in interviews. In addition, Mortimer provided original documents, including discussion questions and previous reports. Unless noted otherwise, all comments related to David Mortimer, "Personal Interview with Author," July 9, 2013.
28. The report also lists all funders. The American Assembly (1997) "The Arts and the Public Purpose," 1.
29. Cherbo and Wyszomirski, eds. *The Public Life of the Arts in America* and Joni Maya Cherbo, Ruth Ann Stewart, and Margaret Jane Wyszomirski, eds. *Understanding the Arts and Creative Sector in the United States* (New Brunswick, NJ: Rutgers University Press, 2008).
30. Margaret Jane Wyszomirski, "Policy Communities and Policy Influence: Securing a Government Role in Cultural Policy for the Twenty-First Century," in *The Politics of Culture*, ed. Gigi Bradford, Michael Gary, and Glenn Wallach (New York: The New Press, 2000), 100.
31. Gary O. Larson, *American Canvas: An Arts Legacy for Our Communities* (Washington, DC: National Endowment for the Arts, 1997).
32. Also David Henry Hwang and Country Music Foundation Director Bill Ivey. President's Committee on the Arts and Humanities, *Creative America: A Report to the President* (Washington, DC: President's Committee on the Arts and Humanities, 1997), 3. http://files.eric.ed.gov/fulltext/ED413276.pdf. A version of the `document is also reprinted in President's Committee on the Arts and the Humanities, "Creative America: A Report to the President," in *The Politics of Culture*, ed. Gigi Bradford, Michael Gary, and Glenn Wallach (New York: The New Press, 2000).

33. The coupling of work and "virtue" for the sake of society's well-being is long-standing in modern Western tradition. Protestants connected redemption to productive "labor on earth" that benefited the public good. British philosopher John Locke saw labor of nature as a testimony to people's commitment to the earthly existence. Marx used Locke's "labor theory of value" to rationalize revolution, since human beings deserved full and fair shares of the products of their labors. Benjamin Barber, *A Place for Us: How to Make Society Civil and Democracy Strong* (New York: Hill and Wang, 1998), 130. In the revised version of an essay authored and circulated as preparatory materials for the 92nd Assembly, Wyszomirski quotes Barber's unpublished 1996 essay, "Serving Democracy by Serving the Arts," to affirm the equating of arts and democratic, publicly good values: "the arts have [...] the capacity simultaneously to offer expression to the particular identities of communities and groups (including those that feel excluded from the dominant community's space) and to capture commonalities and universalities that tie communities and groups together into a national whole." "Raison D'etat, Raisons Des Arts," in *The Public Life of the Arts in America*, 68.
34. "The Arts and the Public Purpose," 9. Wyszomirski acknowledges the meeting's connection to the "Declaration of Independence," in "Raison D'etat, Raisons Des Arts," 51.
35. Foucault, "What Is an Author?" 133.
36. American Assembly (1997), "The Arts and the Public Purpose," 9.
37. Ibid.
38. Della Pollock refers to performative writing as a type of writing that historicizes relationships among "author-subjects, reading subjects, and subjects written-read." Pollock considers performative writing both "evocative" and "citational." See "Performing Writing" in *The Ends of Performance*, eds. Jill Lane and Peggy Phelan (New York, NY: New York University Press), 79–90.
39. Tim Miller, "'The Artists Declaration of Independence,' July 4, 1990," *1001 Beds: Performances, Essays, and Travels*, ed. Glen Johnson (Madison: University of Wisconsin Press, 2006), 101–103.
40. James Bau Graves traces the term "cultural democracy" to Rachel Davis Dubois, an educator in the early twentieth century whose "three domains" of democracy included forms of cultural expression, as well as political rights and economic accessibility. In *Cultural Democracy*, 10–11.
41. See also Karen Finley, *A Different Kind of Intimacy: The Collected Writings of Karen Finley*. (Philadelphia: Running Press, 2000).
42. Taylor describes scenarios as "meaning making paradigms that structure social environments, behaviors, and potential outcomes." *The Archive and the Repertoire* (Durham, NC: Duke University Press, 2003), 28.
43. Ibid., 29–32.
44. The American Assembly (2014a), http://americanassembly.org/about, access date May 6, 2014.
45. Mortimer, Interview with Author, July 9, 2013.
46. To recall scenarios, Taylor notes that we must first "conjure up a physical location...which denotes intentionality, artistic or otherwise," 29.
47. Arden House was sold by Columbia University in 2005. See American Assembly, "Timeline," http://americanassembly.org/american-assembly-timeline, access date May 6, 2014.

48. De Certeau elaborates on his definition of space by referring to it as "composed of intersections of mobile elements. [Space] is in a sense actuated by an ensemble of movements deployed within it." *The Practice of Everyday Life*, trans. Steven Rendall (Berkeley: University of California Press, 1984), 117. Taylor also quotes de Certeau's use of the phrase, "practiced place," in *The Archive and the Repertoire*, 29.
49. Travis Beal Jacobs, *Eisenhower at Columbia* (New Brunswick and London: Transaction Publishers, 2001), 245.
50. Jacobs, 247–249. Arthurs eloquently describes Eisenhower's unique vision in a postscript to a book about Eisenhower and the American Assembly. See Travis Beal Jacobs, *Dwight D. Eisenhower and the Founding of the American Assembly* (New York: American Assembly, 2004).
51. Jacobs, *Eisenhower at Columbia*, 256.
52. For more than three decades, arts-related reports and studies have argued the arts are critical to public policy. See Caroline Violettte and Rachel Taqqu, eds. *Issues in Supporting the Arts: an Anthology Based on the Economic Impact in the Arts Conference* (Ithaca, NY: Graduate School of Business Administration, Cornell University, 1980).
53. Taylor observes that "scenarios, by encapsulating both the setup and the action/behaviors, are formulaic structures," 32.
54. The meeting process can also be found in The American Assembly, "The Arts & Government," 21.
55. Taylor, 31.
56. Ibid., 28.
57. The American Assembly, "The Arts & Government," 6.
58. Taylor, 30.
59. Wyszomirski, "Raison d'etat, Raisons des Arts," in *The Public Life of the Arts in America*, edited by Joni Maya Cherbo and Margaret Jane Wyszomirski (New Brunswick, NJ: Rutgers University Press, 2000), 53.
60. Harry Hillman Chartrand, "Toward an American Arts Industry," in *The Public Life of Art in the United States*, 22–24. See also Chartrand, "The Arts and the Public Purpose: The Economics of It All," in *The Journal of Arts Management, Law, and Society* 28, no. 2 (1988), 5.
61. Anne M. Galligan and Neal Alper (2000), "The Career Matrix: The Pipeline for Artists in the United States," in *The Public Life of Art in the United States*, 171.
62. Ibid., 192.
63. The meeting agenda, which was provided to me by David Mortimer, shows that the participants participated in panel discussions and breakout groups that follow the teleology of the final report, which I discuss later in this chapter. "The 92nd American Assembly, Meeting Agenda, 29 May-1 June 1997."
64. Foucault notes that "discourses are objects of appropriation." In this manner, they instantiate and participate in multiple other discursive operations, "What is an Author?" 109–110.
65. Taylor, 31.
66. Taylor notes that "the scenario forces us to situate our relationship to it, as participants, spectators, or witnesses." Ibid., 32.
67. Ibid., 31.
68. "The Arts and the Public Purpose," 10.

69. Joni Maya Cherbo, Harold Vogel, and Margaret Jane Wyszomirski, "Towards and Arts and Creative Sector," in *Understanding the Arts and Creative Sector in the United States*, ed. J. M. Cherbo, Ruth Ann Stewart, and Margaret Jane Wyszomirski (New Brunswick, NJ: Rutgers University Press, 2008), 9–27.

70. "The Arts and the Public Purpose," 10.

71. Grant Kester (1998), "Rhetorical Questions: The Alternative Arts Sector and the Imaginary Public," in *Art, Activism, and Oppositionality: Essays from Afterimage*, ed. Grant Kester (Durham, NC: Duke University Press), 111–113.

72. Justin Lewis, *Art, Culture and Enterprise: The Politics of Art and the Culture Industries* (New York: Routledge, 1999). See also Justin Lewis, "Designing a Cultural Policy," in *The Politics of Culture*, eds., Gigi Bradford, Michael Gary, and Glenn Wallach (New York: The New Press, 2000), 79–93.

73. "The Arts and the Public Purpose," 9–11.

74. Ibid., 9–14.

75. Ibid., 15.

76. Admittedly, the meeting's structure and quick turnaround might have contributed to the repetition within the document. Since the drafting committee was working quickly to cohere the separate assignments and bring through-line to the work, repetition offered a means to keep the thesis in check. Given the emphatic voice of the document and its aspirations to bring about change, the rhetorical repetitiveness can be also attributed to the planners' motivation to hit the point home. The document not only elucidates between purpose and function but also argues for the terms' traction. Ibid., 18.

77. Pierre Bourdieu posits that "economic capital is at the root of all the other types of capital" even in other forms of capital, which may through interaction effectively conceal its foundational and motivational role there. "The Forms of Capital," in *Handbook of Theory and Research for the Sociology of Education*, ed. John G. Richardson (New York: Greenwood Press, 1986), 252.

78. "The Arts and the Public Purpose," 21.

79. Ibid., 21–22.

80. Ann Markusen and Ann Gadwa, "Creative Placemaking: Executive Summary" (Washington, DC: National Endowment for the Arts, 2010), 3.

81. "The Arts and the Public Purpose," 23–24.

82. Stephanie Strom, "An Artist's Grant That Even Pays for Glasses," *The New York Times*, October 10, 2007, http://www.nytimes.com/2007/10/10/arts/design/10gran.html

83. Bourdieu, 249.

84. Ibid., 248.

85. "The Arts and the Public Purpose,", 26–27.

86. Maria Rosario Jackson, "Art and Cultural Participation," in *Understanding the Arts and Creative Sector in the United States*, 94–95. See also the Surdna Foundation's "Community Engaged Design" program as one example. http://www.surdna.org/what-we-fund/thriving-cultures/135-thriving-cultures/476-community-engaged-design.html, accessed May 5, 2014.

87. "The Arts and the Public Purpose," 27–28.

88. See "OntheBoardsTV," a subscription service created by On the Boards theatre in 2010, http://www.ontheboards.tv, accessed May 5, 2014. See also "Howl Round TV," a project of Howl Round, a Theater Commons, http://www.livestream.com/newplay/, accessed May 5, 2014.

89. "The Arts and the Public Purpose," 28.
90. Ibid.
91. "Strategic National Arts Alumni Project," University of Indiana Center for Post-Secondary Research, http://snaap.indiana.edu/about/staff.cfm, accessed May 5, 2014.
92. "Workshops," The Creative Capital Foundation, "Workshops," http://creative-capital.org/pdp/workshops, accessed May 5, 2014.
93. Bourdieu, 248.
94. "The Arts and the Public Purpose," 31.
95. Maria Rosario Jackson et al., *Investing in Creativity: A Study of the Support Structure for U.S. Artists* (Washington, DC: The Urban Institute, 2003). Ann
96. Margaret C. Ayers, "Trends in Private Sector Giving for Arts and Cultural Exchange," *Grantmakers in the Arts Reader* 21, no. 3 (2010), http://www.giarts.org/article/trends-privatesector-giving-arts-and-cultural-exchange, accessed August 14, 2014. See Alicia Akins, "Nationalism and Government Support for the Arts," May 14, 2014, http://createquity.com/2014/05/nationalism-and-governmentsupport-of-the-arts.html, accessed August 15, 2014. See also The International Federation of Arts Councils and Culture Agencies (IFACCA), "Plans Underway for an International Database of Cultural Policy Profiles," 10 December 2010, http://www.ifacca.org/announcements/2010/12/02/plans-underway-international-database-cultural-pol/, accessed August 15, 2014.
97. Bourdieu, 249.
98. "The Arts and the Public Purpose," 32.
99. See Americans for the Arts, http://www.americansforthearts.org.
100. Bourdieu, 249.
101. Roberto Bedoya, *US Cultural Policy: Its Politics of Participation, Its Creative Potential* (New Orleans: The National Performance Network, 2004). See also Jackson (2012), *Developing Artist-Driven Spaces in Marginalized Communities: Reflections and Implications for the Field* (Washington, DC: Urban Institute).
102. Ann Markusen, "Diversifying Support for Artists," *Grantmakers in the Arts Reader* 24, no. 3 (2013): 27, http://www.giarts.org/article/diversifying-support-artists, access date September 18, 2013.
103. Bedoya, 4, 8.
104. Ibid., 6–8.
105. Ibid.
106. Holly Sidford (2011), *Fusing Arts, Culture, and Social Change* (Washington, DC: National Commitee for Responsible Philanthropy), 1.
107. Arthurs, Interview.
108. Bedoya, 4.
109. Markusen, "Diversifying Support for Artists."
110. Arthurs, Interview.
111. The American Assembly, "Deals and Ideals: For-Profit and Not-for-Profit Arts Connections" (Arden House, Harriman, NY: Columbia University, 1999).
112. The American Assembly, "Art & Intellectual Property: Final Report of the One-hundredth American Assembly" (Arden House, Harriman, NY: Columbia University, 2002).
113. Again, the meeting's attendees would be acting presciently. Within eleven months, Congress would pass the Sonny Bono Copyright Term Extension Act of 1998. Opponents to the legislation's shaping and passing had been

heavily lobbied by the corporate arts interests, in particular the Disney Corporation, arguing that its benefits would primarily support corporate interests over the greater public good by privileging the power of one sector. Steve Zeitlin, "Strangling Culture with a Copyright Law," *New York Times*, April 25, 1998. http://query.nytimes.com/gst/fullpage.html

114. The American Assembly, "The Creative Campus: Final Report of the One Hundred and Fourth American Assembly" (Arden House, Harriman, NY: Columbia University, 2004).

115. "The Arts and the Public Purpose," 11.

3 New Work Now! The Austin New Works Theatre Community (2012)

1. Bonnie Cullum, with Katie Pearl, and JD Nasaw, "Cliffs Notes of Consensus Decisions for the New Works Community Mellon Grant." Unpublished document, circulated via e-mail October 14, 2009. The document makes the following claim on its authorship: Draft 10/6/09 submitted by Bonnie Cullum; Draft 10/12/09 revised by Katie Pearl and JD Nasaw. I cite Heather Barfield as a coleader, because her name is appended to Pearl's announcement of the award on October 10, 2010.

2. The details of the contract were shared with me by Heather Barfield, Interview with Author, March 19, 2014.

3. Austin New Works Theatre Community, "The Austin New Works Theatre Community: Vision and Strategic Plan." Submitted to the Andrew W. Mellon Foundation, January 17, 2013.

4. Richard Florida, *The Rise of the Creative Class: And How It's Transforming Work, Leisure, Community, and Everyday Life* (New York: Basic Books, 2002).

5. In my interviews with many of the plan's leaders, as well as community members, the closer working relationship is mentioned as the first benefit. For the website, see www.neworksaustin.com, accessed March 21, 2014.

6. Michel de Certeau, *The Practice of Everyday Life* , trans. Steven Rendall (Berkeley: University of California Press, 1984), 36–37.

7. Ibid., 37.

8. Ibid., 35–36.

9. Among the recommendations of "The Arts and the Public Purpose" (1997), a report produced by the 92nd American Assembly, is the call for "creative leadership" to support the development of a new arts policy paradigm. (Arden House, Harriman, NY: Columbia University, 1997), 34.

10. The phrase "live music capital of the world..." was adopted by the city leaders in 1991, when research revealed that Austin boasts more live music venues per capita than any state in the nation. The transposition of the nation to the world reflects Texas's outsized ego. See "The Austin Relocation Guide," accessed December 14, 2013. http://www.austinrelocationguide. com/2012/Live-Music-Capital-of-the-World/.

11. Katie Pearl, Correspondence with Author, November 12, 2013.

12. Diane Ragsdale, Correspondence with Author, April 15, 2014.

13. David Dower, *The Gates of Opportunity* (New York: The Andrew W. Mellon Foundation, 2009), 2. Accessed December 8, 2013. http://www.mellon.org

/grant_programs/programs/performing-arts/new-plays-initiative. Dower serves as the Director Artistic Programs at ArtEmerson. See "About," http://howlround.com/authors/david-dower.

14. Ibid., 2. Dower notes that he conducted research in 2006 and completed his first draft in 2007. He revised the report in 2009. Correspondence with Author, July 12, 2014.

15. Ibid., 4.

16. Ibid., 10–11.

17. Both Ragsdale and Dower recall having met with Austin artists at the start of their process; although Dower notes that they came on separate trips. Ragsdale, Correspondence. Dower, Correspondence.

18. Dower, *The Gates of Opportunity*, 2.

19. According to Diane Ragsdale and theatre director Katie Pearl, who served as the Austin project's initial community liaison, an advisor to the foundation visited Austin in 2009 and conducted an initial strategic planning meeting. The group assembled determined shared long- and short-term goals, identified and labeled categories for intervention, and made rules for how they would work together. Based on this work, the group was invited to write a proposal. Pearl, e-mail to author, November 12, 2013. Pearl's e-mail to the community on July 27, 2011 (Weekly Update #33) supports this. Ragsdale confirms this assessment.

20. The Mellon's website offers a picture of how it prioritizes institutional funding: "Although the Foundation does not confine its support to large organizations with national visibility, it does seek to support institutions that contribute to the development and preservation of their art form, provide creative leadership in solving problems or addressing issues unique to the field, and which present the highest level of institutional performance." See "Performing Arts," The Andrew W. Mellon Foundation, accessed December 8, 2013. http://www.mellon.org/grant_programs/programs/performing-arts/arts.

21. "New Plays Initiative," accessed December 8, 2013. http://www.mellon.org/grant_programs/programs/performing-arts/new-plays-initiative.

22. The special meeting called as a result of discussions at the 2001 TCG Conference. See Leonard Jacobs, "In Focus: TCG Confab: 'New Works, New Ways'." *Back Stage—the Performing Arts Weekly* 43.25 (2002): 4–5.

23. Kevin F. McCarthy, Arthur Brooks, Julia Lowell, and Laura Zakaras, *The Performing Arts: Trends and Their Implications* (Santa Monica, CA: RAND Corp., 2001), xvii–xxv.

24. Todd London, with Ben Pesner and Zannie Giraud Voss, *Outrageous Fortune* (New York: Theatre Development Fund, 2009). Ben Pesner also contributed to the revision of Dower's study. Ragsdale, Correspondence with Author.

25. David Dower notes that Duke contributed substantial support to "From Scarcity to Abundance" through its National Sectors Projects program. After the meeting, with Duke support, HowlRound moved to Emerson College. Dower notes that Mellon's support contributed to the development of the American New Voices Play Institute at Arena stage. Dower, Correspondence. All of these outcomes demonstrate that "the gates of opportunity" were wide open to original theatre artists at the start of the Austin artists' process. See "From Scarcity to Abundance: Capturing the Moment for the New Work Sector." Accessed March 14, 2014, http://www.arenastage.org/artistic-development/past-projects/convenings/new-work/.

26. Diane Ragsdale, *In the Intersection* (Boston: Center for Theatre Commons), 2011.
27. According to Pearl's e-mail to the community on July 27, 2011 (Weekly Update #33), the foundation appreciated that the work represented the collective investments of the community.
28. Dower, *The Gates of Opportunity,* 2–3.
29. "Focus on the dreamy dream" was a guiding prompt coined by Madge Darlington, one of the founding CoArtistic Producing Directors of Austin's Rude Mechs Theatre Company, when she led the community's retreat from January 29–30, 2011. Correspondence with Author, March 21, 2014.
30. Christi Moore, Interview with Author, March 13, 2014.
31. Austin New Works Theatre Community, "Vision and Strategic Plan," 3.
32. Barfield, Interview with Author, March 19, 2014.
33. Ibid. Bonnie Cullum states the consensus approach was actually the critical term for her participation; its adoption by the group began with a workshop taught by her on the process. Bonnie Cullum, Interviews with Author, April 17, 2013 and November 25, 2013. Barfield notes that artists who took leadership roles and participated in the retreat were compensated for their participation.
34. Katie Pearl, "Mellon Grant Update!" E-mail, October 10, 2010.
35. Caroline, Reck, "Weekly Update #80 (7–4 to 7–10–10)," July 10, 2010.
36. Caroline, Reck, "Weekly Update #111 (7–4 to 7–10–10)," July 10, 2010.
37. Barfield recalls that newcomers to meetings could effectively stall meetings by asking for all relevant information. In other words, keeping people up-to-date was a tremendous task for a time-based process.
38. Bonnie Cullum, Interview, April 17, 2013.
39. Barfield, Interview.
40. Austin New Works Theatre Community, "Vision and Strategic Plan," Austin, TX, 7–14. Although previous drafts were dated, the final document is undated. The scenic cooperative was funded in 2011 as part of a "Do It!" grant from Theatre Communications Group, which is funded by the MetLife Foundation. See http://www.tcg.org/grants/aha/aha_recipients.cfm, accessed March 21, 2014.
41. See Ann Markusen et al., *Crossover: How Artists Build Careers across Commercial, Nonprofit and Community Work* (Minneapolis: Humphrey Institute of Public Affairs, University of Minnesota, 2006), 11–20.
42. Richard E. Caves refers to "contract theory" as "a relatively new subfield of economics" and implicates its concerns—measuring investment to reward— as the core dynamic in measuring artistic production. See *Creative Industries: Contracts between Art and Commerce* (Cambridge, MA: Harvard University Press, 2000), 11.
43. Ibid.
44. In other words, the contract did not reflect *"bounded rationality,"* the anticipation of all costs and rewards in the final contract. Ibid., 12.
45. Ibid., 1–6.
46. *Create Austin: Cultural Master Plan* (Austin, TX: City of Austin Economic Growth & Redevelopment Services Office, Cultural Affairs Division, 2009), 9.
47. See Austin Creative Alliance, accessed March 14, 2014. http://www.austin-creativealliance.org/about-austin-creative-alliance/.

48. De Certeau, 36.
49. Michel Foucault, *The History of Sexuality: The Will to Knowledge* (London, Penguin, 1976), 63.
50. Austin New Works Theatre Community, 4.
51. Dower, *The Gates of Opportunity*, 8.
52. Kevin F. McCarthy, Arthur Brooks, Julia Lowell, and Laura Zakaras, xvii–xxv.
53. De Certeau, 35.
54. In several distinct ways, the group's work replicates the strategies of *Investing In Creativity* (2003), which took three years and a team of researchers to develop. The plan's first area of "Concentrated Impact," which is titled "Fulcrum: Size, Scale, Influence," addresses *Investing*'s concerns of "Validations," which focuses on how artists are valued by communities, and "Demands and Markets," which measures the reception of work. The "Grid: Facilitated Communications and Information Exchange" section essentially divides its analysis and planning among *Investing*'s focus on at-risk "Communities and [embodied] Networks" and "Information" resources for artists that are emerging. The final section "Resources Center: Economies of Collaboration, Shared Resources and Partnerships" speaks largely to what *Investing* refers to as "Material Supports," which includes space development, fee structure, etc. I note there are fine distinctions, too: the New Works document puts health insurance under the "Fulcrum" section; the "Grid" section includes some focus on audience development. Moreover, the final document fails to include one of *Investing in Creativity*'s key areas of concern: artist training and professional development. This section was actually proposed by the Austin artists in 2010, but its absence from the final document may suggest that the learning curve experienced by the artists reaffirmed a learn-by-doing ethos, common to arts practice. Jackson, et. al., 11.
55. Grant Kester, "Rhetorical Questions: The Alternative Arts Sector and the Imaginary Public," in *Art, Activism, and Oppositionality: Essays from Afterimage*, ed. Grant Kester (Durham, NC: Duke University Press, 1998), 111–113. For more on the NEA's Expansion Arts program, see also Ruth Ann Stewart, "The Arts and Artist in Urban Revitalization," in *Understanding the Arts and Creative Sector*, ed. Joni Maya Cherbo, Ruth Ann Stewart, and Margaret Jane Wyszomirski (New Brunswick, NJ: Rutgers University Press, 2008), 105–128.
56. Artists' participation as subjects of policy resonates with Foucault's notion that culture makes subjects of human beings. See Michel Foucault, "Nietzsche, Genealogy, History," in *Language, Counter-Memory, Practice: Selected Essays and Interviews*, ed. D. F. Bouchard (Ithaca: Cornell University Press, 1977), 163.
57. Observing in the plan that almost all of the participants make their living through "other employment," the members of the Austin New Works Theatre Community foreground the notion that "time is a precious commodity that has to be split between artistry and administration." This assertion appears to shape the proposed organizational model later in the document, when they propose an organizational model with a "low level of sustenance and maintenance." Austin New Works Theatre Community, 4, 48.
58. Joni Maya Cherbo and Margaret Jane Wyszomirski, "Mapping the Public Life of Arts in America," in *The Public Life of Arts in America*, ed. Joni Maya Cherbo and Margaret Jane Wyszomirski (New Brunswick, NJ: Rutgers University Press, 2000), 15–17.

59. As a Theatre Commons, HowlRound "content is free cultural work available to you under a Creative Commons Attribution 4.0 International License (CC BY 4.0)." See "HowlRound: About," http://www.howlround.com/about. Accessed May 18, 2014.

60. Although *Grantmakers in the Arts'* principle constituency is philanthropy and intermediary organizations that support artists, its *Reader* is circulated widely on the Internet. One can subscribe to a print version. To support dialogue between those who study artists and those who practice making art, the *Reader* could benefit from crossover and distribution through HowlRound, which sends out daily e-mails, with artists' commentary.

61. Ann Markusen and Amanda Johnson, *Artists' Centers: Evolution and Impact on Careers, Neighborhoods, and Economies* (Minneapolis: Humphrey Institute of Public Affairs, University of Minnesota, 2006), 11.

62. Ibid.

63. Ibid., 12.

64. Austin New Works Theatre Community, 4.

65. Markusen, "Diversifying Support for Artists." *Grantmakers in the Arts Reader,* September 18, 2013, http://wwwgiarts.org/article/diversifying-support-artists. See also Joli Jensen, *Is Art Good for Us?* (Lanham, MD: Rowan and Littleford, 2002).

66. Markusen and Johnson, 14.

67. See Maria Rosario Jackson, *Developing Artist-Driven Spaces in Marginalized Communities: Reflections and Implications for the Field* (Washington, DC: Urban Institute, 2012).

68. Markusen and Johnson, 14.

69. "New Works Austin: A Collective of Performance Based Companies Dedicated to Creating New Work in Austin," accessed December 10, 2013. http://newworksaustin.com.

70. Austin New Works Theatre Community, "Vision and Strategic Plan" (Austin, TX), 4.

71. Maria Rosario Jackson, "Art and Cultural Participation," in *Understanding the Arts and Creative Sector in the United States,* ed. Joni Maya Cherbo, Ruth Ann Stewart, and Margaret Jane Wyszomirski (New Brunswick, NJ: Rutgers University Press, 2008), 96.

72. Ann Markusen and Ann Gadwa, *Creative Placemaking: Executive Summary* (Washington, DC: National Endowment for the Arts, 2010).

73. Markusen and Johnson, 14.

74. See Fractured Atlas, http://www.fracturedatlas.org.

75. Robert Faires, "In Memoriam: Phyllis Slattery," *The Austin Chronicle.* December 19, 2012. http://www.austinchronicle.com/blogs/arts/2012–12-19/in-memoriam-phyllis-slattery/, accessed December 7, 2013. While the Dance Umbrella's website is currently not active, its Facebook page remains a site where dancers can post information about upcoming opportunities.

76. See http://www.hydeparktheatre.org.

77. Adam Burnet and Jud Knudsen, "The Phantom Seats of Philanthropy," on HowlRound, November 29, 2013, accessed December 14, 2013. http://www.howlround.com/the-phantom-seats-of-philanthropy. HowlRound's host organization, The Center for Theatre Commons, was founded by David Dower, Polly Carl, Vijay Mathew, and Jamie Gahlon to give artists a greater

voice in the making of theatre in the US. See "About" accessed December 14, 2013. http://www.howlround.com/about.

78. In the article, the artists recount how they and collaborator Nick Koster have emptied their savings to make a piece of theatre (*Nightmares, a Demonstration of the Sublime*) that they have taken nationwide, and through which they have learned to appreciate the joy of engaging audiences without the concerns of responding to a funder. Burnett and Knudsen.

79. Joni Maya Cherbo, Harold Vogel, and Margaret Jane Wyszomirski, "Towards and Arts and Creative Sector," in *Understanding the Arts and Creative Sector in the United States*, ed. Joni Maya Cherbo, Ruth Ann Stewart, and Margaret Jane Wyszomirski (New Brunswick, NJ: Rutgers University Press, 2008), 9–27.

80. Sultan is most noted for being a guitar player in the 1990s Austin-based indie band, Poi Dog Pondering.

81. I apparently will succumb to a respiratory infection in 2038, but not, hopefully, before enjoying many nights of theatre as rich as *Adam Sultan* and in a packed house.

82. Steve Moore, Correspondence with Author, March 4, 2014.

83. See Jill Dolan, *Utopia in Performance* (Ann Arbor: University of Michigan Press, 2008).

84. http://rudemechs.com/shows/history/index.htm.

85. In the video of *The Method Gun*, which can be found at *OntheBoardstv*, Thomas Graves introduces the work and its theme, but not before thanking the foundations who are supporting the work.

86. Barfield, Interview.

87. Fusebox Festival, thinkEAST Living Charette, Proposal for funding, March 19, 2014.

88. See McCarthy, Kevin F., Arthur Brooks, Julia Lowell, and Laura Zakaras, *The Performing Arts*.

89. Vijay Mathew and Polly Carl, "Culture Coin: A Commons-Based Complementary Currency for the Arts and its Impact on Scarcity, Virtue, Ethics, and the Imagination," in Aritivate: a Journal of Entrepreneurship in the Arts 2.3 (2003), http://www.artivate.org/?p=531.

90. Ibid.

4 Accounting for Capital: The Creative Capital Foundation (1999–Present)

1. Judith H. Dobrzynski, "Private Donors Unite to Support Art Spurned by Government," *The New York Times*, May 3, 1999, E1.
2. Ibid.
3. Dobrzynski, "Private Donors."
4. The term "moral majority" is credited to fundamentalist preacher and leader Jerry Falwell, who conducted "Moral Majority Crusades" throughout the 1980s. See Susan Friend Harding, *The Rise of Jerry Falwell* (Princeton: Princeton University Press, 2000), 154.
5. Ibid.
6. See Abigail Guay, "In Support of Individual Artists," *Grantmakers in the Arts Reader* 23.1 (2012), http://www.giarts.org/article/support-individual-artists.

7. Dobrizynski, "Private Donors."
8. Ibid.
9. Dobrzynski, "Private Donors."
10. Michel Foucault, "What Is an Author?" in *The Foucault Reader*, ed. Paul Rabinow (New York: Pantheon Books, 1984), 113.
11. Dobrzynski, "Private Donors."
12. Lisa Duggan, *The Twilight of Equality: Neoliberalism, Cultural Politics, and the Attack on Democracy* (Boston: Beacon Press, 2003), 9–10.
13. Margaret Jane Wyszomirski, "Raison d'état, Raisons des Arts: Thinking About Public Purposes," in *The Public Life of the Arts in America*, ed. Joni Maya Cherbo and Margaret Jane Wyszomirski (New Brunswick, NJ: Rutgers University Press, 2000), 53.
14. John Kreidler, "Leverage Lost: Evolution in the Nonprofit Arts Ecosystem," in *The Politics of Culture: Policy Perspectives for Individuals, Institutions, and Communities*, ed. Gigi Bradford, Michael Gary, and Glenn Wallach (New York: New Press, 2000), 131.
15. Ruby Lerner, "Policy, Prisons and Pranks: Artists Collide with the World," *Grantmakers in the Arts Reader* 24, no. 1 (2014),, http://www.giarts.org/article/policy-prisons-and-pranks-artists-collide-world. The text was first delivered as a lecture for the ArtsFwd National Innovation Summit for Arts & Culture, Denver, CO. October 21, 2013, Posted November 7, 2013., http://blog.creative-capital.org/2013/11/ruby-lerner-policy-prison-pranks/.
16. Pierre Bourdieu, "The Forms of Capital," in *Handbook of Theory and Research for the Sociology of Education*, ed. John G. Richardson (New York: Greenwood Press, 1986), 243–252.
17. In the *"embodied state,"* cultural capital is an acknowledged skillset or intellectual accomplishment. In the *"institutionalized state,"* capital can also be channeled through a specific form of training or accreditation. Cultural capital in the *"objectified state"* attaches itself to cultural goods, such as books or films, which may not necessarily have to be produced by the author, but can be cited by him as relative to his work. Bourdieu, "The Forms of Capital," 243–247. Emphases in original.
18. Lewis Hyde, "Being Good Ancestors: Reflections in Arts Funding since World War II," *Kenyon Review* 3.1 (2008), 14–16. See also Felda Hardymon and Ann Laymon, "Creative Capital: Sustaining the Arts," in *Harvard Case Study* (Cambridge, MA: Harvard University, 2010), 4.
19. Ruby Lerner, Interview with Author, May 15, 2014. Gillies credits Lerner with structuring the organization: "Ruby took my skeleton idea of Creative Capital and gave it flesh and blood and a heart," notes Gillies. Hardymon and Laymon, 4.
20. Lerner, Interview.
21. Caron Atlas, Helen Brunner, and Kathie DeNobriga, *At the Intersection: A Programmatic Assessment of Creative Capital's Support to Artists* (New York: Creative Capital Foundation, 2005), 6–7.
22. Creative Capital, *Funding Innovation: An Overview of the First Five Years* (New York: Creative Capital Foundation, 2004), 2.
23. Ibid.
24. Lauren Berlant, *The Queen of America Goes to Washington City: Essays on Sex and Citizenship* (Durham, NC: Duke University Press, 1997), 6–7.

25. Ruby Lerner, "Policy, Prisons and Pranks." In *A Critique of Postcolonial Reason*, cultural theorist Gayatri Chakravorty Spivak assesses the "epistemic violence" that happens within capital transactions. (Cambridge, MA: Harvard University Press, 1999).

26. Phelan suggests the creation of credit union into which wealthier artists might contribute to funds to suppport other artists. See "Serrano, Mapplethorpe, the NEA, and You," *TDR: The Drama Review: The Journal of Performance Studies* 34.1 (1990), 11.

27. Lerner, Interview.

28. Judith H. Dobrzynski, "1,810 Artists Seek Grants from a New Foundation," *The New York Times*, August 25, 1999, http://www.nytimes.com/1999/08/25/arts/1810-artists-seek-grants-from-a-new-foundation.html. Accessed May 18, 2014.

29. Judith H. Dobrzynski, "New Arts Foundation Flooded with Grant Applications," *The Cleveland Plains Dealer*, August 26, 1999; "1,810 Artists Seek Grants from a New Foundation," *The New York Times*, August 25, 1999. *The Cleveland Plains Dealer* article repeats many of the same claims as a version published one day before in *The New York Times* and elaborates on it with Lerner's commentary.

30. Susanne McGee, "Invest in Artists, Not Art: This Nonprofit Has an All-New Approach to Philanthropy," *Barron's*, March 8, 2010, 8.

31. Steve Dollar, "Where Good Ideas Go to Live," *The Wall Street Journal*, January 11, 2013. A20.

32. See Felda Hardymon and Ann Leamon, "Creative Capital: Sustaining the Arts," in *Harvard Case Study* (Cambridge, MA: Harvard University, 2010).

33. Jessica Brater et al., " 'Let Our Freak Flags Fly': Shrek the Musical and the Branding of Diversity," *Theater Journal* 62.2 (2010): 152–153.

34. Lerner, "Policy, Prisons and Pranks." See also "Creative Capital: Our Artists," accessed May 5, 2014, http://creative-capital.org/artistprojects. For a description of The Yes Men, see "The Yes Men," accessed May 5, 2014, http://theyesmen.org. For Laurie Jo Reynolds work see "Creative Time Summit," accessed May 5, 2014, http://creativetime.org/summit/author/laurie-jo-reynolds/. Jae Rhim Lee's work has been featured on *Ted Talks*. See "My Mushroom Body Suit," July 2011, accessed May 5, 2014, http://www.ted.com/talks/jae_rhim_lee. Laura Poitra's work has been featured on *The Nation*. See " 'Nation' Exclusive: Edward Snowden and Laura Poitras Take on America's Runaway Surveillance State," an interview with James Bamford for the National Press Club, April 30, 2103, accessed May 5, 2014, http://www.thenation.com/article/179737/nation-exclusive-edward-snowden-and-laura-poitras-take-americas-runaway-surveillance-#

35. Brater, et al., 152–153.

36. Lerner, "Policy, Prisons and Pranks."

37. Peggy Phelan (1989) calls for a similar solution in "Serrano, Mapplethorpe, the NEA, and You," her contribution to a special comment section of *TDR*. In the article, Phelan asserts that "*the best response to offensive art is different, stronger art*" (emphasis Phelan). Phelan also prescribes an artist payback model that bears some relation to the Creative Capital model. See *TDR: The Drama Review: The Journal of Performance Studies* 34.1 (1990): 4–15.

38. Others included the Joe and Emily Lowe Foundation, the Joyce Mertz-Gilmore Foundation, and the Eli Broad Family Foundation, the Rockefeller

Foundation, as well as Soros. By the year's end, after the article, that number would nearly double, helped by the Gillies' institutional power and the pedigree of the donors. Dobrzynski, "Private Donors." The Creative Capital Foundation website notes that in 1999, it was funded by twenty-two start-up funders. For more, see http://creative-capital.org/aboutus/story/milestones.

39. Lerner, Interview.
40. Isabelle Graw, *High Price: Art between the Market and Celebrity Culture* (Berlin; New York: Sternberg Press, 2009), 15.
41. They included "Catherine R. Stimpson, Dean of the Graduate School of Arts and Science at New York University," and the multidisciplinary performance and recording artist Laurie Anderson. Other board members mentioned included Ronald Feldman, "the New York art dealer," and Louise A. Velazquez, a corporate executive from "a Silicon Valley company that is trying to engage the arts and high-tech in new ventures," as well as Lewis Hyde. Dobrzynski, "Private Donors." A complete list of the organization's board members can be found on the organization's website, http://creative-capital.org/aboutus/board. Accessed May 17, 2014.
42. Foucault ties a discourse's status to the cultural and institutional paradigm in which it circulates. Creative Capital's ties to high-status individuals affirmatively multiply its capital. "What Is an Author?" 107. The full list of Creative Capital Board Members can be found at http://creative-capital.org/aboutus/board.
43. McGee, 8.
44. Ibid.
45. Hilarie M. Sheets, "A Foundation That Means Business," *ARTnews* 109.1 (2010), 42.
46. Ibid.
47. Lerner, "Policy, Prisons, and Pranks."
48. Lerner, Interview.
49. Ibid.
50. Bourdieu, "The Forms of Capital," 242–243.
51. Lerner, Interview.
52. Ibid.
53. See "About Us," accessed September 24, 2014, creative-capital.org/aboutus/whatwedo. As an indication of Creative Capital's growth and command of its discourse consider that these categories were at one time listed as financial support, mediated access to consultants, strategic planning, and networking and training opportunities." Atlas, Brunner, and DeNobriga, *At the Intersection*, 1.
54. The Arts Writers Grants Program awards project-based funding directly to arts writers who write about contemporary visual art. It is the first program of its kind, and founded on two core beliefs: that arts writers are necessary and should be well paid. The Doris Duke Performing Artist Awards support professional and artistic development for individual artists in dance, theatre, and jazz. In addition to providing "access to Creative Capital's professional development services," this unrestricted grant funds long-term research projects, audience development, and matches "contributions to artists' retirement accounts." Finally, the MAP Fund is open to "artists, ensembles, producers and presenters" of contemporary performance who seek to create, produce, or present work that "embodies the spirit of exploration and deep inquiry." MAP has an open submission policy and a vested interest in funding work that engages with

"cultural difference" including "class, gender, generation, race, religion, sexual orientation or other aspects of diversity." See "Affiliated Programs," accessed September 24, 2014, http://creative-capital.org/aboutus/ancillary

55. Following an initial, individual orientation meeting with Creative Capital, the grantee becomes eligible for "Infrastructure Support" funds of $5,000 and receives an "invitation to attend the Annual Retreat and/or participation in the various iterations of the Professional Development Program (PDP)." Once a Grantee has participated in one or more of the following programs, "the Annual Artist Retreat; and/or Strategic Planning Program; and/or the Creative Capital Professional Development Retreat," she is availed of "Special Opportunities and Follow-up Funding as well as opportunities for special presentations on Creative Capital's website." "Apply," accessed September 9, 2013, http://creative-capital.org/ourprogram.

56. Ibid.

57. Lerner, Interview.

58. *The Archive and the Repertoire: Performing Cultural Memory in the Americas* (Durham, NC: Duke University Press, 2003), 16.

59. Battenfield also uses these steps in her account of grant writing and observes that successful grant writing follows from an artist's careful ongoing analysis of her own work, as well as her research and fit to the granting organizaiton. *The Artist's Guide: How to Make a Living Doing What You Love* (New York: Da Capo Press), 217–234.

60. Bourdieu, 247–249.

61. "Our Program," accessed October 6, 2013, http://creative-capital.org/ourprogram.

62. Lerner, Interview.

63. Creative Capital, *Funding Innovation*, 5.

64. Lerner, Interview.

65. See the award guidelines, accessed May 5, 2014, http://creative-capital.org/apply. In his opening chapter, Hyde introduces the concept of an "Indian gift" as a gift that grows through repeated exchange, which is an idea that was common among Native American people who lived in New England during the colonial era. As Hyde notes, upon receiving offerings, the English settlers had done the unthinkable and turned their gifts into commodities. Their failure to give back and give more generously, effectively keeping the cycle going and growing, prompted the native people to ask for their original gifts returned. *The Gift: Creativity and the Artist in the Modern World*, 2nd Ed. (New York: New York University Press, 1999), 3–5.

66. Lerner, Interview.

67. Ibid.

68. I took a one-day version of the PDP at the National Performance Network meeting in Miami in 2005 and a Core Curriculum intensive in San Antonio in 2009.

69. All of Creative Capital's workshops, as well as its pricing structure can be found at "Creative Capital: Our Workshops," accessed May 5, 2014, http://creative-capital.org/pdp/workshops

70. Lerner, Interview.

71. See http://thinaar.blogspot.com. Accessed May 5, 2014.

72. "About US: What We Do," Artists U, accessed October 6, 2013, http://artistsu.com/what-we-do/.

73. For information on *Making Your Life as an Artist*, see http://www.artistsu.org/making/.
74. Andrew Simonet has currently changed from a Co-Founding Artistic Director to "Co-Founder Emeritus" of Headlong Dance Theater, the company he founded in 1993 with David Brick and Amy Smith. Headlong Dance Theater. "History." Accessed October 6, 2013. http://headlong.org/about/. For Jackie Battenfield, visit http://www.jackiebattenfield.com. For Aaron Landsman, visit http://thinaar.com.
75. See "Our Artists," accessed May 5, 2014, http://creative-capital.org/artist-projects, accessed May 5, 2014. A survey of my own e-mail history demonstrates that monthly it sends out its e-mails for professional development opportunities, webinars, and artists titled "On Our Radar." Moreover, Creative Capital regularly sends out e-mail news items announcing program anniversaries ("Celebrating 10 Years of PDP"), "Program News" ("MAP Fund Now Accepting Applications"), or seasonal items ("Summer News").
76. "An actor choosing to keep trust or not (or choosing whether to devote resources to an attempt to keep trust) is doing so on the basis of costs and benefits he himself will experience." James S. Coleman, "Social Capital in the Creation of Human Capital," *American Journal of Sociology* 94 (1988): S117.
77. Ibid., S102.
78. Ibid., S117.
79. Alfie Kohn, *Punished by Rewards* (New York: Houghton Mifflin, 1993).
80. Ibid., Maria Rosario Jackson et al., *Investing in Creativity: A Study of the Support Structure for US Artists (Washington, DC: Urban Institute, 2003)*, 34–46.
81. Ibid., 43
82. Ibid.
83. "Award Guidelines," accessed September 9, 2013, http://creative-capital.org/apply.
84. This report is based on 69 interviews, including 41 grantees, seven applicants who were not funded, seven staff members, four board members, three professional development presenters and seven funders. Atlas, Bruner, and DeNobriga, 1.
85. Ibid., 6–7.
86. Lerner, Interview.
87. Ibid.
88. Lerner, "Policy, Prisons and Pranks."
89. Lerner, "Assessing New Anti-Terrorism Policies: One Organization's Approach," in *Grantmaker in the Arts Reader* 16.1 (2005).
90. John Kreidler, "Leverage Lost: Evolution in the Non-profit Arts Ecosystem," in *The Politics of Culture: Policy Perspectives for Individuals, Institutions, and Communities*, ed. Gigi Bradford, Michael Gary, and Glenn Wallach (New York: New Press, 2000), 151–152.
91. Lerner, Interview.

5 A Survey Course: Teaching Artists and/as Producers (2013)

1. In accordance with Texas House Bill (HB) 2504, each course syllabus is made publically available through the University of Texas at Austin website, www.utexas.edu. See also *Black Watch*, http://www.nationaltheatrescotland.com.

2. See http://forkliftdanceworks.org
3. Ann Markusen et al., *Crossover: How Artists Build Careers across Commercial, Nonprofit and Community Work* (Minneapolis: Humphrey Institute of Public Affairs, University of Minnesota, 2006), 11–20.
4. Jill Dolan, "Rehearsing Democracy: Advocacy, Public Intellectuals, Civic Engagement in Theatre Studies," *Theatre Topics* 11.1 (2001): 1.
5. The American Assembly, "The Arts and the Public Purpose: Final Report of the Ninety-Second American Assembly," (Arden House, Harriman, NY: Columbia University, 1997), 28. Emphasis original.
6. William J. Bennett, "The Humanities, the Universities, and Public Policy," in *The Politics of Culture: Policy Perspectives for Individuals, Institutions, and Communities*, ed. Gigi Bradford, Michael Gary, and Glenn Wallach (New York: New Press, 2000), 226.
7. Ibid., 227.
8. Writes Bennett: "The humanities encompass ideas that develop the sensibility and the intellect of the young, ideas that are not dry rot, ideas that should underlie public policy, ideas about human nature." Ibid., 228.
9. In "The Subject and Power," Foucault scholars Herbert L. Dreyfus and Paul Rabinow argue that human beings are made subject to power through their "subjectification" under a figure of authority, or through their "objectification" in specific disciplinary discourses. By using policy's findings about artists as a teaching tool, I propose that artists can counter both objectification and subjectification and contribute to a more expansive discourse on arts policy. See *Michel Foucault: Beyond Structuralism and Hermeneutics* (Chicago: University of Chicago Press, 1982), 208
10. The American Assembly, "The Creative Campus: Final Report of the One Hundred and Fourth American Assembly" (Arden House, Harriman, NY: Columbia University, 2004), 29.
11. Douglas Dempster, "American Medicis: the Training and Patronage of Professional Artists in American Universities," Background reading Presented to the 104ᵗʰ American Assembly, "The Creative Campus," March 11–13, 2004. http://www.vanderbilt.edu/curbcenter/cms-wp/wp-content/uploads/2004-<shapeText></shapeText>Assembly-Meeting-Creative-Campus-Background-Reading1.pdf, accessed May 20, 2014.
12. Dempster's five streams, or approaches, that have developed in fine arts higher education include "scholarly research, vocational preparation, undergraduate enrichment, community presentation, and master-apprentice pedagogy." Ibid., 7.
13. "I call resistance to curricular change 'curricular stenosis,' because it arises not from a failure to recognize the need for adaptation so much as from a conservative curriculum that monopolizes available credit hours, faculty, and facilities, blocking many well-intentioned efforts to diversify curricula for professional students." Ibid., 21.
14. Andrew Delbanco, *College: What it Was, Is, and Should Be* (Princeton, NJ: Princeton University Press, 2012), 4–5.
15. Clark Kerr, *The Uses of the University*, 5th ed., 1963. (Cambridge: Harvard University Press, 2001).
16. Quoted in Nancy Kindelan, *Artistic Literacy* (New York: Palgrave Macmillan, 2012), 7.

17. The study notes exceptions among four schools in California and one in Chicago. Maria Rosario Jackson et al., *Investing in Creativity: A Study of the Support Structure for US Artists* (Washington, DC: Urban Institute, 2003), 60–61.
18. Ibid., 7.
19. Suzanne Callahan, ed. (Washington, DC: Dance/USA, 2005). The publication, which is geared to students and faculty, responds to "What Becomes of Undergraduate Dance Majors?" (2003), a study tracking dance graduate outcomes for five colleges in New England. "What Becomes" affirms previous research that dancers generally experience a low rate of return for their creative work due to both low pay and also the long hours involved in rehearsal. The five colleges are listed as Mt. Holyoke, Smith, Amherst, Hampshire, and the University of Massachusetts at Amherst. Sarah S. Montgomery and Michael D. Robinson, "What Becomes of Undergraduate Dance Majors?" *Journal of Cultural Economics* 27.1 (2003): 57.
20. Jackson et al., *Investing in Creativity*, 3.
21. "Ranking Methodologies," *The University of Texas at Austin McCombs School of Business*, accessed October 22, 2012, http://www.today.mccombs.utexas.edu/mba-programs-full-time.
22. The UI Center for Post-secondary Research (2011), "Strategic National Arts Alumni Project," University of Indiana Center for Post-Secondary Research, http://snaap.indiana.edu/about/staff.cfm, accessed May 5, 2014.
23. See also Douglas Dempster, "Some Immodest Proposals (and Hunches) for Conservatory Education: Keynote Address to the College Music Society Summit on Music Entrepreneurship Education (January 15, 2010)," in *Disciplining the Arts: Teaching Entrepreneurship in Context*, ed. Gary D. Beckman (Lanham, MD: Rowman & Littlefield Education, 2011), 11.
24. The American Assembly, "The Arts and the Public Purpose," 28. Emphasis original.
25. Of the 120 first-year students invited to complete the survey from the other sections, only 66 responded. The pilot study has since become the dissertation project for Scott Blackshire, a graduate student in Performance as Public Practice, who assisted me in shaping the initial study and running it. Scott offered an assessment of the initial findings and conducted discussions in my class and others before and after the study was administered.
26. All first-year students in the Department of Theatre and Dance are required to take the course; however, some students transfer into the program in their sophomore year.
27. Paul Bonin-Rodriguez, "Anticipated Career and Education Outcomes," The University of Texas at Austin, September 1, 2013.
28. Danielle J. Lindemann, "What Happens to Artistic Aspirants Who Do Not 'Succeed'?" *Work and Occupations* 40.4 (2013): 467.
29. Ibid., 470.
30. My Teaching Assistant, Russ Dembin, is an editor for *The Sondheim Review*, which provided us an opportunity to conduct an intensive case study on Sondheim's oeuvre.
31. See Christopher Isherwood, "The Rats Take the Nacho Cheese," in *The New York Times*, January 27, 2014. http://www.nytimes.com/2014/01/28/theater/stop-hitting-yourself-a-riff-on-excess-at-lincoln-center.html. Accessed May 19, 2014.

32. These included including *Our Country's Good* (1990), *Dial M for Murder* (1954), and *Fall for Dance*.
33. For more on the US's changing demographic, see Joel Kotkin, *The Next Hundred Million Years: America in 2050* (New York: Penguin, 2010).
34. Tanya Saracho, "El Nogalar," *American Theatre* 28.6 (July/August, 2011): 69.
35. Allison Orr and Graham Reynolds, *Trash Dance*, Dir. Andrew Garrison (Panther Creek Pictures, 2012). For more information on Forklift Danceworks, see http://forkliftdanceworks.org.
36. Lisa B. Thompson, *Single Black Female* (New York: Samuel French, 2012).
37. For information on Trouble Puppet Theatre Company, see http://troublepuppet.com.
38. Thompson, "Epilogue," *Beyond the Black Lady* (Urbana and Chicago: University of Illinois Press, 2009), 137–139.
39. Lindemann, 469.
40. Ibid., 470–471. See also Maria Rosario Jackson, "Arts and Cultural Participation," in *Understanding the Arts and Creative Sector in the United States*, ed., Joni Maya Cherbo, Ruth Ann Stewart, and Margaret Jane Wyszomirski (New Brunswick, NJ: Rutgers University Press, 2008), 96.
41. Lindeman, 467–468.
42. Elizabeth L. Lingo and Steven J. Tepper, "Looking Back, Looking Forward: Arts-Based Careers and Creative Work," *Work and Occupations* 40.4 (2013), 340–341.
43. Lindeman, 468.
44. Lingo and Tepper, 341.
45. Sunil Iyengar, "Artists by the Numbers," *Work and Occupations* 40.4 (2013).
46. J. L. Austin, *How to Do Things with Words: the William James Lectures delivered at Harvard University in 1955* (Oxford: Clarendon Press, 1962).
47. Richard Caves, *Creative Industries: Contracts Between Art and Commerce* (Cambridge, MA: Harvard University Press, 2000), 21–23.
48. Linda Essig, "Not about the Benjamins: Arts Entrepreneurship in Research, Education, and Practice." Keynote Address, Arts Business Research Symposium, University of Wisconsin-Madison, March 13, 2014. I am grateful to Linda Essig for providing me with the text of the talk, much of which she shares on her blog, "Creative Infrastrucutre," as part of a series of posts titled, "The Ouroboros," March 4, 2014. http://creativeinfrastructure.org/2014/03/04/preview-the-ouroboros/. Accessed September 24, 2014.
49. Gary D. Beckman, "Disciplining Arts Entrepreneurship Education: A Call to Action," in *Disciplining the Arts: Teaching Entrepreneurship in Context*, ed. Gary D. Beckman (Lanham, MD: Rowan and Littlefield Education, 2011), 25.
50. Meadows School of the Arts, "The Movement," Southern Methodist University, accessed December 16, 2013. http://www.smu.edu/Meadows/TheMovement/ArtsEntrepreneurship.
51. See Jim Hart and Gary D. Beckman, "Arts Entrepreneurship: You Are Closer Than You Think," An TCG (Theatre Communications Group) Circle, accessed December 6, 2013. http://www.tcgcircle.org/2013/08/arts-entrepreneurship-you-are-closer-than-you-think/.
52. *Artivate: a Journal of Arts Entrepreneurship*, www.artivate.org; *Journal of Arts Entrepreneurship Research*, http://jaer.ncsu.edu; and Journal of Arts Entrepreneurship Education, http://jaee.ncsu.edu. In addition to Essig's blog, "Creative Infrastructure," creativeinfrastructure.org, see Barry Hesenius's "Barry's Blog," blog.westaf.org.

53. Gary D. Beckman, "'Adventuring' Arts Entrepreneurship Curricula in Higher Education: Examination of Present Efforts, Obstacles, and Best Practices," *The Journal of Arts Management, Law, and Society* 37.2 (2007): 92.
54. Joseph Schumpeter, *Capitalism, Socialism, and Democracy* (New York: Harper & Row, 1934); Ivan Bull and Gary E. Willard, "Towards a Theory of Entrepreneurship," *Journal of Business Venturing* 8.3 (1993): 183–195. Portions of this chapter have been revised from my article, "What's in a Name?: Typifying Artist Entrepreneurship in Community-Based Training" in *Artivate: A Journal of Entrepreneurship in the Arts* 1.1 (2012): http://www.artivate.org/?p=115.
55. Scott Shane and Sankaran Venkataraman, in *Academy of Management Review*, 25.1 (2000), 217–226. See also J. T. Eckhardt and S. A. Shane, "Opportunities and Entrepreneurship," *Journal of Management* 29, no. 3 (2003): 333–349.
56. Stephen B. Preece, "Performing Arts Entrepreneurship: Toward a Research Agenda," *Journal of Arts Management, Law & Society* 41.2 (2011): 103–120. See also Richard E. Caves, *Creative Industries*.
57. Essig, 1–2.
58. Ibid., 4. At the same time, Essig acknowledges that "good business practices employed by both individual artists and organizations [...] connect artistic innovation with money so that money can feed the artistic process, connecting art to audience." Ibid., 6.
59. Jackson, et al., 60–61. See also Emily Weingarten, "Arts Entrepreneurship—the Student Perspective," *The Savvy Musician*, ed. David Cutler, March 25, 2010. http://www.savvymusician.com/blog/2010/03/arts-entrepreneurship-student/.
60. Beckman, "Disciplining Arts Entrepreneurship," 28.
61. Kelland Thomas, "The Importance of Case Studies in Arts Entrepreneurship Curricula," in *Disciplining the Arts: Teaching Entrepreneurship in Context*, 161–166. See also David `Cutler, "Re-Imagining Arts Higher Education," *The Savvy Musician*, June 19, 2012. http://www.savvymusician.com/blog/2012/06/re-imagining-arts-higher-education/.
62. Dempster, "American Medicis," 14.
63. Owen Kelly, "Art," in *Critical Cultural Policy Studies: A Reader*, ed. Justin Lewis and Toby Miller (Malden, MA: Blackwell, 2003), 188–191.
64. Jim McGuigan, *Culture and the Public Sphere* (New York: Routledge, 1996).
65. Kindelan, 17.
66. Vicky Pollard and Emily Wilson, "The 'Entrepreneurial Mindset' in Creative and Performing Arts Higher Education in Australia," *Artivate: a Journal of Cultural Entrepreneurship* 3.1 (2014), http://www.artivate.org/?p=627, Accessed May 14, 2014.
67. Delbanco, 177.

6 Linking Creative Investments: *Investing in Creativity (2003) and LINC (2003–2013)*

1. Holly Sidford, Laura Lewis Mandeles, and Alan Rapp, *Cornerstones* (New York: Leveraging Investments in Creativity, 2013), 10.
2. Ibid., 52.
3. Margaret Jane Wyszomirski, "Raison D'etat, Raisons Des Arts," in *The Public Life of the Arts in America* (New Brunswick, NJ: Rutgers University Press, 2000), 58–59.

4. Maria Rosario Jackson et al., *Investing in Creativity: A Study of the Support Structure for U.S. Artists* (Washington, DC: The Urban Institute, 2003), 1, 5.
5. Ibid., 2.
6. Ibid., 8.
7. See also Sidford, Mandeles, and Rapp, *Cornerstones*, 26.
8. American Assembly, "The Arts and the Public Purpose: Final Report of the Ninety-Second American Assembly," (Arden House, Harriman, NY: The American Assembly, Columbia University, 1997), 14–15. Many scenarios of the day's events echoed those of the earlier meeting, which I attributed to the policy's own repertoire of development. In addition to the luncheon, which included one of two panel discussions held that day, there was also a breakout session, complete with a rapporteur to document all comments. Holly Sidford, the credited founder of both the study and the LINC initiative, insists that she does not consider the 92nd Assembly, "The Arts and the Public Purpose," to have a direct influence on her work with *Investing in Creativity* and LINC. My analysis takes into account the way that meeting expressed the zeitgeist of the moment and contributed to the policy discourse of that time. Sidford, Interview with Author, August 4, 2013.
9. Margaret Jane Wyszomirski, "Policy Strategies and Administrative Tools" and "Specific Policy Decisions and Actions" represent two major branches of Wyszomirski's metaphoric tree illustration for an ecosystemic approach to contemporary arts and culture policy.
10. James S. Coleman, "Social Capital in the Creation of Human Capital," *American Journal of Sociology* 94 (1988): S117.
11. Pierre Bourdieu, "The Forms of Capital," in *Handbook of Theory and Research for the Sociology of Education*, ed. John G. Richardson (New York: Greenwood Press, 1986), 243–248.
12. Lesley Valdes, "The Age of Audience," in *The Politics of Culture: Policy Perspectives for Individuals, Institutions, and Communities*, ed. Gigi Bradford, Michael Gary, and Glenn Wallach (New York: New Press, 2000), 170–177. See also Mark J. Stern and Susan C. Seiffert, "Representing the City: Art, Culture, and Diversity in Philadelphia." Ibid., 286–300.
13. Sam Miller, Interview with Author, April 11, 2014.
14. Ibid.
15. Observes Judilee Reed: "To me, the Artist Council was a group of artists who were experts in their disciplines and who were interested in tackling some of the questions that LINC was tackling, [but] from their perspective.... The questions we posed and observations that we [received] that were really important as feedback, prompting us to take a step back and test [our assumptions of] success from an artist's perspective." Interview with Author, March 19, 2014.
16. Sidford, Interview.
17. To quote Sidford: "As we talked about what was going on with artists, we came to the conclusion that one of the most important ways to benefit artists over the long term was to establish more accurate information about their needs, their contributions and the programs that existed to support their work." Ibid.
18. Sidford, Interview. Through her research firm, Helicon Collaborative, Sidford has continued to advance new research and practice in cultural policy. See http://heliconcollab.net.

19. Maria Rosario Jackson, Joaquin Herranz, and Florence Kabwasa-Green, *Art and Culture in Communities: Unpacking Participation* (Washington, DC: Urban Institute, 2003); Maria Rosario Jackson and Joaquin Herranz, "Culture Counts in Communities: A Framework for Measurement," (Washington, DC: Urban Institute, 2002); Jackson, Herranz, and Kabwasa-Green, *Art and Culture in Communities: Unpacking Participation*; *Art and Culture in Communities: Systems of Support* (Washington, DC: Urban Institute, 2003); *Art and Culture in Communities: A Framework for Measurement* (Washington, DC: Urban Institute, 2003); Maria Rosario Jackson, Florence Kabwasa-Green, and Joaquin Herranz, *Cultural Vitality in Communities: Interpretation and Indicators* (Washington, DC: Urban Institute, 2006). See also F. Javier Torres, "Revisiting Research: Art and Culture in Communities: Unpacking Participation," *Grantmakers in the Arts Reader* 23.3 (2012).
20. Jackson, Interview with Author, April 5, 2014.
21. Roberto Bedoya (2004) "US Cultural Policy: Its Politics of Participation, Its Creative Potential" (New Orleans: The National Performance Network, 2004). See also Steven Tepper and Elizabeth Lingo, "Looking Back, Looking Forward: Arts-based Careers and Creative Work," *Work and Occcupations* 40.4 (2013).
22. Jackson, Interview.
23. *Investing in Creativity* observes that arts research to date has focused primarily on arts organizations, particularly on employment practices and concerns, and "needs for human and social services." Jackson, et al., 5.
24. Alice R. Bernstein and Margaret B. Wilkerson, "Introduction: Why Artists Need More than Creativity to Survive," in Jackson, et al., *Investing in Creativity*, i.
25. Foucault (1998) observes, "Discourse can be both an instrument and an effect of power, but also a hindrance, a stumbling point of resistance and a starting point for an opposing strategy. Discourse transmits and produces power; it reinforces it, but also . . . renders it fragile and makes it possible to thwart." In *The History of Sexuality: The Will to Knowledge* (London: Penguin), 100–101.
26. Jackson et al., fn 16, page 5.
27. Jackson, "Arts and Cultural Participation," in *Understanding the Arts and Creative Sector in the United States*, ed. Joni Maya Cherbo, Ruth Ann Stewart, and Margart Wyszomirski (New Brunswick, NJ: Rutgers University Press, 2008). 95–96. Various iterations of "The American Perceptions of Artists Survey, 2002," for Seattle, Washington, DC, Seattle, Bonson, Cleveland, New York, Houston, Los Angeles, San Francisco, as well as an "Aggregate File" and a "National Sample" can still be found online. The study traces respondents' associations with art making and artists variously, by comparing the importance of artists to other professions—on average, artists rate higher than politicians, for instance—tracing respondents' histories with art and consumption habits, and their measure of artists' value. See The Urban Institute, "American Perceptions of the Arts Survey 2002," ed. CPANDA (Princeton, NJ: Cultural Policy and the Arts National Data Archive), www.cpanda.org, accessed May 22, 2014.
28. Jackson, et al., 5.
29. Sidford, Interview.
30. Jackson, Interview.
31. Peter Marris, *Witnesses, Engineers and Storytellers: Using Research for Social Policy and Community Action* (College Park, MD: University of Maryland at

College Park, Urban Studies and Planning Program, 1997), 54. Marris' work in this book is coterminous with argumentative policy, which emerged in the academy in the early 1990s. His arguments reflect Fischer and Gottweis' assessment of "the argumentative turn" in policy as represented by its theorists: "Policy making is fundamentally an ongoing discursive struggle over the definition and conceptual framing of problems, the public understanding of the issues, the shared meanings that motivated policy responses, and criteria for evaluation (Stone 2002)." Frank Fischer and Herbert Gottweis, "Introduction: The Argumentative Turn Revisited," in *The Argumentative Turn Revisited: Public Policy as Communicative Practice*, ed. Frank Fischer and Herbert Gottweis (Durham, NC: Duke University Press, 2012), 7.

32. Ibid., 59.
33. Qtd. in Steven J. Tepper and Stephanie Hinton, "The Measure of Meetings: Forums, Deliberations, and Cultural Policy," Working Paper 27 (Princeton, NJ: Princeton University Center for Arts and Cultural Policy Studies, 2003), 9.
34. Drawing on Kingdon's work in *Agendas, Alternatives, and Public Policies* (1984), Tepper and Hinton identify the three streams accordingly:

 The *problem* stream consists of the set of issues that government, the media and the public believe are pressing and in need of attention...Second, the *policy* stream involves the set of alternatives, at any one time, that are considered and debated...Finally, Kingdon discusses the *political* stream, or what others have called the political opportunity structure—in other words, the extent to which decision makers are receptive to new ideas and alternatives."

 Tepper and Hinton locate policy entrepreneurs among political operatives and "foundation officers." I would argue that the investigation and advocacy inherent in Sidford and Jackson's work required that they perform those roles of policy entrepreneurs in conversation with their funders and supporters. Ibid., 8–9. Emphasis original.
35. In addition to Maria-Rosario Jackson, Ph.D., the other writers named are Florence Kabwasa-Green, Daniel Swenson, Joaquin Herranz, Jr., Kadija Ferryman, Caron Atlas, Eric Wallner, and Carole Rosenstein, Ph.D.
36. Sidford, Interview. See also Ann Markusen, "Diversifying Support for Artists," *Grantmakers in the Arts Reader* 24.3 (2013). http://wwwgiarts.org/article/diversifying-support-artists, accessed December 6, 2013.
37. LINC was supported in the end by more than 42 credited foundations and funders. Sidford, Mandeles, and Rapp, *Cornerstones*, preliminary material.
38. Roberta Uno, "Introduction: The Color of Theatre," in *The Color of Theatre: Race, Culture, and Contemporary Performance*, ed. Roberta Uno and Luci Mae San Pablo Burns (London: Continuum, 2002), 3–17.
39. The study acknowledges sites for research were not chosen on a scientific basis, although attention was paid to geographic distribution, but instead represented the urban locations where foundations were willing to invest in research. Jackson, et al., fn. 14, 5.
40. Jackson, Interview.

41. In *The Order of Things* (1966) and *The Archeology of Knowledge* (1969), Foucault engages three modes of subjectivity. Humans become subjects through an experience or internationalized "process of division" in which they are identified and categorized; their subjectivity is maintained by distinct modes of discourse; and finally, through a process of "negotiation with a figure of authority," a subject may shift positions and approach agency. I am applying this dynamic to the concept of artists as equal partners with arts organizations. Herbert L. Dreyfus and Paul Rabinow, *Michel Foucault: Beyond Structuralism and Hermeneutics* (Chicago: University of Chicago Press, 1982), 208.

42. Jackson, Panel Comments, "Valuing Artists, Seeding Innovation: Celebrating 10 years of Leveraging Investments in Creativity." The Ford Foundation, New York, May 14, 2014.

43. John Gaventa, *Power after Lukes: A Review of the Literature* (Brighton: Institute of Development Studies, 2003), 3.

44. Sidford, Interview.

45. Jackson, Interview.

46. Bernstein and Wilkerson, i.

47. Jackson, et. al., 3.

48. Ibid.

49. Ibid.

50. Jackson, Maria, et al., 5.

51. "[T]he scenario forces us to situate ourselves in relationship to it; as participants, spectators, or witnesses." See Diana Taylor, *The Archive and the Repertoire: Performing Cultural Memory in the Americas* (Durham, NC: Duke University Press, 2003), 32.

52. Sidford, "Wellspring: A New Stimulus Package for Creative America," unpublished proposal. 2003, Provided by Sidford to Author. August, 4, 2013.

53. Uno, Interview.

54. Sidford, Interview.

55. In 2012, Reed became a Program Director at the Surdna Foundation and was succeeded by Candace Jackson. Wilson has since become a Program Officer at the Robert Rauschenberg Foundation.

56. Sidford, Mandeles, and Rapp, *Research and Practice* (New York: Leveraging Investments in Creativity, 2013), 2.

57. Ibid., 22–24.

58. Ibid., 30–35, 70–73.

59. Ibid., 54–57.

60. See www.lincnet.net. The website will be available until May 2015. Miller, Interview.

61. Says Reed, "I think it was pretty big breakthrough that we described domains as the full spectrum that people need to be successful—not just as artists. Our big contribution was interpreting *Investing in Creativity* (2003) into a set of programs that could imagine supporting artists not as a protected class. Rather we could help people see the values that artists create." Interview.

62. The additional sites can be found in LINC, "Cornerstones," 26.

63. Some of these include "The Artist as Entrepreneur Institute" in Cleveland, OH, Artists U in Philadelphia, PA, and Artist, Inc. in Kansas City, MO. The

EDGE Professional Development Program in Seattle and Washington State, the Native Artist Training and Professional Development Program, and the Center for Cultural Innovation "Business of Art" program, whose slogan is "Knowledge is power." See Sidford, Mandeles, and Rapp, *Cornerstones*, 56–85. See also http://www.cciarts.org/about_workshops.htm.

64. Between 2009 and 2011, I conducted a study of many of these spaces. See Paul Bonin-Rodriguez, "What's in a Name: Typifying Arts Entrepreneurship in Community-Based Training," in *Artivate: A Journal of Arts Entrepreneurship* 1.1 (2012), www.artivate.org.

65. Holly Sidford, Laura Lewis Mandeles, and Alan Rapp, *Case Studies* (New York: Leveraging Investments in Creativity), 14. See www.chicagoartistsresource.org. The CAR site is now administered by the Chicago Artist Coalition. See http://www.chicagoartistsresource.org. According to Holly Sidford, LINC had originally proposed a national model for such resources, titled the National Information Network for Artists, or NINA; however, the prospect of constructing and maintaining a site proved too large for LINC's resources and its time-datedness. Sidford, Interview.

66. Sidford, Mandeles, and Rapp, *Case Studies*, 6.

67. Ibid., 40–41.

68. Ibid., 50.

69. Ibid., 30–31.

70. Ibid., 34–35. Also, see Holly Sidford, *Fusing Arts, Culture, and Social Change* (Washington, DC: National Commitee for Responsible Philanthropy, 2011).

71. Miller, Interview.

72. Sidford, Mandeles, and Rapp, *Cornerstones*, 40.

73. Ibid., 41. The Ford Foundation's Space for Change program continues to focus specifically on newer arts spaces and established ones that operate in culturally and ethnically diverse communities, where artists can engage local communities. The initiative represents a significant investment from the Foundation: a $10 million annual contribution anticipated for ten years. Uno, Interview. See also "Supporting Diverse Arts Spaces" http://www.ford-foundation.org/issues/freedom-of-expression/supporting-diverse-arts-spaces. Accessed April 24, 2014. See "LINC and the Ford Foundation Award $1 Million in 'Space for Change' Planning Grants to Emerging Arts and Cultural Facilities Across the United States," PR Newswire, February 8, 2011. Accessed April 24, 2013. http://www.prnewswire.com/news-releases/linc-and-the-ford-foundation-award-1-million-in-space-for-change-planning-grants-to-emerging-arts-and-cultural-facilities-across-the-united-states-115567094.html.

74. Sidford, Mandeles, and Rapp, *Case Studies*, 34–35.

75. Ibid.

76. Ibid., *Cornerstones*, 83.

77. Ibid., *Case Studies*, 30–33. The work of Artography continues through its blog. See http://www.artsinachangingamerica.net.

78. Reed, Interview.

79. Writes Ann Markusen, "It is important to remember too that many artists are of the community in which they live, including many artists of color and immigrant artists. Many are also poor. Their relative poverty along with their need for artistic space drives them along the sweat equity route." See

Markusen, "Urban Development and the Politics of a Creative Class: Evidence from a Study of Artists," *Environment and Planning A* 38 (2006): 1937.
80. Sidford, Mandeles, and Rapp, *Cornerstones,* 8.
81. LINC, "Valuing Artists, Seeding Innovation: Celebrating Ten Years of Leveraging Investments in Creativity (Program)" (New York: Leveraging Investments in Creativity, 2013), 8–11.
82. See Holly Sidford, *Fusing Arts, Culture, and Social Change* (Washington, DC: National Commitee for Responsible Philanthropy, 2011), 1.
83. Theaster Gates, Maria-Rosario Jackson, John Killacky, Holly Sidford, and Roberta Uno, Panel Comments, "Valuing Artists, Seeding Innovation: Celebrating 10 years of Leveraging Investments in Creativity" (New York: The Ford Foundation, May 14, 2014).
84. Jackson, Interview with Author, April 5, 2014.
85. Tepper and Hinton, 8–9.
86. Reed, Interview.
87. Ibid.
88. Uno, Interview with Author, April 2, 2014. See http://www.unitedstatesartists.org.
89. Says Uno, "They once had 6 loosely affiliated kindred organizations. [At Ford], we've consciously built out over a decade their network and and their annual summit. Now there are 75 chapter and 250,000 young people involved. They got that HBO 7-part series." Interview. See www.youthspeaks.org.

7 Proposing Place: Creative Placemaking (2010–Present)

1. John Kreidler, "Leverage Lost: Evolution in the Nonprofit Arts Ecosystem," in *The Politics of Culture: Policy Perspectives for Individuals, Institutions, and Communities,* ed. Gigi Bradford, Michael Gary, and Glenn Wallach (New York: New Press, 2000), 147–168.
2. Ann Markusen and Ann Gadwa, *Creative Placemaking: Executive Summary* (Washington, DC: National Endowment for the Arts, 2010), 3.
3. Ibid., 4.
4. Mark J. Stern and Susan C. Seiffert, "Representing the City: Art, Culture, and Diversity in Philadelphia," in *The Politics of Culture: Policy Perspectives for Individuals, Institutions, and Communities,* ed. Gigi Bradford, Michael Gary, and Glenn Wallach (New York: New Press, 2000), 286–300.
5. That is not to say that placemaking is the only innovation in contemporary artistic practice. Another approach been through aesthetics. In January of 2014, Marc Bamuthi Joseph, a performer and Performing Arts director at the Yerba Buena Center, and James Kass, executive director of Youth Speaks, convened "Future Aesthetics 2.0," a meeting and retreat for "hip-hop based artists" that engaged questions of practice and "generational leadership." The meeting was a follow-up to the first "Future Aesthetics" in 2003, which focused on "hip-hop activism," the way in which culturally located performance practices spoke to and bridged generational and cultural communities. The meeting created a space for lateralized policy relations among funders, researchers, and artists. Present at Future Aesthetics 2.0 were representatives from the Doris Duke Charitable Foundation, which funded the project, the

Ford Foundation, which funded the pilot meeting, and Helicon Collaborative, the research firm founded by Holly Sidford. Roberta Uno, "Future Aesthetics 2.0: the World has Changed," in *Grantmakers in the Arts Reader* 25.2 (2014), 24–26.

6. Maria Rosario Jackson, *Building Community, Making Space for Art* (Washington, DC: Urban Institute), 10–11.

7. Jackson, *Developing Artist-Driven Spaces in Marginalized Communities* (Washington, DC: Urban Institute, 2012), 2.

8. Center for Houston's Future, *Arts and Cultural Heritage Community Indicator Report* (Houston: Center for Houston's Future, 2013), 7.

9. From their study of association meetings, policy scholars Steven Tipper and Stephanie Hinton (2003) argue that effective meetings build on relationships among participants that grow through efforts occurring before and after the event. See "The Measure of Meetings: Forums, Deliberations and Cultural Policy, Working Paper 27" (Princeton: Princeton University Center for Arts and Cultural Policy Studies, 2003).

10. Kreidler.

11. Markusen and Gadwa, 16.

12. Grant Kester, "Rhetorical Questions: The Alternative Arts Sector and the Imaginary Public," *Afterimage* (1993), 111–113. See Brian Wallace, Marianne Weems, and Philp Yenawine, eds., *Art Matters: How the Culture Wars Changed America* (New York: New York University Press, 1999).

13. James Bau Graves, *Cultural Democracy: The Arts, Community, and Public Purpose* (Urbana-Champaign: University of Illinois Press, 2005).

14. Markusen, "Creative Economies: Challenges for Artists, Arts Organizations, Cities and Neighborhoods," Keynote Address, Leadership in the Arts Summit, Center for Creative Leadership, University of Houston, April 5, 2014. See also Markusen and Gadwa (2014).

15. John S. and James L. Knight Foundation, "Knight Soul of the Community," www.soulofthecommunity.org/about. Accessed date September 17, 2014. I am grateful to Maria Rosario Jackson for pointing out this connection.

16. Jacqueline Trescott, "Rocco Landesman Takes on Chairmanship of the National Endowment for the Arts," *The Washington Post*, August 26, 2009. Accessed April 22, 2014. http://www.washingtonpost.com/wpdyn/content/article/2009/08/25/AR2009082503250.html.

17. Robin Pogrebin and Jo Beth McGinty, "For New Leader of the Arts Endowment, Lessons from a Shaky Past," *The New York Times*, July 22, 2009. Accessed April 22, 2014. http://www.nytimes.com/2009/07/23/arts/23funding.html. Lee Rosenbaum, "He Produces Controversy," *The Wall Street Journal*, November 9, 2014. Accessed April 22, 2014. http://online.wsj.com/news/articles/SB100014240527487039329045745113203383876750.

18. See National Endowment for the Arts (NEA), "Annual Report, 2011" (Washington, DC), 7.

19. See "Joan Shigekawa," Art Works, accessed April 22, 2014. http://arts.gov/content/joan-shigekawa.

20. Maria Rosario Jackson, Interview with Author, April 5, 2014.

21. See Charles Landry and Franco Bianchini, *The Creative City* (London: Demos, 1995).

22. Florida defines the class as a condition "fundamentally determined by economic function." *The Rise of the Creative Class* (New York: Basic Books, 2002), 8.
23. Ibid., 69. Florida contends that the nature of the creative class's work environment tie its agents to three key values: developing "talent," accessing and using "technology," and living according to "tolerance." Ibid., 249.
24. Ibid., 113–114.
25. In a comprehensive critique that cites other studies, Ann Markusen (2005) challenges Florida's "fuzzy causal logic" which aggregates groups, presuming "distinctive spatial and political proclivities...purely on the basis of educational attainment, and with little demonstrable relationship to creativity." As a "group," artists, argues Markusen, share few of these qualities: their life and work habits, as well as their income sources and voting records, generally differ from those who hold steady work in firms and industries. She notes that Florida also makes politically awkward moves. His notion of diversity relies on census data that marks same-sex household, which he refers to a "gay index" but fails to acknowledge historic challenges faced by marginalized groups, African-Americans primarily. "Urban Development and the Politics of the Creative Class," *Environment and Planning A*, 38 (2005): 1921–1924. See also T. N. Clark, "The City as Entertainment: Machine," *Research in Urban Policy* 9 (Oxford: Elsevier, 2004).
26. Tom Sanchez, Rob Lang, Chris Nelson, and Karen Danielson, "Roundtable Review," in *Journal of American Planning* 71.2 (2007): 203–207.
27. Richard Florida, "More Losers Than Winners in America's New Economic Geography," in *The Atlantic*, 30 January 2013, http://www.citylab.com/work/2013/01/more-losers-winners-americas-new-economic-geography/4465/, access date 19 August 2014. See also Joel Kotkin, "Richard Florida Concedes the Limits of the Creative Class," in *The Daily Beast*, 20 March 2013, http://www.thedailybeast.com/articles/2013/03/20/richard-florida-concedes-the-limits-of-the-creative-class.html, access date 19 August 2014.
28. Joni Maya Cherbo, Harold Vogel, and Margaret Jane Wyszomirski, "Towards an Arts and Creative Sector," in *Understanding the Arts and Creative Sector in the United States*, ed. J. M. Cherbo, Ruth Ann Stewart, and Margaret Jane Wyszomirski (New Brunswick, NJ: Rutgers University Press, 2008), 10.
29. Caron Atlas, "How Arts and Culture Can Advance a Neighborhood-Centered Progressive Agenda" (New York: Arts & Democracy Project: the Naturally Occurring Working Group, 2013), 2. www.c21froall.org, accessed April 23, 2014.
30. Jackson, *Building Community*, 9.
31. See Florida, 192.
32. NEA, "National Endowment for the Arts 2014 Guide" "Annual Report, 2013" (Washington, DC), 12.
33. Ibid., 13. See also NEA, "Annual Report, 2013" (Washington, DC), 6.
34. NEA, "National Endowment for the Arts 2014 Guide," 13.
35. See Hector Garcia Canclini, *Hybrid Cultures*, trans. Christopher L. Chiappari and Silvia Lopez (Minneapolis and London: University of Minnesota Press, 1995), 2–3.

36. Michel de Certeau, *The Practice of Everyday Life*, 1984 (Berkeley, Los Angeles, and London: University of California Press, 1988), 117.
37. Ibid.
38. Yarn bombing has been worldwide since the early 2000s. See Mandy Moore and Leann Prain, *Yarn Bombing* (Vancouver, BC, CA: Arsenal Pulp Press, 2009). See also "Knit the Bridge," about a yarn bombing to the Andy Warhol/7th Street Bridge in 2013. www.knitthebridge.wordpress.com/about/.
39. Markusen and Gadwa, 16.
40. de Certeau, 117.
41. Markusen and Gadwa, 16.
42. The distinctions between intrinsic and instrumental values have been documented in *Gifts of the Muse* (2004). Whereas instrumental values refer to those values that the arts bring to society that can be measured as skills and competencies or housing prices or health, intrinsic values focus on the ways that individuals and communities consider the arts to be of value, without demanding a measureable outcome. See Kevin F. McCarthy et al. (Santa Monica, CA: RAND Corp.).
43. Markusen and Gadwa, 16.
44. NEA, "Annual Report, 2011".(Washington, DC), 4.
45. NEA, "Annual Report, 2013" (Washington, DC), 4.
46. Jamie Bennett, Correspondence with Author, May 27, 2014. Bennett served as Chief of Staff at the NEA from 2009–2013 and now serves as Executive Director of Art Place America. See "Jamie L. Bennett Appointed Executive Director of ArtPlace America," November 2013. Accessed April 22, 2014, http://www.artplaceamerica.org/articles/jamie-l-bennett-appointed-executive-director/.
47. See "ArtPlace Invitation for Letter of Inquiry: ArtPlace America 2014 Innovation Grants Program," accessed April 22, 2014, http://www.artplaceamerica.org/about/.
48. "ArtPlace Invitation for Letter of Inquiry."
49. Ibid.
50. Ibid.
51. de Certeau, xix.
52. Maria Rosario Jackson and Florence Kabwasa Green, *Artist Space Development: Making the Case* (Washington, DC: Urban Institute, 2007), 7.
53. Roberto Bedoya, *People, Land, Art, Culture, and Engagement: Taking Stock of the P.L.A.C.E. Initiative* (Tucson, AZ: Tucson Pima Arts Council, 2014), 7.
54. Ibid., 6–7.
55. Ibid., 7.
56. Ibid., 10.
57. Ibid. 10–11.
58. Ibid. 11–12.
59. Ibid., 13.
60. Ibid., 15, 28–33.
61. Roberto Bedoya, Interview with the Author, 14 August 2014.
62. Ibid.
63. Ann Markusen, "Diversifying Support for Artists," *Grantmakers in the Arts Reader* 24.3 (2013): 27, http://www.giarts.org/article/diversifying-support-artists, accessed September 18, 2013.

64. See http://www.publicartstpaul.org/air_my.html, accessed May 29, 2014.
65. Markusen, "Creative Economies: Challenges for Artists, Arts Organizations, Cities and Neighborhoods," Keynote Address, Leadership in the Arts Summit, University of Houston, April 5, 2014.
66. Liz Lerman, *Hiking the Horizontal* (Middletown, CT: Wesleyan University Press), 90–92.
67. Grisha Coleman, "Listening as the Land Talks Back: Ecology, Embodiment and Information in the Science Fictions of Echo::System," in *Leonardo Journal* 46.3 (2013) (Cambridge, MA: MIT Press), 23–46.
68. See www.forkliftdanceworks.com, accessed May 23, 2014.
69. Ronald Feldman Fine Arts, which represents Ukeles, has published her manifesto. See http://feldmangallery.com/media/pdfs/Ukeles_MANIFESTO.pdf. Access date, May 29, 2014.
70. Orr, Interview.
71. Barfield, Interview with Author, March 19, 2014.
72. See Howl Round TV: "Symposium on 'Entrepreneurship, the Arts, and Creative Placemaking,'" Pave Program in Arts Entrepreneurship, Arizona State University, 12–13 April 2013, http://howlround.com/livestreaming-on-howlround-tv-symposium-on-entrepreneurship-the-arts-and-creative-place-making/, last accessed 22 August 2014.

8 Coda: Performing Policy

1. Ann Markusen, *How Cities Can Nurture Cultural Entrepreneurs* (Kansas City, MO: The Kauffman Foundation, 2012).
2. Steven J. Tepper and Stephanie Hinton, "The Measure of Meetings: Forums, Deliberations, and Cultural Policy," Working Paper 27 (Princeton, NJ: Princeton University Center for Arts and Cultural Policy Studies, 2003), 9.
3. Markusen, et al., *Crossover: How Artists Build Careers across Commercial, Nonprofit and Community Work* (Minneapolis: Humphrey Institute of Public Affairs, University of Minnesota, 2006).
4. Center for Houston's Future, *Arts and Cultural Heritage Community Indicator Report* (Houston: Center for Houston's Future, 2013), 18.
5. Tepper and Hinton, 3.
6. After the successful citizens' filibuster (which occurred during the first special session), Perry called a second special session (as he said he would) to give the GOP more time to pass the bill. The reason the filibuster was successful was that the GOP tried to sneak the abortion bill in the last 10 days of the first special session, thus making a filibuster possible. When the bill passed in the second special session, it passed in the middle of the month—the GOP made sure it would not come down to a matter of the clock. Kirk Bohls, "Abortion bill filibuster hit by GOP challenges," *The Austin American-Statesman*, June 26, 2013.
7. Ibid. I am especially grateful to Nicole Gurgel for her assistance in compiling accounts of this event.

Bibliography

Adams, Don and Arlene Goldbard. *Crossroads: Reflections on Politics and Culture.* Talmage, CA: DNA Press, 1990.

Alexander, Jane. *Command Performance: An Actress in the Theater of Politics.* New York: Public Affairs, 2000.

Alper, Neil O., and Gregory H. Wassall. "More Than Once in a Blue Moon: Multiple Jobholdings by American Artists." Washington, DC: National Endowment for the Arts, 2000.

American Assembly. "The Arts & Government: Questions for the Nineties." Arden House, Harriman, NY: The American Assembly, Columbia University, 1990.

———. "Art & Intellectual Property: Final Report of the One-hundredth American Assembly." Arden House, Harriman, NY: Columbia University, 2002.

———. "The Arts and Public Policy in the United States, Final Report of the Sixty-Seventh American Assembly." Arden House, Harriman, NY: The American Assembly, Columbia University, 1984.

———. "The Arts and the Public Purpose: Final Report of the Ninety-Second American Assembly." Arden House, Harriman, NY: Columbia University, 1997.

———. "The Creative Campus: Final Report of the One Hundred and Fourth American Assembly." Arden House, Harriman, NY: Columbia University, 2004.

———. "Deals and Ideals: For-Profit and Not-for-Profit Arts Connections." Arden House, Harriman, NY: Columbia University, 1999.

———. "The Future of the Performing Arts, Final Report of the Fifty-Third American Assembly." Arden House, Harriman, NY: The American Assembly, Columbia University, 1977.

Anderson, Christopher and Travis E. Poling. "Marbut Is in Dispute over Visitation Rights," *San Antonio Express-News*, March 15, 1998, 1B.

Anderson, Jack. "David Mcclain, 51, Cincinnati Ballet Director," *The New York Times*, December 16, 1984.

Anderson, Sheila McNerney. "The Founding of Theatre Arts Philanthropy in America: W. Mcneil Anderson, 1957–65." In *Angels in American Theatre: Patrons, Patronage, and Philanthropy*, edited by Robert A. Schanke, 173–189. Carbondale: Southern Illinois University Press, 2007.

Ankins, Alicia. "Nationalism and Government Support for the Arts." *Create Equity* (14 May 2014). http://createquity.com/2014/05/nationalism-and-government-support-of-the-arts.html,

Arthurs, Alberta, Interview with Author. July 30, 2014.

"Artists and the Economic Recession Survey: A Summary of Findings, May 2010." New York: Leveraging Investments in Creativity, 2010.

Atlas, Caron. "Cultural Policy: In the Board Rooms and on the Streets." *Community Arts Network* (2004). http://www.communityarts.net/readingroom/archive/intro-publicpolicy.php.

————. "How Arts and Culture Can Advance a Neighbhorhood-Centered Progressive Agenda" *Towards a 21st Century for All: Progressive Policies for New York City in 2014 and Beyond*. New York: Arts & Democracy Project, 2013. www. c21froall.org.

Atlas, Caron, Helen Brunner, and Kathie DeNobriga. *At the Intersection: A Programmatic Assessment of Creative Capital's Support to Artists*. New York: Creative Capital Foundation, 2005.

Austin, J. L. *How to Do Things with Words*. 2 ed. Cambridge, MA: Harvard University Press, 1975.

Ayers, Margaret C. "Trends in Private Sector Giving for Arts and Cultural Exchange." *Grantmakers in Arts Reader* 21.3 (2010).

Barabási, Albert-László. *Linked*. New York: Plume, 2003.

Barber, Benjamin. *A Place for Us: How to Make Society Civil and Democracy Strong*. New York: Hill and Wang, 1998.

Barfield, Heather. Interview with Author. March 19, 2014.

Barthes, Roland. "The Death of the Author." Translated by Stephen Heath. In *The Norton Anthology of Theory and Criticism, 2nd Edition*, edited by Vincent B. Leitch, William E. Cain, Laura Finke, Barbara Johnson, John McGowan, T. Denean Sharpley-Whiting and Jeffrey Williams, 1322–26. New York and London: W. W. Norton & Company, 1968.

Battenfield, Jackie. *The Artist's Guide: How to Make a Living Doing What You Love*. New York: Da Capo Press, 2009.

Bauerlein, Mark, and Ellen Grantham. *National Endowment for the Arts : A History, 1965–2008*. Washington, DC: National Endowment for the Arts, 2009.

Baumol, William J., and William G. Bowen. *Performing Arts, the Economic Dilemma: A Study of Problems Common to Theater, Opera, Music, and Dance*. New York: Twentieth Century Fund, 1966.

Becker, Jo. "An Evangelical Is Back from Exile, Lifting Romney," *The New York Times*, September 22, 2012.

Becker, Carole "The Artist as Public Intellectual." In *The Politics of Culture*, edited by Gigi Bradford, Michael Gary, and Glenn Wallach, 236–46. New York: The New Press, 2000.

————. "Introduction: Presenting the Problem." In *The Subversive Imagination*, edited by Carole Becker, xi–xx. London: Routledge, 1994.

Beckman, Gary D. "'Adventuring' Arts Entrepreneurship Curricula in Higher Education: Examination of Present Efforts, Obstacles, and Best Practices." *The Journal of Arts Management, Law, and Society* 37, no. 2 (2007): 87–112.

————. "Disciplining Arts Entrepreneurship Education: A Call to Action," in *Disciplining the Arts: Teaching Entrepreneurship in Context*, ed. Gary D. Beckman, 25–34. Lanham, MD: Rowan and Littlefield Education, 2011.

Bedoya, Roberto. Interview with Author. August 14, 2014.

————. *People, Land, Art, Culture, and Engagement: Taking Stock of the P.L.A.C.E. Initiative*. Tucson, AZ: Tucson Pima Arts Council, 2014.

————. *U.S. Cultural Policy: Its Politics of Participation, Its Creative Potential*. New Orleans, LA: The National Performance Network, 2004.

Benedict, Stephen, ed. *Public Money & the Muse: Essays on Government Funding for the Arts*. New York: W. W. Norton & Company, 1991.

Bennett, Jamie. Correspondence with Author. May 27, 2014.

Bennett, William, "The Humanities, the Universities, and Public Policy." *The Politics of Culture: Policy Perspectives for Individuals, Institutions, and Communities,* ed. Gigi Bradford, Michael Gary, and Glenn Wallach, 226–235. New York: New Press, 2000.

Berlant, Lauren. *The Queen of America Goes to Washington City: Essays on Sex and Citizenship.* Durham, NC: Duke University Press, 1997.

Bernstein, Alice and Margaret B. Wilkerson. "Introduction: Why Artists Need More Than Creativity to Survive." Maria Rosario Jackson et al., *Investing in Creativity: A Study of the Support Structure for US Artists,* i–ii. Washington, DC: Urban Institute, 2003.

Bernstein, Robin. *Racial Innocence.* New York: New York University Press, 2011.

Besharov, Gregory. "The Outbreak of the Cost Disease: Baumol and Bowen's Founding of Cultural Economics." *History of Political Economy* 37, no. 3 (2005): 412–30.

Bhabha, Homi K. *The Location of Culture.* New York: Routledge, 1994.

Binkiewicz, Donna M. *Federalizing the Muse: United States Arts Policy and the National Endowment for the Arts, 1965–1980.* Chapel Hill: University of North Carolina Press, 2004.

Bohls, Kirk. "Abortion bill filibuster hit by GOP challenges." *The Austin American-Statesman,* June 26, 2013.

Bonin-Rodriguez, Paul. "The Staged Business of Writing for/about Art: Artists in Public Practice." *Theatre Topics* 16, no. 1 (2014): 25–37.

———. "What's in a Name? Typifying Artist Entrepreneurship in Community-Based Training." *Artivate: A Journal of Entrepreneurship in the Arts* 1, no.1 (2012): http://www.artivate.org/?p=115.

Bordo, Susan, *Unbearable Weight: Feminism, Western Culture, and the Body.* Berkeley and London: University of California Press, 1993.

Bourdieu, Pierre. "The Forms of Capital." Translated by Richard Nice. In *Handbook of Theory and Research for the Sociology of Education,* edited by John G. Richardson, 241–58. New York: Greenwood Press, 1986.

———. *Outline of a Theory of Practice.* Translated by Richard Nice. Cambridge: Cambridge University Press, 1989.

———. "Structures, *Habitus,* Practice." Translated by Richard Nice. In *Logic of Practice,* 52–65. Stanford, CA: Stanford University Press, 1990.

Bradford, Gigi. "Defining a Cultural Polilcy: Introduction." In *The Politics of Culture: Policy Perspectives for Individuals, Institutions, and Communities,* edited by Gigi Bradford, Michael Gary, and Glenn Wallach, 11–14. New York: The New Press, 2000.

Braisted, Paul J., ed. *Cultural Affairs and Foreign Relations.* Revised ed. Washington DC : Columbia Books, 1962.

Brater, Jessica, et al. " 'Let Our Freak Flags Fly': Shrek the Musical and the Branding of Diversity." *Theater Journal* 62, no. 2 (2010): 151–172.

Brenson, Michael. *Visionaries and Outcasts: The NEA, Congress, and the Place of the Visual Artist in America.* New York: New Press, 2001.

Buffett, Peter. "The Charitable-Industrial Complex," *The New York Times,* July 26, 2013, http://www.nytimes.com/2013/07/27/opinion/the-charitable-industrial-complex.html.

Burnet, Adam and Jud Knudsen, "The Phantom Seats of Philanthropy," on HowlRound, November 29, 2013. Accessed December 14, 2013. http://www.howlround.com/the-phantom-seats-of-philanthropy

Cardona, Wally. "Success in 10 Minutes or Less: Reflections on Life and Work as a Contemporary Artist." In *Dance from the Campus to the Real World (and Back Again)*, edited by Suzanne Callahan, 128–31. Washington, DC: Dance/ USA, 2005.

Case, Sue-Ellen. "Introduction." In *Split Britches: Lesbian Practice, Feminist Performance*, edited by Sue-Ellen Case, 1–34. London and New York: Routledge, 1996.

Casey, Rick. "Beyond Weakness: The Marbut Affair," *San Antonio Express-News*, September 26, 1999. 3A.

Caves, Richard E. *Creative Industries: Contracts between Art and Commerce.* Cambridge, MA: Harvard University Press, 2000.

Center for Houston's Future. *Arts and Cultural Heritagem Community Indicator Report.* Houston: Center for Houston's Future, 2013.

Chartrand, Harry Hillman. "The Arts and the Public Purpose: The Economics of It All." *The Journal of Arts Management, Law, and Society* 28, no. 2 (Summer 1998): 5.

———. "Toward an American Arts Industry." In *The Public Life of Art in America*, edited by Joni Maya Cherbo and Margaret Jane Wyszomirski, 22–49 New Brunswick, NJ: Rutgers University Press, 2000.

Cherbo, Joni Maya. "About Artists." In *Understanding the Arts and Creative Sector in the United States*, edited by Joni Maya Cherbo, Ruth Ann Stewart, and Margaret Jane Wyszomirski, 75–91. New Brunswick, NJ: Rutgers University Press, 2008.

Cherbo, Joni Maya, and Margaret Jane Wyszomirski. "Mapping the Public Life of Arts in America." In *The Public Life of Arts in America*, edited by Joni Maya Cherbo and Margaret Jane Wyszomirski, 3–21. New Brunswick, NJ: Rutgers University Press, 2000.

Cherbo, Joni Maya, Harold Vogel, and Margaret Jane Wyszomirski. "Towards and Arts and Creative Sector." In *Understanding the Arts and Creative Sector in the United States*, edited by Joni Maya Cherbo, Ruth Ann Stewart, and Margaret Jane Wyszomirski, 9–27. New Brunswick, NJ: Rutgers University Press, 2008.

Cohen-Cruz, Jan. *Engaging Performance: Theatre as Call and Response.* London and New York: Routledge, 2010.

———. *Local Acts: Community-Based Performance in the United States.* New Brunswick, NJ: Rutgers University Press, 2005.

Coleman, Grisha, "Listening as the Land Talks Back: Ecology, Embodiment and Information in the Science Fictions of Echo::System." *Leonardo Journal* 46, no. 3 (2013), Cambridge: MIT Press: 23–46.

Coleman, James. "Social Capital in the Creation of Human Capital." *American Journal of Sociology* 94 (1988): S95–S120.

Create Austin: Cultural Master Plan. Austin, TX: City of Austin Economic Growth Redevelopment Services Office, Cultural Affairs Division, 2009. 9.

Creative Capital Foundation. *Creative Capital Funding Innovation: An Overview of the First Five Years.* New York: Creative Capital Foundation, 2004.

Cullum, Bonnie. Interview with Author. April 17, 2013.

Cvetkovich, Ann. *An Archive of Feelings: Trauma, Sexuality, and Lesbian Public Cultures.* Durham, NC : Duke University Press, 2003.

Darlington, Madge. Correspondence with Author, 2014.

De Certeau, Michel. *The Practice of Everyday Life.* Translated by Steven Rendall. Berkeley: University of California Press, 1984.

Delbanco, Andrew. *College: What it Was, Is, and Should Be*. Princeton, NJ: Princeton University Press, 2012.

Dempster, Douglas. "American Medicis: The Training and Patronage of Professional Artists in American Universities." Background reading presented to the 104th American Assembly, "The Creative Campus," March 11–13, 2004. http://www.vanderbilt.edu/curbcenter/cms-wp/wp-content/uploads/2004-Assembly-Meeting-Creative-Campus-Background-Reading1.pdf

———. "Some Immodest Proposals (and Hunches) for Conservatory Education: Keynote Address to the College Music Society Summit on Music Entrepreneurship Education (January 15, 2010)." In *Disciplining the Arts: Teaching Entrepreneurship in Context*, ed. Gary D. Beckman, 3–15. Lanham, MD: Rowman & Littlefield Education, 2011.

Dobrzynski, Judith H. "1,810 Artists Seek Grants from a New Foundation," *The New York Times*, August 25, 1999. http://www.nytimes.com/1999/08/25/arts/1810-artists-seek-grants-from-a-new-foundation.html.

———. "New Arts Foundation Flooded with Grant Applications." *The Cleveland Plains Dealer*, August 26, 1999.

———. "Private Donors Unite to Support Art Spurned by Government," *The New York Times*, May 3, 1999. http://www.nytimes.com/1999/05/03/arts/private-donors-unite-to-support-art-spurned-by-the-government.html.

Dollar, Steve. "Where Good Ideas Go to Live," *The Wall Street Journal*, January 11, 2013. http://blog.creative-capital.org/wp-content/uploads/2013/01/Creative_Capital_WSJ_1.11.13.pdf.

Dolan, Jill. *Geographies of Learning*. Middletown, CT: Wesleyan University Press, 2001.

———. "Introduction: A Certain Kind of Successful." In *Peggy Shaw, Menopausal Gentleman: The Solo Performances of Peggy Shaw*, edited by Jill Dolan, 1–38. Ann Arbor: University of Michigan Press, 2011.

———. "Rehearsing Democracy: Advocacy, Public Intellectuals, Civic Engagement in Theatre Studies." *Theatre Topics* 11, no. 1 (2001): 1–17.

———. *Utopia in Performance*. Ann Arbor: University of Michigan Press, 2008.

Dower, David. Correspondence with Author, July 12, 2014.

———. *The Gates of Opportunity*. New York: The Andrew W. Mellon Foundation, 2009.

Dreyfus, Hubert L. and Paul Rabinow. *Michel Foucault: Beyond Structuralism and Hermeneutics*. Chicago: University of Chicago Press, 1982.

Duggan, Lisa. *The Twilight of Equality? Neoliberalism, Cultural Politics, and the Attack on Democracy*. Boston, MA: Beacon Press, 2003.

Essig, Linda. "Not about the Benjamins: Arts Entrepreneurship in Research, Education, and Practice." Keynote Address. Arts Business Research Symposium, University of Wisconsin-Madison, March 13, 2014.

Faires, Robert. "In Memoriam: Phyllis Slattery," *The Austin Chronicle*, December 19, 2012. http://www.austinchronicle.com/blogs/arts/2012–12–19/in-memoriam-phyllis-slattery/

Fischer, Frank and Herbert Gottweis. "Introduction: The Argumentative Turn Revisited." In *The Argumentative Turn Revisited: Public Policy as Communicative Practice*, edited by Frank Fischer and Herbert Gottweis, 1–27. Durham, NC: Duke University Press, 2012.

Florida, Richard. "More Losers Than Winners in America's New Economic Geography." *The Atlantic*. 30 January 2013.

———. *The Rise of the Creative Class: And How It's Transforming Work, Leisure, Community, and Everyday Life*. New York: Basic Books, 2002.

Foucault, Michel. *The History of Sexuality: The Will to Knowledge*. London: Penguin, 1998.

———. "Nietzsche, Genealogy, History." In *Language, Counter-Memory, Practice: Selected Essays and Interviews*, edited by D. F. Bouchard, 139–164. Ithaca, NY: Cornell University Press, 1977.

———. "What Is an Author?" In *The Foucault Reader*, edited by Paul Rabinow, 108–113. New York: Pantheon Books, 1984.

Frasz, Alexis. "New Perspectives in Research: Revisiting Landmark Reports." *Grantmakers in the Arts Reader* 23, no. 3 (2012).

Frey, Bruno S. *Arts & Economics: Analysis & Cultural Policy*. Berlin: Springer-Verlag, 2000. 145.

Fusebox Festival, thinkEAST Living Charette, Proposal for funding March 19, 2014.

Galligan, Anne M., and Neal Alper. "The Career Matrix: The Pipeline for Artists in the United States." In *The Public Life of Art in the United States*, edited by Joni Maya Cherbo and Margaret Jane Wyszomirski, 171–201. New Brunswick, NJ: Rutgers University Press, 2000.

Garcia Canclini, Hector. *Hybrid Cultures*. Translated by Christopher L. Chiappari and Silvia Lopez. Minneapolis and London: University of Minnesota Press, 1995.

Gaventa, John. *Power after Lukes: A Review of the Literature*. Brighton: Institute of Development Studies, 2003.

Goldbard, Arlene. "Artists Call for Cultural Policy," *PetitionOnline*, August 19, 2004. http://www.petitiononline.com/art2004/petition.html.

Gore, Tipper. *Raising PG Kids in an X-Rated Society*. Nashville, TN: Abingdon Press, 1987.

Gramsci, Antonio. *Prison Notebooks*. Edited by Joseph A. Buttigieg. New York: Columbia University Press, 1992.

Graves, James Bau. *Cultural Democracy: The Arts, Community, and Public Purpose*. Urbana-Champaign: University of Illinois Press, 2005.

Graw, Isabelle. *High Price: Art between the Market and Celebrity Culture*. Berlin; New York: Sternberg Press, 2009.

Greenhouse, Linda. "Supreme Court, 9–0, Rejects Clinton Request to Put Off Suit on Sexual Harassment," *The New York Times*, May 28, 1997.Accessed May 2, 2014.

Grodach, Carl and Michael Seman. "The Cultural Economy in Recession: Examining the US Experience." *Cities* 33 (2012), 15–28.

Guay, Abigail. "In Support of Individual Artists," *Grantmakers in the Arts Reader* 23, no. 1 (2012).

Harding, Susan Friend. *The Rise of Jerry Falwell* (Princeton: Princeton University Press, 2000).

Hardt, Michael, and Antonio Negri, *Empire*. Cambridge and London: Harvard University Press, 2000.

Hardymon, Felda, and Ann Laymon. "Creative Capital: Sustaining the Arts." In *Harvard Case Study*, 24. Cambridge, MA: Harvard University 2010.

Hawkesworth, Mary. "From Policy Frames to Discursive Frames Analysis." In *Argumentative Policy Revisited*, edited by Frank Fischer and Herbert Gottweis, 114–146. Durham, NC: Duke University Press, 2012).

Hay, Deborah. Interview with Author, April 25, 2014.

Hyde, Lewis. "Being Good Ancestors: Reflections in Arts Funding since World War II." *Kenyon Review* 3, no. 1 (2008): 5–18.

———. "The Children of John Adams: A Historical View of the Fight over Arts Funding." In *Art Matters: How the Culture Wars Changed America*, edited by Brian Wallis, Marianne Weems, and Philip Yenawine, 253–74. New York: New York University Press, 1999.

———. *The Gift: Creativity and the Artist in the Modern World*, 2nd ed. New York: Vintage Books, 2007.

International Federation of Arts and Culture Agencies (IFACCA). "Plans Underway for an International Database of Cultural Policy Profiles." *IFACCA* (December 2010).

Ivey, Bill. "America Needs a New System for Supporting the Arts." *The Chronicle of Higher Education* 51, no. 22 (2005).

———. *Arts, Inc.: How Greed and Neglect Have Destroyed Our Cultural Rights*, ed. Bill J. Series Ivey. Berkeley, CA: University of California Press, 2008.

———. "Towards a 21st Century Arts Agenda." Paper presented at the Grantmakers in the Arts, Cleveland, OH, 2004.

Iyengar, Sunil. "Artists by the Numbers." *Work and Occupations* 40, no. 4 (2013): 496–505.

Jackson, Maria Rosario. "Art and Cultural Participation. *Understanding the Arts and Creative Sector in the United States*, edited by Joni Maya Cherbo, Ruth Ann Stewart, and Margaret Jane Wyszomirski. New Brunswick, NJ: Rutgers University Press, 2008. 92–104.

———. "The Artist and Their Publics in Cross-Sectoral Projects—Lessons Learned and Future Questions." Keynote Address, Leadership in the Arts Summit, University of Houston, April 5, 2014.

———. *Building Community: Making Space for Art*. Washington, DC: Urban Institute, 2011.

———. "Cultural Kitchens: Nurturing Organic Creative Expression." In *Grantmaker in the Arts: Supporting a Creative America*. Seattle WA: giaarts, 2011.

———. *Developing Artist-Driven Spaces in Marginalized Communities: Reflections and Implications for the Field*. Washington, DC: Urban Institute, 2012.

———. Interview with Author. April 5, 2014.

———. "Revisiting the Themes from the 'Investing in Creativity' Study: Support for Artists Pursuing Hybrid Work." *Workforce Forum*. Washington, DC: NEA, 2009.

Jackson, Maria Rosario, Florence Kabwasa-Green, Daniel Swenson, Joaquin Herranz, Kadjya Ferryman, Caron Atlas, Eric Wallner, and Carole E. Rosenstein. *Investing in Creativity: A Study of the Support Structure for US Artists*. Washington, DC: Urban Institute, 2003.

Jackson, Maria Rosario, Florence Kabwasa-Green, and Joaquin Herranz. *Cultural Vitality in Communities: Interpretation and Indicators*. Washington, DC: Urban Institute, 2006.

Jackson, Maria Rosario, and Joaquin Herranz. *Culture Counts in Communities: A Framework for Measurement*. Washington, DC: Urban Institute, 2002.

Jackson, Maria Rosario, Joaquin Herranz, and Florence Kabwasa-Green. *Art and Culture in Communities: A Framework for Measurement.* Washington, DC: Urban Institute, 2003.
———. *Art and Culture in Communities: Systems of Support.* Washington, DC: Urban Institute, 2003.
———. *Art and Culture in Communities: Unpacking Participation.* Washington, DC: Urban Institute, 2003.
Jackson, Shannon. *Social Works: Performing Art, Supporting Publics.* New York: Routledge, 2011.
Jacobs, Jane. *The Death and Life of Great American Cities.* 1st Vintage Books ed. New York: Random House, 1961.
Jacobs, Leonard. 2002. "In Focus: TCG Confab; 'New Works, New Ways.'" *Back Stage—the Performing Arts Weekly* 43 (25): 4–4, 40. http://ezproxy.lib.utexas.edu/login?url=http://search.proquest.com/docview/1592239?accountid=7118.
Jacobs, Travis Beal. *Eisenhower at Columbia.* Piscataway, NJ: Transaction Publishers, 2001.
Jarrett, Sara. "Dancers Working: Mile-High Majesty," *Pointe,* May 2001, 28.
Jefferson, Margo. "Words to the Wise Performance Artist: Get Help. Collaborate. Grow," *The New York Times,* January 1, 2005, 3.
Jensen, Joli. "Expressive Logic: A New Premise in Arts Advocacy." *The Journal of Management, Law, and Society* 33, no. 1 (2003): 26.
Kammen, Michael. "Culture and the State in America." In *The Politics of Culture: Policy Perspectives for Individuals, Institutions, and Communities,* edited by Gigi Bradford, Michael Gary, and Glenn Wallach, 114–40. New York: New Press, 2000.
Kastely, Amy. "Our Chosen Path: Esperanza vs. the City of San Antonio." *Esperanza Peace and Justice Center,* 2002. September 16, 2013. http://www.esperanzacenter.org/cityofsatodos_fs.htm.
Keen, Bill. "14 Stories: Building Stronger Communities by Supporting American Artists." Edited by Wolf Brown. New York: Leveraging Investments in Creativity, 2010.
Kelly, Owen. "Art." *Critical Cultural Policy Studies: A Reader.* Edited by Justin Lewis and Toby Miller Malden, MA: Blackwell, 2003. 188–191.
Kerr, Clark. *The Uses of the University,* 5th ed., 1963. Cambridge: Harvard University Press, 2001.
Kester, Grant. *The One and the Many: Contemporary Collaborative Art in a Global Context.* Durham, NC, and London: Duke University Press, 2011.
———. "Rhetorical Questions: The Alternative Arts Sector and the Imaginary Public." In *Art, Activism, and Oppositionality: Essays from Afterimage,* edited by Grant Kester, 103–35. Durham, NC: Duke University Press, 1998.
Kilborn, Peter T., and Sam Howe Verhovek. "Clinton Welfare Shift Ends Tortuous Journey," *New York Times,* 1996. http://www.nytimes.com/1996/08/02/us/clinton-s-welfare-shift-ends-tortuous-journey.html.
———. "From Neolithic Prehistory to the Classical Era." *Grantmakers in the Arts Reader* 17, no. 3 (2006). Accessed December 1, 2013, http://www.giarts.org/article/neolithic-prehistory-classical-era.
Kindelan, Nancy. *Artistic Literacy.* New York: Palgrave Macmillan, 2012. 7.
Kohn, Alfie. *Punished by Rewards.* New York: Houghton Mifflin, 1993.

Kreidler, John. "Leverage Lost: Evolution in the Non-profit Arts Ecosystem." In *The Politics of Culture*, edited by Gigi Bradford, Michael Gary, and Glenn Wallach, 147–68. New York: The New Press, 2000.

Lang, Robert E., and Karen A. Danielson. "Review Roundtable: Richard Florida, Meet Claude Fischer." *Journal of the American Planning Association* 71, no. 2 (2007): 203–30.

Larson, Gary O. *American Canvas: An Arts Legacy for Our Communities.* Washington, DC: National Endowment for the Arts, 1997.

Lee, Sherman, ed. *On Understanding Art Museums.* Englewood Cliffs, NJ: Prentice-Hall, 1975.

Lerman, Liz. *Hiking the Horizontal: Field Notes from a Choreographer.* Middletown, CT: Wesleyan University Press, 2011.

Lerner, Ruby. Interview with Author. May 15, 2014.

———. "Policy, Prisons and Pranks: Artists Collide with the World," *Grantmaker in the Arts Reader* 24, no. 1 (2014). Accessed May 17, 2014, http://www.giarts. org/article/policy-prisons-and-pranks-artists-collide-world.

Lewis, Justin. *Art, Culture and Enterprise: The Politics of Art and the Culture Industries.* New York: Routledge, 1990.

———. "Designing a Cultural Policy." In *The Politics of Culture*, edited by Gigi Bradford, Michael Gary, and Glenn Wallach, 79–93. New York: The New Press, 2000.

LINC (Leveraging Investments in Creativity). "Valuing Artists, Seeding Innovation: Celebrating Ten Years of Leveraging Investments in Creativity (Program)." New York: Leveraging Investments in Creativity, 2013.

Lindemann, Danielle J. "What Happens to Artistic Aspirants Who Do Not 'Succeed'?" *Work and Occupations* 40, no. 4 (2013): 465–80.

Lingo, Elizabeth L., and Steven J. Tepper, "Looking Back, Looking Forward: Arts-Based Careers and Creative Work," *Work and Occupations* 40, no. 4 (2013): 337–363.

London, Todd, with Ben Pesner and Zannie Giraud Voss. *Outrageous Fortune.* New York: Theatre Development Fund, 2009.

Loney, Glenn. "Fabulous Invalid Rallies: Broadway 1995–96." *New Theatre Quarterly* 12, no. 48 (1996).

Lowry, W. McNeil, ed. *The Arts and Public Policy in the United States.* Englewood Cliffs, NJ: Prentice-Hall, 1984.

———, ed. *The Performing Arts in American Society.* Englewood Cliffs, NJ: Prentice-Hall, 1977.

Markusen Ann, "Creative Economies: Challenges for Artists, Arts Organizations, Cities and Neighborhoods," Keynote Address, Leadership in the Arts Summit, Center for Creative Leadership, University of Houston, April 5, 2014.

———. "Diversifying Support for Artists." *Grantmakers in the Arts Reader* 24, no. 3 (2013): 27. http://www.giarts.org/article/diversifying-support-artists.

———. "How Cities Can Nurture Cultural Entrepreneurs." *Policy Brief for the Ewing Marion Kauffman Foundation.* Kansas City, MO: Mayor's Conference on Entrepreneurship, 2013.

———. "Urban Development and the Politics of a Creative Class: Evidence from a Study of Artists." *Environment and Planning* 38 (2006): 1921–40.

Markusen, Ann, and Amanda Johnson. *Artists' Centers: Evolution and Impact on Careers, Neighborhoods, and Economies.* Minneapolis: Humphrey Institute of Public Affairs, University of Minnesota, 2006.

Markusen, Ann, and Anne Gadwa. *Creative Placemaking*. Washington, DC: National Endowment for the Arts, 2010.

Markusen, Ann, Sam Gilmore, Amanda Johnson, Titus Levi, and Andrea Martinez. *Crossover: How Artists Build Careers across Commercial, Nonprofit and Community Work*. Minneapolis: Humphrey Institute of Public Affairs, University of Minnesota, 2006.

Marris, Peter. *Witnesses, Engineers and Storytellers: Using Research for Social Policy and Community Action*. College Park: University of Maryland at College Park, Urban Studies and Planning Program, 1997.

Matthew, Vijay, and Polly Carl. "Culture Coin: A Commons-Based Complementary Currency for Arts and its Impact on Scarcity, Virtue, Ethics, and the Imagination." *Artitvate: A Jouranl of Entrepeneurship in the Arts* 2, no 3 (2003).

McCarthy, Kevin F., Arthur Brooks, Julia Lowell, and Laura Zakaras. *The Performing Arts: Trends and Their Implications*. Santa Monica, CA: RAND Corp., 2001.

McCarthy, Kevin F., Elizabeth H. Ondaatje, Laura Zakaras, and Arthur Brooks. *Gifts of the Muse: Reframing the Debate about the Benefits of the Arts*. Santa Monica, CA: RAND Corp., 2004.

McGee, Susanne. "Invest in Artists, Not Art: This Nonprofit Has an All-New Approach to Philanthropy," *Barron's*, March 8, 2010.

McGilchrist, Iain. *The Master and His Emissary: The Divided Brain and the Making of the Western World*. New Haven, CT: Yale University Press, 2009.

McGuigan, Jim. *Culture and the Public Sphere*. New York: Routledge, 1996.

Meacham, John. "The History of the American Dream: Is It Still Real?" *Time Magazine*, July 2, 2012. http://content.time.com/time/covers/0,16641, 20120702,00.html.

Meadows School of the Arts. "The Movement," Southern Methodist University, accessed December 16, 2013, http://www.smu.edu/Meadows/TheMovement/ ArtsEntrepreneurship.

Miller, Sam. Interview with Author. April 11, 2014.

Miller, Tim. "Artists' Declaration of Independence July 4, 1990." *1001 Beds: Performances, Essays, and Travels*, edited by Glen Johnson, 101–3. Madison: University of Wisconsin Press, 2006.

Montgomery, Sarah S. and Michael D. Robinson, "What Becomes of Undergraduate Dance Majors?" *Journal of Cultural Economics* 27.1 (2003): 57.

Moore, Christi. Interview with Author, March 13, 2014.

Moore, Steve. Correspondence with Author, March 4, 2014.

Mortimer, David. Interview with author July 16–August 9, 2013.

National Endowment for the Arts. "Annual Reports 2011 and 2013" Washington, DC: National Endowment for the Arts.

————. *How Art Works: The National Endowments for the Arts' Five-Year Research Agenda with a System Map and Measurement Model*. Washington, DC: The National Endowment for the Arts, 2012.

————. "Survey of Public Participation in the Arts." *Research Report #57*. Washington, DC: National Endowment for the Arts, 2012.

National Endowment for the Arts, et al., Petitioners v. Karen Finley, et al. 524 U.S. 569 (1998).

Nunberg, Geoffrey. "The Entrepreneurial Spirit." In *Fresh Air Commentary*. NPR, October 28, 2004.

Office of the President Committee on the Arts and Humanities. *Creative America: A Report to the President*. Washington, DC: President's Committee on the Arts and Humanities, 1997.

Orr, Allison. Interview with Author, May 28, 2014.

Orr, Allison, and Graham Reynolds. *Trash Dance*. Dir. Andrew Garrison. Panther Creek Pictures, 2012.

Otterman, Catherine. "Catholic Leader Is Turned Away at Exhibit He Deemed Offensive," *The New York Times*, September 28, 2012.

Pearl, Katie. Correspondence with Author. November 12, 2013.

Peterson, Betsy. "Cultural Policy Research in the United States: An Introduction to Studies and Articles Relevant to Folk Arts and Traditional Culture." Supported by the Public Programs Section of the American Folklore Society, 2011.

Phelan, Peggy. "Serrano, Mapplethorpe, the NEA, and You." *TDR: The Drama Review: The Journal of Performance Studies* 34, no. 1 (1990): 4–15.

Pogrebin, Robin, and Jo Beth McGinty, "For New Leader of the Arts Endowment, Lessons from a Shaky Past," *The New York Times*, July 22, 2009. Accessed April 22, 2014.

Pollard, Vicky and Emily Wilson, "The 'Entrepreneurial Mindset' in Creative and Performing Arts Higher Education in Australia," *Artivate: a Journal of Cultural Entrepreneurship* 3.1 (2014).

Pollock, Della. "Performing Writing." *The Ends of Performance*, edited by Peggy Phelan and Jill Lane, 73–103. New York: New York University Press, 1998.

Preece, Stephen B. "Performing Arts Entrepreneurship: Toward a Research Agenda," *Journal of Arts Management, Law & Society* 41.2 (2011): 103–120.

Rabinow, Paul. ed. *The Foucault Reader*. New York: Pantheon Books, 1984.

Ragsdale, Diane. Correspondence with Author, April 15, 2014.

———. *In the Intersection*. Boston: Center for Theatre Commons, 2011.

Reed, Judilee. Interview with Author. March 19, 2014.

Richelieu, David Anthony. "Council's Art Attack Echoes with History," *San Antonio Express-News*, September 27, 1997, 1B.

Rodriguez, Dylan. "The Political Logic of the Non-Profit Industrial Complex." In *The Revolution Will Not Be Funded*, edited by Women of Color against Violence INCITE! 21–40. Boston, MA: South End Press, 2007.

Rosenbaum, Lee. "He Produces Controversy," *The Wall Street Journal*, November 9, 2014. Accessed April 22, 2014, http://online.wsj.com/news/articles/SB10001 4240527487039329045745113203383 76750.

Sanchez, Tom, Rob Lang, Chris Nelson, and Karen Danielson, "Roundtable Review." *Journal of American Planning* 71.2 (2007): 203–207.

Schneider, Rebecca. *Performing Remains: Art and War in Times of Theatrical Reenactment*. New York: Routledge, 2011.

Schulman, Sarah. *My American History: Lesbian and Gay Life during the Reagan/Bush Years*. New York: Routledge, 1994.

Schumpeter, Joseph. *Capitalism, Socialism, and Democracy*. New York: Harper & Row, 1934.

Shane, Scott, and Sankaran Venkataraman. "The Promise of Entrepeneurship as a Field of Research." *Academy of Management Review* 25, no. 1 (2000): 217–26.

Sheets, Hilarie M. "A Foundation That Means Business." *ARTnews* 109, no. 1 (2010): 42–43.

Sidford, Holly. *Fusing Arts, Culture, and Social Change*. Washington, DC: National Commitee for Responsible Philanthropy, 2011.

———.Interview with Author. August 4, 2013.

———. "Wellspring: A New Stimulus Package for Creative America," unpublished proposal. 2003.

Sidford, Holly, Laura Lewis Mandeles, and Alan Rapp. *Case Studies*. New York: Leveraging Investments in Creativity, 2013.

———. *Cornerstones*. New York: Leveraging Investments in Creativity, 2013.

———. *Research and Practice*. New York: Leveraging Investments in Creativity, 2013.

Smith, Andrea. "Introduction: The Revolution Will Not Be Funded." In *The Revolution Will Not Be Funded*, edited by INCITE! Women of Color Against Violence INCITE! 1–18. Cambridge, MA: South End Press, 2007.

Smith, Ruth. "A Case of Selling Art and Selling Out." *The New York Times*. September 10, 2013.

Spivak, Gayatri Chakravorty. *A Critique of Postcolonial Reason*. Cambridge, MA: Harvard University Press, 1999

Stern, Mark J., and Susan C. Seiffert, "Representing the City: Art, Culture, and Diversity in Philadelphia." In *The Politics of Culture: Policy Perspectives for Individuals, Institutions, and Communities*. Edited by Gigi Bradford, Michael Gary, and Glenn Wallach. New York: New Press, 2000. 286–300.

Strom, Stephanie, "An Artist's Grant That Even Pays for Glasses," *The New York Times*, October 10, 2007. http://www.nytimes.com/2007/10/10/arts/design/10gran.html.

Sullivan, Kevin. "Freedom, Funding, and the Constitution." *Public Money & the Muse: Essays on Government Funding for the Arts*. Edited by S. Benedict, 80–95. New York: W. W. Norton & Company, 1991.

"The Supreme Court: Supreme Court Roundup; Justices Uphold Decency Test in Awarding Arts Grants, Backing Subjective Judgments," *The New York Times*, June 25,1998.

"Survey of Public Participation in the Arts." In *Research Report #57*. Washington, DC: National Endowment for the Arts, 2012.

Taylor, Andrew. *Renegotiation: An Overview of U.S. Arts Industry Insights, 2003–2007*. Fairfield, CT: AMS Planning and Research Corp, 2003. Accessed December 11, 2013, http://artsusa.org/pdf/about_us/renegotiation.pdf.

Taylor, Diana. *The Archive and the Repertoire: Performing Cultural Memory in the Americas*. Durham, NC: Duke University Press, 2003.

Tepper, Steven J. "Art as Research: The Unique Value of the Artistic Lens." *Grantmakers in the Arts Reader* 24, no. 3 (2013).

———. "The Culture Wars: A Reassessment," Policy Brief. Princeton, NJ: Princeton University Center for Arts and Cultural Policy Studies, 2000.

———. "Why Public Funding of the Arts Needs to Find a New Frontier." *Wealth Management* First Quarter (2005): 30–31.

Tepper, Steven J., and Stephanie Hinton. "The Measure of Meetings: Forums, Deliberations, and Cultural Policy." Working Paper 27. Princeton, NJ: Princeton University Center for Arts and Cultural Policy Studies, 2003.

Thomas, Kelland. "The Importance of Case Studies in Arts Entrepreneurship Curricula." *Disciplining the Arts: Teaching Entrepreneurship in Context*, ed. Gary D. Beckman, 161–66. Lanham, MD: Rowan and Littlefield Education, 2011.

Thompson, Lisa B. "Epilogue," *Beyond the Black Lady*. Urbana and Chicago: University of Illinois Press, 2009. 137–139.

———. *Single Black Female*. New York: Samuel French, 2012.

Torres, F. Javier. "Revisiting Research: Art and Culture in Communities: Unpacking Participation." *Grantmakers in the Arts Reader* 23, no. 3 (2012).

Trescott, Jacqueline. "Rocco Landesman Takes on Chairmanship of the National Endowment for the Arts," *The Washington Post*, August 26, 2009.

Trivers, Robert. *Natural Selection and Social Theory: Selected Papers of Robert Trivers*. Oxford: Oxford University Press, 2002.

Tumulty, Karen, and Laurence I. Barrett. "Man with a Vision." *Time* 145, no. 1 (1995).

Tumulty, Karen, and John F. Dickerson. "Hey, Bill, That's Ours!" *Time* 150, no. 2 (1997): 49.

Uno, Roberta. "Future Aesthetics 2.0: the World has Changed." *Grantmakers in the Arts Reader*. 25, no. 2 (2014): 24–26.

———. Interview with Author, April 2, 2014.

———. "Introduction: The Color of Theatre." *The Color of Theatre: Race, Culture, and Contemporary Performance*, ed. Roberta Uno and Luci Mae San Pablo Burns. London: Continuum, 2002. 3–17.

Valdes, Leslie. "The Age of Audience." *The Politics of Culture: Policy Perspectives for Individuals, Institutions, and Communities*. Edited by Gigi Bradford, Michael Gary, and Glenn Wallach. New York: New Press, 2000. 170–77.

Violette, Caroline and Rachel Taqqu, eds., *Issues in Supporting the Arts: An Anthology Based on the Economic Impact in the Arts Conference*. Ithaca, NY: Graduate School of Business Administration, Cornell University, 1980.

Williams, Chris. "Group Says Arts Cut Actually Targeted Gays," *San Antonio Express-News*, September 19, 1997.

Worthen, W. B. "Antigone's Bones." *TDR: The Drama Review* 52, no. 3 (2008): 10–33.

Wyszomirski, Margaret Jane. "Policy Communities and Policy Influence: Securing a Government Role in Cultural Policy for the Twenty-First Century." In *The Politics of Culture*, edited by Gigi Bradford, Michael Gary, and Glenn Wallach, 95–107. New York: The New Press, 2000.

———. "Raison D'etat, Raisons Des Arts." In *The Public Life of the Arts in America*, edited by Joni Maya Cherbo and Margaret Jane Wyszomirski, 50–78. New Brunswick, NJ: Rutgers University Press, 2000.

Yerkes, Susan. "First They Rob Peter—Now They Mug Paul, *San Antonio Express-News*, August 27, 1997.

Zeitlin, Steve. "Strangling Culture with a Copyright Law," *The New York Times*, April 25, 1998. http://query.nytimes.com/gst/fullpage.html?res=9507eed6123 ff936a15757c0a96e958260.

Index

ACIP (aka Arts and Culture Indicators Project), 12, 19, 111, 132
activist, 12, 24–5, 107, 112–13
scholarship, 102
Adam Sultan. See Steve Moore
Adams, Don, 30, 156n.8
African American Cultural Heritage District, 139
Alexander, Jane, 33–4, 153n.72
Alper, Neal, 40, 160n.61
Alternate ROOTs, xi, 74, 125
altruism, 84, 147n.6, 155n.97
The American Assembly, xvii, 36, 156n.16, 157n.20, 158n.21, 158n.22, 158n.24, 159n.44, 159n.47, 160n.50, 162n.111, 162n.112
"The Arts and the Public Purpose," 26, 29–31, 34–5, 36–9, 43, 47–8, 51, 154n.86, 156n.11, 158n.28, 159n.36, 160n.54, 160n.57, 160n.63, 163n.9, 174n.5, 175n.24, 178n.8
founding of, 32–3
"The Creative Campus," 92, 163n.114, 174n.10, 174n.11
Anderson, Charles, 97–8
Andrew W. Mellon Foundation, 50, 52–4, 56–8, 60, 65–6, 163n.3, 163n.13, 164n.20, 164n.21, 164n.25, 165n.34
"Anticipated Career and Education Outcomes" study, 90, 95, 99, 175n.27
archive, 1–2, 10, 14, 22, 30–1, 40, 44, 47, 57, 60, 68, 74, 79, 82, 105, 153n.67, 156n.16, 179n.27
and repertoire, 11, 23, 36, 39, 41, 108–9, 116, 145, 148n.5, 159n.42, 160n.48, 172n.58, 181n.51
Arden House, 37, 51, 154n.86, 156n.11, 158n.21, 159n.47,

162n.111, 162n.112, 163n.114, 163n.9, 174n.5, 174n.10, 178n.8
argumentative policy. *See* policy
Art Works, 132, 184n.19
Arthurs, Alberta, xvii, 31–4, 36–7, 46, 111, 156n.15, 156n.16, 157n.18, 157n.20, 158n.25, 158n.27, 160n.50, 162n.107, 162n.110
The Artist as Entrepreneur Institute, 125, 181n.63
artist-producer *and* artist as producer, 3–6, 25–7, 31, 46, 55, 61, 69, 75, 85, 105, 109, 120, 128, 140, 143–5
Artists, Inc., 125, 181n.63
"artists' centers," 17, 62–4, 130, 154n.76, 167n.61
Artists U, 84, 125, 172n.72, 181n.63
Artography. *See* Leveraging Investments in Creativity
Artplace America, 124, 186n.46, 186n.47, 186n.48
"The Arts and the Public Purpose." *See* The American Assembly
Atlas, Caron, 133, 149n.19, 154n.87, 169n.21, 180n.35, 185n.29
Austin
Circle of Theatres (ACOT), 58
Creative Alliance, 54–5, 58, 63–4, 141, 165n.47
New Works Theatre Community, xvii, 26, 50–4, 56–8, 61–2, 64–6, 68–70, 131, 143, 163n.3, 165n.31, 165n.40, 166n.50, 166n.57, 167n.64, 167n.70
scenery cooperative, 52
awards. *See* grants

Bailey, Steve, xviii
Balfe, Judith Higgins, 39
Barfield, Heather, 54, 68, 163n.1, 163n.2, 165n.32, 165n.33, 165n.37, 165n.39, 168n.86, 187n.71

Battenfield, Jackie, 84, 172n.59, 173n.74
Becker, Carole, 5, 29, 155n.2
Beckman, Gary D., 102–4, 175n.23, 176n.49, 176n.51, 177n.53
Bedoya, Roberto, 46–7, 136–8, 141, 148n.3, 153n.70, 162n.101, 162n.103, 162n.108, 179n.21, 186n.53, 186n.61
Bennett, Jamie, 186n.46
Bennett, William, 91–2, 174n.6, 174n.8
Beresford, Susan, 110
Berlant, Lauren, 76, 156n.3, 169n.24
Bernstein, Alice, 112, 150n.28, 179n.24
Bernstein, Robin, 151n.41
Bhabha, Homi K., 3, 148n.8
Bordo, Susan, 9, 151n.40, 152n.54
Bourdieu, Pierre, 8–10, 27, 44–5, 74, 78, 80, 151n.38, 161n.77, 161n.83, 162n.93, 162n.97, 162n.100, 169n.16, 169n.17, 171n.50, 172n.60, 178n.11
Bradford, Gigi, 19, 149n.12, 154n.80, 154n.88, 158n.30, 158n.32, 161n.72, 169n.14, 173n.90, 174n.6, 178n.12, 183n.4
brand, 83–5
 branding, 129, 170n.33
 iconic, 60, 77–9
Brenson, Michael, 18, 153n.72, 154n.81, 154n.83, 155n.1
Buffett, Peter, 25
Bush, George H. W., 32, 153n.71
Bush, George W., 20
 Executive Order 13224, 87

capital
 cultural, 8, 21, 44, 56, 74, 78, 82, 85, 109, 169n.17
 economic, 43, 69, 80, 109, 161n.77
 social, 8, 27, 30, 40, 45, 58, 74, 78, 82, 85–6, 109, 173n.76, 178n.10
 trust, 8, 122
capitalism, 3, 27, 78, 177n.54
Cardona, Wally, 4, 149n.14
Carl, Polly, 61, 69, 167n.77, 168n.89
Carlson, Andrew, 90

Casa Libre en la Solana, 137
Case, Sue-Ellen, 150n.35
Caves, Richard, 150n.29, 151n.43, 154n.94, 165n.42, 176n.47, 177n.56
Chartrand, Harry Hillman, 39, 160n.60
Cherbo, Joni Maya, 16, 33, 133, 154n.74, 154n.79, 154n.93, 155n.101, 158n.29, 160n.59, 161n.69, 166n.55, 166n.58, 167n.71, 168n.79, 169n.13, 176n.40, 179n.27, 185n.28
Chicago Artists Resources, 119
Clean and Sober Theatre (CAST), 137
Clinton, Bill, 29, 156n.6
 administration, 18
Cohen-Cruz, Jan, xviii, 5, 22, 150n.21, 155n.95, 155n.96
Coleman, Grisha, xvii–xviii, 109, 125, 139, 187n.67
Columbia University. *See* The American Assembly, Arden House, Dwight D. Eisenhower
contract
 complete, 56
 complex, 22, 56
 theory, 56, 165n.46
Create Austin, 57–8, 64, 66, 165n.46
"The Creative Campus." *See* The American Assembly
Creative Capital Foundation, xvii, 4, 15, 27, 44, 71, 73, 75, 77, 85–6, 88, 108, 130, 150n.27, 162n.92, 169n.21, 169n.22, 171n.38
 Fellowship, 79
creative class, 50, 132–3, 147n.1, 148n.6, 154n.93, 163n.4, 183n.79, 185n.22, 185n.23, 185n.25, 185n.27
creative placemaking. *See* placemaking
Crossover, 14, 45, 91, 95, 118, 149n.15, 153n.64, 154n.91, 165n.41, 174n.3, 187n.3
Cullum, Bonnie, 54, 163n.1, 165n.33, 165n.38

cultural
 commons, 47, 141
 democracy, 5, 30, 124, 130,
 150n.21, 156n.7, 159n.40,
 184n.13
 policy (*see* policy)
 kitchens, 128
culture war(s), xii–xiii, 19, 23, 26, 34,
 46–8, 71, 76, 78, 96, 106, 111–12,
 122, 124, 137, 147n.3, 153n.73,
 156n.5, 156n.9, 184n.12
 San Antonio, 130
curator, 7, 72
curriculum, 83–4, 95, 99, 104,
 172n.68
 development, 93, 174n.13
 humanities-based, 90, 105

Dance from the Campus to the Real
 World, 94, 149n.14
Dance Umbrella, 64, 167n.75
Davies, Molly, 109
Davis, Wendy, 145–6
de Certeau, 25, 37, 51, 134, 136,
 155n.102, 155n.104, 160n.48,
 163n.6, 166n.48, 166n.53,
 186n.36, 186n.40, 186n.51
de Genevieve, Barbara, 16
The Declaration of Independence,
 34–5, 159n.34, 159n.39
Delbanco, Andrew, 93–4, 105,
 174n.14, 177n.67
Dembin, Russ, 97, 175n.30
Dempster, Douglas, 92–4, 100, 174n.11,
 174n.12, 175n.23, 177n.62
diversity, 71, 74, 83, 87, 109, 114,
 119, 128, 133–4, 136
 cultural, 58, 63
 ethnic, 29, 87, 144
Dobrzynski, Judith, 71, 78–9, 168n.1,
 168n.3, 169n.9, 169n.11,
 170n.28, 170n.29, 171n.38,
 171n.41
Dolan, Jill, 7, 150n.33, 150n.34,
 168n.83, 174n.4
Doris Duke Charitable Foundation,
 53, 183n.5
 Performing Arts Awards, 81,
 171n.54

Dower, David, xvii, 52–3, 61,
 163–4n.13, 164n.14, 164n.17,
 164n.18, 164n.25, 165n.28,
 166n.51, 167n.77
Duggan, Lisa, 154n.84, 154n.90,
 169n.12

Eisenhower, Dwight D., 37–8, 48,
 160n.49, 160n.50, 160n.51
entrepreneur, entrepreneurial,
 entrepreneurship
 artist, 4, 91, 84, 102–24, 134, 141
 critique of, 4–5
 cultural, 5, 76, 144
 policy, 113, 124, 126, 144, 180n.34
 skills, 96
 training, 27, 47, 99, 101
Esperanza Peace and Justice Center,
 xii–xiii
Essig, Linda, 103, 149n.16, 149n.17,
 176n.48, 176n.52, 177n.57,
 177n.58
ethical hybridity. *See* hybridity

fellowships
 Guggenheim, 79
 see also Creative Capital
 Foundation, grants, National
 Endowment for the Arts, United
 States Artists
"Finding Voice," 137
Finley, Karen, xiii, 35, 47, 147n.4,
 153n.71, 159n.41
First People's Fund, 123, 125
Fischer, Frank, 151n.44, 154n.85,
 180n.31
Fleck, John, 35, 153n.71
Florida, Richard, 50, 132–3, 141,
 163n.4, 185n.22, 185n.23,
 185n.25, 185n.27, 185n.31
Ford Era, 17, 20, 32, 37, 61, 127
Ford Foundation, xvii, 17, 32–3,
 88, 107, 110, 112, 114, 116–17,
 119–21, 125, 157n.20, 181n.42,
 182n.73, 183n.83, 183–4n.5
Foucault, Michel, 9, 115, 156n.10,
 159n.35, 166n.49, 166n.55,
 169n.10, 181n.41
 author function, 8

Foucault, Michel—*Continued*
　　discourse, 150n.36, 160n.64,
　　　171n.42, 179n.25
　　power, 58–9, 151n.38, 174n.9
Fractured Atlas, 63, 167n.74
Frohnmeyer, John, 32
Fusebox Festival, 59, 68, 168n.87
Fusing Arts, Culture, and Social Change,
　　122, 148n.3, 162n.106, 182n.70,
　　183n.82

Galligan, Ann, 40, 160n.61
Garcia Canclini, Hector, 4, 149n.11,
　　185n.35
　　see also hybridity
Gates, Theaster, 109, 121–2, 183n.83
Gill, Brendan, 74
Gillies, Archibald, 71, 73–5, 78, 83,
　　169n.19, 171n.38
Goldbard, Arlene, 30, 154n.89,
　　156n.8
Gottweis, Herbert, 151n.44, 154n.85,
　　180n.31
grants
　　awards, 15, 24, 26–8, 43, 71–8, 117,
　　　123, 135, 138
　　epistemes, 81, 101, 120, 142
　　leveraged, 17, 88
　　opinions on, 46, 86, 122
　　terms, 57
grassroots cultural policy, 22
Graves, James Bau, 150n.21, 156n.7,
　　159n.40, 184n.13
Graw, Isabella, 78, 171n.40
Green, Brent, 79, 81
Green, Florence Kabwasa, 136,
　　152n.58, 179n.19, 180n.35,
　　186n.52

Hardt, Michel, 3, 148n.9
Hart, Jim, 176n.51
Hay, Deborah, 6, 150n.30
Herranz, Joaquín, 152n.58, 179n.19,
　　180n.35
higher education
　　fine arts, 90–6, 100, 102–3,
　　　174n.12, 187n.69
　　see also Clark Kerr, Andrew
　　　Delbanco, and Nancy Kindelan

Hinton, Stephanie, 148n.1, 156n.16,
　　180n.33, 180n.34, 183n.85,
　　184n.9, 187n.2, 187n.5
Hodsoll, Frank, 33–4
Houston, Sterling, ix
HowlRound, 61, 65, 163–3n.13,
　　164n.25, 167n.59, 167n.60, 167n.77
Hughes, Holly, x, 35, 153n.71
hybrid
　　artists, 74, 139
　　careers, 5
　　cultures, 3–4
　　identity, 3
　　knowledge, 118
　　training, 93–5, 100, 104
hybridity, 3, 134, 143, 148n.8
　　ethical, 25, 94
Hyde, Lewis, 6, 74, 83, 150n.27,
　　153n.73, 156n.9, 169n.18,
　　171n.41, 172n.65

Institute of Curatorial Practice (ICIP), 7
instrumental values. *See* values
International Sonoran Desert
　　Alliance, 120
intrinsic values. *See* values
Ivey, Bill, 48, 154n.77, 158n.32

Jackson, Maria Rosario, 63, 121–2,
　　136, 148n.2, 148n.3, 149n.10,
　　150n.20, 152n.58, 161n.86,
　　167n.67, 167n.71, 176n.40,
　　179n.19, 180n.35, 184n.6,
　　184n.15, 184n.20, 186n.52
　　Investing in Creativity, 110, 150n.28,
　　　151n.45, 153n.63, 155n.101,
　　　162n.95, 173n.80, 175n.17,
　　　178n.4, 183n.83
　　see "cultural kitchen" and "hybrid
　　　career"
Jacobs, Jane, 13
Jefferson, Margo, 6, 150n.31
Jefferson, Thomas, 34
Johnson, Amanda, 62, 154n.76,
　　154n.91, 167n.61, 167n.66,
　　167n.68, 167n.73
Johnson, Lyndon Baines
　　Great Society, 18, 146
Jump-Start Performance Co., 8–9

Kayim, Gülgün, 138–9
Keegan, Colleen, 83–4
Kerr, Clark, 93, 174n.15
Kester, Grant, 5, 60, 150n.23,
 150n.24, 161n.71, 166n.55,
 184n.12 Killacky, John, 114,
 122–3, 183n.83
Kindelan, Nancy, 93–4, 105, 174n.16,
 177n.65
Kingdon, John, 113, 180n.34
Knight Foundation, 131, 184n.15
Kozaka, Hirokazu, xvii
Kreidler, John, 17, 149n.12, 154n.75,
 154n.77, 154n.78, 169n.14,
 173n.90, 183n.1, 184n.10

labor, 5, 17, 20, 35, 64, 132, 148n.6,
 159n.33
 discounted, 12, 53, 57
Landesman, Rocco, 131–3, 138,
 184n.16
Landsman, Aaron, 84, 132, 173n.74
Languages of the Stage (LOS), 90, 96,
 100
Lee, Jae Rhim, 170n.34
Leeson, Lynne Hershman, 79
Lerman, Liz, 5, 109, 114, 139–40,
 150n.22, 187n.66
Lerner, Ruby, 73–80, 83–4, 87, 89,
 169n.15, 169n.19, 169n.20,
 170n.25, 170n.27, 170n.34,
 170n.36, 171n.39, 171n.47, 171n.48,
 171n.51, 172n.57, 172n.62, 172n.64,
 172n.66, 172n.70, 173n.86, 173n.88,
 173n.89, 173n.91
Leveraging Investments in Creativity
 (LINC), xvii, 15, 23, 27, 97–8,
 114, 116, 120, 126, 143, 153n.67,
 178n.8, 180n.37, 181n.62,
 182n.65, 182n.73, 183n.81
 Artist Council, 109–10, 121, 125,
 178n.15
 artists' health care, 118–19, 124
 Artography, 118–20, 125, 182n.77
 capstone event, 108, 121, 123
 Creative Communities Program,
 118, 122
 domains, 108, 115, 117–18, 130,
 181n.61

space development, 118–20, 124,
 136, 166n.54
time-dated (aka 10-year initiative),
 116–17, 123, 182n.65
"Liberation Lyrics," 137
LINC. *See* Leveraging Investments in
 Creativity
Lindemann, Danielle J., 100,
 175n.28, 176n.39
Lingo, Elizabeth, 100, 176n.42,
 176n.44, 179n.21
Lipschtick Collective, 63
Los Cenzontles, 120
Lynn, Kirk, 91, 98

Mapplethorpe, Robert, 16, 170n.26,
 170n.37
Markusen, Ann, xviii, 14, 46–7, 62,
 131, 138, 141, 147n.1, 48n.6,
 149n.15, 149n.18, 153n.64,
 154n.76, 154n.91, 154n.93,
 161n.80, 162n.103, 162n.109,
 165n.41, 167n.61, 167n.65,
 167n.66, 167n.68, 167n.72,
 167n.73, 174n.3, 180n.36,
 182–3n.79, 183n.2, 184n.14,
 185n.25, 186n.39, 186n.41,
 186n.43, 186n.63, 187n.65,
 187n.1, 187n.3
Marris, Peter, 113, 179–80n.31
Matthew, Vijay, 61
McCarthy, Kevin F., 14, 151n.42,
 152n.56, 153n.61, 154n.75,
 164n.23, 166n.52, 168n.88,
 186n.42
Mellon Foundation. *See* Andrew W.
 Mellon Foundation
Miller, Sam, 109, 114, 117, 120, 123,
 150n.32, 153n.67
Miller, Tim, ix, 35, 153n.71, 159n.39
Moore, Christi, 54, 165n.30
Moore, Steve
 Adam Sultan, 66, 168n.81
 The Physical Plant Theater, 66–7,
 168n.82
Mortimer, David, 33, 36, 38, 40,
 158n.27, 159n.45, 160n.63
movement. *See* arts and culture
 movement

National Association of Artist
 Organizations (NAAO)
 see Roberto Bedoya
National Association of Latino Arts
 and Cultures (NALAC), 125
National Endowment for the Arts, 15,
 18, 20, 27, 32–3, 39, 71,
 100, 111, 124, 127, 152n.59,
 154n.82, 155n.100, 155n.105,
 155n.1, 157n.20, 158n.22,
 158n.24, 158n.26, 158n.31,
 161n.80, 167n.72, 183n.2,
 184n.16, 184n.18, 185n.32,
 185n.34
 Our Town, 28, 135–6
 v Finley, et al., xiii, 35, 47, 147n.4,
 153n.71
 Workshop Program, 60
National Performance Network,
 148n.3, 162n.101, 172n.68,
 179n.21
NEA Four, 16, 35, 153n.71
Negri, Antonio, 3, 148n.9
neoliberalism, 20, 138, 154n.84,
 169n.12
NEW ARTiculations Dance Company,
 137
New WORLD Theatre, 114
NYFA
 New York Foundation for the Arts
 Source, 15, 113

Orr, Allison
 and Forklift Danceworks, 91, 98,
 139–41, 176n.35, 187n.70

Pa'I Foundation, 3, 120
 see also Vicky Holt Takamine
partnership(s), 43, 46, 69, 108–9, 123,
 126, 128, 133–5, 137, 166n.54
 lateralized, 135
Pasqua Yaqui Nation, 136
Pearl, Katie, 54–5, 163n.1, 163n.11,
 164n.19, 165n.34
Performance analysis, 2
performance studies, 2, 7, 152n.54,
 170n.26, 170n.37
performative acts, 35, 100
performative writing, 10, 159n.38

The Performing Arts in a New Era, 12,
 53, 152n.56
 see also Kevin F. McCarthy
Peters, Monnie, 39
Phelan, Peggy, 76, 159n.38, 170n.26,
 170n.37
philanthropy
 critiques of, 24, 65–6, 121–2,
 124–5, 130
 practices, 2, 27, 46, 63, 75, 77, 78
 responses of, 117, 125, 127
 see also INCITE and Peter Buffett
place
 critical context, 112
 theory of (*see* Michel de Certeau)
PLACE (People, Land, Art, Culture,
 and Engagement), 136–8
placemaking
 creative, 12, 26–8, 43–4, 63, 124,
 127–31, 134–8, 141, 143–4,
 155n.105, 161n.80, 167n.72,
 183n.2, 183n.5, 187n.72
policy
 argumentative, 10, 113, 151n.44,
 154n.85, 179–80n.31
 artist-driven, 44–6, 51, 124, 142,
 148n.3, 148n.7, 162n.101,
 167n.67, 184n.7
 arts and creative, 21, 66, 89, 133,
 154n.92, 155n.101, 158n.29,
 161n.69, 161n.86, 166n.55,
 167n.71, 168n.79, 176n.40,
 179n.27, 185n.28, 187n.72
 arts and culture, 13, 20–2, 36, 79,
 142, 178n.9
 cultural, 1–4, 7–11, 14, 16,
 19–23, 25–6, 30–1, 43, 58,
 63, 71, 75, 85, 89, 91–2,
 104, 111, 128, 142–4,
 148n.1, 148n.3, 152n.55,
 153n.70, 154n.87, 154n.88,
 154n.89, 157n.98, 156n.4,
 156n.5, 156n.16, 158n.30,
 161n.72, 162n.96, 162n.101,
 177n.62, 178n.18, 179n.21,
 179n.27, 180n.33, 184n.9,
 187n.2
 entrepreneurship (*see*
 "entrepreneur")

public, 10, 30, 32, 36–8, 48, 91–2, 123, 130, 135, 146, 151n.20, 157–8n.20, 158n.25, 160n.52, 174n.6, 174n.8, 179–80n.31
research, 10, 23, 89, 95, 144, 152n.55
strategies, 10, 41, 108, 178n.9
studies, 9–10, 57, 70
urban, 5, 111, 127–8, 135, 152–3n.60, 185n.52
Pourier, Lori. *See* First People's Fund
preditor, 7
President's Committee on the Arts and Humanities, 33–4, 158n.32
public
good, 5, 18, 34, 37, 49, 74, 108, 159n.33, 162–2n.113
Leveraging Arts Paradigm, 16
policy (*see* policy)
purpose, xvii, 23, 26, 29–30, 32–4, 43–8, 72–3, 85, 88, 91, 93–4, 108, 111, 115–16, 131, 137, 140–1, 143, 150n.21, 154n.86, 156n.7, 156n.11, 158n.28, 159n.34, 159n.36, 160n.60, 160n.68, 161n.70, 161n.73, 161n.78, 161n.81, 161n.85, 161n.87, 162n.89, 162n.94, 162n.98, 163n.115, 163n.9, 174n.5, 175n.24, 178n.8, 184n.13

race, xi, 2, 16, 19, 31, 65, 86, 91, 97–9, 111, 122, 132, 146, 171–2n.54
racism
structural, 122
Ragsdale, Diane, 52–4, 61, 163n.12, 164n.17, 164n.19, 164n.24, 165n.26
RAND
Corporation, 12–14, 151n.42, 153n.61, 164n.23, 186n.42
Reagan, Ronald, 33, 156n.3
Reagan Era, 18, 73, 76, 153n.71
Reck, Caroline, 54–5, 165n.35, 165n.36
Reed, Judilee, 109, 117–18, 120, 124–5, 134, 178n.15, 181n.55, 181n.61, 182n.78, 183n.86

revolution, 34, 88, 93, 155n.98, 159n.33
Reynolds, Laurie Jo, 77, 170n.34
Riggs, Marlon, 16, 153n.71
Ritter, Daniel, 33
Rockefeller Foundation, 14, 31–3, 111, 132, 157n.18, 170–1n.38
Rodriguez, Eugene. *See* Los Cenzontles
Rodriguez, Favianna, 109
Roosevelt, Franklin Delano
New Deal, 18
ROOTS. *See* Alternate ROOTS
Rossen, Rebecca, 90
Rude Mechs, also as Rude Mechanicals, 59, 63, 91, 165n.29
Fixing King John, 98
The Method Gun, 67, 168n.85
Stop Hitting Yourself!, 97–8

Salvage Vanguard Theatre, 59, 63
Sapphire, 16
Saracho, Tanya, 176n.34
Schumpeter, Joseph, 103, 177n.54
Scriptworks, 54, 64
Seiffert, Susan, 14, 178n.12, 183n.4
Serrano, Andreas, 16, 170n.26, 170n.37
Shane, Scott, 103, 177n.55
Shaw, Peggy, 7, 150n.34
Shigekawa, Joan, 111, 131–3, 138, 184n.19
Sidford, Holly, 14, 46, 110–18, 122, 148n.3, 149n.10, 151n.37, 162n.106, 177n.1, 178n.7, 178n.8, 178n.16, 178n.17, 178n.18, 179n.29, 180n.34, 180n.36, 180n.37, 181n.44, 181n.52, 181n.54, 181n.56, 181–2n.63, 182n.65, 182n.66, 182n.70, 182n.72, 182n.74, 183n.80, 183n.82, 183n.83, 183–4n.5
Wellspring, 116
Simonet, Andrew, xvii, 84, 173n.74
Slattery, Phyllis. *See* Dance Umbrella
SNAAP. *See* Strategic National Arts Alumni Project
space(s)
alternative, 42, 60, 127

space(s)—*Continued*
 development, 118–20, 124, 136,
 166n.54, 186n.52
 theory of (*see* de Certeau)
Stern, Mark, 14, 178n.12, 183n.4
Strategic National Arts Alumni
 Project (SNAAP), 44–5, 90–1,
 96, 99–100, 104, 162n.91,
 175n.22
Sundiata, Sekou, 109

Takamine, Vicky Holt, 3, 120
Taylor, Diana, 11, 36, 38–41, 81,
 148n.5, 151n.46, 151n.47,
 152n.54, 159n.42, 159n.46,
 160n.48, 160n.53, 160n.55,
 160n.58, 160n.65, 160n.66,
 181n.51
Teatro Vivo, 63
Tepper, Steven J., 14, 29, 100, 148n.1,
 156n.5, 156n.16, 176n.42,
 176n.44, 179n.21, 180n.33,
 180n.34, 183n.85, 187n.2,
 187n.5
Thomas, Kelland, 104, 168n.85,
 177n.61
Thompson, Lisa B., 97–9, 176n.36,
 176n.38
Tohono O'odham nation, 121, 136
Transforming Arts Teaching, 94
Trash Dance, film, 98, 139–40,
 176n.35
 see also Allison Orr
Trouble Puppet Theatre, 66, 97–8,
 276n.37
Tucson Pima Arts Council, 47, 136–7,
 186n.53

Ukeles, Mierle Laderman, 140,
 187n.69
Uno, Roberta, 114, 117–18, 121–5,
 147n.2, 180n.38, 181n.53,
 182n.73, 183n.83, 183n.88,
 183n.89, 183–4n.5
Urban Institute, xvii, 13–14, 110–11,
 114, 121, 179n.27
Urban Word, 120

values
 instrumental, 134, 186n.42
 intrinsic, 135, 186n.42
Venkataraman, Sankaran, 103,
 177n.55
Vincent, Christine, 110
Vogel, Harold L., 133, 154n.92,
 161n.69, 168n.79, 185n.28
VORTEX Theatre, 51, 59, 63, 67–8
 see also Bonnie Cullum

Warhol, Andy, 78, 186 n.38
 Foundation, 71, 74, 78, 80–81
Wellspring. *See* Holly Sidford
Williams/Coleman Amendment, 16
Wilson, Risë, 118, 181n.55
Wyszomirski, Margaret Jane, 16, 29,
 33, 108, 133, 154n.74, 154n.92,
 155n.101, 156n.4, 158n.29,
 158n.30, 160n.59, 161n.69,
 166n.55, 166n.58, 167n.71,
 168n.79, 169n.13, 176n.40,
 177n.3, 178n.9

The Yes Men, 77, 170n.34
Young, Marcus, 138
Youth Speaks, 125, 183n.5

CPSIA information can be obtained
at www.ICGtesting.com
Printed in the USA
LVOW09*1413060217

523350LV00006B/28/P